Saul Steinberg

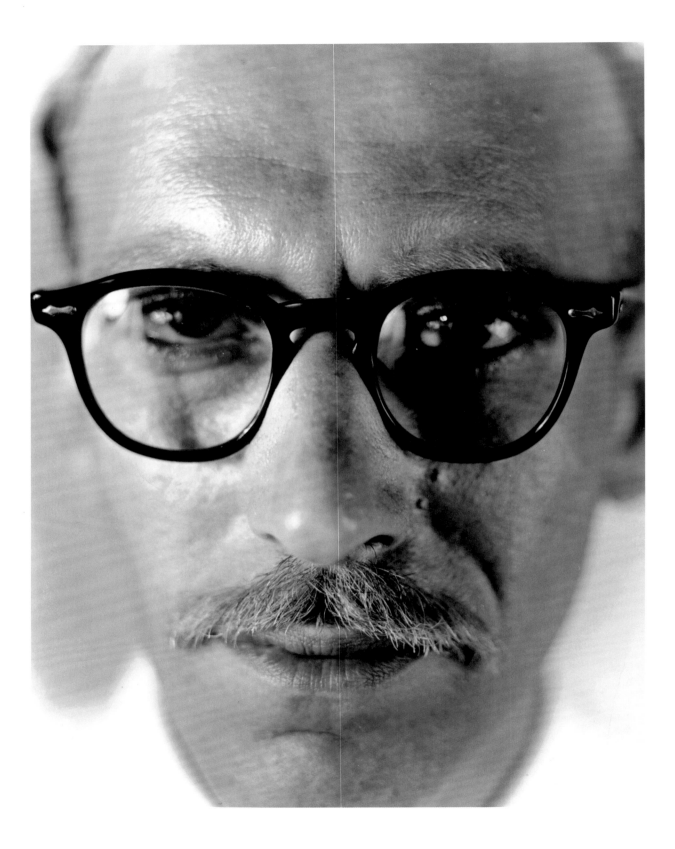

Saul Steinberg

ILLUMINATIONS

Joel Smith

Introduction by Charles Simic

YALE UNIVERSITY PRESS, NEW HAVEN AND LONDON

This book was published on the occasion of the exhibition *Saul Steinberg: Illuminations*, organized at the Frances Lehman Loeb Art Center, Vassar College, Poughkeepsie, New York.

Major funding for the publication has been provided by a generous gift from Carol and Douglas Cohen.

Funding for the exhibition and publication have been provided by the Horace W. Goldsmith Foundation and Furthermore: a program of the J. M. Kaplan Fund.

Exhibition Itinerary

The Morgan Library & Museum, New York
November 30, 2006–March 4, 2007

Smithsonian American Art Museum, Washington, D.C.
April 6–June 24, 2007

Cincinnati Art Museum, Cincinnati, Ohio
July 20–September 20, 2007

Frances Lehman Loeb Art Center, Vassar College,
Poughkeepsie, New York
November 2, 2007–February 24, 2008

Project Director: Mary DelMonico
Designer: Katy Homans
Printing and binding: Conti Tipocolor, Italy

Published in 2006 by
Yale University Press
P.O. Box 209040
New Haven, Connecticut 06520-9040
www.yalebooks.com

Library of Congress Cataloging-in-Publication Data
Smith, Joel, 1964–
Saul Steinberg : illuminations / Joel Smith ; with an introduction by Charles Simic.
p. cm.
Published on the occasion of an exhibition, organized by the Frances Lehman Loeb Art Center, Vassar College, Poughkeepsie, N.Y. and held at the Morgan Library, N.Y., Nov. 30, 2006–Mar. 4, 2007 and other locations.
Includes bibliographical references and index.
ISBN-13: 978-0-300-11586-4 (hardcover : alk. paper)
ISBN-10: 0-300-11586-5 (hardcover : alk. paper)
ISBN-13: 978-0-300-12179-7 (pbk. : alk. paper)
ISBN-10: 0-300-12179-2 (pbk. : alk. paper)
1. Steinberg, Saul—Exhibitions. I. Steinberg, Saul. II. Vassar College. Frances Lehman Loeb Art Center. III. Pierpont Morgan Library. IV. Title.
N6537.S7A4 2006
741.5—dc22

2006011854

The paper in this book meets the guidelines for permanence and durability of the Committee on Production Guidelines for Book Longevity of the Council on Library Resources.
10 9 8 7 6 5 4 3 2 1

Front cover: *Untitled (Pineapple)*, c. 1970 (detail, cat. 65).
Back cover: *I Do, I Have, I Am*, 1971 (cat. 67).

Frontispiece: Saul Steinberg, c. 1950. Photograph by Charles Eames © 2006 Eames Office LLC (www.eamesoffice.com). YCAL.

Contents

Foreword

Saul Steinberg never wanted for critical champions or an enthusiastic public. One of the most popular and widely acclaimed artists at *The New Yorker*, he also had a successful parallel career in the galleries and museums of the Americas and Europe. Nevertheless, the traveling Steinberg retrospective organized by the Whitney Museum of American Art in 1978 marks the last time the museum-going public had an opportunity to see the artist's work in depth. The present show catches us up on what Steinberg, actively reinventing himself till the end, did in the two decades that followed. At the same time, it brings to light a great variety of work he did in the 1940s and 1950s, highly visible in its time but all but forgotten by his later years.

This exhibition, the brainchild of Joel Smith, former Frances Lehman Loeb Art Center curator, found its genesis at Vassar College—an institution that encourages broad and independent curatorial thinking. Smith's revisionist approach to Steinberg's role in postwar American art represents the kind of curatorial research and thinking that thrives in an academic museum. But the subtlety and trenchant wit of Steinberg's art, and its revealed import for modernist studies, reach out beyond the campus to a national and international audience.

As befits Saul Steinberg, who made his career in New York City, the exhibition will begin its four-venue tour at the newly renovated Morgan Library & Museum in New York. Our thanks go to Charles E. Pierce, Jr., its director, for agreeing to be the opening venue. It has been a pleasure to work with the staff at the Morgan. I would also like to thank our other museum partners, the Smithsonian American Art Museum in Washington, D.C., and its director, Elizabeth Broun, as well as the Cincinnati Art Museum and its former director Timothy Rub for their commitment to welcoming Saul Steinberg's art into their institutions and into the consciousness of their publics.

Saul Steinberg: Illuminations received the full support of The Saul Steinberg Foundation, which opened its repository of material to Joel Smith and became an indispensable collaborator. Our gratitude goes to the Foundation and, particularly, to its director, Sheila Schwartz. Her unwavering support and dedication to this project have resulted not only in an excellent selection of work for the exhibition but also in an exceptionally comprehensive and beautifully produced catalogue. We were also very fortunate to receive funding for this exhibition and its publication from the Horace W. Goldsmith Foundation and Furthermore: a program of the J.M. Kaplan Fund. We are indebted to these foundations for their significant support.

Steinberg's great visual wit is a quickly acquired taste. I hope his nimble mind and pen will enhance the worldview of the many visitors to this exhibition.

JAMES MUNDY

The Anne Hendricks Bass Director
Frances Lehman Loeb Art Center, Vassar College

Untitled (Family Group),
1965–68. Ink, pencil, colored
pencil, crayon, and ballpoint pen
on paper, 23½ x 14 in. (59.7 x
35.6 cm). Collection of Carol and
Douglas Cohen.

7

Acknowledgments

A few years ago, proposing a Steinberg retrospective raised a formidable logistical challenge, for much of the artist's oeuvre resides in widely scattered, largely uncatalogued private collections. Moreover, owing to a stipulation in Steinberg's will, the drawings and sketchbooks he gave along with his papers to the Beinecke Library at Yale—some thousands of works—cannot be exhibited until 2009. But a collection of larger works, bequeathed by the artist to The Saul Steinberg Foundation, raised the tantalizing possibility of a full-length career survey. Key loans from a dozen other collections brought the retrospective to fruition. My first debt is to the lenders, who agreed to part with extraordinary objects for several months for the benefit of the public, and whose generosity has in many cases included gifts of time, memories, and suggestions.

The research leading to this exhibition and catalogue began in 2002. Since then, the support of The Saul Steinberg Foundation, New York, has been indispensable and constant. Wherever a fact in this book is rendered correctly—not to mention intelligibly—the Foundation's executive director, Sheila Schwartz, deserves no small part of the credit. James Mundy, director of the Frances Lehman Loeb Art Center, Vassar College, backed the project during the three years it dominated my mind, and my fellow staff members at Vassar, notably registrar Joann Potter, assistant registrar Karen Casey Hines, coordinator of education and public programs Kelly Thompson, and preparator Bruce Bundock, helped make the concept a reality. Since moving to a new position at the Princeton University Art Museum late in 2005, I have relied on the understanding of my director, Susan Taylor, who recognized that finishing a job right—especially while starting another one—takes time and attention.

The Kautz Family Foundation provided invaluable research support during my time at Vassar, and a Jackson Brothers Fellowship at the Beinecke Library, Yale University, in the fall of 2005 made it possible to carry out the final phase of research. For their gracious assistance during that visit and my previous stays in New Haven, I am grateful to the library's staff and curators.

The quality of the book is owed to the dedicated efforts of Teresa Christiansen, photographer; Mary DelMonico, project director; Katy Homans, designer; and, at Yale University Press, Patricia J. Fidler, publisher, art and architecture.

It is absurd that an artist's first full-scale scholarly monograph should bear the name of a lone author. This book could not have existed without the aid of an international corps of allies and experts, whose research and legwork, undertaken for the Foundation or at my request, swelled the documentary files: in Brussels, Anne Adriaens-Pannier, Musées Royaux des Beaux-Arts, and Claude Haber; in São Paulo, Daniel Bueno; in Bergamo, Piervaleriano Angelini; in Milan, Aldo Buzzi and Franco Gambarelli; in Venice, Francesca Pellicciari; in Roncole Verdi, Alberto and Carlotta Guareschi of the Guareschi Foundation; in Washington, D.C., Radu Ioanid, United States Holocaust Memorial Museum. Key assistance in New York came from Greg Captain and his staff at The New Yorker Imaging Center; Arne Glimcher, Marc Glimcher, Elizabeth Sullivan, and Beth Zopf of PaceWildenstein; Adam Baumgold of the Adam Baumgold Gallery; Margaret Poser; Liana Finck; John P. Jacob, director, Estate of Inge Morath;

and Alexander S.C. Rower, director, the Calder Foundation. Richard and Ronay Menschel offered unfailing encouragement and countless kindnesses. Mia Fineman's part in this book is unclassifiable and immeasurable.

Footnotes are too narrow and literal a device to reflect the extent of my debt to Steinberg's friends and colleagues. For insights on the artist's life, mind, world, and times, I am grateful to Roger Angell, Prudence Crowther, Ian Frazier, Lee Lorenz, Frank Modell, Françoise Mouly, Leo Steinberg, Hedda Sterne, Anton van Dalen, and Karen Van Langen. Special thanks to Charles Simic for his inspired and inspiring introduction. —J.S.

This book is dedicated to Hedda Sterne.

Lenders to the Exhibition

Angelini Collection

Tom Bloom

Carol and Douglas Cohen

Carol and B.J. Cutler

Lawrence Danson

Sivia Loria

Richard and Ronay Menschel

The Saul Steinberg Foundation

Hedda Sterne

Michael Ulick

Anton van Dalen

Two private collections

The Passport, p. 39.

Abbreviations and Notes to the Reader

Archives

SSF The Saul Steinberg Foundation, New York. The Foundation is the repository for artworks by Steinberg as well as original archival material and copies of documents related to the artist. Works held by the Foundation are identified by their inventory numbers.

StL The contents of Steinberg's New York City library, bequeathed by the artist to Anton van Dalen.

TNYR *The New Yorker* Records, Manuscripts Division, New York Public Library.

YCAL Yale Collection of American Literature, Beinecke Rare Book and Manuscript Library, Yale University, New Haven, to which the artist bequeathed his papers, sketchbooks, and smaller works of art. The Saul Steinberg Papers are Uncat. Mss. 126. Box numbers and folder titles refer to this collection unless otherwise indicated. Some cited materials were assigned new locations in the fall of 2004, after the author had examined them. In such cases, the former box location appears in brackets.

Sketchbooks and single-sheet drawings are identified by their YCAL inventory numbers alone.

References

All in Line (1945), **The Art of Living** (1949), **The Passport** (1954), **The Labyrinth** (1960), **The New World** (1965), **Le Masque** (1966), **The Inspector** (1973), **The Discovery of America** (1992) Books of drawings compiled by Steinberg (see Bibliography, p. 268). All but the last are unpaginated. For convenience of reference, page numbers have been assigned, p. 1 being the first drawing following the title page.

Glueck 1970 Grace Glueck, "The Artist Speaks: Saul Steinberg," *Art in America* 58 (November–December 1970), pp. 110–17.

Gopnik interview Adam Gopnik, typescript interview with Steinberg, dated February 1986, YCAL, box 78, folder "Talk with Gopnik."

IVAM 2002 *Saul Steinberg*, exhibition catalogue. Valencia: Institut Valencià d'Art Modern, 2002.

June 1986 interview Unsigned typescript titled "Saul Steinberg Interview," dated June 1986, YCAL, box 78, folder "Talk with Gopnik."

Lettere Saul Steinberg, *Lettere a Aldo Buzzi 1945–1999*, ed. Aldo Buzzi (Milan: Adelphi Edizioni, 2002). The translations used in the present catalogue were made by John Shepley (letters, 1945–77) and James Marcus (letters, 1978–99) for an English edition now in preparation.

Loria 1995 *Saul Steinberg: Fifty Works from the Collection of Sivia and Jeffrey Loria* (New York: Jeffrey H. Loria, 1995).

Reflections Saul Steinberg with Aldo Buzzi, *Reflections and Shadows*, trans. John Shepley (New York: Random House, 2002).

Smith 2005 Joel Smith, *Steinberg at The New Yorker*, introduction by Ian Frazier (New York: Harry N. Abrams, 2005).

WMAA 1978 Harold Rosenberg, *Saul Steinberg*, exh. cat. (New York: Whitney Museum of American Art, 1978), with a chronology by Steinberg, pp. 234–45.

Catalogue Entries

The catalogue entries of many works include prior publication data under the heading "Published." Listed here are a work's first known appearance in print, its publication in the artist's own books (see above), contemporaneous reprints in selected periodicals or books, and reproductions in exhibition catalogues. Subsequent secondary republications of images are cited when relevant to Steinberg's own intentions or the critical reception of the work.

The Labyrinth, p. 250.

Steinberg's Bazaar

CHARLES SIMIC

To walk the streets of New York City with Saul Steinberg was as pleasurable an experience as looking at one of his drawings. He'd stop and point out things to me: a dog who barked now and then as if to reassure himself that he was still a dog; tropical fish in the window of a pet store watching pop-eyed as a long-legged woman in a short skirt extricated herself from a limousine; a small, red-cheeked boy on Lexington Avenue proudly pulling by a long string a smiling wooden monkey on wheels. Steinberg's comic sense was involuntary. These street scenes were, like his cartoons, in no need of captions. There was always the element of surprise, and yet one understood at once what one was seeing. We would be talking about god-knows-what and here would be a sight to either confirm or contradict what we had just said. Dickens needed the immense labyrinth of London streets to write his novels; Steinberg's work is, of course, unimaginable without New York, and yet there was a hidden side to it. As an immigrant he could not help but remember many other places. He walked out of his front door with eyes wide open as if he had just arrived from a foreign country, rediscovering the street and the city where he lived for many years.

Born in Romania in 1914, Steinberg grew up in Bucharest, studied architecture in Italy, and with the war already in progress managed to reach the United States in 1942. I got to know him well toward the end of his life. Saul said that the reason we understood each other perfectly was that we were both reared in what he called "the Turkish delight manner." I knew exactly what he meant. When I was growing up in Belgrade, our homes combined Western-style furniture with furnishings that could have come from a sultan's seraglio. In every room, the Ottoman and Austro-Hungarian Empires still fought their battles. Most of the time one took in stride such a clash of civilizations. The city itself was surrounded by countryside by and large untouched by modern life. One could literally take a pick in what century one wanted to spend one's holidays. There was the twentieth century in the heart of the city, with its neon lights, movie houses, sidewalk cafés, and streets packed with cars; the nineteenth century in older neighborhoods, with horse-pulled wagons, beer taverns, gypsy peddlers, and backyards of apartment houses and small homes where children played happily in company of chickens, ducks, and an occasional pig. Depending on how far one ventured into the interior over the unpaved roads, one was liable to find every century back to the fourteenth. That mixture of cultures, religions, and ethnic groups, many of which went about still wearing their peasant costumes, gave the Romanian and Serbian towns of the period the look of Ellis Island. The United States may have been made-to-order for Steinberg, but the Balkans he came from was already a huge costume party.

In cities, there were buildings that simulated Paris and Vienna next door to mosques and houses that would have looked at home in Istanbul. Many stores still had picture signs on their shingles to help the illiterate customer. There'd be a man wearing a hat, a man smoking a pipe, a fat man with a napkin around his neck holding a fork and a knife. Steinberg had an uncle who was a painter of that type of

Luna Park, 1968. Collage, crayon, and watercolor on paper, 29 x 23 in. (73.7 x 58.4 cm). Private collection.

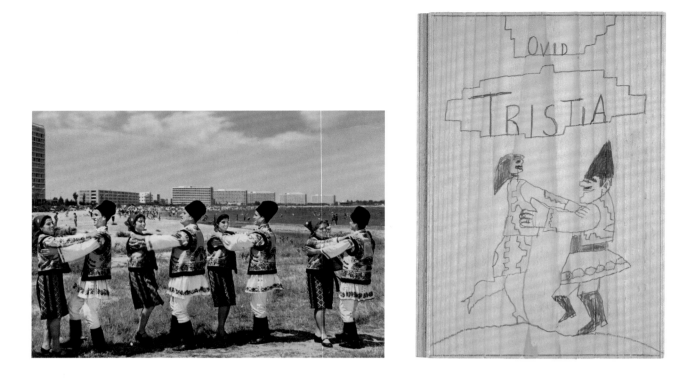

image. His father, too, was an artist of sorts. He manufactured boxes for chocolates, bonbons, and sugar-coated almonds with glossy imitations or reproductions of famous paintings like Raphael's *Sistine Madonna*, its pensive angel with an elbow propped on a cloud. In his memoir, Steinberg tells of another uncle who kept in the window of his shop—which sold watches, musical instruments, gramophones, and records—an automation of a clown who moved his head and eyes to lure the country yokels. Even in his youth, Steinberg was familiar with an amalgam of styles and ready-made sentiments and clichés whose American equivalents he was to encounter when he came to United States.

I recall my own arrival in New York, August 1954, when the city was only five days away by ship, but felt as distant as Tibet feels today. We checked into a hotel just off Times Square and after quickly freshening up ran out to see the famous billboards and signs. The city was full of surprises. There were skyscrapers, but also shacks, streets full of enormous yellow cabs, drugstores selling ice cream and sandwiches, greasy spoons with booths and jukeboxes built, as Steinberg said, according to the laws of Catholic, Chinese, and Hindu altars, dance halls, penny arcades, pawnshops with trumpets, violins, radios, and roller skates displayed in their windows, cigar stores with racks of movie magazines and comic books, novelty shops with exploding cigars, false beards, spoons with realistic dead flies on them, street vendors selling potato peelers, beauty schools that taught young women manners, storefront churches, shoe shine parlors, Salvation Army bands, banks that looked like Roman temples, policemen mounted on horses with revolvers on their hips bending down to write parking tickets, appliance stores with dozens of TV sets all showing the same baseball game, street preachers waving dog-eared Bibles and announcing that the end of the world is near to a motley crowd wearing business suits, straw hats, Hawaiian shirts, blue jeans, and, strangest of all, neckties with bathing beauties painted on them. As exotic as Manhattan was, even more foreign-looking to a European was the borough of Queens, across the river, with its rows of identical houses, boulevards lined with gas stations, diners, supermarkets, car washes, miniature golf courses, and the view of the city skyline in the distance. Being an immigrant made one into a child again, Steinberg said. A child who talked funny and noticed things natives never did. Beauty in America came as a surprise; it seemed to be an accident, and was unlike any experience of beauty he'd had before.

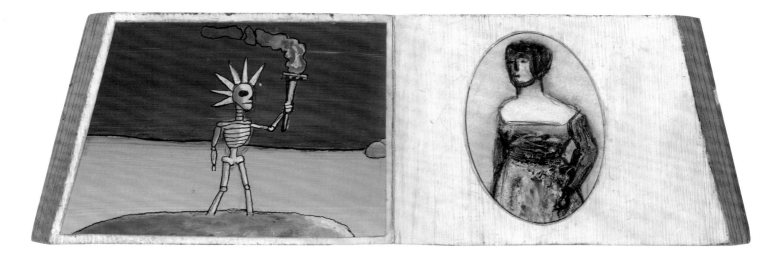

Open book (Death as Liberty and portrait), c. 1990. Pencil, paint, oil, marker pen, and ink on canvas mounted on carved gessoed wood, 14¾ x 4¾ x ⅜ in. (37.5 x 12.1 x 2.2 cm). SSF 5910.

Steinberg was like an old-time explorer. A modern de Soto or La Salle who set out by bus to discover the vast continent beyond the Mississippi River. The drawings he made on these trips are a kind of journal, an explorer's account of the fabulous creatures and landscapes he encountered on his way. Everything interested him: billboards, cars, shop windows, diners, menus, postcards, labels, graffiti, posters, and other such things that one rarely, if ever, saw in American art of that time. His books of drawings are like old Sears, Roebuck catalogues where one used to find everything from wedding dresses to snow boots and bicycles. Of course, this is not how most immigrants saw America. We are familiar with the elitism of European intellectuals who came in the 1930s and 1940s and their horror of popular culture. Steinberg was neither horrified nor seduced by bad taste. Beauty queens on pedestals, old ladies playing bingo, with rhinestone eyeglasses and feathers and strawberries on their hats, drive-in Chinese restaurants shaped like pagodas that sold both chop suey and tamales—all were lovingly depicted in his drawings. America was a place where the aesthetic ideas an artist brought from elsewhere had to be radically revised. To find the new, one had to give up the old, he would say.

Most immigrants didn't bring much with them to America beyond a few possessions. That usually included family photographs, birth, wedding, and death certificates, old passports and school pictures and diplomas stamped with official seals, scribbled over with multiple signatures and smudged with thumbprints. Dog-eared, yellow and crumbling, tucked away in attics and closets, they continued to disintegrate. As one can see from this exhibition, Steinberg made frequent use of these documents in his art. They are far more melancholy than they are funny, since they commemorate lives from which only one illegible scrap of paper remains. Of course, he too was a part of that vanished world. It haunted him. The memory of the Balkans' bloody history was a constant topic of our conversation. The older he grew, the darker his vision became. America changed for him in 1960s. The war in Vietnam and the violence in the cities frightened him. Steinberg's cops and soldiers on the streets of American cities recall the goose-stepping Fascists in his drawings of Mussolini's Italy. They have the appearance of little wind-up toys, self-important and mean. The gap between America's idealized image of itself embodied in its myths and the very different reality was the constant subject of his art. While in his earlier work he poked fun at our quirks and self-delusions, by the 1970s his vision of America had become

nightmarish. The old, serene mask of happiness had turned ugly with anger and pain. In place of a long-legged drum majorette leading a parade of smug, identical looking businessmen, there was now a skeleton bearing the torch of Liberty. One doesn't think of Steinberg's art as being political, but given how much Hitler and Stalin were responsible for how his life turned out, it was almost inevitable that his art would become more and more so.

Seven years after his death, Saul Steinberg is both a familiar name and an artist in need of discovery. This strange, posthumous fate would have puzzled him and confirmed his suspicion that the critics never had any idea what to do with him. In order to make himself an original, an artist usually tends to cultivate one style, one idea of art, to the exclusion of all the others. That was not how Steinberg went about it. Every style, every technique of representation—from children's drawings and idle doodles of grownups to classical, baroque, mannerist, expressionist, and other more or less abstract ways of image-making—can be found in his work and at times within the same drawing. For Steinberg to draw in a certain way was to express a point of view, construct a version of reality that implicitly carried both philosophical assumptions and unsuspected comic consequences. Like all immigrants, Steinberg had to reinvent himself, and he did so continuously in his drawings. He was between worlds, in more ways than one, which is not a bad place to be for someone who wants to elude being classified as this or that. With a lightness of touch that concealed his keen intellect, the depth and complexity of his ideas, he reminds us that the fantastic and the natural, the comic and the serious all belong together. Since most immigrants' lives, as a matter of course, resemble the Theater of the Absurd, taking such contradictions in stride was perfectly understandable on his part. For many of us, the story of exile ended up being a philosophy of laughter.

The Art of Living, 1949, p. 16.

Untitled (Subway), c. 1983. Ink, colored pencil, pencil, and marker pen on paper, 13 x 19½ in. (33 x 49.5 cm). YCAL 4134.

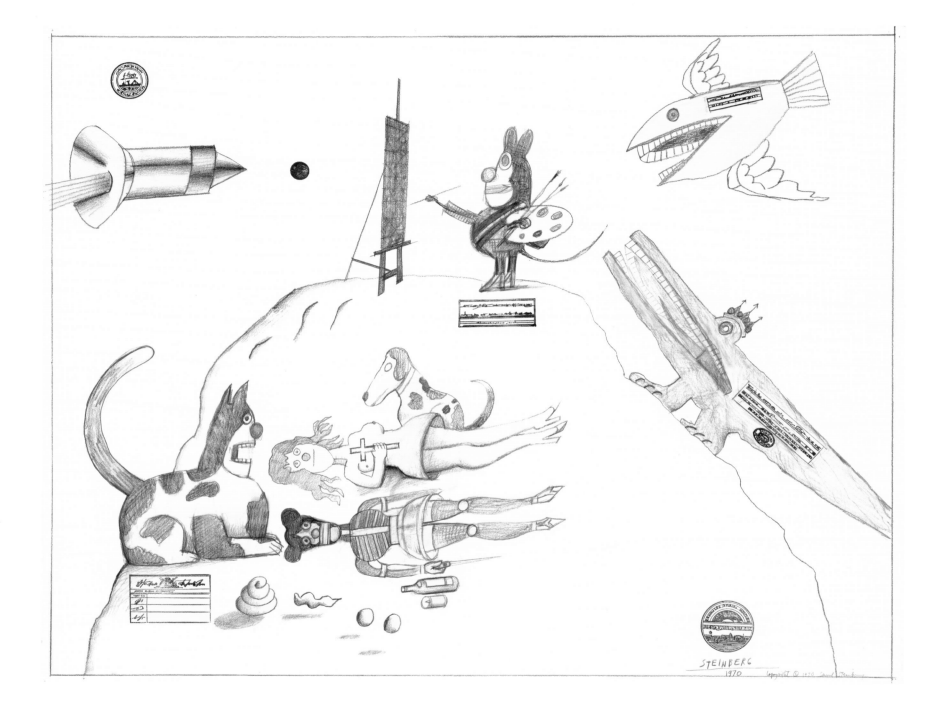

STEINBERG
1970

Illuminations, or The Dog in the Postcard

JOEL SMITH

All the value of my book, if it has one, will be to have been able to walk steadily on a hair suspended between the double abyss of lyricism and vulgarity....

GUSTAVE FLAUBERT, 1852[1]

Artist: as its title declares, a vocational self-portrait (fig. 1). Saul Steinberg's Artist, palette in hand, plies his trade atop an exposed crag. It hardly looks like Parnassus. To judge by the mixed company he keeps, we might be seeing Flaubert's "double abyss," yawning out to either side. A tricolor sash, though doubtless well intended by its conferring academy, does not manage to lend our pop-eyed, pot-bellied, cartoon-mouse hero much dignity—nor much protection, as he is beset from all sides by power, sex, race, drink, status, violence, bureaucracy. The canvas on his easel is turned too obliquely to be read, but surely the buzzing impedimenta around the Artist—which are, after all, the material he has to work with—are making themselves at home there. Whether disguising them in surreal masquerade or distilling them into abstract form, he is turning his shades into subject matter, his obstacles into illuminations.

Steinberg differed from his Artist in an important respect: his art took shape not on stretched canvas but on sheets of drawing paper, often en route to the printed page. The difference transcends a question of materials, but it begins there. Primed canvas is an artworld aristocrat, destined for life in a framed estate on a lit gallery wall, guarded by a stern-faced label. The citizen-objects Steinberg turned out were lower born. His drawing sheet was cousin to the ephemera he saved, studied, and imitated (cats. 20, 21, 30, 64): the paperwork that substantiates a life in, as he politely called it, "organized society." A birth certificate, a school photo, a diploma, a paycheck, a passport, a postcard, an obituary—for Steinberg they comprised a paper concordance to the capacities of the human animal. He drew from (and into) this great extended family of human gestures on paper because his subject was the public life of the private mind, as seen in the bottomless archive modernity churned out, each sheet certified (as is many a Steinberg drawing, including *Artist*) by the seals and scribbles of official business.

Steinberg's business was illumination, in several senses of the word. His art's history, for one, was not painting's history, but originated in the illuminated manuscript, where word and image had been equal partners in an art addressed to readers.[2] "Cartooning" and "illustration" were only the most recent names assigned to art made for communication—a tradition that, as Steinberg said, had "remained modern through a lack of respectability."[3] Its mission, advanced by predecessors such as James Gillray

and Honoré Daumier, J.J. Grandville and Thomas Nast, was to illuminate: to throw light upon subjects that were (in Steinberg's phrase) "too small to be noticed," or too rude to discuss, or too distant from the hearthside to have entered public awareness.[4]

For Steinberg, finally, the word "illuminations" carried a more specific charge. Having grown to maturity through a series of emigrations, from Bucharest to Milan to New York, he found his one inalienable homeland in literature. Among his strongest identifications was with Arthur Rimbaud (1854–1891), who in late adolescence had written the prose-poems published as *Illuminations*. Even more evocative to Steinberg than Rimbaud's writing was his life, a masterpiece no modernist rebel would ever top. Rimbaud conjured his works of sheer genius as though out of thin air, and at age twenty-one disappeared as though into it. His self-imposed exile to life as a trader in Africa, beyond the reach of any academy's sash-bearer, became Steinberg's emblem for the unassimilability of the true artist, whom he liked to define as one who leaves home to "become someone else."[5]

This absorption with Rimbaud reflects an important strain of the artist's imagination: as he reminded himself in a note, "A good part of my mind is 19th century."[6] Besides his friends among the New York School painters, Steinberg found his spiritual contemporaries in Stendhal, Dickens, Flaubert, Gogol, Tolstoy—the inventors of the modern novel, who had set out on their journey without benefit of a road map. Steinberg's work appeared in public, for that matter, more often in literary company than with art: his six-decade association with *The New Yorker* magazine gave him a place in the week-to-week reading life of a bright, nonspecialized, curious constituency.[7] Publication in books and magazines put Steinberg's images before thousands more viewers than his painter friends could dream of. And here-in lies a challenge for criticism. Steinberg called himself a "writer who draws."[8] More to the point, his art behaved, socially, like writing; that is to say, it was ubiquitous in middlebrow daily life, which meant it was widely admired, perpetually thought about—and a longshot for making it into the literature of "art history."

A history of twentieth-century art that makes room for Steinberg's career in all its complexity will supply a more compelling account of modernism than exists today, and not only because Steinberg will be in it. A point vaguely granted but never really addressed in art history is that mass-produced, mass-consumed imagery was more than an enriching sideshow to "modernist" visual invention. The printed page, indeed, supplied the dominant source and central clearinghouse for modern imagery, beside which fine art's proper dispensation is that of a vital, engaging footnote. (In relation to this unexceptionable truism, which supplied the initial motive for Pop Art, the academy has by and large been like the dog in the Zen parable: Andy Warhol pointed at the moon, and art historians have looked at his finger.[9]) How, then, to discuss an artist whose work made itself at home all up and down the scale of brow-heights—an artist who created one of the most widely known (and widely exploited) images in postwar history (cat. 76)—and who is to be found in no general survey of modern art?[10]

Though he has been too seldom recognized as such, Steinberg was among the key creative figures who fled from Europe to the United States to escape Fascist persecution.[11] He figured prominently in a distinctive postwar network of Europeans and Americans (identified today with John Entenza's *Arts & Architecture* magazine, the houses of Richard Neutra, and the designs of Charles and Ray Eames) who converted the promise of modernism into terms that fit mass culture. They translated what had been—in America, especially—a quiet rustle of movement within the elite visual canon into the functional stylebook and iconography of postwar life. Along with the highbrow avant-garde, whose disputes and triumphs have assumed center stage in art historical surveys, there was a middlebrow

avant-garde that addressed the possibilities of mass-produced and mass-distributed artwork—and thus, in substantial ways, transformed mass sensibilities.[12]

The most recent American retrospective of Steinberg's career—in fact, his last solo museum exhibition in America—was organized at the Whitney Museum of American Art in 1978. The selection of work for that show was driven by Steinberg's priorities of the moment; as a result, his gallery-oriented, collector-owned artwork of the preceding fifteen years or so dominated, at the expense of art he had created, chiefly for publication, during the first half of his career. Rather than extend that approach to the end of the artist's life, or counter it with an equally distorted image of him as a simple populist, the present survey represents an attempt to see Steinberg in the round. His story is that of a perpetual work in process, periodically reinvented as he slipped the bonds of one mode or discipline after another. In training and in predisposition (though never in practice), he was an architect. Yet he owed his skill as a constructor of instantly legible images to his self-education as a cartoonist. The same qualities that lifted his cartoons above the limitations of the genre pushed upon him the mantle of artist—and with it, a new set of limitations. By the end of his life, Steinberg maintained a healthy distance from questions about his "placement." He at least had the satisfaction of knowing that his career, end to end, was unlike any other. He owed his unique achievements to his origins in a time and place off the cultural map, to the pursuit of an unvalorized but cherished art form, and to his unfashionable grounding in history and literature. These facets of Steinberg's life and work made him the Artist and—to propose a broader, more generous term, better fitted to his singular role—the Illuminator he was.

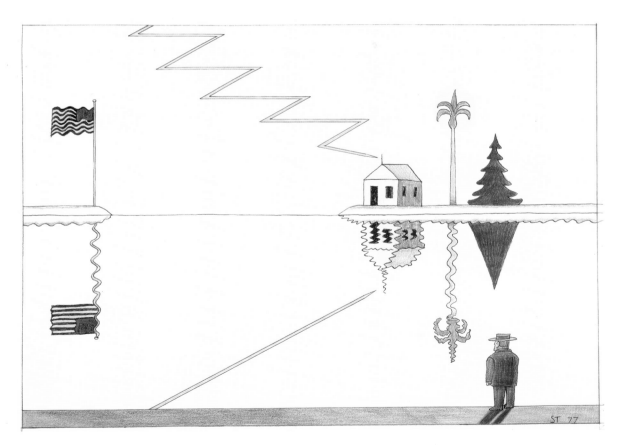

2. *Untitled (Reflections)*, 1977. Pencil, ink, colored pencil, and crayon on paper, 13¾ x 19 in. (34.9 x 48.3 cm). SSF 6277.

[Painters] *did* think about the possibility that the things—the horse, the chair, the man—were abstractions,
but they let that go, because if they kept thinking about it, they would have been led to give up painting altogether,
and would probably have ended up in the philosopher's tower. When they got those strange, deep ideas,
they got rid of them by painting a particular smile on one of the faces in the picture they were working on.

WILLEM DE KOONING, 1951

[B]ecoming an artist was not, it is not an intention. I don't think that anybody starts with the absolute
idea of being an artist. . . . Sure, you decide to become a museum artist, you can decide that, but in my eyes that's
just as bad as becoming a commercial artist, in the sense that you are not anymore a modern artist.
You are subjected to the pope and the prince. The nature of the modern artist is to search,
is to be in a precarious position and to be non-professional.

SAUL STEINBERG, 1986

(ON KNOWING WHAT GIVES US) PLEASURE:
It is idle to say that this is easily known—it is the highest and most neglected of all arts and branches of education.

THE NOTEBOOKS OF SAMUEL BUTLER (1874–1902)[13]

"This is like a drawing," Saul Steinberg remarked to his visitor.[14] It was 1972, and they were standing in the stairwell a few flights down from his studio, which occupied the entire top floor of a late-Victorian wedding-cake tower on the west side of Union Square. Up in the studio, a few minutes earlier, Steinberg had rung for the elevator; no response. Host and guest had begun making their way down the stairs when they heard the cage clattering up from below. Though Steinberg called out as it passed, the operator was obliged to check on the now-phantom buzzer upstairs. As the elevator came rumbling back down again, Steinberg made his comment.

"This is like a drawing" fit among the analogies and metaphors he had been offering all morning to his visitor, a Vassar student who had come to interview him for her senior thesis. In its koanlike opacity, the remark is vintage Steinberg (just how *does* missing an elevator resemble a drawing?). Typical, too, is its slow-dawning clarity: drawing, as Steinberg meant it, gave form to life's uncharted stuff, such as the ill-calibrated movements of two mutually ignorant parties trying to rendezvous. On another occasion he had called drawing "a way of reasoning on paper."[15] But it went deeper than reason. "The only real drawing is primitive," he had once replied when asked his opinion of modern draftsmanship. "The cave artists were drawing for contemporaries. We don't have that anymore. [It's all] graphology and false bravado. The only things left are latrine and telephone booth drawings."[16] During the decades Steinberg drew—from the late 1930s to the end of the twentieth century—drawing was the wrong choice of métier for any artist who craved the adulation of the avant-garde, or who hoped to wow the crowds with mastery of craft. But it offered Steinberg an idiom less self-important than painting, and a more compelling test of wit than the clever insider's game of Duchampian art-as-philosophy that seduced so many in his generation. Most important, drawing was a sufficiently deft partner to keep pace with him: his pens and pencils, fellow travelers in what became a daily, virtually devotional practice, were up for any adventure his mind undertook, switching gears from caricature to rebus to cosmological chart in the space of a few strokes.

In the drawings he created by the thousands in the course of six decades, Steinberg's hand did on paper what his mind did all day. He satirized, analyzed, genealogized, forecast, weighed, deflated, calculated, queried, diagnosed, unearthed, punned, flirted, tested, remembered, and reimagined. He excelled in these higher functions, but those who knew him marveled most at Steinberg the "world-class noticer."[17] His sketchbooks show just how intimately joined were the mechanics of noticing and recording. Who but the owner-operator of Steinberg's drawing hand would have noticed that on the blank page of a dockside at Brindisi, the silhouettes of a sailor, a cyclist, a lamppost, and a tugboat had

3. Talk balloon with artist and dog, c. 1965. Ink, oil, and rubber stamp on cut primed canvas, 3½ x 21¼ in. (8.9 x 54 cm). SSF 5045.

become rubber-stamp versions of themselves (fig. 5)? That the rooftop signage of Brussels flashed an electric Babel of German, English, French, Italian, and Spanish trademarks (fig. 6)? That the streets of Georgia, USSR, were thick with doubles of her son, Joseph Stalin, each one sporting "big nose, narrow eyes, a moustache like a sparrow" (fig. 7)?[18] That the uncanny vistas of America's Great Basin spoke a patois of road map and Cubist still life (fig. 8)? He was equipped with an outsider's eye that saw everything as though it were new and a hand that seemed to have been waiting to put it all down on paper. The combination was no ordinary one, and it was the product of no ordinary life.

Saul was born in 1914 in the village of Râmnicul Sărat to middle-class Russian Jews, second- and third-generation in Romania. In his infancy the family—his parents Rosa and Moritz (Moise, son of a tailor) and older sister Lica—moved to Bucharest, where Moritz joined Saul's uncles at a dignified end of the small trades. They were sign painters, watchmakers, dealers in books and stationery. Moritz ran a printing, bookbinding, and boxmaking shop. Saul's sensory memories of childhood were defined by the weight of a block of type, the smell of fresh ink on a funerary ribbon, the sight of high-stacked bonbon boxes bearing a chromolithographed *Angelus* after Millet. The uncles' trades provided an unplanned approach to art through its quiet backstreets, such as the modern heraldry of shop-window signage.[19] Though a reluctant student at his Latin-oriented school, Saul was a voracious reader, whose serious mien masked a burgeoning imagination (fig. 4).

Family life was dominated by Rosa, a tower of temper, status anxiety, and swift judgment. A shared attunement, which Steinberg called his "radar with mother," isolated him from Moritz (who feared them both), gave him a lifelong alertness to feminine power (fig. 9), and put a human face on his earliest notions of tyranny (fig. 10).[20] "When I first heard of Sub Rosa I said: that's us! All of us Under Rosa," he reflected in his seventies. "I discover only now . . . that Rosa was timid. Her arrogance."[21] Rosa's pride was tested by the privations of life after the Great War, when uncles and cousins sent care packages from such exotic-sounding places as Denver and "Bronx." (The latter lost its article in translation to become "an explosive place, a fantastic name—imagine, to live in Bronx!") Toys from the Hoover Relief were Steinberg's first magical objects, "to revere—not for play. Sublime. America was the judge, innocent, remote [from] local intrigue and taboo, the constant hope of the oppressed."[22] Romania's virulently anti-Semitic nationalism boiled up in scattered pogroms in the 1920s; its casualties included his

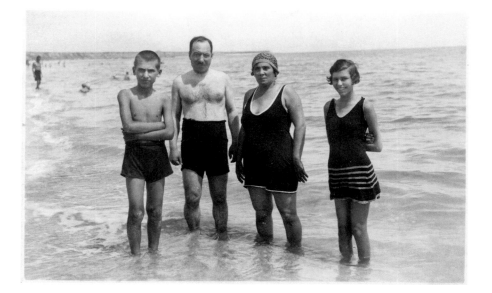

4. Saul, Moritz, Rosa, and Lica Steinberg, Black Sea, c. 1926. YCAL.

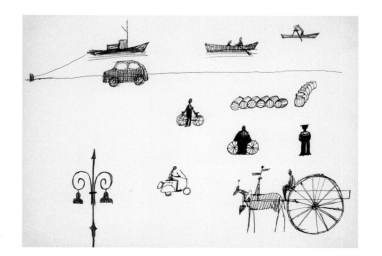

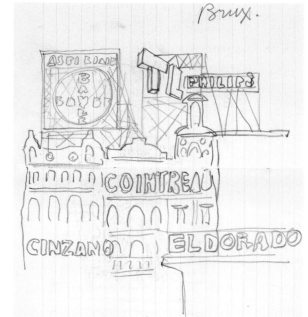

Left to right:

5. Brindisi, c. 1958. Ballpoint pen. YCAL sketchbook 3196.

6. Brussels, summer 1952. Pencil. YCAL sketchbook 4862.

7. Tbilisi, February 1956. Ballpoint pen. YCAL sketchbook 4869.

8. Desert landscape, c. 1965. Pencil and colored pencil. YCAL sketchbook 4930.

9. *Untitled*, c. 1960. Ink on paper, 11¼ x 7¾ in. (28.6 x 19.7 cm). YCAL 1416.

10. "On seeing a broom in a pick-up truck, I revert for a moment to my earliest notions: The driver is the servant, the passenger is the master. Right away the broom acquires authority, anger, the unpredictability and arrogance of the master." Ex-voto drawing, c. 1983. Pencil on paper. YCAL 3529.

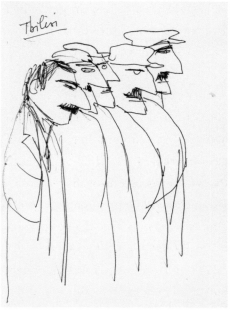

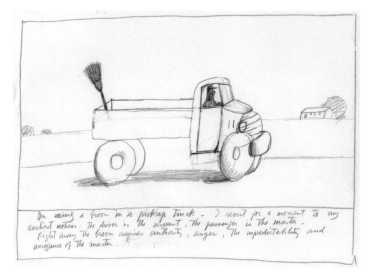

ZIA ELENA

— Sono tanto nervosa in questi giorni, dottore!

11. *San Lorenzo* (Milan), c. 1935. Ink over pencil. YCAL.

12. "I'm so high-strung these days, doctor!" *Bertoldo*, no. 6, January 21, 1938, p. 2.

reflexive boyhood patriotism (see cat. 63). The "fucking patria" (in writing, he reserved profanity for Romania) was for escaping.[23]

After a year at the University of Bucharest, Steinberg left in 1933 for Milan to enroll as an architecture student at the Reggio Politecnico. He later denied that the cribbed-Bauhaus curriculum had exerted a deep influence. It was, he said, "a comfortable school . . . where one learned mostly from schoolmates"; but the discipline of architecture brought purpose to "the continuous line of my drawing . . . a way of writing from my illiterate days."[24] His line would soon assume, when called for, a literate look, taut and efficient (fig. 11). Behind this earnest mask, however, a greater gift wanted expressing. Opportunity knocked in 1936 with the inauguration of *Bertoldo*, a twice-weekly humorous journal in newspaper format. Steinberg entered its offices, a short walk from his lodgings at the Casa dello Studente, to submit a cartoon.[25] In the tradition of professional pseudonyms, it was signed "Xavier" (for the absurdity of the initial X), and its protagonist was a top-hatted Victorian lifted freely from an established contributor's work. Probing with one hand beneath his thick, torso-obscuring beard, he exclaims: "Heavens! I forgot to wear a tie!"[26] Well, good enough; it was soon in print. Steinberg began to contribute drawings regularly, to fit captions authored by himself and by others (cats. 1, 2).

Though the next five years lie off the map for non-Italian Steinberg fans, the work he did in this period for *Bertoldo*—and for its weekly competitor, *Il Settebello*, where his full-page feature "Il

Milione" became a billed attraction—represents no minor chapter of his career. With three weekly deadlines (and paychecks), a growing fan base in the compulsively conversational world of Milan's bars and *carambola* dens, writers jockeying to feed him stacks of gags, a growing pack of imitators to be outdone, and the émigré's secret weapon—nothing to lose—Steinberg issued an avalanche of drawings from 1936 to 1940. His success drew the attention of Cesare (later Cesar) Civita of Milan's Mondadori publishing house, who would turn out to be a crucial ally.

Some precocious artists (Picasso most famously) absorb first and individuate later; the sources of their singularity are hard to identify. Steinberg's, however, are distinct, integral, and difficult to rank. Living "under Rosa," and under the primitive anti-Semitism of Romania, had taught him to disguise his resentment of power and to make a tactical retreat to the life of the mind. Architectural training, as he noted, was "marvelous training for anything but architecture. The frightening thought that what you draw may become a building makes for reasoned lines."[27] The profession of cartooning rewarded his instinct for encryption: the presumed triviality of comic journalism granted cartoonists unique license to critique Fascism—under the triple guise of absurdity, historical recasting (those Victorians), and metaphor.

The starter ingredients come together in Steinberg's *Bertoldo* cartoons starring high-strung Zia Elena (Aunt Helen, fig. 12). Is she a veiled caricature of Mussolini or a hyperbolic rewrite of Rosa? As surely as she was both, she was safely deniable as either one. A clean, muscular line composes her world, boring holes back into the page and pulling forms upright upon it; one's eye travels repeatedly to the horizon and back, happily collecting new details on each trip. Dramatically tipped-up horizons like this appear throughout Italian art of the 1930s—possibly a collective tic of tribute to her one international star, Giorgio De Chirico.[28] For the single-frame cartoonist, who works within a limited floor plan, a raised horizon means extra footage for comical habitation. Steinberg made the method a mainstay, even when he was given plenty of working space, as in the five-column-wide features called "Panorami di Steinberg" (fig. 14). It appears, too, in an interior decoration scheme of the late 1930s (fig. 13)—a document of the vocational sideline that was the closest he ever came to practicing architecture.[29]

In the short term, an architectural career was closed to Steinberg by Italy's race laws of 1938, which—though enforcement varied wildly—officially barred Jews from the professions. Even his cartoons, from this time onward, had to appear without a credit line in *Bertoldo*.[30] In later years, he would relish the irony of his 1940 diploma, granting a (useless) doctoral degree to Saul Steinberg "of the Hebrew race" by the power vested in "His Majesty Vittorio Emanuele III, King of Italy and of Albania, Emperor of Ethiopia." Soon every stone in that proud edifice of power was going to crumble, leaving only Steinberg and the Hebrew Race.[31] Not soon enough, though. For now, where to go? To return "home" was less thinkable than ever—the Romanian state began seizing property from Jews in August 1940 and by November was a German ally. His best hope now was the same one untold thousands of other European Jews were aiming for: immigration to the United States.

Many details of the horrible year that followed were lost through Steinberg's lifelong reluctance to grant the period close attention—and by his support (if not propagation) of the myth that he casually rubber-stamped his way through immigration and onto a boat out of Portugal.[32] The truth is that, with his student status expired, his prospects of legal Italian residence nil (the racial laws mandated the expulsion of foreign Jews), and American immigration quotas tight, the best he could hope for was a year's visa for residence in the limbo of the Dominican Republic. Even that much would take doing. In Milan, his week-to-week life came to consist of dodging the police, shuffling between friends' apartments and that

13. Perspective of interior, c. 1938. Gouache on board. Angelini Collection.

14. "Panorami di Steinberg," *Bertoldo*, no. 12, February 11, 1938, p. 6. Ink and collage, 26⅜ x 19⁵⁄₁₆ in. (67 x 49 cm). Il Club dei Ventitré (Archivio Guareschi), Roncole Verdi.

15. "But it *is* half man and half horse." *The New Yorker*, October 25, 1941, p. 15.

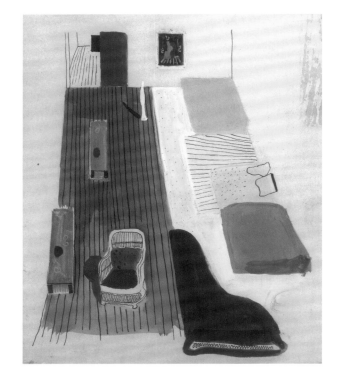

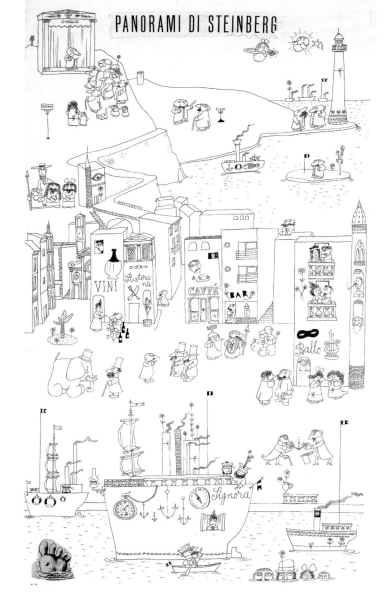

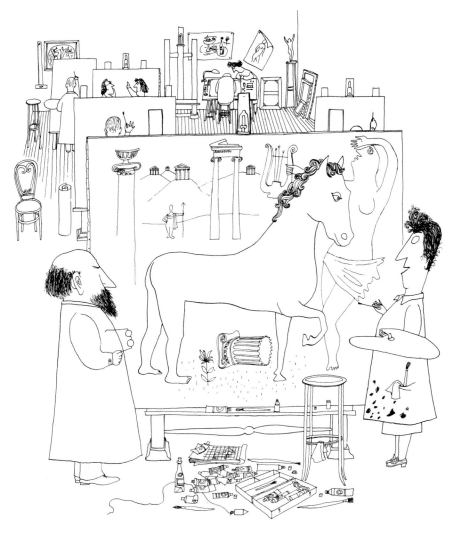

"But it is half man and half horse."

of his girlfriend Ada Ongari, trying to obtain transit visas, and publishing all the cartoons he could.[33] Meanwhile, advocates in the New World worked on securing his way to safe ground in the Caribbean. One eager ally was Cesar Civita, by now an independent illustrators' agent with offices in New York and Buenos Aires; another was Steinberg's New York cousin Henrietta Danson, whose team included her employer, radio personality Cornelius Vanderbilt, Jr., and her husband, Harold, a publicity director for Paramount Pictures. Regular letter campaigns to the Department of Immigration in Washington, D.C., were soon underway, and Civita managed to land Steinberg portfolios in *Harper's Bazaar* and *Life* as well as Argentine and Brazilian publications.[34]

In September 1940, having got as far as Lisbon, Steinberg suffered a paperwork disaster: the preceding months of progress were wiped out when he ran afoul of the Portuguese authorities and was sent back to Milan to start over.[35] By spring 1941, he was convinced that the only way to obtain the Italian visa stamp he needed was to turn himself in to the police. He got the stamp, though at the cost of six weeks' internment in what he called, in quotation marks, a prison "camp" in Tortoreto, in the Abruzzi: "a villa," he clarified, "from which you could see the sea, but you weren't allowed to go to it." (Italian Fascism, in his unrepresentative experience, was distinguished by an "inefficiency that would then be converted into a lack of injustice."[36]) It was while he was at Tortoreto that he was at last cleared to depart for Lisbon. He sailed on June 20, 1941.

Two days out, Steinberg recorded in his diary the news of Hitler's invasion of Russia. Under such circumstances, he was fortunate to be on his way to Ciudad Trujillo, Dominican Republic—a hot, uneventful port town full of refugees from Fascist Spain, Germany, and Italy, toughing out the wait for American visas. Steinberg did not trust his fortunes to the luck of the quota. Needing not only money but evidence of American employability, that year he mailed some forty packets, containing over three hundred drawings in all, by sea to Cesar Civita in Buenos Aires and by air to the agent's brother Victor in New York.[37] Victor's chief lieutenant, Gertrude Einstein, sent letters back briefing Steinberg on the responses she'd received from American editors. His compositions began to tighten up, his figures losing the squeeze-toy plumpness that had been his saleable trademark in Milan. Still, only his cartoons and covers for the Argentine market moved; higher-paying New York proved harder to crack.[38]

The breakthrough came with a cartoon portraying a student painter and her misassembled centaur, horse in front, man behind (fig. 15). It was a shameless retread of a *Bertoldo* gag, but Einstein ran it past James Geraghty, art editor at *The New Yorker*, and it flew.[39] Steinberg's debut, printed at nearly full-page scale in the October 25, 1941 issue, foreshadowed a time years ahead when his art-about-art would supply a visual epitome of the magazine's casual sophistication. More immediately, Geraghty's conversion to fandom heralded demand for Steinberg in the American cartoon market—even though the demand would initially be for a very different kind of cartoon.

The Japanese attack on Pearl Harbor on December 7, 1941 brought war to the Americas. Steinberg asked his diary only whether Ada's letters would continue coming through, but he knew everything had changed.[40] His log of mailed drawings reflects a concerted shift to topicality, as entries such as *oculista nuda* give way to *Hitler tombe, Duce riviste*, and—more telling still—English-language entries, such as *Aryan marriage* and *Strategic retreat*. America's newfound outrage licensed him, at last, to vent fury at the dictators whose idiotic evil had left him stranded on a dusty rock in the Caribbean. In January 1942, his work came to the editorial pages of New York's *PM* newspaper. What became a weekly series of political cartoons won him quick renown and many new jobs. *The New Yorker*'s editor, Harold Ross, suddenly

wanted lots of war stuff, too, and the thick wish-list memos Geraghty mailed out to cartoonists found a willing respondent in Ciudad Trujillo.[41]

By July 1942, when Steinberg hit his luck with the quota and made his way to New York—by airplane to Miami, then (at Einstein's suggestion) by bus up the East Coast—he was a strong favorite at *The New Yorker*. Steady employment was fine, but after four years in the paperwork labyrinth, he was eager to end his status as immigrant without citizenship. During wartime, the immediate route to a passport was military service, but Steinberg's nearsightedness threatened to disqualify him. Ross began working his highly placed friends, most notably Elmer Davis, director of the Office of War Information, and William J. Donovan of the Office of Strategic Services (OSS), in an effort to land Steinberg a propaganda job that would suit his skills and allow him, incidentally, to keep drawing for the magazine.[42] As a propagandist, he was a proven commodity. His work had already been part of an invitational anti-Axis cartoon exhibition, which had opened in February at the Art Students League, appeared around the country, and enjoyed a triumphant return to Manhattan as "Cartoons of Today" at The Metropolitan Museum of Art.[43]

New York, theoretically a challenging town for a stranger, lay open to Steinberg on three fronts. First, among the Milan friends he looked up was Costantino Nivola, a former publication designer for Olivetti who had arrived in 1939 with his wife, Ruth Guggenheim. The charismatic Nivola linked worlds by way of his art directorship at modern-minded *Interiors* magazine, a studio on East 8th Street, and a regular table at Del Pezzo, an authentic parlor-level Italian restaurant near Rockefeller Center, where he introduced native and émigré artists, writers, designers, and architects to one another.[44] Second, Steinberg's association with *The New Yorker* amounted to membership in an equally luminary and sociable hometown club. He made quick friends with Geraghty, Charles Addams, and William Steig, among others. Finally, as for romance (the answer to the mail-from-girlfriend question had been briefly yes, then no), Steinberg met with parallel good fortune, and his future wife, the day he accepted an invitation to tea at the walk-up studio apartment of a fan on East 50th Street. She was Hedda Sterne, a Romanian-born painter a few years his senior, who had come to Manhattan by way of Vienna, Paris, and London. Her side of the conversation, she later realized, must have sounded like "the most ridiculous name-dropping," because she "didn't know anyone normal, just friends from the boat"—yet another roster of creative stars, including arts impresario Peggy Guggenheim, architect Frederick Kiesler, and a flock of artists.[45] Sterne, it would turn out, was the last-arriving European (after Willem de Kooning, Arshile Gorky, Hans Hofmann, and John Graham) to figure in what became America's first export-worthy movement in painting. Thus the triple nexus that would define Steinberg's American life in the coming six decades—design and architecture, the so-called New York School of painters, and the magazine intelligentsia—fell into place around him during his first months in town.

Soon after ringing in 1943 with Nivola and a new friend, Alexander Calder, Steinberg took a train to Hollywood to see the movie studios in operation.[46] The trip was cut short when Gertrude Einstein wrote to alert him that his draft number had come up.[47] Though commissioned in the Naval Reserve in February, Steinberg maintained a full drawing and publishing schedule. By April, when he was in Washington, D.C., preparing to ship out, he and Nivola were the subjects of a two-artist show organized by Steinberg's future dealer, Betty Parsons, in the 55th Street bookstore/gallery where she clerked.[48]

In what the artist's baffled correspondents could only regard as self-satire on the part of military intelligence, Steinberg—variously fluent in Romanian, Spanish, French, Italian, and English—was

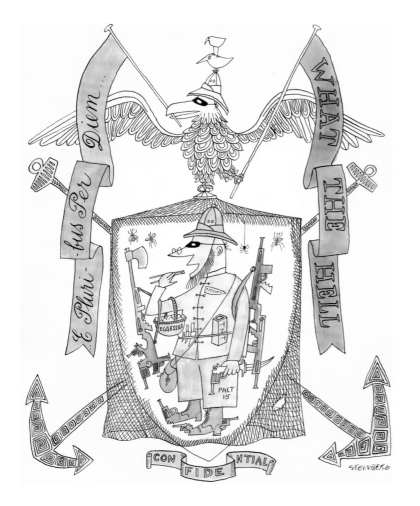

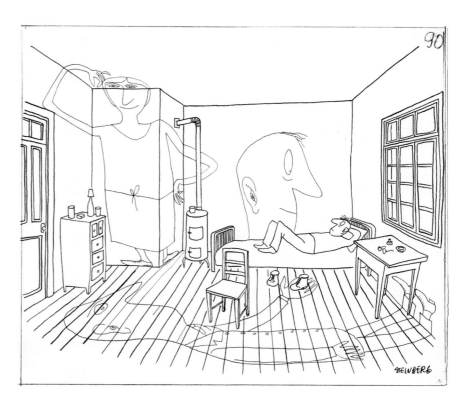

assigned to remote Happy Valley, outside Kunming, in China's western Yunnan province. He was stationed with the Sino-American Cooperative Organization (SACO), which operated under the contending auspices of the Navy and the OSS. Its mission was to relay weather trends to the Pacific Theater and train native saboteurs against the Japanese, two functions that would seem to fall well outside the duties of a "Psychological Warfare Artist."[49] In the latter capacity, Steinberg illustrated a wry informational brochure for personnel assigned to China, and designed a distinctly nonthreatening coat of arms for SACO (fig. 16).[50] He drew on his own time, too—and on any available surface (fig. 17); a roommate recalls going out for an hour and returning to find one wall turned into a lifesize Manhattan annex, with "a table, two chairs, a bottle of whisky and two glasses, near a window which looked down on Times Square."[51] When a higher-up in the OSS, possibly Donovan himself, paid an inspection visit to Happy Valley, Steinberg promptly found himself taken off the Navy's hands and reassigned to more suitable Morale Operations (propaganda) duty in, successively, Algiers, Naples, and Rome.[52] His initial period in China, his journey to North Africa via Calcutta, and his months of service in occupied Italy went into ten portfolios of drawings that appeared periodically in *The New Yorker* throughout 1944–45.[53] The sixty-nine drawings covered twenty full pages, making a major contribution to the magazine's war coverage and cementing Steinberg's stateside reputation.

Though Steinberg was later pleased to veil his OSS work in cloak-and-dagger mystique, it appears that the greater part of it amounted to drawing political cartoons while dressed in uniform. He kept on turning out travesties of Mussolini, Himmler, and Hitler (fig. 18), which were a few shades fiercer than those he had done for *PM*, and were distributed through military channels to anti-Axis periodicals

16. *E Pluribus Per Diem (SACO Warrior)*, 1943. Ink and watercolor on paper, 18 x 14 in. (45.7 x 35.6 cm). Private collection.

17. "Decorations I made in a room (U.S. Army Hotel) where I've been living for a few days. Glad when I moved." Ink and pencil on paper, 10½ x 11¾ in. (26.7 x 29.8 cm). YCAL 5266.

around the Continent.[54] But one rather more complex project foreshadows his later preoccupation with style as language and as disguise. The Rome office of Morale Operations published issues of fake newspapers, which were meant to pass as the output of (nonexistent) German and Italian Resistance movements. To create ersatz art for the ersatz *Das Neue Deutschland,* Steinberg adopted the graphic persona of an amateur German agitator, whose Expressionist instincts appear to reflect a bit of art school in the 1920s (fig. 19).[55] This special type of spy-art—American propaganda masquerading as German—called for stylistic restraint and specificity; the smallest flourish too original or, on the other hand, too parodic, would have rung false and given the whole game away.

Such a disciplined balance between artiness and joking—between the pitfalls Flaubert called "lyricism and vulgarity"—was well suited to Steinberg's temperament, and he would hold to it. "I deal with mediocrity and clichés," he stressed decades later; "I am not only involved with the sublime."[56] It is worth bearing in mind, too, that his orientation to American life occurred within the military machine, filtered through a spy agency's paranoia. In October 1944, he was reassigned to the OSS offices in Washington, where he gave an internal interview on Morale Operations that makes for a compelling preview of his postwar views on the artist's covert, adversarial role within society. "MO personnel," he told the interviewing officer, "should be extremely intelligent and crafty minded. They should be recruited long before any war, and should be infiltrated in the countries where they should work. . . . There is no need to communicate with them or for them to communicate with [their home agency]. They . . . know, better than the people outside do, . . . in what way they can best poison the minds of the population."[57]

Once stateside, Steinberg set about going undercover—that is, getting his American art career moving. In October he and Sterne married, and he began commuting between the Washington office and New York by train, in lieutenant's uniform, while assembling the first collection of his drawings. Victor Civita had secured a book contract with Duell, Sloan & Pearce, publishers of William Steig's books, and an initial title, *Everybody in Line* ("Title for book and world of future," Steinberg noted), was hit upon during a sociable evening at home in early 1945, attended by Steig, James Geraghty, and others.[58] In one landmark week, April 26–May 2, Steinberg's diary records that *All in Line,* as the book had been retitled, was scheduled to appear in June; that Mussolini had been strung up in Milan's Piazza Loretto; that Hitler was dead; and—the next day, as though fulfilling a personal vow—that Steinberg had resigned from the OSS.[59]

All in Line proved a quick bestseller in stores and through book clubs, vaulting Steinberg from minor success story to genuine celebrity author. In that year of victories, the book's popularity probably had less to do with its opening half—a charming if uneven compilation of Steinberg's American-published gag cartoons to date—than with its closing sixty pages, "War," which featured reprints of his anti-Fascist cartoons as well as expanded versions of the already widely republished *New Yorker* war portfolios, "China," India," "North Africa," and "Italy" (fig. 20). In June 1945, with the Pacific conflict grinding toward its end, these drawings struck just the right note for an early look back at a won but still unfinished war. They handed American readers victory as a victor wants it, inevitable and nearly blood-free. In the *PM* cartoons, Hitler and Mussolini are mocked rather than demonized, the better to be flicked into history's dustbin; the *New Yorker* portfolios bypass atrocities to highlight the trivia and tedium of war. By avoiding histrionics in his war imagery, Steinberg had always projected the implicit confidence millions of Americans were only now beginning to feel, that normality was just around the corner. Not until the next year, when he was included in the traveling "Fourteen Americans" show

Der Schuldige

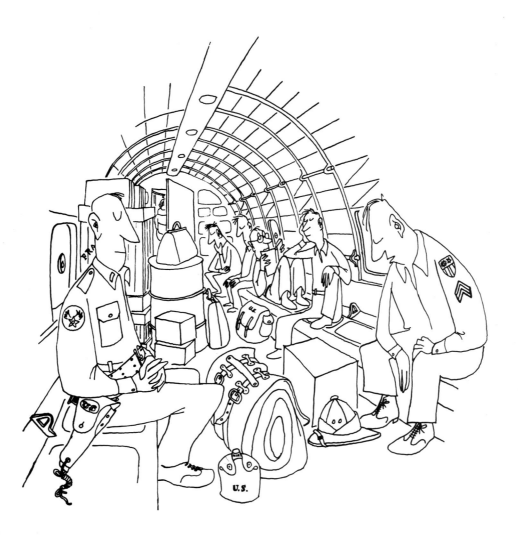

18. Propaganda drawing (Hitler as a two-faced wolf), 1944. From a photostat in the papers of a Rome branch OSS comrade, Hermann Broch de Rothermann, YCAL.

19. *Der Schuldige (The Guilty One)*, in a fake Resistance newspaper, *Das Neue Deutschland*, July 26, 1944, produced by the OSS. Hermann Broch de Rothermann Papers, YCAL.

20. *All in Line*, 1945, p. 62. Drawing first published as "Flying In," in "Fourteenth Air Force, China," *The New Yorker*, February 5, 1944, p. 20.

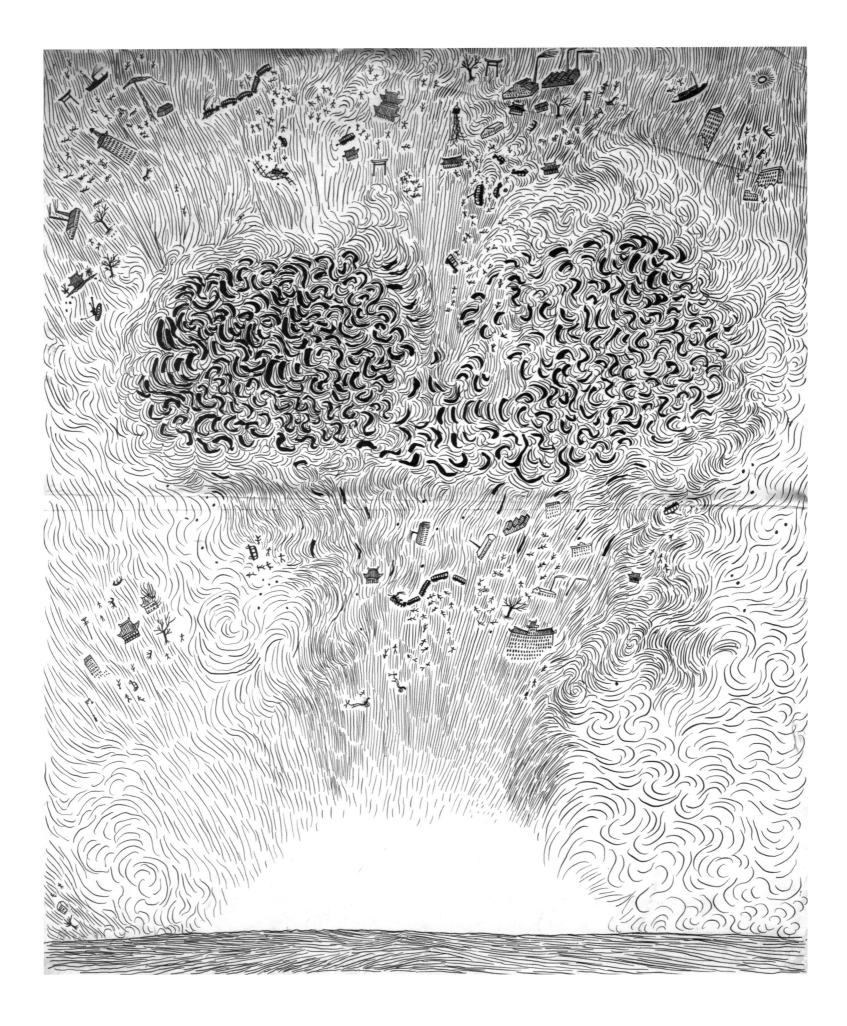

organized by Dorothy C. Miller for The Museum of Modern Art, did Steinberg present images reckoning the costs of the war, such as the destruction of Monte Cassino (cat. 5) and, even more harrowing, the vaporizing of Hiroshima (fig. 21). Alone of the work in "Fourteen Americans," these images would be missing from the pages of his next book. As suggested by its title, *The Art of Living* (1949), American life soon turned attention in on itself and would have little time to spare for soul-searching about the past.[60]

For the moment, the nation's state of self-absorption suited Steinberg, who was eager to apply himself to peacetime scenes and subjects. It remained the case, however, as Geraghty put it in a memo in 1945, that "Steinberg needs excitement."[61] In 1947, he bought a used Cadillac convertible from Igor Stravinsky, and he and Sterne—feeling plenty conspicuous at first—hit the road (fig. 22). Over the next decade, they would drive throughout all the forty-eight states. A hunger for sensation never let Steinberg sit still for long. After a couple of hours at the drafting table, drawing threatened to become work, and he needed to clean his eyes by taking a walk, paying visits, or shooting some pool. After a few weeks, at most, it was time for a real excursion—to Alaska, Faulkner's South, Las Vegas, or the battlefields of the Civil War. And nearly every year, he would take a drive or bus ride for several weeks all around the country, or spend months in Europe, or both. "I am as much refreshed by a journey as some artists are said to be by incessantly falling in love," he said.[62] Travel was not a break from anything so much as it was the central part of his process, neither work nor leisure but a comprehensive art of living.

Steinberg saw and portrayed an America different from anyone else's. The usual explanation, that he viewed America with an outsider's eye, is sometimes to the point. For example, he and his friend Richard Lindner got an early jump on Pop Art by seeing that color in America—in contrast to the palette of Italy or Germany, respectively—had nothing to do with nature; its keynotes were fresh paint and packaging (cat. 17).[63] However, the mere fact of foreignness does less to explain Steinberg's singularity than two more specific causes: first, his relationship to the viewing public, which did much to shape the repertoire of topics he explored in his cartoons; and second, the artistic interest he took in artless documents, which became a central preoccupation in all of his work.

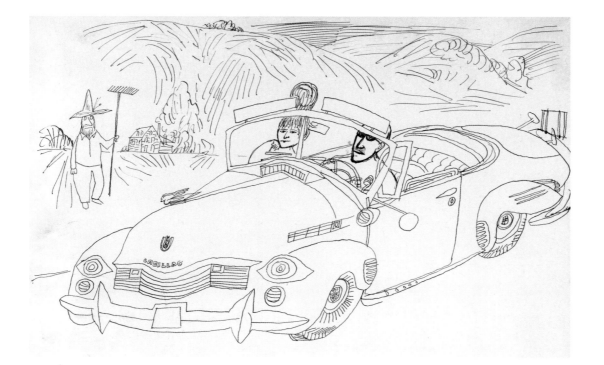

21. *Hiroshima*, 1945. Ink drawing. Whereabouts unknown. From a photostat in Steinberg's papers. YCAL.

22. Self-portrait with Hedda Sterne, Cadillac, and farmer, Vermont, summer 1947. Ink, 11½ x 14⅛ in. (29.2 x 35.9 cm). SSF 4513.

23. *The New Yorker*,
July 12, 1947, p. 21.

24. *The New Yorker*,
August 29, 1953, p. 27.

25. *The New Yorker*,
March 13, 1948, p. 34.

In his busy years from World War II until the mid-1960s, Steinberg was defined in the public eye first as a *New Yorker* cartoonist and second as a mass-market artist in other capacities—a creator of magazine features, advertising art, and books; a public muralist; a designer of printed fabrics, holiday cards, and stage sets.[64] It was by way of what today would be called his successful "brand" in the mass-market arts that Steinberg enjoyed a third career—as an exhibiting artist whose original drawings were acquired from galleries by (largely private) collectors of contemporary art. His work for *The New Yorker*, though it represented only a specialized sampling of his talent, was the base, a continually renewed reference point, for the rest of his art.

Scholarship has caught up with *The New Yorker*'s cartoons, recognizing that they comprise an informal archive of upper-middlebrow American views and aspirations at midcentury.[65] But such a view fits other cartoonists better than it does Steinberg. As an artist of "AA" (most-wanted, highest-paid) status at the postwar magazine, Steinberg was not one, like those in the broader talent pool, to whom the editors looked for cartoons on perennial or topical themes such as women drivers, Congress, the rise of television, or suburban sprawl.[66] Instead, he—like Charles Addams, William Steig, Helen Hokinson, or Peter Arno—was charged to bring to the magazine's pages a universe that was distinctively his own. His job was to make *The New Yorker* Steinbergian. And so, even as he stuck to the format of the gag cartoon, Steinberg set about evolving a highly idiosyncratic, intellectually customized America—a place where symbols conformed to style (fig. 23), style submitted to comfort (cat. 11), work overtook identity (fig. 24), and safety came first (fig. 25). The world in Steinberg's *New Yorker* cartoons, even in the early years, is a speculative, theatrical place, as abstracted from reality as the scenarios in the Commedia dell'Arte—an experimental sound stage whose cast happens to have been drawn from present-day life.

In short, Steinberg was neither artist nor cartoonist. Compared, on the one hand, to his fellow "Fourteen Americans" in the 1946 MoMA show and, on the other, to a stringer cartoonist bringing a stack of "roughs" to Geraghty, he was a hybrid. Technically, he was an adjunct of *The New Yorker*— a "barnacle on the ship," in the old newsroom phrase for a cartoonist.[67] But within the community created by the magazine, which increasingly meant middlebrow America at large, his presence on a page

26. William Steig, *About People* (New York, 1939), pp. 64–65.

27. *Steinberg's Umgang mit Menschen*, 1954, p. 4.

was as distinct and for-its-own-sake as that of Picasso on a museum wall. Steinberg turned the magazine page into a venue for art, not just a place where art was "reproduced." The printed cartoon, on a page you held in your hands, was the artwork Steinberg had meant you to see. It owed much of its meaning to the fact that you knew tens of thousands of other readers were seeing it in the same week. The collaboration (Steinberg liked the word "complicity") of artist, publication, and reader defined a constituency—Steinberg people.[68]

Steinberg at the postwar *New Yorker* had come a long way from the blithe young skit-sketcher at *Bertoldo*. In 1945 he said of military life: "I think it has damaged me. There is an inside discipline which does not allow me to do freely what is not logical. I can not think of what is absurd anymore."[69] What sounds like a handicap for a cartoonist was his strength. In time, he and Steig would both exercise the option of the "AA" artist to "not have to be funny"—a negation comparable, for a cartoonist, to Jackson Pollock's learning to paint without a brush.[70] While Cold War America had a surplus of painters steeped in A-bomb gloom, and of gag cartoonists trying to shoo gloom away, Steinberg and Steig tapped a wide-open market for thoughtful drawings fueled by anxiety. Steig had reached the territory first, with books such as *About People* (1939; fig. 26) and *The Lonely Ones* (1942), in which the mood was agonistic, the mode surreal and abstract. Highbrow critics meant well, but missed the point, when they looked at Steinberg's images so hard that Steigian angst came through.[71] Steinberg, while no less interior-oriented than Steig, was not one to anatomize emotional states. Instead, he let his minimalist line speak by way of understatement and irresolution, ceding half the thinker's role to the viewer. Addressing the readership of an economic boom period, keener on self-decipherment than self-criticism, he was more philosopher than psychologist; his recurring images of people drawing themselves into being (fig. 27) gave the age of pop Existentialism its defining image of everyman as author and editor of himself.

His absorption with the higher reality of representations led Steinberg to evolve a unique variation on documentary art—namely, art *about* the documents that pass through one's hands every day, such as press photos, passports, flyers, and postcards. He probed these non-art objects not for information about their putative subjects, but for insights into their physical qualities and visual codes. He

ST 1953

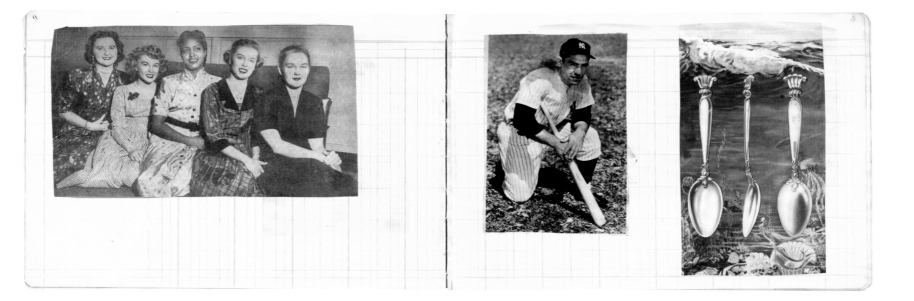

taught his hand the many faux-authentic subdialects of traveling papers and diplomas (cats. 20, 21), and adopted the habit of issuing them to friends (fig. 28). By drawing on the surfaces of photographic prints (fig. 29; cat. 14), he turned a type of document that is usually looked *through*, as a window onto reality, into a picture plane. In his studio, he covered the walls and filled scrapbooks with ephemera of every kind, in an exuberant anti-order that let beauty queens face off against Yogi Berra, next door to spoons cavorting in an underwater world (fig. 30).[72] He was not researching the way reality "looks" but internalizing the ways in which it *shows itself*. He saw that in a society obsessed with its representations the fictionality of flatland had come to infect every surface, from the false fronts of buildings to a hostess' foundation makeup to the certified falsehoods of tourist imagery (cats. 24, 40, 54).

Steinberg's attunement to documents reflected, in part, an uncanny form of visual literacy that made him see any mark on a flat surface—a letter, a number, a word—as "a reality" (cats. 48, 67), and to see every object and person as the product of a specific "handwriting" (cat. 26). He drew documents and wrote landscapes (cat. 39). He saw a typographer's squibs as bits of nature freeze-dried (cat. 46). In a cracked piece of wood with nail-holes in it, he could find a map of Eastern Long Island (fig. 31). Where there was language, he saw it: "Two or three letter words are beautiful. I see the word. When people speak I see words coming out of their mouths."[73] And where there was something to see, he was prone to convert it into notation; in a 1943 sketchbook, he rendered his first cross-country train trip as a diagram of days and miles (fig. 32). As time progresses, from left to right, a horizon line bisects the nights (a series of dark rectangles) and charts major phases of topography.

On paper as in person, intimacy was Steinberg's element. Much of his art is best seen on a book's printed pages, which address not an audience but a singular reader. A book of drawings, to him, was a work of micro-architecture; in the world contained between its covers, picture space and corporeal space (that of the page-turning hand, the scanning eye) find their common language. In one sketchbook spread, Steinberg used the hinge between the left and right pages to imitate the join between two walls of a room (fig. 33); in another, the pages become two sides of a shaded street leading to a sun-filled plaza (fig. 34). Thanks to the liberal intelligence of a reading eye, such "pop-up" spreads, which occur also in his books (p. 116), can be read with the volume held either flat or open at a 90-degree angle—a variation that seems absurd in the more rigid, literal-minded visual regime of painting (fig. 35).[74]

28. *Document for Henri Cartier-Bresson*, 1947. Ink and collage on paper, 14⅜ x 11³⁄₁₆ in. (36.5 x 28.4 cm). Fondation Henri Cartier-Bresson, Paris.

29. *Car*, 1953. Conté crayon on gelatin silver print, 10¾ x 13¾ in. (27.3 x 34.9 cm). SSF 6400.

30. Spread in a Steinberg scrapbook, with clippings from a newspaper, a baseball program, and a magazine advertisement, c. 1953. YCAL.

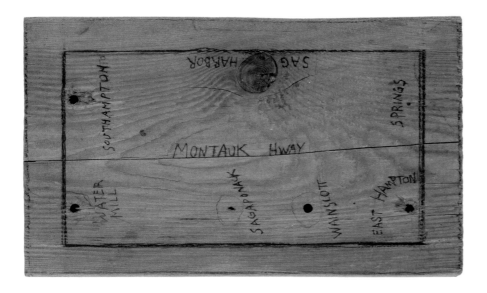

Above:

31. *Untitled (Montauk Highway Map)*, c. 1975. Pencil, marker, and gouache on bored and cracked wood, 8⅝ x 5¼ x 1½ in. (21.9 x 13.3 x 3.8 cm). SSF 5651.

32. Fragment (Chicago to Utah) of a multipage penciled chart of a cross-country train trip, 1943. YCAL sketchbook 3200.

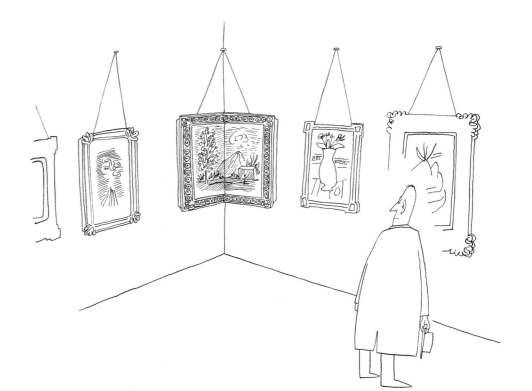

Center:

33, 34. Spreads from YCAL sketchbook 4949, c. 1949.

Above:

35. *The New Yorker*, April 6, 1946, p. 27.

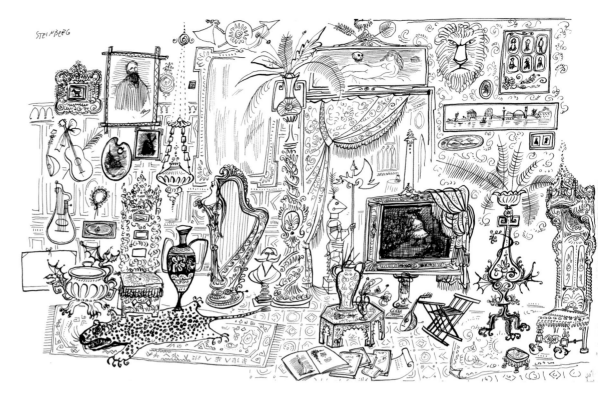

Steinberg performed a kind of travel research via documents, learning at least as much about a place—about America, for instance—by studying the way it represented itself in postcards, news imagery, advertising, and historical recreations as he did by traveling through it physically. Soon after arriving in New York, he had seen an exhibition at The Metropolitan Museum of Art called "I Remember That: An Exhibition of Interiors of a Generation Ago," featuring watercolors by the eccentric Perkins Harnly (fig. 36).[75] Judged by conventional standards for perspective, technique, restraint, or historical accuracy, Harnly's renderings had notable defects—which are precisely what make his version of the bric-a-brac-infested clumsiness of Grand Rapids interiors ring true. His subject matter was, of course, right up Steinberg's alley (fig. 37), but even more important was the pointed linking of a subject (manic overdecoration) to a suitable representational technique (the page crammed with detail from corner to corner). The idea of a higher caricature, of catching subjects in the act of stylized self-representation, was one which Steinberg would find peculiarly well suited to drawing America. It was baffling to him that American artists should be scouring the native countryside in search of Mont Saint-Victoire or trying, like Reginald Marsh, to turn the Bowery into something out of Rubens, when the everyday reality around them was full of subjects that were halfway to art in themselves. Young women on the subway in armor-plated dresses impersonated the Statue of Liberty (cat. 16). They were human avatars of a spirit of half-conscious imitation that pervaded the American scene, most visible to Steinberg's eye in architecture. In a block of Gilded Age false fronts he read a history of expired European conceits (cat. 24)—relics of an age now falling, in turn, to the bottom-line logic of a stronger god, the ledger (fig. 39). Through the idiom of scenic caricature, Steinberg practiced, in pictorial form, what postwar architects, planners, and designers were aiming for in the real world: a purposive critique of the built environment, apprehensible to the nonspecialist (fig. 38).[76] "I began with architecture, and after that I drew," he explained, attributing his edge as a draftsman of ideas to the fact that he had set out not to create Art, but to be clear.[77] This instinct—more, even, than the urge to be funny—made him a perfect fit at *The New Yorker*.

38. *The Passport*, 1954, p. 144.

39. *Graph Paper Architecture*, 1954. Ink and collage on paper, 14½ x 11½ in. (36.8 x 29.2 cm). Private collection.

D'ORSAY

40. Advertisement for D'Orsay perfume, *The New Yorker*, May 4, 1946, p. 7.

41. *Views of Paris*, Patterson Fabrics silk cloth, 1949. Pattern from a drawing first issued as a Piazza Prints scarf, 1946. SSF 9021.

But if drawing in elegantly minimal line for *The New Yorker* satisfied Steinberg's taste for precision and obliquity, he went elsewhere in search of richness, visual and financial.[78] From Geraghty and Ross he got meticulous feedback, but he considered much of his other publication work "unedited."[79] That had its advantages: good ideas, perfectly tuned, took work, but the mere task of drawing, as Sterne puts it, was "easier for him to do than to stop."[80] A postwar trend toward crisp, linear design in the magazines had been on his side, as had the end of wartime paper rationing, and Steinberg supplied detail-rich drawings (cat. 8) to fill the newly enlarged pages of architectural journals. Advertising work often demanded nothing more specific than a lot of Steinbergian detail, the idea being simply to arrest the speeding eye of a reader (fig. 40). Moreover, once his style and name had become draws, saleable product came straight out of his pile of finished work: sometimes, the task of "designing" a fabric (fig. 41) or compiling a pictorial feature meant little more than finding some unpublished work to submit.[81]

Even Steinberg's labor-saving instincts, however, met with a challenge in murals. The seven mural projects he completed between 1947 and 1961—three apiece in the United States and Europe, and one on the ships of a transatlantic line—demanded a merger of technical ingenuity and visual invention, as he experimented to fit a page-illuminator's style to architectural scale. For his first commission, in 1947, on the seventh floor of the Bonwit Teller department store in New York, Steinberg drew a Central Park equestrian scene at his characteristic scale—half a sheet of Strathmore drawing paper, about 14 by 23 inches—and turned it over to "an army of hooligans" to render at full size. This method

42. Skyline Room, Terrace Plaza Hotel, Cincinnati, featuring Steinberg mural, installed 1948. Postcard, c. 1950. Cincinnati Art Museum files.

43. *The Art of Living*, 1949, p. 70. Detail of drawing for American Export Lines mural, 1948.

44. *An Exhibition for Modern Living*, 1949, catalogue, p. 31. Detail of Steinberg mural.

proved imperfect; even keeping an eye on their progress interrupted his summer in Vermont.[82] Late the same year, he executed an 89-foot-long mural of Cincinnati for the Skyline Room at that city's new Terrace Plaza Hotel, where the other commissions included a mural by Joan Miró and a mobile by Calder. This time Steinberg rented the vast studio of his photographer friend Gjon Mili and painted the eight oil-on-canvas panels himself. Though more pleased by the results (fig. 42) than he had been at Bonwit, his initial enthusiasm did not survive the prolonged effort. Months later, still exhausted, he speculated that "those nuts who construct cathedrals out of toothpicks must feel like this when they've finished. For a while you stop eating so as not to use toothpicks."[83] In 1948, having been tapped to create a series of bar murals for the "Four Aces" ships of the American Export Line, Steinberg at last arrived at a solution to the vast labor of mural work: treat the wall like a published page. After an ocean crossing that doubled as research, he submitted by mail, from Paris, a set of drawings portraying life aboard a liner (fig. 43), which were photographically enlarged onto vinyl, one set per ship. The result was four murals (and fees) for the effort of one.[84]

Steinberg employed the same technique in 1949 in a mural for Alexander Girard's landmark show of modernist interior design and housewares, "An Exhibition for Modern Living." Installed at The Detroit Institute of Arts and the J.L. Hudson Department Store, the show plotted a common cause for art, industry, and new design; its two hundred exhibitors ranged from Charles and Ray Eames and Florence Knoll to Alexander Calder and Mark Tobey. Steinberg explained his role: "The architects are showing the good things that have been done (in their opinion) in the last twenty years. And I show . . . the ugly or stupid things that have been done."[85] Giant photographic lineshots of his drawings, touched with color following his specifications, portrayed a city in cutaway view, its interiors stocked with such necessities of life as aerodynamic toasters and antimacassar-draped Eames chairs. The catalogue featured ten pages of mural details (fig. 44), and the show's signature image and catalogue cover was a *New Yorker* cartoon (cat. 11). The exhibition, for which Steinberg accepted a token fee, sealed his identity within design and architecture circles as the draftsman-laureate of modernism.[86]

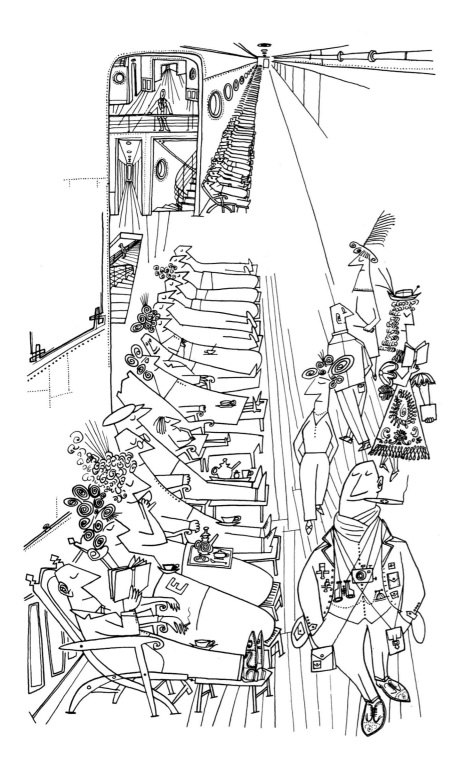
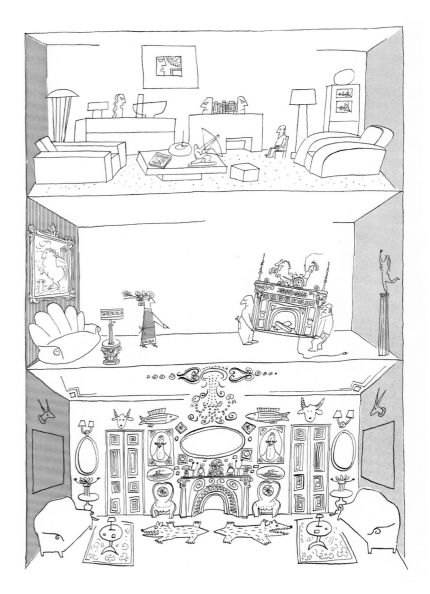

An intense period of solo exhibitions began with a show at Rome's Galleria L'Obelisco in 1951, followed early the next year by the first of Steinberg's trademark two-gallery shows in New York, at the Betty Parsons and Sidney Janis galleries.[87] In May, he went to London to see a show of his work installed at the Institute of Contemporary Arts, and in the fall he and Sterne traveled together to Brazil, where twin one-artist shows were mounted at the Museu de Arte in São Paulo.[88] April 1953 saw his initial exhibition at the Galerie Maeght in Paris, which represented him into the 1980s. The debut was marked by the first Steinberg issue in the gallery's exquisitely printed monograph series, *Derrière le Miroir*.

The next year, Steinberg rolled many of his thoughts on architecture into one of his most ambitious, and ephemeral, murals, which existed from late August to December 1954 in the park beside Milan's Palazzo dell'Arte. For the 10th Milan Triennial, an architecture and design exposition, the BBPR firm (Belgiojoso, Peressutti, and Rogers) had designed a "children's labyrinth" consisting of six roofless, coiling walls in a three-leaf clover formation, a Calder mobile at their center (fig. 45).[89] Working on long paper scrolls, Steinberg executed line drawings for the labyrinth's three leaves (see discussion and images, cat. 31).[90] Each drawing was then enlarged onto wall-scale paper, which was laid over a fresh layer of wet plaster on the walls. Craftsmen, in a technique known as *sgraffito*, incised the designs and peeled the paper away. The artist then incised freehand on remaining sections of the labyrinth walls, improvising details such as the tower of the Castello Sforzesco, a sight visible (to adults) from within the walls (fig. 46). In its appeal to adult and child alike, the *labirinto dei ragazzi* was a hit, even among skeptics of contemporary design. *The New York Times* called most of the other exhibits in Milan "[s]erious, professional and well-meaning," but pronounced the labyrinth the Triennial's only encouraging sign of "humanity and humor."[91] The simplified linear style of this work represented the nearest Steinberg ever came to replicating, in his monumental public commissions, the intelligent restraint that guided his hand at *The New Yorker*.

Being at *The New Yorker* was a condition more social than physical for Steinberg. He was, by preference, often on the road, and even when in town he drew at home and submitted work by post or messenger rather than join the weekly ritual of Tuesday (later Wednesday) art submissions. The spacious house on East 71st Street that he and Sterne moved into in 1952 hosted wide-ranging circles from the arts, but with a few exceptions, their visual art world was one of painters and photographers, not *New Yorker* artists. Steinberg's *New Yorker* friends tended to be writers, including Joseph Mitchell, Geoffrey Hellman, S.J. Perelman, Mary McCarthy, and—in the overseas contingent—Janet Flanner and Vladimir Nabokov. Finding himself welcome among diverse writers probably helped to revise his self-image, from cartoonist to "writer who draws." The difference was not merely a matter of status but of audience or, more precisely, of attention span: a writer doesn't plant gags to gratify a page-flipper but starts up and sustains the mental machinery of *readers*.

Steinberg certainly heard from readers. The magazine forwarded him fan- and foemail over the years that brought a constant chorus of praise, confession, and baffled anger, and probably inspired his reflections on the varieties of (in)comprehension. In a 1952 memo he divides readers into the far- and the near-sighted; later he ponders the pluses and minuses of sophistication for everyone: "Introspection has affected the middle classes"; "Introspection is too good for you"; and still later, "The transition from peasant to middle class destroys in 6 months 2000 years of civilization."[92]

The demand for Steinberg's touch, on projects of every variety, scale, and locale, rode high throughout the 1950s. In American markets, his much-imitated style embodied droll cosmopolitanism,

47. *The Labyrinth*, 1960, p. 123.

48. *The South*, 1955. Ink and pencil (watercolor added, c. 1990), 14½ x 23 in. (36.8 x 58.4 cm). SSF 6473.

49. From "Moscow in Winter," *The New Yorker*, June 9, 1956, p. 31.

while to European eyes, his humor tempered the most worrying aspects of an Americanizing world—the disappearance of the past and the rise of conformity (fig. 47). Moreover, art directors and editors on both sides of the Atlantic exploited something that viewers simply enjoyed: Steinberg's pen was fast. He became a natural candidate for last-minute jobs, as when *New Yorker* managing editor William Shawn reached him by telegram in Mexico City in April 1947 to ask for a portrait of Le Corbusier for a profile in the magazine. Steinberg could oblige, and even beat the schedule, thanks to both his simple technique and his familiarity with the architect, whom he knew from meals at Del Pezzo.[93]

The fame Steinberg won at *The New Yorker* gave him a wealth of publishing options elsewhere. In the 1950s, *The New Yorker*, alone among the so-called "mass-class" magazines, still printed no color art on its inside pages, and would not do so until 1989. The competition, by contrast, afforded an easy-going, high-paying outlet for Steinberg's color work—not to mention benefits such as going on the road with the Milwaukee Braves, which he did as an artist for *Life* in 1954 (see cat. 33). Geraghty had less leverage with his friend than ever, and was getting only a fraction of the work he could have used—including, in March 1954, what was still only Steinberg's second cover. Of the twenty-five drawings Steinberg published in the magazine that year, most were "spots" or "spot-pluses"—that is, filler drawings, pulled from material on file.[94]

Beyond magazine illustration lay other profitable worlds. In 1952, Steinberg had begun providing Christmas and Valentine's Day designs to the Hallmark greeting card company, which now paid him, for a few days' work, roughly what *The New Yorker* did in a year. The advertising market, which had caught up to his minimalist style, was bottomless.[95] And his book publisher, Harper Brothers, was eager for another Steinberg volume. When his third, most overstuffed and diverse book of drawings, *The Passport*, came out in October 1954, Geraghty wrote: "On my knees I wish to God there were some way you could devise to make drawings for covers and black-and-whites to please yourself and to please us. There *must* be an area where our demands coincide with your aspirations."[96] Steinberg had evidently been pressing *The New Yorker* to accommodate a greater range of his art—having made, among other things, numerous trips throughout the South, gathering visual notes for a travelogue portfolio, which was never printed (fig. 48).[97] But no overhaul of the magazine's visual persona was in the cards, and Geraghty knew it. "The Magazine Steinberg and the Gallery Steinberg can't be the same person," he pleaded, "and you shouldn't ask that they be."

What finally came of this stand-off—whether at Steinberg's suggestion or the magazine's—was something the artist simply could not have arranged for himself. In the course of the following year, through the personal efforts of editor William Shawn, traveling papers were secured for Steinberg to visit the Soviet Union as a reporter for the magazine. He made the trip in February 1956, traveling for three weeks in Moscow, Kiev, Odessa, Tashkent, Tbilisi, and Samarkand.[98] He then cleared his debt to the magazine immediately, turning in two long portfolios (fig. 49), which were printed under the heading "A Reporter at Large—Samarkand, U.S.S.R." (May 12, 1956) and "Winter in Moscow" (June 9, 1956).

The climax of Steinberg's career in public murals came with *The Americans*, created for the 1958 World's Fair in Brussels. The sections of the mural, totaling over 260 running feet, were mounted on a group of free-standing walls amid the open floor plan of Edward Durrell Stone's domed American pavilion. Before arriving in Brussels, Steinberg submitted some fifteen pen-and-ink line drawings of American spaces (including cat. 37). Photographically enlarged to nearly 10 feet high, the scenes were put together to produce composite landscapes, each one embodying a facet of "America" as the European imagination

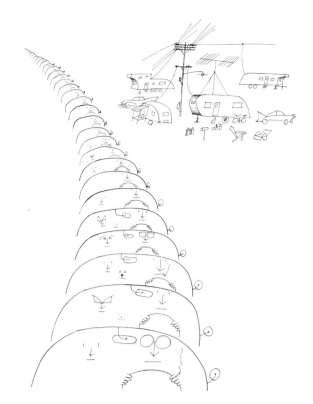

50. *Main Street—Small Town.*
Section of *The Americans* mural,
1958. Collage and mixed media
on wall-mounted photographic
prints, 118 x 238 in. (300 x
605 cm). Musées Royaux des
Beaux-Arts de Belgique, Brussels.
From a printer's color proof at
SSF.

knew it: *The Road*; *Main Street— Small Town*; *Downtown—Big City*; *Farmers*; *Drugstore*; *Cocktail Party*; *Baseball*; and (in a simplified merger of hot-weather states) *California, Florida, and Texas.*[99] These wide-open scenes served Steinberg as backdrops for a cast of craft-paper "Americans" he created and pasted up onsite (fig. 50).[100]

His Americans were larger than life, but only in the literal sense. Morally and culturally, it was a crowd so true-to-life that the director of the pavilion's art displays cherished hopes for "considerable controversy," predicting to a reporter that "Americans will be annoyed, perhaps even outraged, to see themselves portrayed as expressionless, bespectacled, and T-shirted."[101] There were, it turned out, two controversies about the American showing at the fair that year, but both resulted from attempts to avoid controversy. The selection of fine art on exhibition played it so safe that abstractionist and figurative camps alike complained.[102] More troubling was the premature shutting down of Leo Lionni's annex pavilion, titled "America's Unfinished Business," which featured images of the desegregation of schools that had been underway in Little Rock, Arkansas, since September.[103] In a year when the Soviets could crow either about American racial politics or the success of Sputnik, the American pavilion sidestepped substantive themes for what one observer called "an atmosphere of largeness and of liberty," focused on "the daily life of its people."[104] This, whether Steinberg had intended it or not, was where his marching Shriners, bland businessmen, stone-faced dirt farmers, feral tots, and smoking women in halters came in. As he told a reporter, "I don't show any people working because they do that the same everywhere. What I draw is the American who eats, sleeps, reads, plays, amuses himself."[105]

Life changed for Steinberg around 1960, and his art with it. He moved twice, into the country and downtown. In 1959, he had closed on a house near the tip of Long Island, across the road from Nivola's, near Amagansett.[106] For the rest of his life, "the country" would deeply enrich the subject matter and

51. *The New Yorker*, August 11, 1962, p. 25.

the sensory repertoire of his art—as soon as he got over his fear of nighttime noises, which sent him hurrying back to the city after his first overnight stay.[107] In June 1960, the month he turned forty-six, he separated from Hedda, moving out of their Upper East Side duplex and into a fifteenth-floor downtown apartment in a new complex, Washington Square Village—a "utopia à la Ville Radieuse," in his words. The Greenwich Village location had attracted him, he said, because it was "always full of people and tourists, always open and crowded so that it looks—at night—like Venice."[108]

With proceeds from his 1958 Brussels mural, Steinberg had bought an indigo 1958 Jaguar and shipped it to New York.[109] The car and the bachelor pad were not the only changes brought by midlife. Steinberg's father and mother, living in France, died a little more than a year apart, in August 1960 and October 1961, respectively. And at the home of friends, he was introduced to Sigrid Spaeth, a recently arrived German photography and design student, twenty-two years his junior.[110] Their relationship, though it would turn deeply, complicatedly unhappy for much of the thirty-six years to come, was cause for joy in its first few seasons. He even shaved off his trademark mustache, thus exchanging a longstanding European mask for an American one that, he hoped, would allow him to travel incognito.[111]

Equally altered was his approach to publishing. After eighteen years and only two covers for *The New Yorker*, from 1959 onward Steinberg contributed covers regularly, publishing nearly ninety over the next four decades. While the covers provided an outlet for his work in color, his drawings inside the magazine also became more frequent and more conceptual (fig. 51).[112] Moreover, as his commitment to *The New Yorker* deepened, he turned his back on most other magazines, and indeed all the most remunerative lines of work he had pursued during his first two American decades—advertising art, murals, color features for mass-market magazines, and greeting card designs. He also began placing a new emphasis on creating art for gallery sale, which meant working more regularly in color, in adventurously mixed media, and in theme-and-variation series.

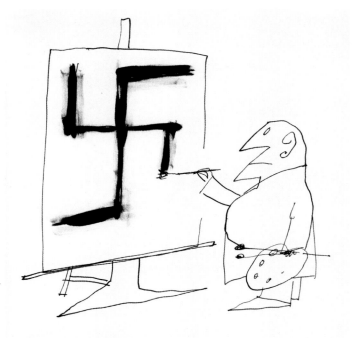

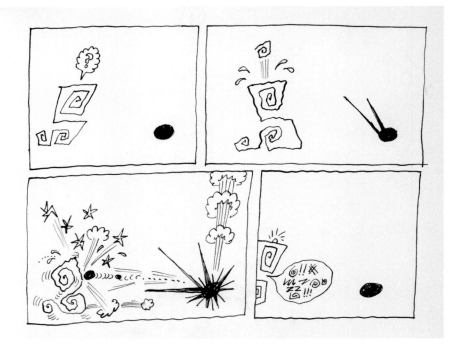

Underlying all these modes of self-reinvention is a change in temper that divides Steinberg's career into two phases of sensibility, roughly before and after 1960. The depth of the shift hides beneath surface consistencies in his work—most notably, his continued use of the visual language of the cartoon. If in earlier years the cartoon had been his hand's native language, the mold in which he reflexively cast all his ideas, by 1960 it existed in his mind, and on his drawing table, in tension with other possibilities. He engaged abstraction, for example, in a (probably unpublishable) 1960 cartoon portraying a gestural painter whose Franz Kline-ish spontaneity yields some surprising cargo (fig. 52). Another drawing in the same sketchbook (fig. 53) shows that even when a cartoonist jettisons figuration entirely, a cartoon conveys narrative action—thanks to telegraphic elements such as sweat-plewds for anxiety, parallel lines for speed, and a trembling line for fear. The comics, with its rich and hermetic sign system, qualifies as a school of abstract art—albeit one easily understood by all.

Had Steinberg remained on the track of his 1950s activity, continuing to supply magazines with diverting decorations and newspapers with sprightly interviews, he would have assured himself a reliable if limited niche in the history of popular art. The less predictable path he chose led to his present, uniquely unsettled situation, between the identities of illustrator, cartoonist, and what he called—soft contempt tempered by envy—"a museum artist."[113] A few circumstances beyond Steinberg's control have contributed to his consistent exclusion from master narratives of Art History. For one, curatorial practice keeps light-sensitive works on paper out of the brightly lit permanent collection galleries of museums; for another, America's arriviste academies lack the confidence to grant humor equal status with other genres of art—witness the rarity of Best Film awards for comedies. But in a deeper sense, Steinberg's exclusion from the canon can be laid to choices he made at mid-career, on at least three counts.

Most fundamentally, in his exhibition-oriented art he declined to specialize. Instead of holding himself to one easily summarized stylistic track, he continued exploring any visual idiom that met his needs. On the face of it, variety is welcome in the museum canon. Walk through the twentieth-century rooms of a major museum, and it looks as though art's possibilities jetted off in every direction (Mondrian! O'Keeffe! Pollock! Lichtenstein! Serra!). But it is a diversity achieved by stage-managing a

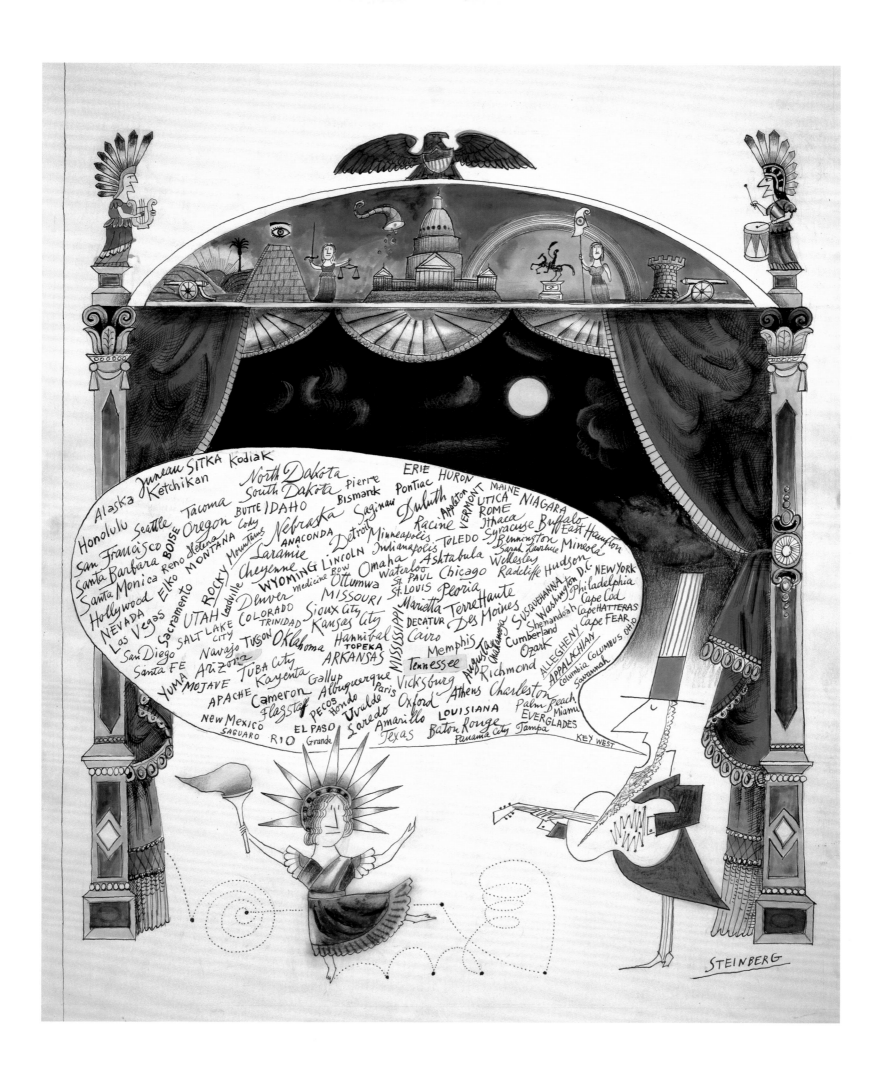

shortlist of art-stars, each one reduced to a market-friendly cartoon (squares! smooth stuff! dribbles! comics painted big! metal slabs!). The reduction process works best on artists who—either through intuition or dealer encouragement—streamline their output into an obliging shtick, the kind of virus to which collectors, critics, and museums will prove susceptible. If Steinberg's oeuvre resists such reduction, it is because his shtick consisted of absorbing every visual mode that seized his connoisseurial attention. His range has cost him. As José Ortega y Gasset observed, a society founded on specialization reflexively "gives the name of 'dilettantism' to any curiosity for the general scheme of knowledge."[114] The same freedom of movement that made Steinberg the artist he was also makes him appear, through the goggles of a market-driven art world, indecisive or trivial.

55. René Magritte, *L'Usage de la parole (The Use of Speech)*, 1928. Oil on canvas, 28¾ x 21¼ in. (73 x 54 cm). Private collection, formerly collection of Saul Steinberg.

56. Drawing for "Saul Steinberg Stops for the Night," spread in *Fortune*, June 1956. Ink, colored pencil, and pencil on paper, 27⅛ x 44 in. (68.9 x 111.8 cm). Private collection.

57. *The Labyrinth*, 1960, pp. 28–29.

Steinberg complicated his legacy in a second way by making art that pleased markedly different audiences. Neither the comics and cartoon world nor the art world thinks of him as entirely their own, thanks in great measure to his absurd, beautiful covers for *The New Yorker*, in which the notionally separate regimes meet (fig. 54, cats. 45–47). In preference to a corny two-toned schema dividing High from Low, Steinberg spoke of art in terms of the respectable and the vulgar, which he regarded not as mutually exclusive qualities, but as nuances to be balanced. Kultur and commerce did the least mischief when they were reconciled. In a statement on posters for a commercial art annual, he wrote: "Trade will gain by its contact with art, be it ever so slight, like brushing elbows. We remember the actors Toulouse-Lautrec painted only because of Lautrec."[115] Yet of René Magritte's oeuvre, for example, he most admired the early work, in which the diligent young sign painter was still in evidence and informing the avant-gardist. The Magritte he owned (fig. 55) was divided into two frames, like a primal comic strip or a pair of ad posters—but also like an artist's canvas flipped to face the wall, revealing its stretcher bars.

The third obstacle against Steinberg's canonization was that by 1960 he had come to regard all classification as a trap, a "crocodile," to be given the slip whenever possible.[116] His adult life falls into two broad movements: an all too successful pursuit of celebrity, and an equally concerted retreat to what he called "normalcy."[117] Since 1945, when *All in Line* hit the bestseller lists, Steinberg had made fame his plaything throughout Europe and the Americas. As STEINBERG, he had played a living Steinberg cartoon for columnist and camera, cladding his slim frame in finely tailored but eccentrically combined clothes, topped by one of the dozens of hats (coachman's derby, planter's panama, jockey's and conductor's caps) that were his mock-disguises. Almost every year through the late 1950s, he had sailed first class on "the queens" to Europe, where he stayed in luxury hotels, adding their oversize invoices to his growing stack of desk-clerk graphology (cat. 64).[118] As surely as *The New Yorker* was the basis for his reputation, deeper-pocketed patrons—fashion magazines, the greeting card business, *Life* and *Fortune*—underwrote his lifestyle (fig. 56). Then, very late in 1960, just in time to miss the Christmas market, his fourth book, *The Labyrinth*, came out (fig. 57). His most challenging and exquisitely designed book to date introduced him, at forty-six, to flat sales and hostile reviews. "I'm as flattered as Stendhal," he told a friend.[119]

Intentionally or not, he had crossed a line from populism to "difficulty" that he would not recross. In the coming years, critics caught on. "The urbane and bourgeois triviality of the *New Yorker* cartoon," Max Kozloff wrote in *The Nation* in 1966, "turns out to be the coy cover-up of a rather Byzantine artist who has something more substantial to tell us."[120] The coming change had been signaled in the credit lines for his magazine work in the late 1950s, where STEINBERG the brand had given way to Saul Steinberg the author, artist, adult. Where he had once left his wordless art alone on the page, he now began appending recondite statements: "This is my version of the nose problem—the equivalent in

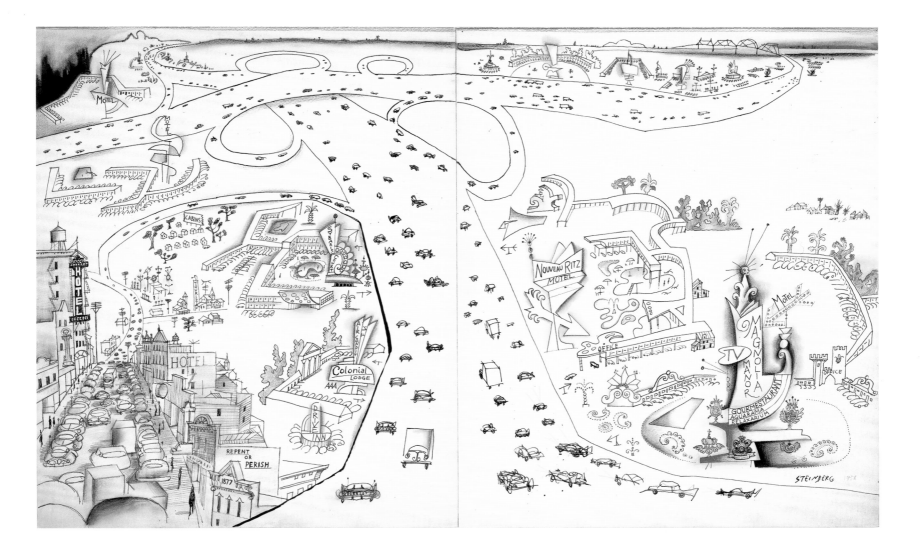

58. Drawing in "The Nose Problem," *Location* (Spring 1963), pp. 37–40.

drawing of Gogol's treatment of the same problem in literature" (fig. 58).[121] And in interviews, his former casual put-ons gave way to a more sincere effort to derail the culture-tidying work of Art History. (See his November 9, 1961 letter to Katherine Kuh, Appendix, p. 249.)

The upward shift of Steinberg's brow only perfected his fit at *The New Yorker*, where he turned his attention to covers (cats. 45–47). *The New Yorker* cover, a weekly work of full-color, representational art, held a unique position in postwar American visual culture. By the early 1960s, about a decade into William Shawn's tenure as editor, the covers sometimes gave off a whiff of the art in New York's galleries. By addressing contemporary experience while avoiding newsy topicality, the covers expressed to perfection the tone of upper-middlebrow detachment that distinguished *The New Yorker* from its middle-middlebrow neighbors (*Time*), whose cover images were keyed to their timely contents; from low-middlebrow magazines (*The Saturday Evening Post*) that put up a propagandistic front of chipper triviality; and from the highbrow journals (*Partisan Review* and up), which eschewed cover art altogether.[122]

Steinberg later commented that until the 1960s, when he found a voice suited to covers and thematic portfolios, his drawings for the magazine had been "really a way of making a living. I didn't think of [them] as being Art, or having to do with autobiography or with my real impulses. They were controlled by the censorship of myself as an editor, as somebody who is doing some art for a certain public and has to make it understood, slowly."[123] The magazine's cover—a potentially but not necessarily comic venue—supplied him with an art space well suited to "breaking certain taboos, especially giving more credit to the reader for his intelligence, so that certain things that were very stenographic and more like secrets of myself, I made public." Ultimately, he would even come to regret that many of his innovations that "seemed to be mysterious—have now become clichés, such as . . . the transformation of the conversation, of the balloon into symbols" (cat. 45).

59. *The New World*, p. 23, from *The New Yorker*, April 24, 1965, p. 41.

Two of his remarks about films, the first in 1956, the second in 1963, provide a window onto the respective mindsets of Steinberg I and Steinberg II.[124] Steinberg seldom confessed to jealousy of—or wholehearted identification with—another artist's work, but he did so when he saw Federico Fellini's *I Vitelloni* (1953)—"one of the rare times when I'm sorry not to have gone into cinema"—and Ermanno Olmi's *Il Posto* (1961), of which he said, "I should have made this film."[125] Both movies tell coming-of-age stories. Fellini's warm memoir of "fatted calves" kicking around in their provincial hometown, which ends with the youngest one's bittersweet escape to the bigger world, suited the perspective of an artist just entering nostalgic middle age. Steinberg had, for example, experienced his recent trip to the Soviet Union as "a trip for my nose, a voyage to the odors of Eastern Europe and my childhood . . . like a visit to my past, a travel in time."[126] The view of oncoming adulthood in *Il Posto*, by contrast, is unsentimental, if no less deeply felt: Olmi shows a shy young man coming to Milan and taking his first steps into a life of crushing corporate routine. By the time he saw this film, Steinberg was crafting paper-bag masks, as scary as they are funny, that give the lie to every role conferred by social life (cat. 40). He was at work, too, on the probing socio-philosophical drawings that would go into his fifth book, *The New World* (1965; fig. 59), and he was beginning to use rubber stamps to construct images of a world infested with conformist inauthenticity.

What Fellini's biographer has said of the director in the year of *I Vitelloni* could be said as well of young Steinberg in the same period: "At that moment he had great creative ease, . . . even on a personal level. . . . [He] later became more cultured, wiser, more intelligent, but less—rich. Definitely not as funny. . . . His cheerfulness faded until, by the end, he was almost gloomy. Fellini was made just to be young, to live those years with that intensity, that passion."[127] Throughout the 1940s and 1950s, Steinberg's own "creative ease"—the phrase fits beautifully—was universally marveled at, but in later years he was mortified to recall what had come to seem to him a glib gimmickry, in art and lifestyle, by

60. Devil and child, 1954. Ink. YCAL sketchbook 3128.

61. Gawkers, 1954. Ink. YCAL sketchbook 3128.

62. Shriner, 1954. Ink. YCAL sketchbook 3128.

63. *Untitled (Five Women)*, 1971. Pencil and colored pencil on paper, 13¾ x 22¾ in. (33.7 x 57.8 cm). SSF 71.

64. *Art Lovers*, 1965. Colored pencil on paper, 14½ x 23 in. (36.8 x 58.4 cm). Private collection.

which he had "impressed headwaiters"—his phrase for empty notoriety.[128] What he loved about *Il Posto* was its achievement of "true compassion by not exaggerating." Olmi, by day a documentary filmmaker for a power company in Milan, had made the film with no professional actors, shooting on weekends and using the company's headquarters for his sets. *Il Posto* allows facts and faces to speak for themselves, and Steinberg's summary of the result, "compassion by not exaggerating," sounds like a disavowal of the means of caricature.

In fact, Steinberg had been issuing such disavowals for years, out of a desire to distance his work from that of highly regarded but "exaggeration"-prone colleagues in the graphic arts (Robert Osborn, possibly) whose strained efforts struck him as only so much "graphology and false bravado."[129] In 1952, for example, he had taken pains to describe his art as "the antithesis of expressionism. Expressionism—the direct outpouring of the artist's emotion or state of mind or hatreds—seems to me a kind of blackmail on the spectator, the Grand Guignol of art."[130] And indeed, on those rare occasions when he confronted truly grim topics, it had been his consistent practice to defuse them through wit, as in a 1954 sketch of a curly-haired waif dandled by a demon (fig. 60).[131] Pages in the same sketchbook find him taking stabs at genuine grotesquerie, moral (gawkers gather around a corpse on a sidewalk, fig. 61) and physical (a Shriner in full regalia dissolves into scabby hatching, fig. 62). But what's most telling about these sketches is that they were just that—sketches; nothing so close to "Grand Guignol" ever squeaked into the published oeuvre of Steinberg I.

If Steinberg II, by contrast, went on to make regular company players of his nightmare visions (fig. 63; cats. 62, 66, 69), the point is not that he had crossed over to some simple kind of shock cartooning. Just the reverse is true: after 1960, more and more of Steinberg's art is best understood as caricature—but of a peculiar, high-functioning order. Years later, he found, and underlined, a phrase well suited to his own art in the words of a Russian literary critic who described Gogol's grotesques as

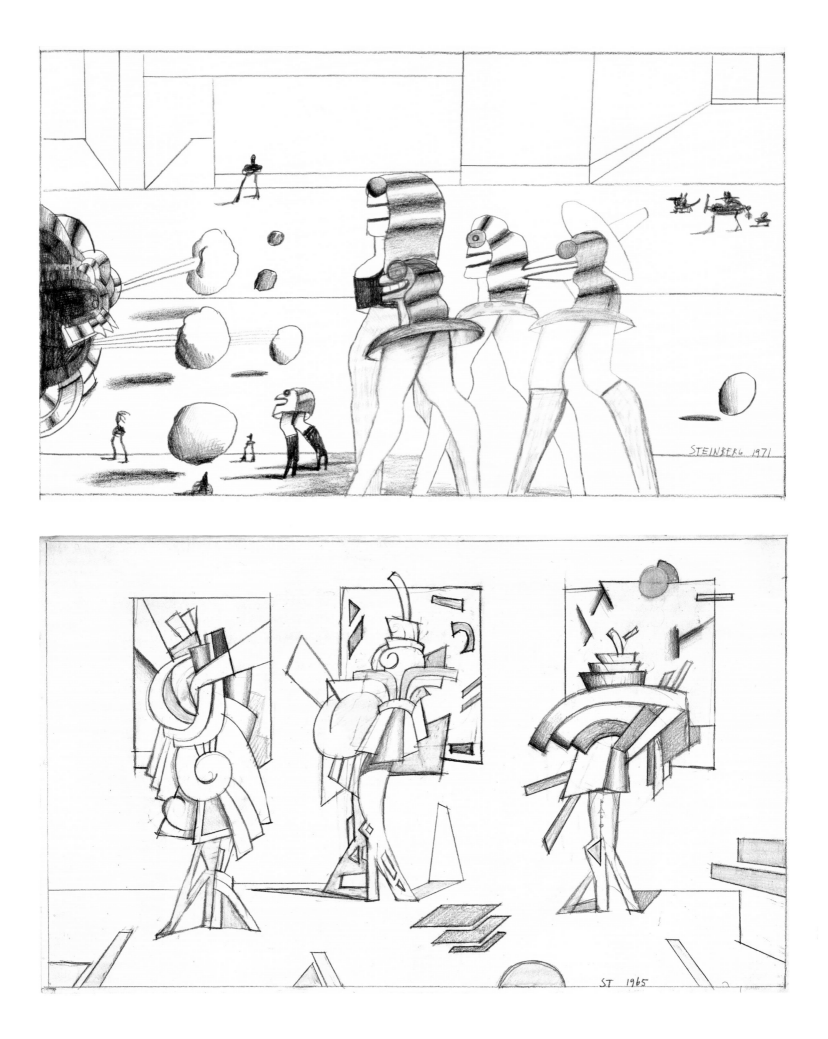

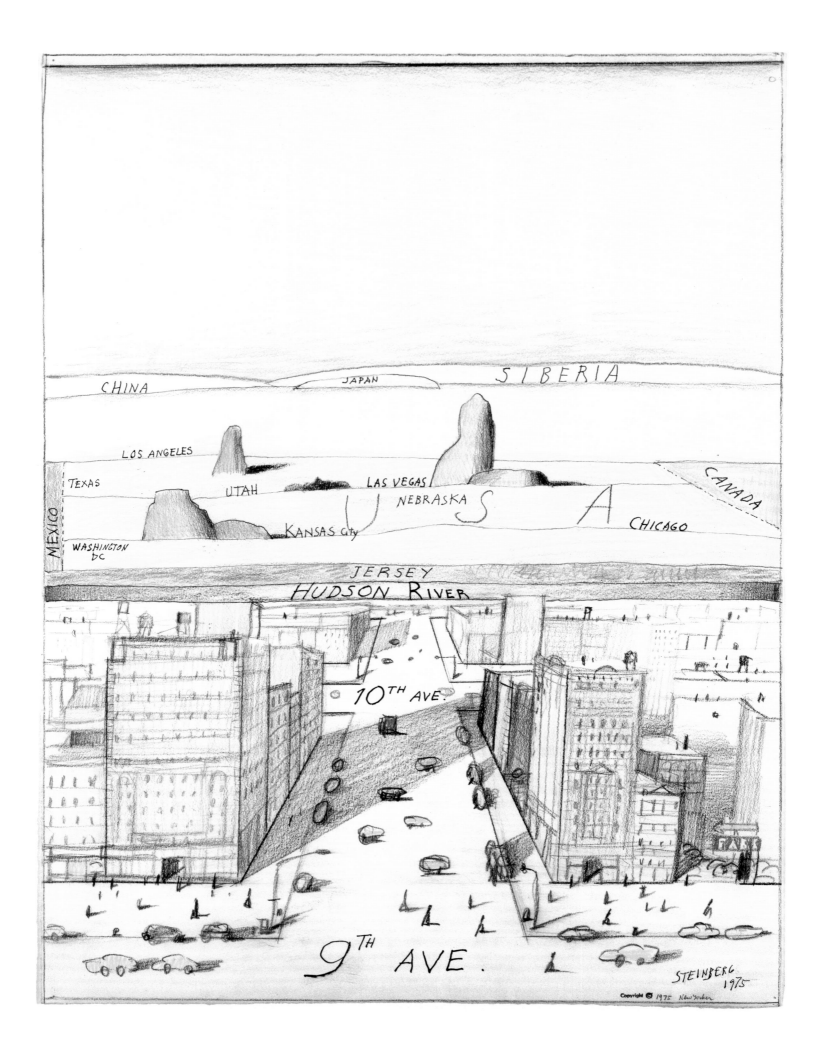

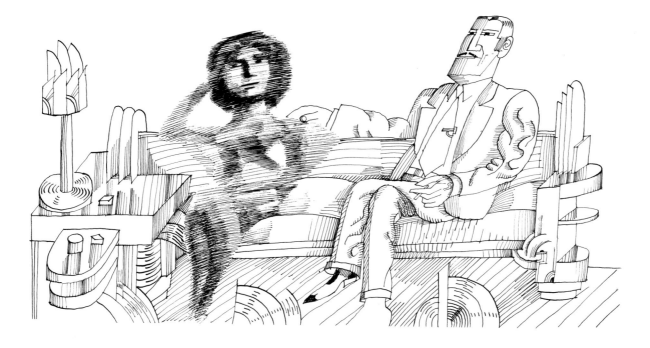

"*introspective caricatures* of the fauns of his own mind."[132] Increasingly, Steinberg, like Gogol, resorted to the broadest effects of graphic epitome, metaphor, and intensification—not in order to reduce reality to the level of a cartoon, but to suggest that the mind does so. Art lovers metamorphose into spinoffs of the art they scrutinize (fig. 64); global geography rejigs itself to suit the perceptual limitations of an urbanite (fig. 65); a television-era girl and her radio-age host exist on utterly separate wavelengths (fig. 66); and even nature is only as sublime as the observer's mind can make it (cat. 81).

65. *View of the World from 9th Ave.*, 1975 (cat. 76A).

66. *The Inspector*, 1973, p. 71.

It was when Steinberg was well into his fifties, and America deep into war in Vietnam, that the thugs, rage-rigid cops, and stallion-legged raptor-women came crowding onto the stage of his art. His arrival at this grotesque note fit the psychedelic key of the late 1960s, though in his case it was not a product of drug use. He had been taking hallucinogens occasionally since the mid-fifties, but he considered them "the opposite of art"—things that helped one become "probably a good spectator but not an artist."[133] Nor did his intense hallucinatory imagery reflect profound fear of the freaks in the Village, whom he regarded as dress-up actors emulating Hollywood renditions of fierceness and dissolution.[134] His newly phantasmagoric style represented, instead, a continuation of his old modus operandi, whereby he used the "handwriting" of his subject to represent the subject itself.

In this respect, the impetus behind Steinberg's shape-shifting street creatures was the rise of underground comics as the visual expression of hippie culture. The downtown streets were Steinberg's daily beat at the time; from Washington Square Village, he walked every day to 33 Union Square, where he had taken a top-floor studio in 1968. *The East Village Other*, an underground paper he picked up regularly through 1969, reflected the Village youth scene's collapse into a battleground between utopian hopes and political paranoia.[135] Articles in the *EVO* bristled with fury at the war and the police, but the "comix" artists who were published there, and in its semi-regular comix supplement, *Gothic Blimp Works*—R. Crumb, Gilbert Shelton, Vaughn Bodé, and Spain Rodriguez, among others—were focused on another kind of war. It was a war on conformity and the Protestant work ethic, which they waged by drawing far-out, drug-addled fantasies. Their willful regression to subpolitical madcap might have looked familiar to a veteran of *Bertoldo*.[136] (The spelling "comix" itself passed cryptic judgment on the

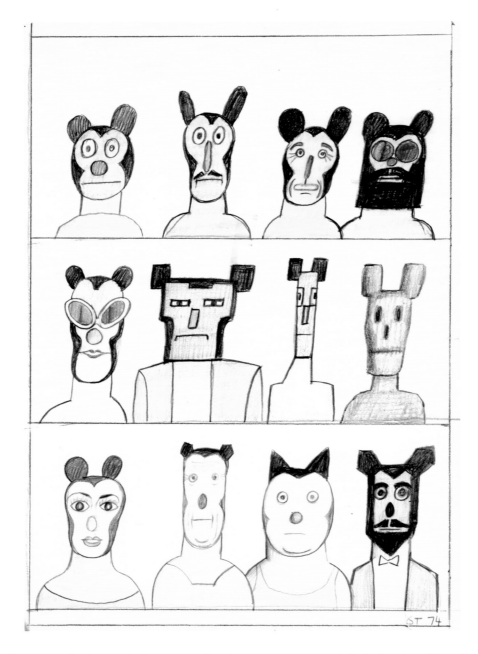

67. *Untitled (Lineup)*, 1974.
Colored pencil, crayon, and
pencil on paper, 17½ x 12 in.
(44.5 x 30.5 cm). YCAL 1762.

infantilization wrought by capitalism upon its citizen-consumers. A linked misspelling in the underground press was "Amerika," by which the war-waging Great Society was equated with Nazi Germany.)

Many of Steinberg's issues of *EVO* and *GBW*, in his papers at Yale, are folded open to the work of Kim Deitch. Deitch was everywhere in the New York press in 1969, and his serial strip (variously "Deja vu" and "Deja Voo") was the sole color feature in *Gothic Blimp Works*.[137] Waldo, Deitch's lead character, was a strung-out-looking black cat in 1920s cartoon mode—Felix fallen on hard times, and thus a concise symbol, perhaps, for the latter-day troubles besetting the American dream. Variant Waldos began popping up in Steinberg's work around this time (cats. 62, 66, top right street corner). Indeed, from now on a signal presence in Steinberg's art would be that of refugees from other comics regimes, looking hardened by life in a complicated world (fig. 67).

Reviewing Steinberg's dual show at the Parsons and Janis galleries in late 1969, John Ashbery compared the problem critics now faced regarding the artist to the one that had plagued the composer Erik Satie. Just as Satie, a "combination of mascot and confessor for some of the great musicians of his day," had

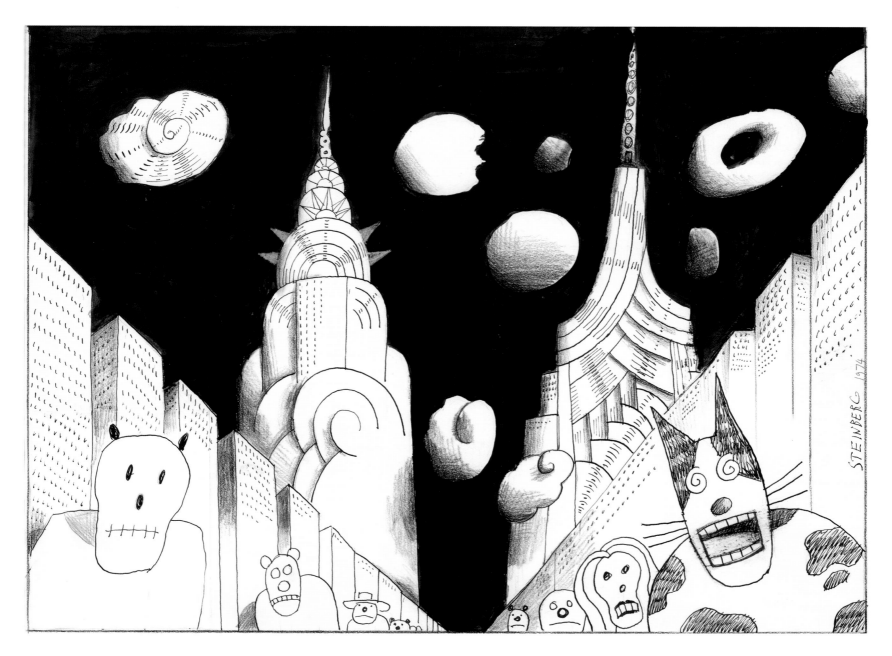

68. Drawing for Robert Caro, "Annals of Politics" (on Robert Moses), part I, *The New Yorker*, July 22, 1974. Ink, colored pencil, and collage, 14½ x 19¼ in. (36.8 x 48.9 cm). SSF 5168.

been in his lifetime only "the object of a slightly patronizing cult," so Steinberg, "court gadfly to the New York School," defied incorporation into his era's solemnized pantheon. There was cause for hope in this parallel, Ashbery ventured, since "future generations may end up wondering, as has happened with Satie, just what [Steinberg's] contemporaries were being so serious about."[138] Though the relationship between Steinberg and his peers had not changed much in the preceding decade, Ashbery's assessment announced a bigger change in the art world, which was beginning to find a language for accepting Steinberg's sui generis status.

Seniority had its benefits and costs. *The New Yorker*, by this time, gladly bent to accommodate any stylistic turn his work took, even the comix-tinged kind (fig. 68).[139] (Steinberg's 1969 series of seven full-page newspaper ads for *The New Yorker* even includes a design, fig. 69, in which the "magazine for people who read" is figured as a page of comix for people who don't.) The magazine also paid him well enough to render moot the constraints a competing patron would have imposed. In 1971, inspired by Nabokov's example, Steinberg booked himself into a clinic in Switzerland, where he quit, cold turkey and forever, his pack-a-day smoking habit, a courtly gesture of mercy to his hale but aging body.[140] (He

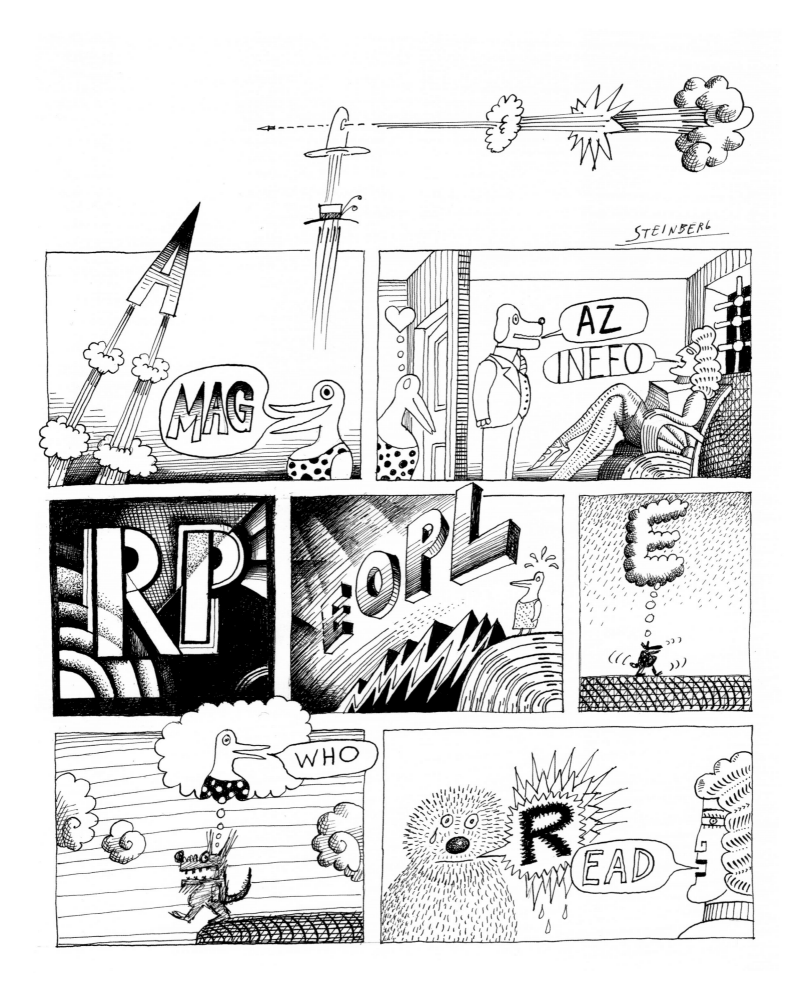

69. *A Magazine for People Who Read III*, 1969 (drawing for full-page *New York Times* advertisement, November 21, 1969, for *The New Yorker*). Ink, pencil, and collage on paper, 23 x 14½ in. (58.4 x 36.8 cm). YCAL 6364.

70. Steinberg with Papoose in the studio, Amagansett, 1974.

would tell Sterne, years later, that no day or hour passed without his thinking of a cigarette.)[141] Finished with his downtown adventure, in 1973 he pulled up stakes from his Village apartment and bought a duplex at Park Avenue and East 75th Street—apartment below, studio above. The move put him a short walk from the 71st Street house, where Sterne still lived, and from Books & Co., a shop where he would become a regular.[142] He grew back the mustache. He started wearing a cap, an ordinary one.

In town and country his life grew quieter, taking shape around his voluminous reading, the company of old friends, a daily but contained work habit, and—also in 1973—the addition of a large studio wing to the Amagansett house. Glass side doors kept the studio in touch with the sylvan grounds he had come to love. On the high end wall (fig. 70) there sprouted a menagerie of grotesques from his sketchbooks—one or two figures per page—ready to be mixed and matched into Manhattanite dystopias and memory-caricatures of Fascist-era Milan. This exorcistic method took turns in his work day with the calming watercolor pieces he called "sunsets" or "postcards" (fig. 71; cat. 68) and meditative collage still lifes, in which he drafted pieces of paper ephemera into a mutant Cubism of his own

71. *Five Sunsets*, 1974.
Watercolor, ink, rubber stamp,
and collage on paper, 29¾ x
22 in. (75.6 x 55.9 cm). Private
collection.

72. *The New Yorker Airmail*,
1974. Pencil, colored pencil, col-
lage, and ink on paper, 19¾ x
25⅝ in. (50.2 x 65.1 cm). SSF
7263.

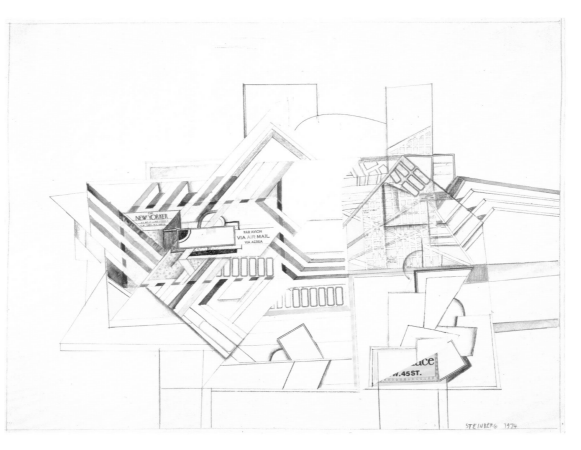

design (fig. 72; cat. 64). He also became absorbed in the discipline of direct observation, creating what he called, in Italian, *dal vero* ("from the truth") drawings of modest tabletop arrangements (cat. 72), or Sigrid sewing or reading while the black cat Papoose prowled around, or of neighbors and visitors whom he asked to pose (cat. 73).

The fantastic and the mundane meet in a genre of sculptural assemblage that he now began to practice, one that was less trompe-l'oeil than trompe-l'esprit. Out of such modest found materials as prison artists use, Steinberg reconstituted the objects of everyday life at life scale—pens and pencils whittled from sticks; a chip of wood turned into an appointment book by a coat of vermilion, "1971" carved on its face; a camera cobbled out of a block of wood, bottle caps, a hinge, a pushpin, and string, and so on (figs. 73–75 and p. 196). These makeshift sketches in three dimensions—which he saved, gave away, or incorporated into the "drawing table" assemblages that first figured in his 1973 shows at the Maeght, Janis, and Parsons galleries (cat. 71)—belong to the genre of philosophical toys, objects designed to impart knowledge to the user. The game they play is that of visual representation itself, wherein (to reduce it to fundamentals) a viewer's eye gets convinced to side with the artist and pretend that one thing (a piece of paper or a chunk of wood) is something else.

73. Three false envelopes, posted August–September 1982. Mixed media on wood, 4 x 7½ x ⅛ in. (10.2 x 19.1 x .2 cm) each. SSF 4650, 4651, 4652.

74. *Tango Bergamasco*, 1965. Mixed media on sheet metal, 15¾ x 15¾ in. (38.7 x 40 cm). SSF 4770.

75. Hammer and pocket watch boxed set, c. 1974. Mixed media on wood, hammer, and pocket watch, 6¼ x 12½ x 2½ in. (15.9 x 31.7 x 6.4 cm). SSF 5706.

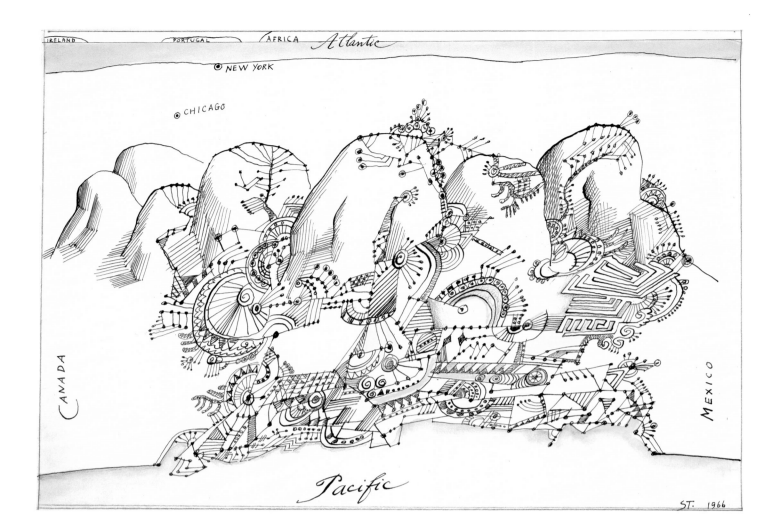

76. *The West Coast*, 1966. Watercolor, ink, and colored pencil on paper, 14 x 20 in. (35.6 x 50.8 cm). Private collection.

In 1973, Steinberg picked up a promising graphic idea he had set aside several years earlier. Among the drawings he had created for a three-part *New Yorker* profile on Los Angeles in 1966 were schematic views of North America as seen from someplace over the Pacific. This sidelong approach caused the kingdom of tinsel to loom up in the foreground, the way it might in an Angelino's mind—a world apart from the continent beyond the mountains (fig. 76).[143] Now, by maintaining the same point of view but shifting his focus to the far coast, Steinberg conceived of the USA the way a Manhattanite might think of it—as "the West Side," an outsize suburb of New York, with the Mississippi running through it (fig. 77). There the idea sat until two years later, when a sequence of drafts led him to the definitive reverse perspective—the *View of the World from 9th Avenue* (cat. 76)—which ran on the cover of *The New Yorker* on March 29, 1976.[144]

By *View of the World* he would be known, like it or not, for the rest of his life. Besieged by demand, *The New Yorker* quickly issued the cover as a large poster, which went through numerous editions in two years.[145] If Steinberg was flattered at first, he soon grew uneasy at the runaway popularity of the image, which like Assessor Kovalyov's nose had escaped its owner's control and would not be coming back. Even more disturbing was the popular interpretation that saw him endorsing local chauvinism; for him, he told a friend, *The View* clearly represented the mindset of "the crummy people."[146] The crowning offense was the unending parade of imitations, adaptations, and pirate products derived from the image, which Steinberg chose to fight in court only once. For an obvious and clumsy imitation of *The View* in posters for the 1984 movie *Moscow on the Hudson*, he ultimately received a sizable

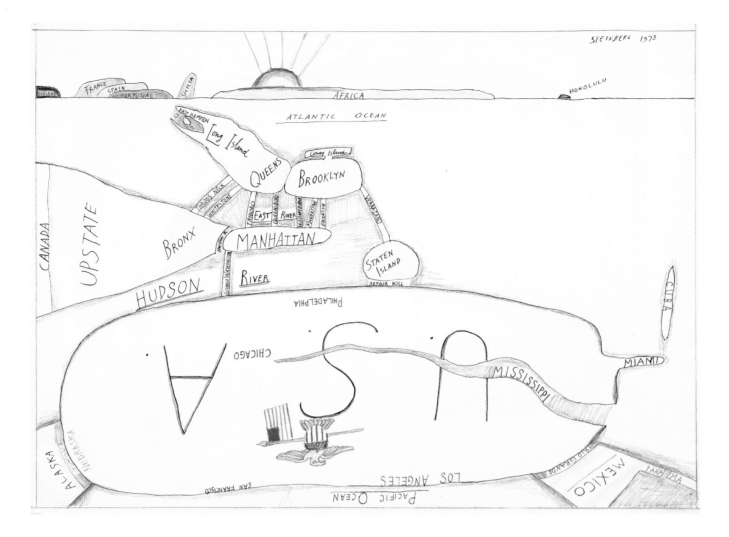

financial settlement from Columbia Pictures. At least as satisfying as the money was Judge Louis L. Stanton's summary judgment, which—in a Steinbergian dream of what art criticism should be—went through the case on the basis of soberly considered visual specifics, and literally awarded creativity its due. Steinberg, regarding it as among the best analyses of his art ever written, mailed copies of the decision to friends.[147]

Since the mid-sixties, Steinberg had been hearing, pondering, and putting off proposals for a retrospective exhibition. The idea would have been simple to dismiss if it had not appealed to him on some level. But he resisted, fearful that retrospection and the dreaded "Art Book" (catalogue) turned an artist into an inert "work of art," an object of scrutiny rather than a self-invention in progress.[148] He assented at last to a large traveling exhibition with close to two hundred works borrowed from over sixty lenders, originating at the Whitney Museum of American Art in 1978. As a crucial point in the project's favor, the catalogue's text was written by his friend Harold Rosenberg, culture and art critic for journals, including *Partisan Review, Dissent,* and, since 1963, *The New Yorker*.

 In characteristically dialectical fashion, Rosenberg concluded that Steinberg's key contribution to the art world was to have created a role for himself at its outer edge, thus making it "impossible for art to acknowledge his legitimacy without changing its conception of itself."[149] For decades the two friends had been conducting what Steinberg called a "free speech" dialogue on every conceivable topic; for Steinberg, this would remain his model for challenging but "non-professional" conversation.[150]

Rosenberg's death, shortly after the show opened, came as a hard blow, harder even than Nabokov's the year before. Their deaths, in turn, marked only the beginning of an unrelieved pattern of losses that would shadow the final quarter of Steinberg's life, reminding him of his own limited time.[151]

As though to prove that the museum's "Art Book" had not been the tombstone of his career, he stepped up his activity on all fronts. In 1982 he switched his representation from Parsons and Janis to the Pace Gallery, resulting in a dramatic shift up for his prices and the scale of his work.[152] And between 1978 and 1988 he published no fewer than twenty-eight portfolios of drawings in *The New Yorker*, ranging in subject matter from postcards to dreams, from villas to Lexington Avenue, and across time, from walking to school in Bucharest ("Cousins," 1979) to the romantic assignations of adulthood ("Kiss," 1985).[153] These portfolios amount to his own unregulated, "free-speaking" version of a retrospective, in which—using a stripped-down, unostentatious visual vocabulary—he allowed himself to look back, inward or around as needed, reinventing his life as wordless literature. Memories that were too singular to fit in portfolios he rendered as captioned "ex-voto" drawings, an informal genre that allowed him to accept into his repertoire mental images from past days, years, or decades (fig. 10; cat. 82)—what he called, in one caption, "film exposed 60 years ago and only now developed and printed."[154]

He accepted, too, the "reasonably clumsy" manner that aging brought into his drawing, displacing his onetime encyclopedic mastery of techniques.[155] He seemed relieved to have evolved beyond the use of style for arch purposes to a form of drawing as naturally self-expressive as handwriting. He had long dismissed as "political" all art motivated by the narratives of capitalized Art History—art that "overthrew" art, art that was neo- or post- or retro-.[156] The modern artist, lacking the sort of directives his predecessors had got from "the pope and the prince," had proven susceptible to the master plans of movement leaders and critics, whose manifestos supplied helpful direction for the directionless. To Steinberg, the dutiful corps of Pointillists who had sprung up after Seurat, the international academy of second-act Picassos who had hoped to translate Cubism into a replicable code, and the method-actor Abstractionists who came along in Pollock's footsteps were so many rubber stamps—historically important, in their way (because "we judge a period by the quality of its lousy art"[157]); yet sad, insofar as they had made themselves tools of a historical bureaucracy they could not see.

78. Steinberg seated in lotus position, Amagansett, 1995.

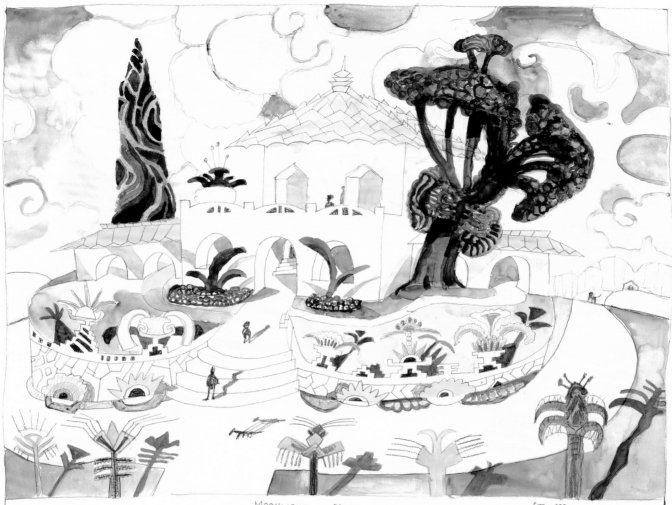

MOONLIGHT IN BRENTWOOD ST 1990

79. *Moonlight in Brentwood*, 1990. Crayon and watercolor on paper, 23 x 29 in. (58.4 x 73.7 cm). Private collection.

The only artistic progress worth making was away from the style politics of one's time, which were frighteningly arbitrary. Steinberg had arrived in Milan just as the Nazis were shutting down the Bauhaus school in Germany, and just in time to see its utopian program bent into the brutalist design ethic of "Milanese Bauhaus." Surrealism—the ratified avant-garde mode of his youth—had ostensibly liberated the subconscious of poet and painter, but in fact, as doctrine, it drafted even sleep into the cause of conformity, as writers and artists began to dream surreally—or pretend they did. What an artist needed most, in Steinberg's view, was a venue that would not infect one's intentions, a means of reaching the public that did not become a prison. First under Harold Ross and then under William Shawn, *The New Yorker* had supplied Steinberg with a haven "more intelligent than its time," where he was free to cut a path off the policed highways of art in his time.[158]

It came, therefore, as a shock to Steinberg's sense of security and justice when S.I. Newhouse, who had bought the magazine in 1985, replaced Shawn with a new editor, Robert Gottlieb, two years later. In silent protest, Steinberg put himself more or less on leave, a state of affairs that would continue for five years. Withholding art from *The New Yorker* became part of a private life defined, increasingly, by its elective austerities. He discovered the solitary pleasures of yoga and Zen meditation, which Sterne had long practiced and which became his private solace, writing, "Zen is being inside with oneself in silence, an escape from the constant chatter of introspection & conversation."[159] Formerly one to order his suits and boots from London, he now attired himself—as nattily as ever—in Upper East Side thrift-store

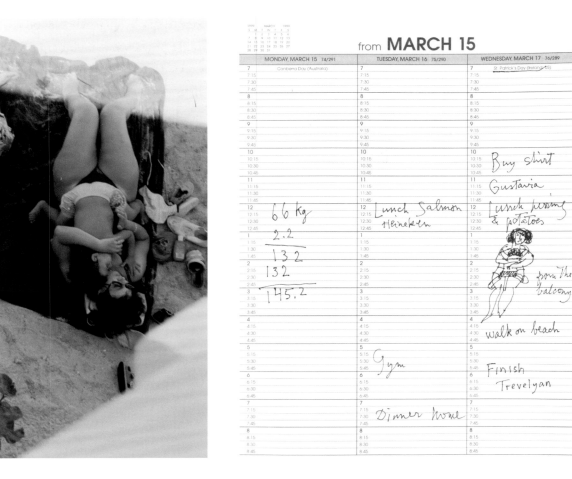

80. Snapshot made by Prudence Crowther, St. Bart's, March 1999. YCAL.

81. Sketch in appointment book, March 17, 1999. YCAL.

finds.[160] On a 1993 trip to the Costa del Sol, he found the place ruined, and himself hemmed in, by "stupid rich."[161] He took refuge from the tasteless excess around him by writing a "List of good things & places," headed by elegantly simple Swiss hotels and the clinic where he had been checking in for periodic fasts since the early 1970s.[162] The list goes on to enumerate pleasures as focused and idiosyncratic as the art he was making by this time—a connoisseur's minimalism: "crocus, electric pencil sharpener, a great shower, redwing song in spring, cat casual greeting."

During his hiatus from *The New Yorker*, Steinberg found other outlets for his drawings. He collaborated with writer Ian Frazier on *Canal Street* (1990), a limited-edition book; printed two portfolios (1990, 1994) in the literary journal *Grand Street*; issued his final (and only full-color) book of drawings, *The Discovery of America* (1992), which included his idylls of a lush, otherworldly Southern California (fig. 79); and turned over a group of marker pen drawings to *The New York Review of Books*, to be used as occasional illustrations with review articles (1994–96).[163] In the latter case, he in effect made himself a colleague to J.J. Grandville (1803–1847) and Honoré Daumier (1808–1879), the brilliant nineteenth-century illustrators who serve, in clip-art form, as the journal's extended art staff. He time-traveled through literature in another sense, too, by drawing portraits from period photographs of his personal pantheon of writers and painters (cat. 91).

Late in 1991 Steinberg gave *The New Yorker* the go-ahead to use five cover designs that had been accepted in the final years of Shawn's tenure. By the time that cache ran out, in May 1993, Shawn had died, a king in exile, and Steinberg felt further from reconciliation with the magazine than ever. But by the end of the year, new editor Tina Brown and her art editor, Françoise Mouly, had persuaded him to resume his contributions. He turned in only covers and titled portfolio features, which were

printed in the full color Brown had made standard on the inside pages.[164] The arrangement suited both artist and editor: Brown had lured a prized name back to the magazine's pages, while Steinberg saw his work handled like that of an honored guest, rather than being swept into the collective persona of a publication he now regarded as the merest ghost of his "wife" of many decades.[165]

In 1995, personal troubles began to mount. On a winter trip to St. Bart's, Sigrid Spaeth—long under treatment for depression—suffered a severe mental crisis, and Steinberg rushed her back to New York for hospitalization.[166] Steinberg himself, increasingly in despair, began taking Librium for anxiety. Early the next year, while on the upswing from a thyroid cancer scare, he considered making a token gesture toward the future by buying a computer or cell phone, which, he concluded, "won't do me any good. Yet it bothers me to live in a world that I don't understand. I already figured out that unless you're an expert, the computer is nothing more than a joke."[167] That October, Spaeth committed suicide. Steinberg, haunted by remorse, withdrew more deeply than ever to the consolation of close friendships. In the country, his diary came to consist, occasionally for days at a time, of lists of books read and friends called, hour by hour. In December 1998, just a day after beginning a month's program of shock treatment for what had become intolerable depression, he learned that the closest of his remaining Long Island friends, novelist William Gaddis, had died.

On a recovery trip to St. Bart's, in March 1999, Steinberg stood on a hotel balcony. Looking down at the beach, he saw a woman lying on a towel, a young boy's sandy body wrapped around hers in slumber. He asked his traveling companion to snap some aide-mémoire photographs, and in his diary—rarely, for this late date—drew a sketch (figs. 80, 81). Tender and sensual, a rich, ordinary, unanticipated image of the cycle of life, the coupling might be Steinberg's last drawing. In early May, he was diagnosed with advanced pancreatic cancer. He died two weeks later.

Steinberg did all he could to put his art beyond summary, and he resisted being fit into the larger narratives of art in his era. Though neither the spirit nor the effect of those intentions can be shrugged off, a faithful chronicler is compelled to venture conclusions.

First, his art sprang from the cartoon. The discipline he learned as a cartoonist—comparable, among writers, to that of a poet—continued to define his art in two distinct ways: it lent coherence and consistency to his visual vocabulary, and it gave him the means (and the habit) of perpetual search and discovery. Both qualities speak in the more than two hundred sketchbooks he left behind.

For the consistency comics brought to Steinberg's career over the years consider two sketchbook drawings widely separated in time and motive. In 1957, while traveling through Franco's Spain, he sat in flamenco cafés and limbered his caricaturist's muscles with sketches that explore the unities of regional body type, posture, and physiognomy (fig. 82). Some thirty-five years later, in a book of sketches for illustrations in *The New York Review of Books*, he drew a severe burlesque of recent relations between the Continent and Uncle Sam, figured as a plump harlot and her pony-tailed, leather-jacketed pimp (fig. 83). For all their differences, these two images have in common a simple—"composition" would overstate it, so call it a schema. In its simplicity, the schema points to a deep continuity spanning Steinberg's work. Though he liked to call himself a novelist, his gift was for the short form—*pensées* for the eye.

Hence Steinberg's lifelong fidelity to the fundamentals of cartoon craft, including three qualities exemplified in these drawings: an energetic contour outline, which defines each player on the page as distinctly as an animated cartoon character on its cel; vivid dualities (woman and man, ornate and simple, figure and reflection) that seduce the reader into the participatory role he called "complicity";

82. Spain, 1957. Ballpoint pen. YCAL sketchbook 4928.

83. Europe and Sam, c. 1994. Marker pen. YCAL sketchbook 4935.

84–86. Untitled sketches for *Canal Street*, 1989–90. Pencil and colored pencil. YCAL sketchbook 4931.

and finally, a strategic recourse to full profile. To take the profile view, as a caricaturist is aware, is to translate all the ambiguities of a face or figure into a shape—into a character, which signifies its owner as unmistakably as a 5 does its quantity, or a Z its sound. The same sidelong approach seals the figure off from us psychologically. "For me, people are profiles," Steinberg said; "a face seen front is not quite drawing."[168]

If cartooning as a genre lent constancy to Steinberg's visual vocabulary over the long haul, as a métier it continually allowed or obliged him to put every idea, mood, or theme through many swift changes in a short span of time. He called his daily drawing "the best calisthenics one can have," almost as if he were prescribing a solution for the art world's mental and visual flab.[169]

Here—taking a random sample—are three nearly consecutive sketchbook pages on which Steinberg auditioned ideas for an image in *Canal Street* (1990; figs. 84–86). As Ian Frazier's text in their collaborative book explains, Canal Street is a truck-jammed route that slices its way crosstown between the Manhattan Bridge and the Holland Tunnel, thus treating Manhattan like a shortcut from Brooklyn to New Jersey—from an outer borough to the mainland. Steinberg's sketches adapt this idea to a familiar theme of his art: Manhattan's self-absorbed attitude toward its host nation.

The first, maplike sketch pictures Manhattan as an allegorical almanac of the human condition, with streets named Doubt, Power, Envy, and so on (fig. 84). If Manhattan is the whole realm of Life, then the tunnel's maw must stand for the kingdom's only known exit. A second sketch weds two cartoonish nightmares of the Gothamite (fig. 85). Sloshing across the Hudson, armed with claws and a goony grin, comes a cowboy-hatted monster-rube—Hillbillzilla! In a third sketch (fig. 86), off-kilter gravity hints at the approach Steinberg would take in the book itself (cat. 88). Here the Holland Tunnel is (metaphorically as well as literally) a Black Hole, throwing physics out of whack as it describes the limit (philosophical as well as geographic) of the New Yorker's universe.

Sketches such as these three lend truth to the impression, gladly encouraged by Steinberg, that inventions poured out of him whole, from mind to hand to paper. But when asked, point blank, whether he made "preliminary drawings," he countered, "I wouldn't call them preliminary. I'd call them searching."[170] The scope of that task of "searching"—the process of working through a specific problem on

87. *Untitled (Bucharest)*,
c. 1990. Colored pencil on paper,
11 x 14 in. (27.9 x 35.6 cm).
YCAL 1551.

paper—was, in his later years, all the "art history" he needed. He was a complex creature of his century, self-made through emigration, wide travel, study, reading, and experience. But he was keenly aware that his job at the drawing table was to banish all of that and learn something new, on paper.

Where does Steinberg fit—where, in the long run, will he be seen to fit—among his peers? When his admirers call him "great," they don't just mean his cartoons were swell; they mean his art earned a place among the great modern oeuvres. If the laurel crown seems out of place on Steinberg's head, part of the reason is that his characteristic mode was humor, while greatness is habitually equated with gravity. Just as problematically, his genius followed a singular logic all its own, which respected neither the measure nor the pattern of Art History. Perhaps it is worth drawing a clear distinction between two kinds of greatness.

A handful of artists—include Picasso, Duchamp, Warhol—can be said to have genuinely reinvented the possibilities of art in the twentieth century. They are great artists in a broad, generic sense: to ignore what they did and what it meant is to fundamentally misunderstand their era's art. Steinberg has no place, and coveted none, in that company of paradigm-shifters.

He bids fair, however, for membership in another, more humanly scaled class of greats, amid peers such as Klee and Mondrian. They did not rewrite history; they are great by virtue of their singularity. Each, on a detour all his own, took an idea or a sensibility as far as it could go. In tribute, history has promoted their names to the status of modifiers: Kleelike whimsy, Mondrianesque purity. "Steinbergian" is not out of place in that glossary . . . but Steinbergian what? What made Steinberg Steinbergian? What is the quality that renders him an emblematic figure in the art of his epoch?

Roger Angell's description of him as a "world-class noticer" is apt. Steinberg was virtuosic—unparalleled—in both the sheer range of phenomena he absorbed into his repertoire and in his ability

88. Bulevardul Elisabeta, Bucharest, photocopy enlargement, c. 1988, of c. 1924 postcard, 11 x 17 in. (27.9 x 43.2 cm). YCAL.

to reinvent himself on paper in order to convey new perceptions about it all. This dual virtuosity was, of course, an expression of Steinberg's intellectual depth and breadth, but as an achievement in art, it owes much to his choice of métier. He became Steinbergian by being a draftsman-by-way-of-cartoons, working in the intellectual and sensory world of fine art painting. Comic drawing put at his disposal a rich, coherent graphic vocabulary—one which had been tested, refined, and rendered highly pliable in the course of its evolution as a popular form, and which was just waiting for its virtuoso.

In 1989, while Ceaucescu's Romania was going the way of Mussolini's Italy (fig. 87), Steinberg invented a means of travel back into the "attractive and comprehensible time" preserved in his collection of old European gravure postcards. Using a photocopy machine, he blew several postcards up to the scale of large easel paintings and tacked the enlargements to his studio wall. Then he sat and watched them, like a cinema of stills. The railway platforms, small town squares, town halls, and casinos of the Belle Époque, though gnarled into knobby black-and-white by repeated copying, came alive for him. In this way he took historical core samples of "the world just before I was born," in a range of locales such as Bucharest, Buzau (where his grandfather had been a military tailor, and where the family spent its summers), Moscow, Brest, Heidelberg, Lille, and Avignon.[171]

Steinberg appears to have begun making the photocopies as self-therapy, or as an aid to meditation, and to have been in no hurry to force their conversion into art. One tangible product, however, was a portfolio for the periodical *Grand Street*, in which six oil pastel drawings of dogs appear alongside reproductions of selected postcards from his collection.[172] The common thread is revealed in full-page close-ups: amid a trove of accidental detail (painted signage, period costume and posture, changing foliage, the drying mud-rut of a wagon wheel), each postcard happens to include, somewhere, a tiny

dog. Steinberg gathered these and other postcards into a looseleaf portfolio of oversize photocopies, titled "DOGS" (fig. 88).[173] As you turn the leaves, you at first play a simple game of find-the-dog. But then an unexpected poetic effect kicks in; you catch the contagion of each dog's indifference to all that a postcard is intended to document. A dog is absorbed in sniffing a footprint, or waiting for its master, or alert to the dangers of the street. It has no notion of the so-called fact that it is surrounded by "Bucureşti.—Bulevardul Elisabeta." A dog lives in its perceptual moment; it registers the world not through canned representations, but *dal vero*. Steinberg stand-ins, the dogs in these postcards at once expose and undo the human pretensions around them, inviting us to imagine our way into a world as freshly seen as the worlds they knew.

Steinberg is the dog in the postcard of modern art history: he walks around among those posing for the camera, but obeys his own itinerary, follows his nose, is oriented by his own landmarks. Like some of his heroes—Flaubert, Rimbaud, Joyce, Duchamp—he belongs in the canon precisely insofar as he did not, could not, adjust himself to its priorities. Historians of the future, trying to make enduring sense of Steinberg's century, could do worse than guide themselves along the path of his illuminations.

89. *The New Yorker*, May 22, 1943.

Catalogue

1
Untitled (Autopsy)

c. 1936–38
Ink on paper, 13 x 9⅝ in. (33.1 x 24.5 cm)
Angelini Collection

2
Untitled (Zia Elena)

1937
Ink on paper, 13³⁄₁₆ x 9⅝ in. (33.5 x 24.5 cm)
Angelini Collection
Caption: Mascalzone d'un macchinista! Ti insegnerò io a non cedere il passo alle signore! (Scoundrel of an engineer! That'll teach you to yield the road to ladies!)
Published: *Bertoldo*, no. 96, November 30, 1937, p. 2.

"God knows what I admired when I started," Steinberg once reflected, when asked to name his affinities as a young draftsman. "I had absolutely no schooling, no interest in Art— . . . people have told me that I derive [my line] from Klee, for instance. My answer to this [is that] we both had the same influences: children's drawings, peasant embroideries, insane art—and also in my

"In Russia: Rebellious Hair."
Drawing for *Bertoldo*, no. 16,
February 25, 1938. Ink on paper,
13 x 9⁷⁄₁₆ in. (33.5 x 24.5 cm).
Il Club dei Ventitré (Archivio
Guareschi), Roncole Verdi.

case later the traffic with architecture, which had to do with a bit of Bauhausy philosophy of transforming writing into drawing—basically a Bauhaus fantasy."[1]

Steinberg's other important teacher was cartooning—a different way of "transforming writing into drawing." In 1936, when he was three years into the architectural program at Milan's Reggio Politecnico, he began drawing for the twice-weekly comic tabloid *Bertoldo*. His work was soon appearing regularly there and, by 1938, in a weekly competitor, *Settebello*. The pages of both journals, dense with humorous prose, verse, and filler gags, were enlivened by single-frame and strip cartoons. Many issues also included a nearly full-page drawing such as Steinberg's "Panorami" features (fig. 14, p. 28), each of which incorporates a dozen or more captions and sight gags. Most of his cartoons were scripted by *Bertoldo* writers, whose stock comedic mode turned clichés on their heads and called for rendering puns and everyday phrases literally (left and p. 92).[2] The lost caption of the present, unpublished autopsy scene surely diagnosed the patient as a victim of love.

Later, whenever Italian publishers proposed anthologizing his voluminous *Bertoldo* work, Steinberg vetoed the idea, evidently feeling that his training period failed, in retrospect, to anticipate his future career.[3] Perhaps he flinched, too, at the evidence of some early influences. His loose, playful technique built on the example of a *Bertoldo* regular, Giovanni Mosca, whose splay-footed figures inhabited an intentionally crude stage-set world.[4] But Steinberg's line, for all its simplicity, often assumed an unlikely elegance, deriving second-level humor from the juxtaposition of delicate style to outrageous goings-on, such as the rampages of his recurring character Zia Elena (see also fig. 12, p. 26).

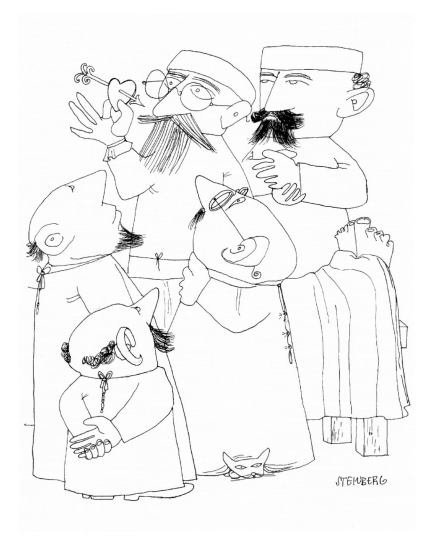

3
Untitled (Seated Group)

c. 1941
Gouache on cardboard, 12 x 12 in. (30.5 x 30.5 cm)
Collection of Lawrence Danson
Published: Danson, *Ontario Review* (2000–01), cover.

When Steinberg touched down on American soil in July 1942—flying into Miami from Ciudad Trujillo via Port-au-Prince—his property (so he always claimed) consisted of "an orange." (Despite this inauspicious start, he remembered wondering, as he surveyed the tarmac: "Where are the reporters?"[5]) In fact his luggage contained, among other things, paintings he had produced during the preceding year, while waiting out the immigration quota in Ciudad Trujillo. Writing in March to his New York cousin Henrietta Danson, who was working to secure his US visa, he remarked that in January's "National Exibition [*sic*] of Fine Arts . . . I had great success with 3 small paintings."[6]

Of Steinberg's few known paintings of this period (all in gouache on cardboard), the two most finished are this seated group, which he gave to Henrietta, and a closely related standing man, dated 1941, which he kept.[7] The setup in both is one he had employed frequently in the cartoons published in Milan: in a narrow room, its walls hung with pictorial oddities, sitters pose formally, as though for a portrait photograph, beside a window that gives onto the world outside. Here the outdoor scene is enlivened by both naturalist and fantastic details—on the one hand, tropical foliage (an actual feature of Steinberg's view in Ciudad Trujillo[8]) and, on the other, a man-eating bird flying overhead, its fuselage bearing a fried-egg insignia. The operative mode inside the room is neither realist nor surrealist; more subtly, it is a place where reality is caught in the act of "playing" itself, originals trying to resemble their conventional representations.

Topmost on the wall is an obscure rebus, an emblematic tangling of verbal and visual cues. Below it hangs a vignetted old portrait photograph, in pose and coiffure a vague echo of Steinberg's mother, Rosa, as seen in a 1912 double portrait with his father.[9] Seated to the left of the photograph, and resembling it, is a woman holding a girl on her lap; the girl, in turn, has posed her dolls to face the painter—a case of motherhood mimicked by childhood play and people imitated by toys. A small stripe-shirted boy lies on the floor. His jaunty pose—seen often in Steinberg's early work[10]—invokes a generic photographic precedent: the reclining-cherub attitude (derived from Baroque painting) once expected of boys seated at the center of the front row of a group portrait, such as Saul's kindergarten class picture.

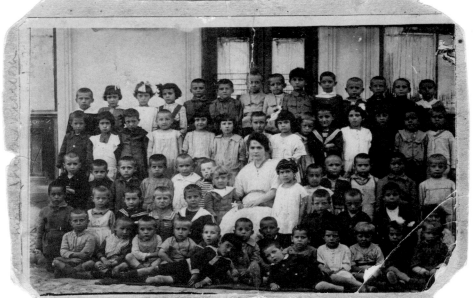

Kindergarten, Bucharest, 1920. Back row, far left and third from left, Saul and Lica Steinberg. YCAL.

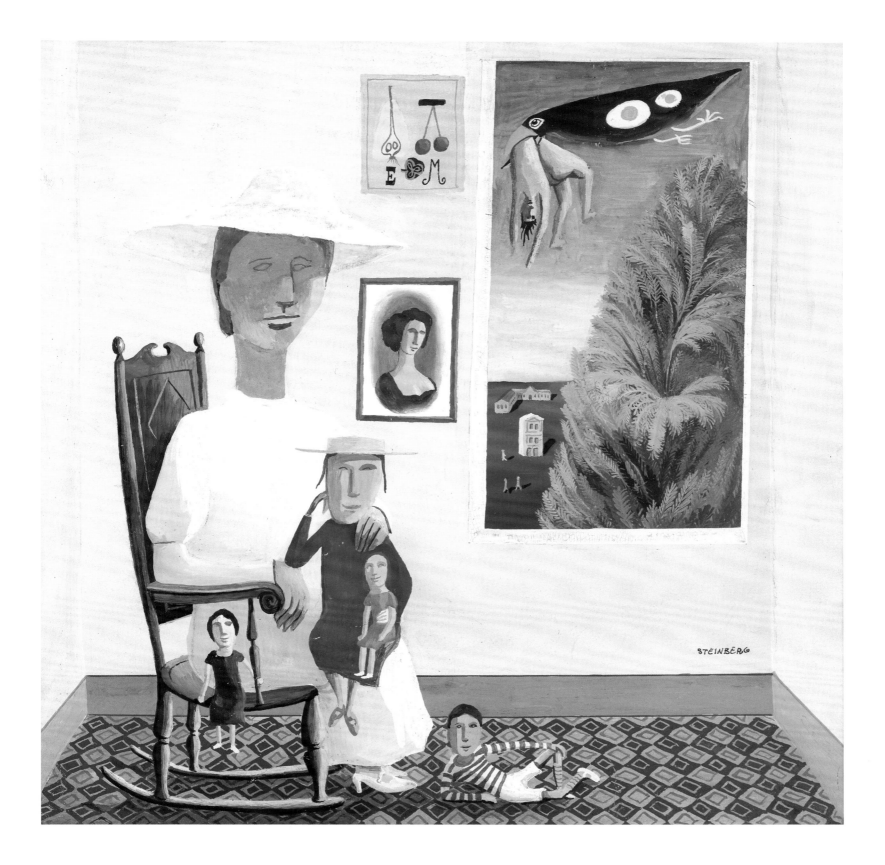

4
Strada Palas

1942
Ink, pencil, and watercolor on paper, 14⅞ x 21¾ in. (37.8 x 55.2 cm)
The Saul Steinberg Foundation, New York, SSF 1894

The artist's family is seen breakfasting at home on Strada Palas (Palace Street) in Bucharest. Saul, ready for school in a uniform with an arm patch—bearing "a number, like an automobile"[11]—assumes an outside observer's role. As a draftsman, too, he takes a disengaged perspective, evoking the dynamics of the household only in subtle details. Through body language he registers his mother's coiled vigor, his sister's sleepiness, his father's rectitude. The servant, a Romany girl, is tinted red, after the same graphic convention used in period representations of American Indians. Certain details (the table's base assembly, bent into an unblinking eye; the blue-glass seltzer bottle) remind us that the remembered viewpoint is that of someone close to the floor. At the center of the scene is the window facing the courtyard—"one of those huge courtyards inside a block of houses that are found in all Balkan countries"—the centerpiece, as Steinberg later recalled, of "a society with no mysteries," where "anyone could look in at the window."[12]

This memory drawing figured in the first exhibition to show Steinberg's work in any depth, mounted by Betty Parsons at the Wakefield Gallery, New York, in April 1943, while the artist was awaiting assignment overseas with the Navy.[13] The two-artist show paired Steinberg's color drawings with paintings by Costantino Nivola (p. 30). Other surviving drawings from the show include wry send-ups of lowly pictorial genres, such as the penny-dreadful crime scene and the factory viewed from on high—cousins to the framed family photographs and floral chromolithograph on the wall back in Strada Palas.[14] The present work was probably drawn in the Dominican Republic, at a time when Steinberg's immigration to America was as uncertain as the chances of his family's survival in Bucharest. Its intimacy and seriousness seem to have set it apart in the exhibition, where its initial asking price (at $60, higher than others in the show) was replaced by "NFS" (not for sale). Steinberg appears never to have exhibited it again.

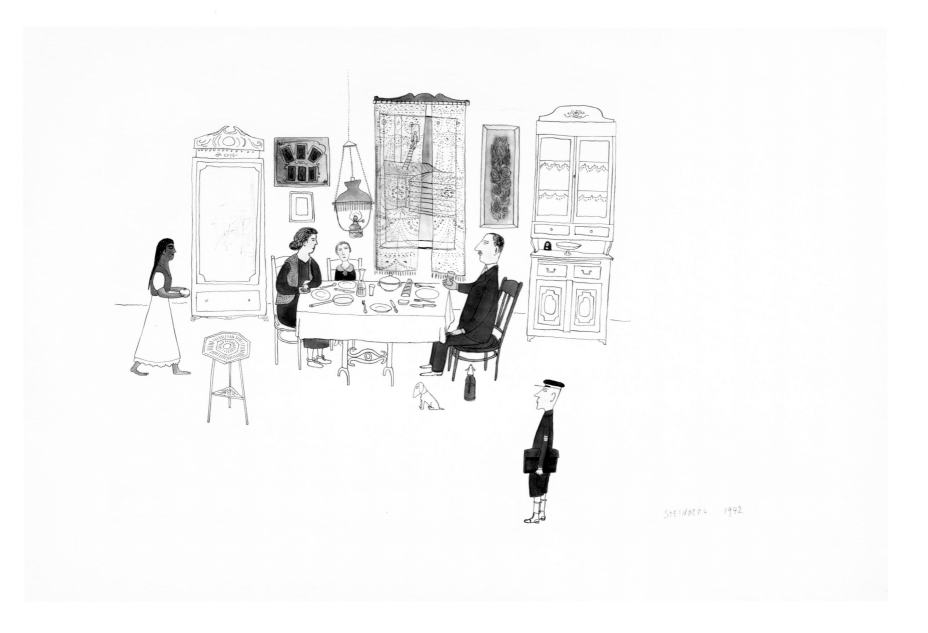

STEINBERG 1942

5
Cassino

1945
Ink over pencil on paper, 14½ x 23⅛ in. (36.8 x 58.7 cm)
The Saul Steinberg Foundation, New York, SSF 1224
Published: "Steinberg: The Line of Fancy," *Art News* 44 (July 1945), p. 24; The Museum of Modern Art, *Fourteen Americans*, 1946, n.p.

Steinberg's wartime service with Naval Intelligence and the OSS showed him World War II from the inside. For the armed noncombatant, war was a blend of random travel, boredom, and bureaucracy, which he illustrated in portfolios for *The New Yorker* (fig. 20, p. 33). Writing from Rome on the eve of his thirtieth birthday, he told art editor James Geraghty that he hoped to create "separate small series like: WACS, British troopship, German prisoners, etc. This war and this world is full of interesting things, and I could work eight hours a day about it. I never before looked around to find ideas for drawings, but I think it's a good way. Too bad I don't have much free time."[15]

Time to reflect on the war came only after Steinberg returned stateside. His section in the 1946 Museum of Modern Art exhibition "Fourteen Americans" included a five-stop tour of American bombardment around the world: Hiroshima (fig. 21, p. 34), the South Pacific, Nuremberg, China, and Monte Cassino.[16] The latter siege, in February–May 1944, was an acknowledged human, cultural, and historical disaster. Allied bombing reduced the German-occupied mountaintop abbey and most of its art to rubble; the pile, in turn, provided an impenetrable stronghold for the Germans, and Allied losses mounted into the thousands. Steinberg's dense skein of strokes renders Cassino neither a field for heroism nor the site of news on the move, but a vignette fixed in history, like his bomber plane in its web of background lines. Optically, the busy texture of his penwork recalls the visual war dispatches of a century before, such as the wood engravings after Winslow Homer's drawings and Mathew Brady's photographs, published during the American Civil War.

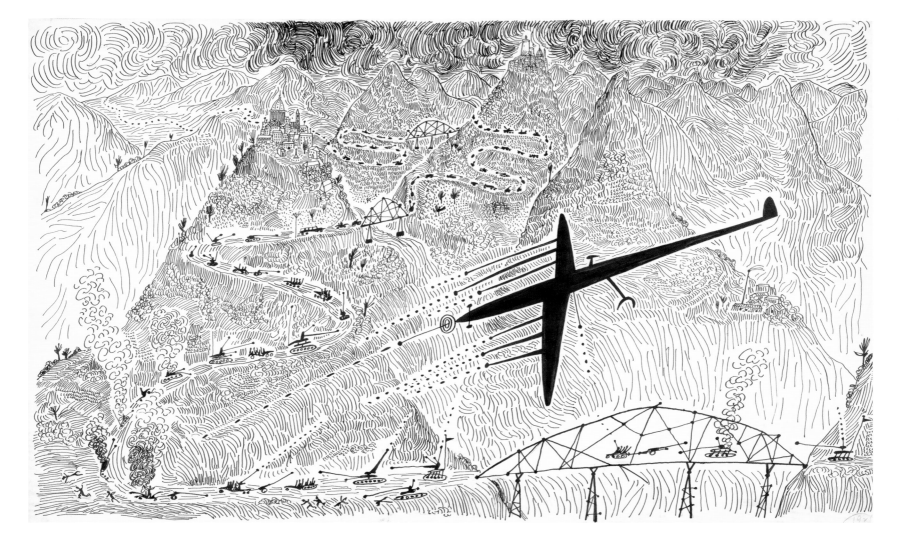

6
Head

1945
Ink over pencil on paper, 14½ x 23¼ in. (36.8 x 60.3 cm)
The Saul Steinberg Foundation, New York, SSF 1892
Published: The Museum of Modern Art, *Fourteen Americans*, 1946, n.p.; *The Art of Living*, p. 139; WMAA 1978, p. 18.

7
Monuments: The Important People

1945
Ink over pencil on paper, 14 x 23 in. (35.6 x 58.4 cm)
The Saul Steinberg Foundation, New York, SSF 1905
Published: *The Art of Living*, p. 65.

In addition to twenty-five Steinberg drawings, MoMA's "Fourteen Americans" exhibition included zinc-plate prints of *Head* and of a variant version of *Monuments*, printed on brightly colored sheets of paper.[17] In the choice of zinc plates, the intense palette, and the irreverent sensibility of these drawings, Steinberg was emulating a genre of imagery he admired and collected, namely the *hojas volantes* ("flying leaves," or broadsides) of Mexican artist José Guadalupe Posada (1852–1913).[18] Whether illuminating the lyric sheets of a topical song or celebrating the Day of the Dead, Posada's prints functioned as hybrids of journalism and art, in the tradition of Gillray, Goya, and Daumier. As such, they supplied an appealing model for Steinberg as he tested his voice as a social commentator (from the Picassoid angst of *Head* to the populist skepticism of *Monuments*) and weighed the options for distributing his own art. However, an impression of *Head* on green paper retained by the artist (SSF 4795) reveals a flaw in his self-publishing plan. Zinc plates, which are soft and quick to wear down, had helped lend a light touch to Posada's bold prints, but the same effect caused Steinberg's fine hatching lines to break up into illegibility, so that only a few impressions could be printed.

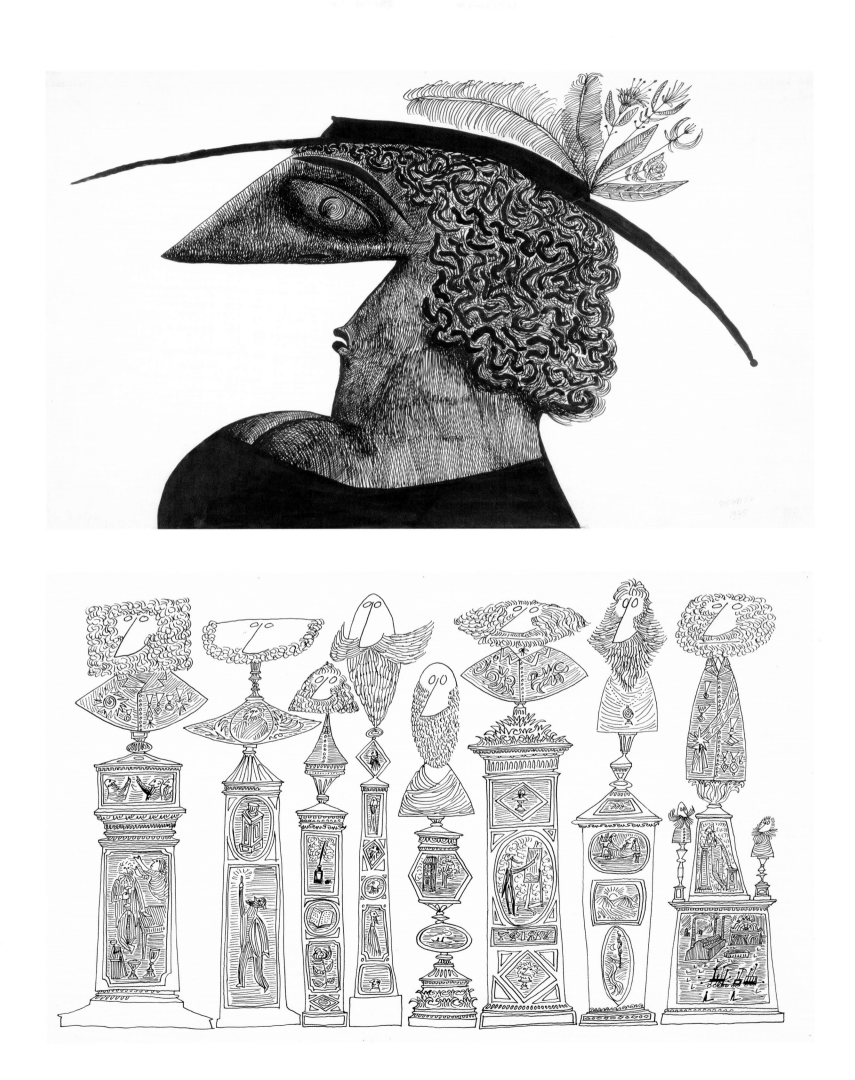

Underground

1946
Ink on paper, 23 x 14 in. (58.4 x 35.6 cm)
Collection of Richard and Ronay Menschel
Published: *Architectural Forum* 84 (May 1946), p. 114; *The Art of Living*, p. 17.

In December 1945, the Navy released Steinberg to inactive duty, and he resumed civilian life in New York City. Peacetime brought changes to the magazine business, too. In January 1946, *Architectural Forum*, following a common trend in postwar publishing, marked the end of paper rationing by expanding its trim size and adding more graphic content, and color, to its inside pages. In four successive issues, from February to May, the magazine published full-page line drawings by Steinberg. His series chronicled the surplus energy of a city leaving wartime routines behind. The first two images, *Drug Store* and *Movie Palace*, celebrated urban institutions that would slide into decline as middle-class money fled the city in the years ahead. The third and fourth, *Doubling Up* and *Underground*, portrayed situations with greater staying power—respectively, the sub-sub-subdivision of prewar apartments, and the subway.[19]

Steinberg took evident pleasure in exploring downward- and backward-plunging spaces like the one in *Underground*. Among the handful of *Bertoldo* cartoon tearsheets he retained is one portraying a woman in a labyrinthine residence. She opens a trapdoor to reveal a figure downstairs, crouching beneath a table: her husband, she explains, "has an inferiority complex." (The Italian pun links the psychological syndrome to the physical condition of being beneath something.) The link between this cartoon and *Underground* is a view down the cellar hatch of Steinberg's boyhood home, one in a series of memory sketches he drew in early 1946. This quick process of reinvention—in which a saved cartoon became the basis for a sketch, which in turn gave rise to a drawing satisfying a paid commission—was characteristic of Steinberg's methods in a period when he often had several competing deadlines to meet.

"That's my husband; he has an inferiority complex." *Bertoldo*, no. 13, March 28, 1941, p. 3.

Kitchen with cellar hatch, 1946. Ink. YCAL sketchbook 4850.

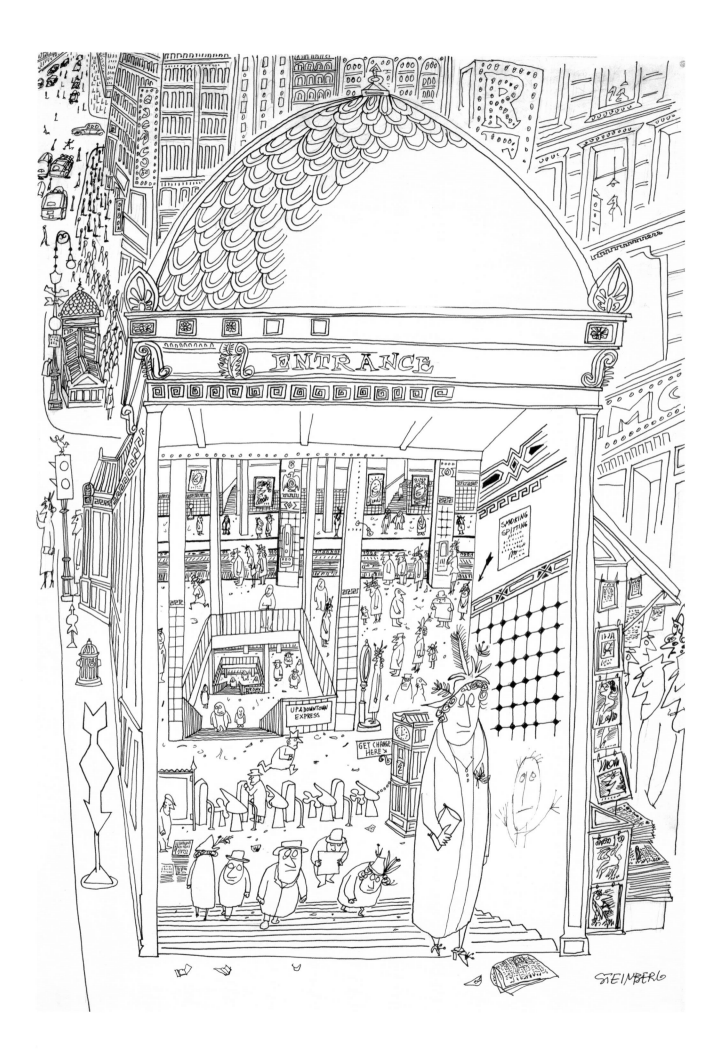

Ruth N., East Jamaica, Vermont, August 1947

1947
Ink on paper, 11 x 14 in. (27.9 x 35.6 cm)
The Saul Steinberg Foundation, New York, SSF 3890

Steinberg and his wife, Hedda Sterne, spent the summer of 1947 in a large rented house in Vermont. Between business trips to New York in his newly acquired Cadillac convertible, Steinberg read Proust (confessing, "he sort of bores me") and spent "a real summer à la Jean Jacques Rousseau."[20] The idyll included drawing visitors such as Ruth and Costantino Nivola from life. This and other studies of Ruth on a couch exemplify the reclining-

woman motif that pops up throughout Steinberg's work at this time, for example, in a feature on perfumes in *Harper's Bazaar*; in the sheet-music art for an operetta by Gian-Carlo Menotti; and in a lithograph (SSF 2687), the drawing for which (below) appeared, in turn, in his 1949 book *The Art of Living*—though with the nude subject's nipples and pubic hair discreetly whited-out.[21]

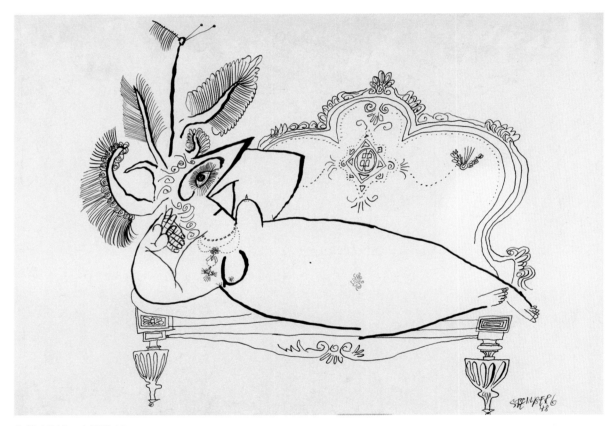

Untitled (Odalisque), 1948. Ink on paper, 12¾ x 19½ in. (32.4 x 49.5 cm). YCAL 1319.

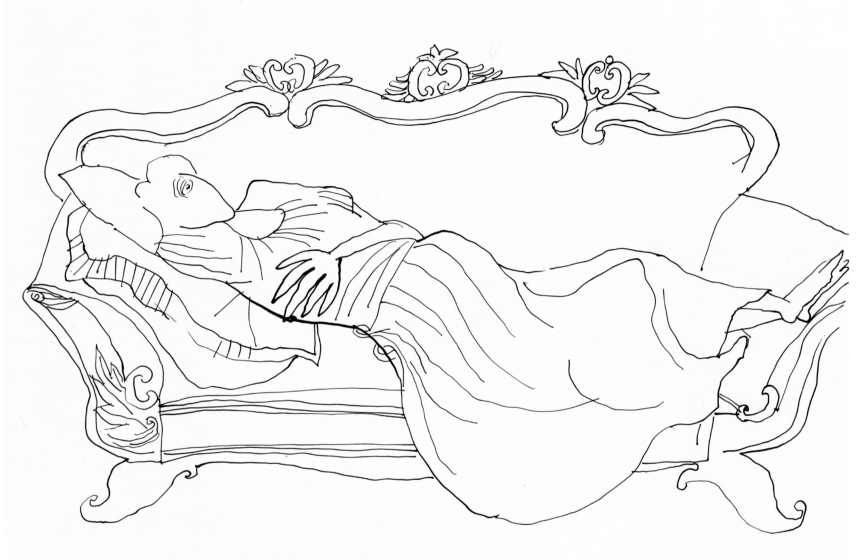

ST.

RUTH N.
East Jamaica - Vermont
AUG. 1947

10
B Movie

1948
Ink, colored pencil, crayon, watercolor, pencil, rubber stamps, and collage on paper, 14½ x 23⅛ in. (36.8 x 58.7 cm)
The Saul Steinberg Foundation, New York, SSF 1887
Published: " . . . and Europe," *Look*, January 1, 1952, p. 54.

The title Steinberg gave this drawing refers to the caption it bore in the four-page portfolio of his European travel drawings in *Look*: "The fabulous Simplon-Orient Express, passing through northern Italy in the course of its long trip from Istanbul to Paris, is about the only railway link between the East and the West. Passengers look like the cast of a B-picture of intrigue, espionage, secret missions."

Steinberg trusted few art directors at the color magazines to handle his work with intelligence, and so he negotiated for creative control, which in this case extended even to page layouts and captions. In return, Fleur Cowles, *Look*'s famously commanding editor, pressed for drawings of specific topics, such as a gondola (which she got) and a tour bus (which she did not), along with "anything else you want to call transportation."[22] Steinberg pulled from his files a railway study he had drawn a few years earlier, when the remaining prewar rolling stock of a recovering Europe rewarded American travelers with colorful tableaus—and, in the artist's case, a whiff of home. Contrary to the timid itineraries promoted in travel journalism of the 1950s, he once commented, "My sort of country goes from the eastern outskirts of Milan all the way to Afghanistan."[23]

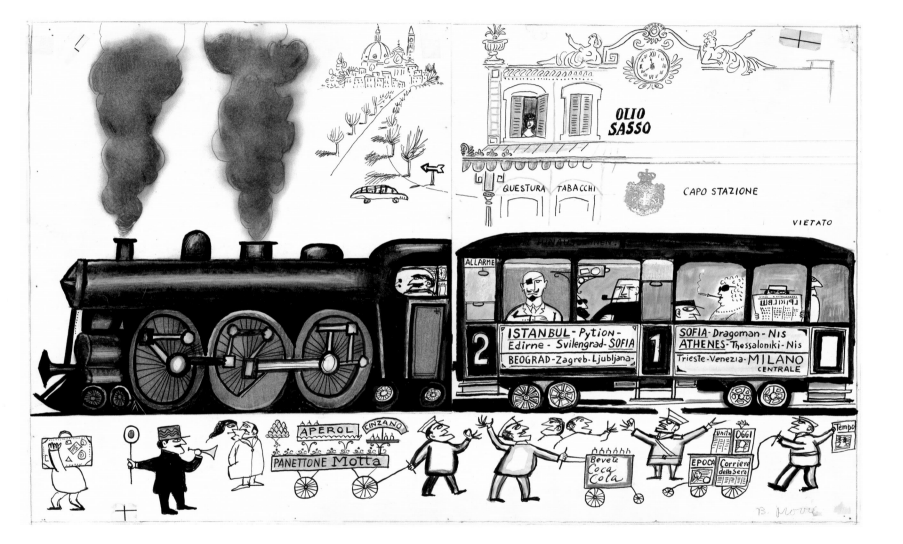

11
Feet on Chair

1946
Ink over pencil on paper, 9⅞ x 9¼ in. (25.1 x 23.5 cm)
Collection of Anton van Dalen
Published: *The New Yorker*, October 12, 1946, p. 31; The Detroit Institute of Arts, *An Exhibition for Modern Living*, 1949, cover, exhibition banner;
The Art of Living, cover (variant) and p. 5.

Everyman votes with his feet in what still qualified, in the late 1940s, as a live issue in American home furnishing: the choice between Grand Rapids simulations of Old World style and the spare, undecorated line of modernism. Chairs—simple in function, variable in style, and, to Steinberg's eye, not so much objects as "ghosts" of their occupants—provided perfect emblems for the stakes of the decision.[24] Steinberg had lampooned the discomfort of faux-refined seating in a 1943 magazine feature, "Psychoanalyze Your Furniture," which he followed up with a series of chair-themed drawings (1945–46), including this one, for *The New Yorker* and for *Interiors* magazine. The latter sequence would lead off his 1949 collection, *The Art of Living* (the working title for which was, notably, *The Wrong Century*).[25]

As that book took shape, curator Alexander Girard was assembling his design exhibition "For Modern Living" in Detroit (see p. 46). Girard conceived two installations to offset the displays of contemporary furnishing: a mural by Steinberg and, in an adjacent gallery, a historical display of seating titled "The Background of Modern Design."[26] The latter display demonstrated that the cantilevered chair—acme of contemporary high design—had evolved not through the efforts of style-conscious prettifiers but out of functional innovations, such as the spring-steel mower saddle.[27]

As the exhibition's opening date approached, Girard selected Steinberg's comfort-minded, style-blind, feet-up reader for his banner and cover image. The drawing, by showing that a sitter's backside is the final authority on chair design, embodies a principal theme of the exhibition. A passage from Thoreau's *Walden*, quoted in the catalogue, cast the principle more broadly, arguing that "architectural beauty . . . has gradually grown from within outward . . . out of some unconscious truthfulness . . . , without ever a thought for the appearance; and whatever additional beauty of this kind is destined to be produced will be preceded by a like unconscious beauty of life."[28]

Untitled (Art Viewers)

c. 1949
Ink on paper, 18½ x 14⅛ in. (47 x 35.9 cm)
Collection of Carol and Douglas Cohen

Art about art was one of Steinberg's routes to a favorite theme: the reciprocal influence of seer and seen, recreating the world through the Möbius process of perception and imitation.[29] His cartoons on art and design for *The New Yorker* made him a natural candidate to illustrate his friend Russell Lynes' articles in *Harper's* (1947, 1949) on the history of America's tastemakers—"architects, designers, merchants, critics, geniuses and frauds, messiahs and men of art."[30] Two of Steinberg's illustrations reappeared, in turn, in an *Art News* story about the 1949 Wadsworth Atheneum exhibition "Pictures within Pictures," a history of so-called gallery paintings.[31]

The exhibition included Samuel F.B. Morse's *Gallery of the Louvre*, 1831–33, itself a key instance of concerted American tastemaking. For the edification of his countrymen, Morse filled his painted version of the Salon Carré with ancient, Renaissance, and Baroque masterpieces, in place of the contemporary French art that had confronted him in the real-life Salon. Morse's painting might have provided a point of departure for Steinberg's composition, including details such as his female statue in the right-hand corner, where Morse had installed the Artemis of Versailles. But where Morse wished away the art of the nineteenth century, Steinberg curates a gleeful survey of its worst excesses—from Alexandre Cabanel's much-copied *Birth of Venus* (lower left, drawing the gentleman's eye) to a mawkish music lesson (right of the doorway).

Steinberg created a more restrained version of this burlesque scene for the back cover of S.N. Behrman's biography of art dealer Joseph Duveen, a classic study of tastemaking originally published as a series of articles—with Steinberg illustrations—in *The New Yorker*.[32]

Samuel F.B. Morse, *Gallery of the Louvre*, 1831–33. Oil on canvas, 73¾ x 108 in. (187.3 x 274.3 cm). Terra Foundation for American Art, Chicago; Daniel J. Terra Collection, 1992.51.

Back leaf of dust jacket for S.N. Behrman, *Duveen* (New York, 1952).

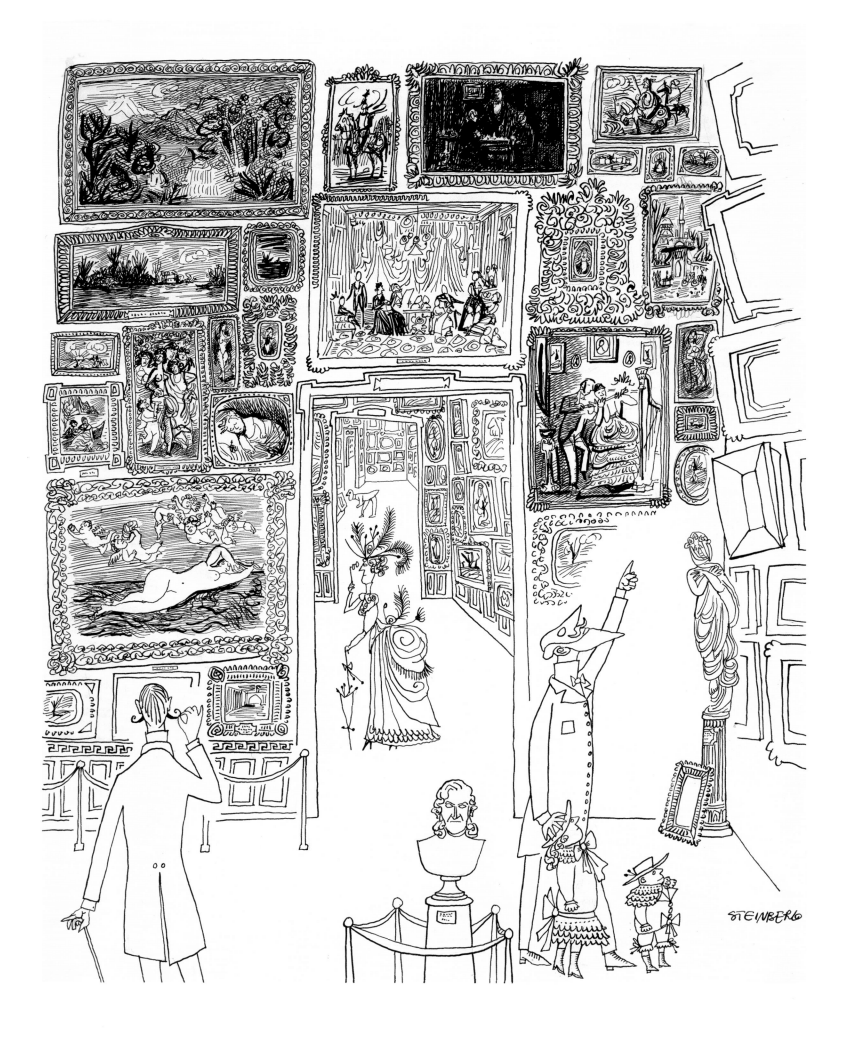

13
Woman in Tub

1949
Gelatin silver print, 12¾ x 11¼ in. (32.4 x 28.6 cm)
The Saul Steinberg Foundation, New York, SSF 6404
Published: *Steinberg*, exh. brochure (Rome: Galleria L'Obelisco, 1951), n.p;
International Poster Annual '51 (New York: Pellegrini and Cudahy, 1951), p. 177 (variant); The *Passport*, p. 57.

14
Excavation

1951–52
Ink on gelatin silver print, 13⅞ x 10⅞ in. (35.2 x 27.6 cm)
The Saul Steinberg Foundation, New York, SSF 6403
Published: *The Passport*, p. 157.

For about a decade, beginning in the late 1940s, Steinberg engaged photography from a variety of angles. He acquired his first camera in 1947, a studio with a darkroom in 1949.[33] A certain degree of aesthetic ambition is evinced in the photographs he made on trips to Mexico, the Soviet Union (pp. 138, 258), and Alaska. He also made wash drawings in Duco lacquer that simulate the look of murky or faded photographic prints, and drew cartoons that comment on the camera's role in giving form to memory and self-image.[34] And beginning in 1949, he created hybrid photo-cartoons, either by drawing on objects which were then photographed, as in *Woman in Tub*, or by drawing on the surfaces of straight photographic prints, as in *Excavation*.[35]

Line drawings and photographs often met up in *New Yorker* advertising, which was, famously, the only place in the magazine where photography appeared at all.

Such ads generally have a dual effect: they emphasize the tangibility of the product—a photographed dress, shoe, or bottle of vermouth stands out the more "really" when juxtaposed with a line-shot drawing—and at the same time, they underline (so to speak) the product's honored inclusion in *The New Yorker*'s universe, where lines rule.

Steinberg was among the staff artists who created ads exploiting this dynamic, and his techniques were widely imitated.[36] But, as in the two works shown here, his natural inclination was to complicate rather than clarify: *Woman in Tub* promotes his drawn line to the status of a camera-authenticated reality, while *Excavation* tugs the supposed realism of camera vision closer to the phantasm of drawing. In short, a photograph, for all the vaunted uniqueness of its medium, was (like the graph paper "flyscreen" below) just one more piece of paper whose special qualities made it a Steinberg waiting to happen.

Mexico City, April 1947. Commercially processed snapshot bearing Steinberg's enlargement and cropping directions. YCAL.

Advertisement for Noilly Prat Vermouth, *The New Yorker*, September 24, 1955, p. 129.

Untitled (Flyscreen), c. 1950. Ink on graph paper, 11 x 8½ in. (27.9 x 21.6 cm). YCAL 4511.

15
Women

1950
Ink on paper, 14⅜ x 23 in. (36.5 x 58.4 cm)
The Saul Steinberg Foundation, New York, SSF 4540
Published: "New Laughs from New York," *The Sketch* (London), May 21, 1952, p. 493; *Habitat* (Brazil), no. 9 (1952), cover.

16
Three Liberties

1949–51
Ink and watercolor on paper, 14 x 23 in. (35.6 x 58.4 cm)
The Saul Steinberg Foundation, New York, SSF 6470
Published: *The Art of Living* (partial; before color added), p. 21; *The Discovery of America*, p. 10.

Steinberg clipped a local resident's letter to a New York tabloid, headlined, "SEES DANGEROUS DAMES":

> *The average woman, young or old, seems to walk around New York with her head held high, jaw firmly set, eyes blazing and nostrils flaring. Her fists are usually clenched and she seems to be just itching for a fight with members of either sex. Why is this? Wotinell's the matter with you babes these days? Why aren't you all happy? Don't you know being a female in this great country of ours is the sweetest racket there is?* MOE.[37]

Moe could be one of the quiet men who shrink to the background, then disappear, in Steinberg's super-calligraphic sidewalk and subway studies of the late 1940s (see also p. 16). Steinberg's predecessor in social profiling, the great poster artist Steinlen, shuffled gender, class, and age variety into his dense social typologies, but Steinberg knew where the action had come to reside in his time and place. Whereas America's men were a uniform mass of dull breadwinners, its women embodied all the drive, panache, appetite, and self-regard of their era, whether outdoing one another on the sidewalk or incarnating Liberty (the statue, and the mode of life) on their straphanging way to work.[38]

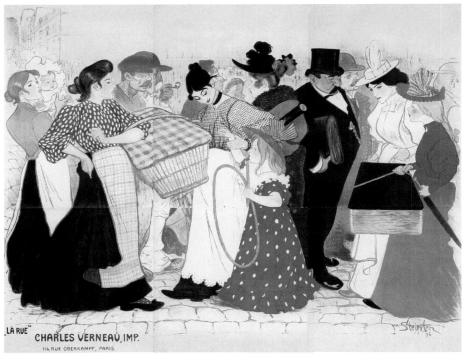

Théophile Alexandre Steinlen, *La Rue*, 1896. Lithographic poster in colors (before lettering), 93¹¹⁄₁₆ x 119¹¹⁄₁₆ in. (238 x 304 cm). Private collection.

Parade 2

1950
Ink, watercolor, and pencil on paper, 14 x 23 in. (35.6 x 58.4 cm)
The Saul Steinberg Foundation, New York, SSF 166
Published: *The Discovery of America*, p. 5.

The parade, a theme the artist took up in 1950, would evolve into a central Steinberg metaphor for the pageantry of social identity. In his parades, the surrounding city is reduced to a scattering of utility manhole covers, over which everyone struts, strides, and floats. Three of his books are jump-started by parade sequences featuring, respectively, signature- and rubber-stamp-hoisting businessmen (*The Passport*), phalanxes of "types" (housewives, spacemen, etc.) marching, like the Lilliputian suits of *Parade 2*, in troop formation (*The Inspector*), and majorettes (*The Discovery of America*).[39] The initial appeal of drawing parades was simple: "It gives me an excuse to be staring at people."[40] It also provided an excuse to work in panoramic frieze format, presenting the viewer—as parades themselves do—with endless variations on the theme of self-celebration as unwitting self-exposure.

Steinberg's early parades included a 25-foot scroll, published as a spread in *Life* in 1951, and an eleven-panel sequence (21 feet long) acquired by The Metropolitan Museum of Art in 1952. A set of ten recombinable parade scenes, including *Parade 2*, occupied the center of a long picture rail in his show at the Betty Parsons Gallery in January that year.[41]

Cowboys

1951
Ink on paper, 14 x 22 in. (35.6 x 55.9 cm)
The Saul Steinberg Foundation, New York, SSF 1927
Published: "New Laughs from New York," *The Sketch* (London), May 21, 1952, p. 493.

When describing the Americanness of Steinberg's art, British and Continental critics liked to cite his spurred, grimacing, cinch-waisted gunslingers. But Steinberg was never more European than when he made the cowboy his emblem for the enduring dime-novel theatrics of American heroism. This cheerfully rhythmic scene of mayhem, soon to be honed down to a trio of bad guys for a fabric design, sets the cowboy in the context of the real-life Great Plains as Steinberg saw them from a Greyhound window seat—an aerial-sprouting land of gas stations, grocery chains, and department store outlets. In this culture of commerce, the white-hat lived on (along with the Indian chief, the baseball star, and the local beauty queen) as a rentable mainstay of parking lot promotional events.

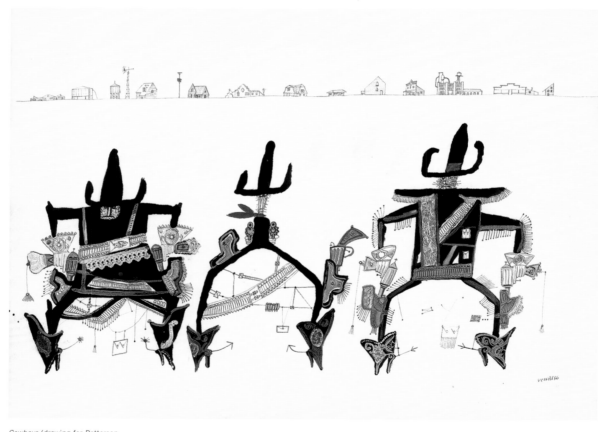

Cowboys (drawing for Patterson Fabrics design), c. 1952. Ink, Duco, collage, and gouache, 21½ x 29½ in. (54.6 x 74.9 cm). Private collection.

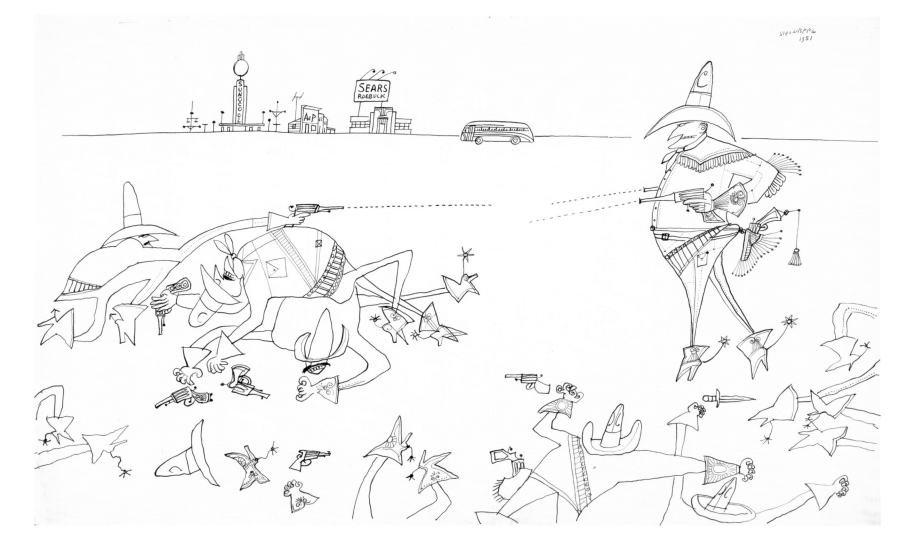

Ex-Voto: Execution of King

1951
Ink, crayon, pencil, and colored pencil on paper, 14⅜ x 19¼ in. (36.5 x 48.9 cm)
The Saul Steinberg Foundation, New York, SSF 1384

Execution of King was the largest in a group of so-called ex-votos in the artist's 1952 Betty Parsons Gallery show. In Steinberg's versions of this apotropaic type of imagery, the perils warded off by representation are of a singularly modern character: a Calder mobile falls on a cocktail party-goer's head; parade floats collide; the FBI comes knocking.[42] But though disaster may modernize, dread is timeless. Steinberg assured a reporter that his ex-votos were drawn "with sympathy for the real primitive, and a bit stupid in style as they should be."[43]

In their perverse vividness, Steinberg's ex-votos resemble the horrifyingly explicit Mexican samples he collected (below). His loving attention to mortal incidents allows a cynic to doubt whether the buyer of an image such as *Execution of King* has the well-being of kings sincerely at heart. (Billy Wilder, Hollywood's arch-misanthrope and a major Steinberg patron, acquired a close variant.) In an ambiguity which only strengthens the hint of wish-fulfillment, or Schadenfreude, in the ex-voto tradition, Steinberg's illegible pseudo-inscriptions could just as easily be passing along how-to tips as pleas to an intercessor.

Mexican ex-voto painting. Magazine clipping in a Steinberg scrapbook, c. 1953. YCAL.

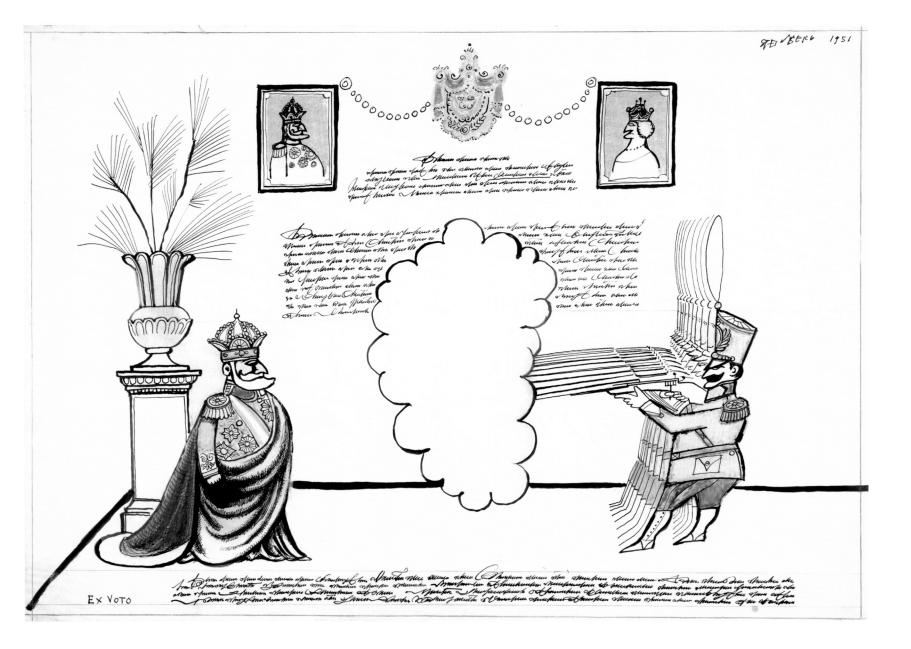

EX VOTO

20
Passport

1951
Ink, thumbprints, rubber stamp, and collage on folded and stained paper, 14¾ x 11⅝ in. (37.5 x 29.5 cm)
Collection of Richard and Ronay Menschel

21
Large Document

1951
Ink, rubber stamp, and collage on paper, 29 x 23 in. (73.7 x 58.4 cm)
Private collection, New York
Published: *The Passport*, p. 1; Loria 1995, no. 4; Museum of Contemporary Art, North Miami, *American Short Stories*, 2003, no. 1.

Steinberg long encouraged the belief that he had begun his career of false documentation in earnest, by forging himself a paper trail out of wartime Europe (pp. 27–29). In fact, his escape had been only too dependent on the genuine signatures and rubber stamps that adorn his Romanian passport—marks which allowed him to pass through Spain into Portugal, and, via Ellis Island, the Dominican Republic. Small wonder that he should have remained alert to the talismanic power of the autograph all his life (cat. 94).

Steinberg's earliest known effort in false hand-writing came in response to curator Dorothy C. Miller's request for an "Artist's Statement" to accompany his work in the "Fourteen Americans" show at The Museum of Modern Art in 1946. By 1947, he had begun selectively issuing papers to friends, according to need. Passports and safe-passage letters went to his most peripatetic friends, such as photographer Henri Cartier-Bresson (fig. 28, p. 38) and *New Yorker* correspondents John Hersey and Janet Flanner. He also turned out diplomas and

Artist's Statement for "Fourteen Americans," 1946. Ink on paper, 3¾ x 7⅞ in. (9.5 x 20 cm). Private collection, formerly collection of Dorothy C. Miller.

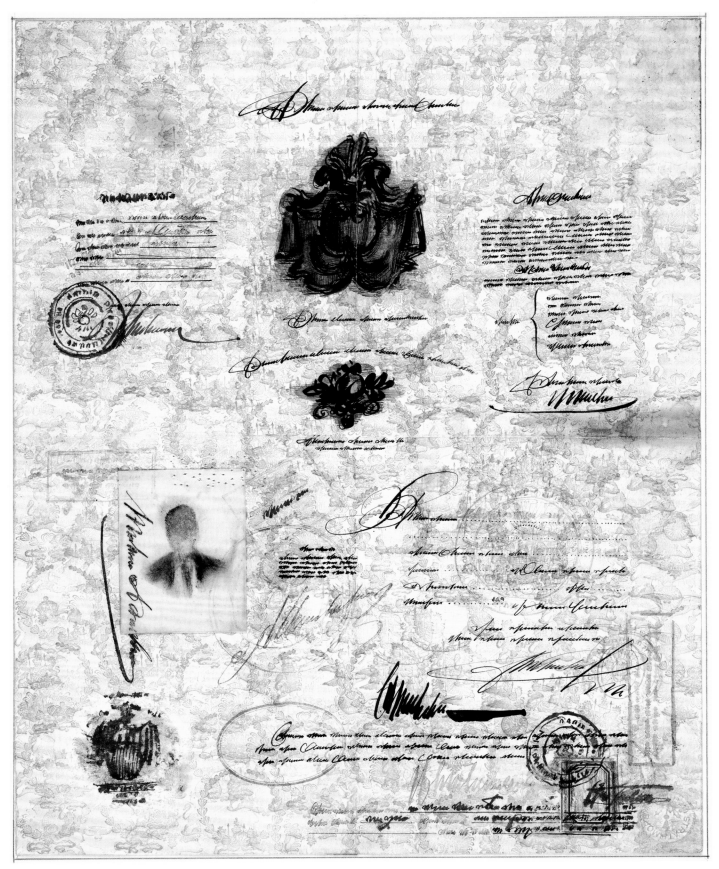

award certificates—at first inscribing them on printed blanks from a stationer, later on large sheets—to suit great occasions, such as births (issued to the newborn), major birthdays, and retirements. Hedda Sterne earned dual Steinberg degrees in the disciplines of cooking and dishwashing.[44]

To take the false documents for mere parody—a glib deflating of institutional authority—is to miss much of their visual thrill. Yes, false signatures, such as those in *Large Document*, satirize the pomposity of officialdom, but they also present Steinberg's hand-sized variation on the abstract art of his time. Asked to name the artists who had influenced him most, he was willing to offer a few names, but he called calligraphy "my true teacher."[45] The history of handwriting, if such a thing could be written, would present a highly specialized case study in the evolution of style—a miniature art history, running parallel to the full-scale inventions of sculpture, architecture, and painting. Steinberg's flourishes are non-figurative (i.e.,

analphabetic, illegible), to be sure, but—far from resisting interpretation—they are virtually impossible *not* to interpret, thanks to the readerly instinct that leads us to see a given style of handwriting as vigorous, or sluggish, or fanciful, or severe (below).

An article of faith for Steinberg, as for the New York School painters, was the "intimate relationship between consciousness and motor expression" (the phrase sounds like modern art criticism, but it comes from a graphology textbook).[46] The best Abstract Expressionists, he noted, painted with their whole bodies, "according to their kinetic system, their muscular system." When this cathartic principle was brought down to the manual scale of his work, the result was a calligraphy beyond literacy, expressing the hand's intelligence with the purity of gestures in conversation (see cat. 22). Beauty for its own sake did not engage him, Steinberg explained; "I want to say something. And as I say it, out of politeness, I make it look beautiful and economically correct."[47]

Handwriting samples in Jules Crépieux-Jamin, *A B C de la Graphologie* (Paris, 1929), vol. 2, pp. 126–27.

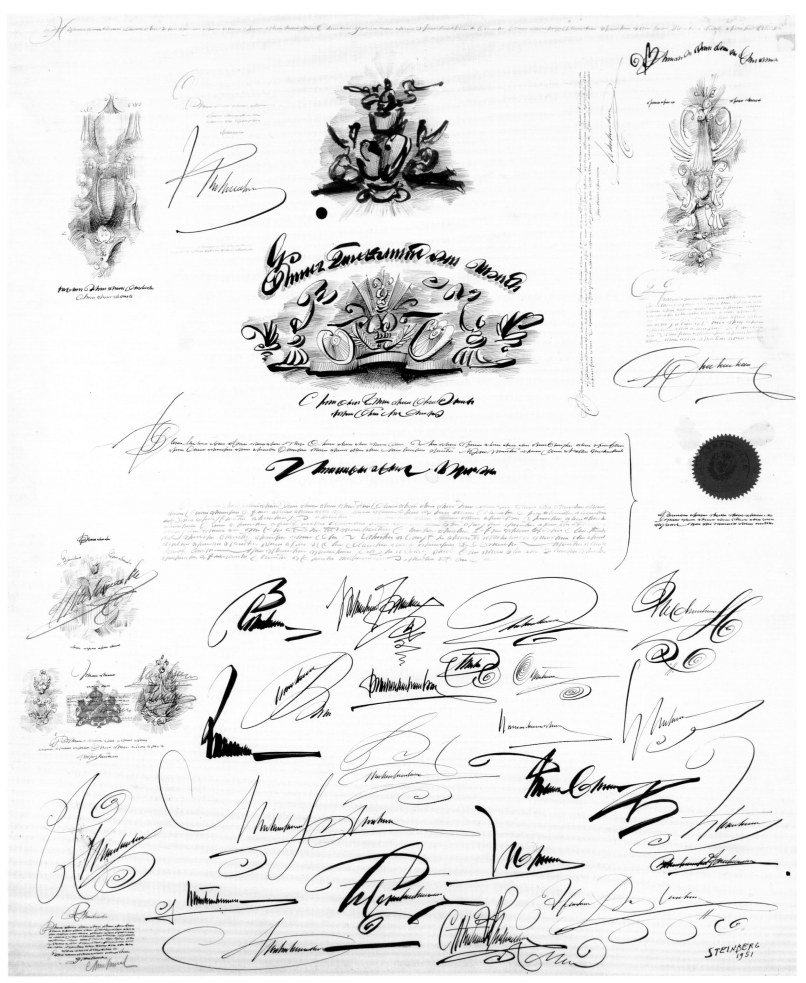

STEINBERG
1951

21

Piazza San Marco, Venice

1951
Ink and colored inks on paper, 23 x 29 in. (58.4 x 73.7 cm)
Collection of Hedda Sterne
Published: Tyrwhitt et al., eds., *The Heart of the City: Towards a Humanisation of Urban Life* (CIAM, no. 8), 1952, endpapers; WMAA 1978, p. 39.

In the *Piazza San Marco*, which Steinberg drew in at least four versions, many of his key preoccupations came together: iconic architecture; open public space, its character defined by the habits of a people rather than law or business; the mingling of regimes (East and West in the domed basilica; native, visitor, and pigeon on the piazza); and the stark contrast between southern Europe's eloquent body language—diagrammed in swirls and dotted lines—and the affectless coma of Americans. The image also marks the start of Steinberg's enduring love affair with "views"—the artless, readymade representations through which a site becomes a sight. His model, in this case, could have been any of innumerable views in which the piazza serves as backdrop for a lineup of social types, from Canaletto to the illustrations in early Grand Tour guidebooks to a postcard in the accordion set being hawked, so imploringly, at center right.

The present drawing, the only version of the scene known to include color, was Steinberg's gift to Hedda Sterne in 1951. A second version, featuring a flight of pigeons from the top of the campanile, appeared on the invitation card for his exhibition at the Parsons and Janis galleries in January–February 1952.[48] When that drawing was bought off Janis' wall on the first day of the show, Steinberg quickly provided a replacement, likewise soon sold. In late 1953, the artist drew a fourth version, which Janis again sold, this time before it was even finished, to another gallery visitor.[49] This was probably the version printed the next year in *The Passport*, spanning the breadth of two pages—a publication format for which it appears to have been intended, judging by the absence of any detail at its vertical center.

Piazza San Marco, Venice. Engraved illustration in a nineteenth-century traveler's guidebook.

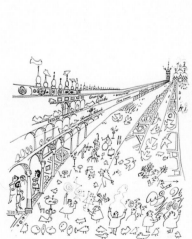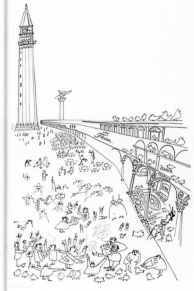

The Passport, 1954, pp. 100–01.

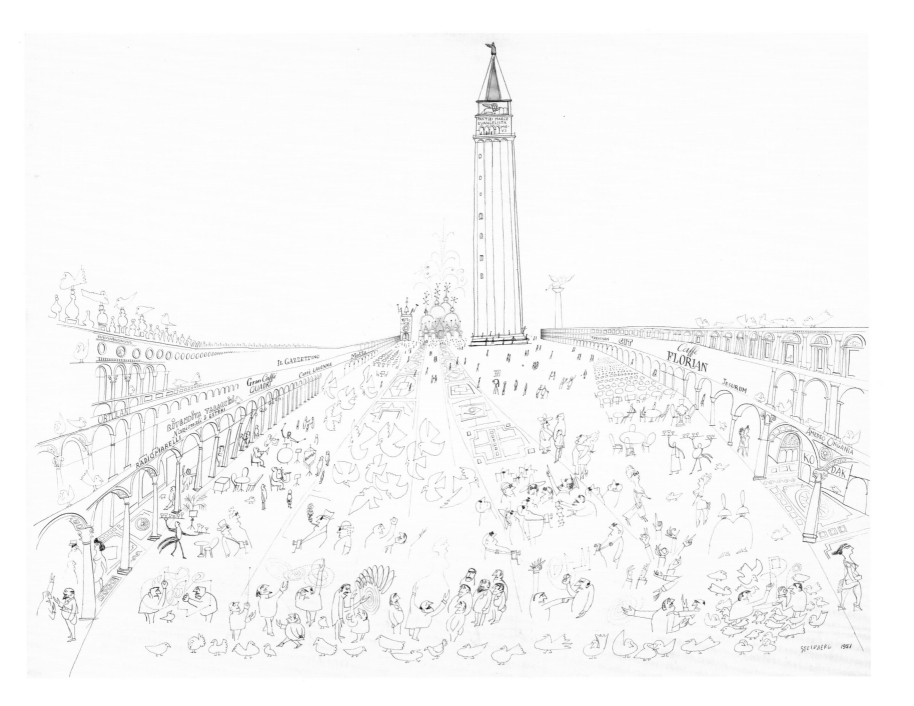

Two Christmas Cards

23A. Santa Claus as Christmas tree
Offset printing, black-and-white lineshot, 7 x 5 in. (17.8 x 12.7 cm)
Published by The Museum of Modern Art, 1949 or later
Collection of Tom Bloom
Published: George Buday, *The Story of the Christmas Card* (London: Oldhams, 1951), p. 43.

23B. Santa Claus and birds in tree
Offset printing, color halftone, 5½ x 4½ in. (14 x 11.4 cm)
Published by Hallmark Cards, Inc., 1952 or later
Collection of Tom Bloom

When Steinberg began designing Christmas cards for The Museum of Modern Art in 1945, his inaugural effort featured Santa Claus riding a reindeer bareback amid a flurry of snowflakey abstractions. His line casually united contemporary high style and the popular cartoon—a formula ideally suited to the wares of an institution trying to sell the American public on modernism—and he stuck with it in the cards he designed for MoMA and for Brentano's Books through 1952. The formula had not been his invention, however. In 1944, while he was off at war, his friend Alexander Calder got the ball rolling with line illustrations for the nursery rhyme collection *Three Young Rats*, a collaboration with then-MoMA curator James Johnson Sweeney.[50]

The book's introduction offered a convincing brief for Calder's great popularity among highbrow audiences of the day. The most natural of modernists, Sweeney asserted, was the child, or a childlike artist. "Intensity of focus is the child's gift," he wrote; "the child has a near-sighted eye for detail, both psychological and physical. The child is closer to the carpet, to the ground—to the primitive—than the adult." A child's mind, he went on, "thinks by image. And it takes mischievous pleasure in contriving out of these images incongruous associations that often have the quality of fresh and startling

metaphors."[51] To this already engaging formula, Steinberg added a line as virtuosic as Calder's was "primitive" and a mind bursting with unspent cartoon ideas. In cards for MoMA, his Santa went on to figure-skate, play the violin, surmount a monument, shake hands with his own double, and become one with the Yule tree.[52] Invariably shod in wingtips, Steinberg's Santa is your warm, eccentric, infinitely wealthy uncle—a figure of infantile (meaning perfect) fantasy. The museum cards attracted attention, allowing Steinberg to cross over in 1952 from MoMA's relatively small buyership to a huge one at Hallmark.[53]

If the pleasure of association with the museum had made its low rates acceptable, Hallmark's rates erased the deficit. From 1953 to 1959, each January brought Steinberg a $10,000 check from the card company—not a bad full year's salary at the time—for a batch of designs he could turn out in short order. Hallmark had the equipment and the craftsmen to make cards as opulent and diverse as MoMA's were simple, and Steinberg tested the limits of color, die-cut, and relief printing, notably with designs in which architecture is rendered entirely in intaglio. He carried over from his MoMA designs (along with the wingtips) a strong affinity between Santa and birds—magical stand-ins, in effect, for good little boys and girls.[54]

Steinberg's first Christmas card for The Museum of Modern Art, 1945. YCAL.

Alexander Calder, drawing in *Three Young Rats* (New York, 1944).

Printer's proof for a relief-printed Christmas card, c. 1955. YCAL.

Here sits the Lord-Mayor,
Here sit his men,
Here sits the cock,
Here sits the hen,
Here sit the little chickens,
Here they run in,
Chin-chopper, chin-chopper,
Chin-chopper, chin!

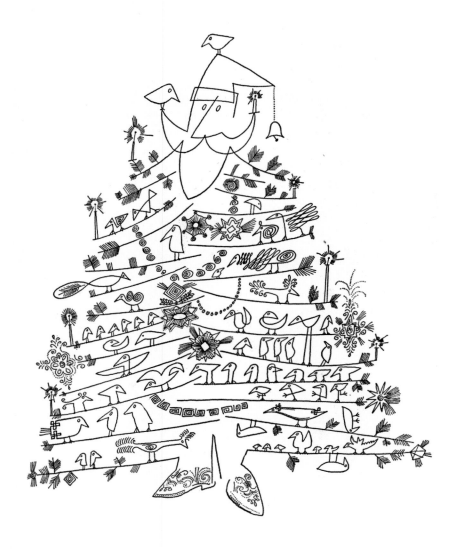
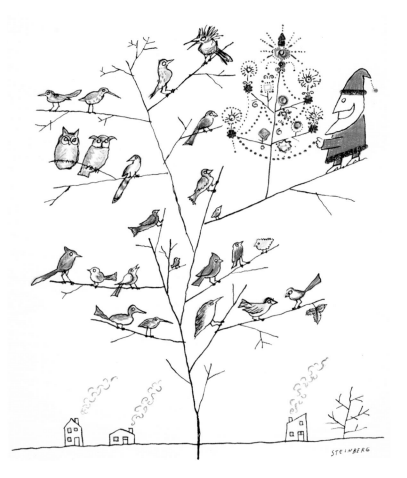

Cornices

c. 1952
Ink on paper, 14½ x 19⅜ in. (36.8 x 49.2 cm)
The Saul Steinberg Foundation, New York, SSF 1997
Published: *The Passport*, p. 163.

In July 1952, Steinberg traveled to Chicago twice, ostensibly to cover the Democratic and Republican Party conventions for *The New Yorker*.[55] The anticipated portfolio never took shape (in fact, he might have given the conventions a miss), but from his window seat on the train he gathered useful visual notes on middle-American industrial sprawl.[56] His eyes also opened to the varieties of the post–Civil War false front, still the dominant architectural form to be seen on the Main Streets of American whistle-stops.

For the lovingly close, nearly clinical attention Steinberg brought to studies such as this one, he had a model in the 1930s work of Walker Evans. Evans was Special Photographic Editor at *Fortune* magazine, a card-playing friend, a fellow postcard devotee, and, for Steinberg, an artist on the level of Picasso and Joyce.[57] In the second half of his landmark book *American Photographs* (1938), Evans had shown that the American road, when seen closely and clearly, with its factory barracks, gas stations, union halls, and portrait studios, presented the moving self-portrait of an ignored and enduring past. Adapting the lesson to drawing gave Steinberg his start on the micro-documentary practice with which he would reinvigorate his eye and hand repeatedly in the decades ahead.

Walker Evans, *Main Street Block, Selma, Alabama*, 1935. Gelatin silver print. The New York Public Library, Astor, Lenox and Tilden Foundations; Walker Evans Collection, Photography Collection, Miriam and Ira D. Wallach Division of Art, Prints and Photographs.

25
Vichy Water Still Life

c. 1953

Ink, pencil, watercolor, Duco lacquer, wash, veneer, and collage on paper, 14½ x 23 in. (36.8 x 58.4 cm)

The Saul Steinberg Foundation, New York, SSF 7026

By the early 1950s, Steinberg liked to tell reporters he had first been "inspired to take up art at the age of eight by a master forger living next door."[58] Such childhood inspirations had a way of coming to mind at requisite moments: a few years earlier, when his art had been all meandering line, his mother's cake decorations had been the start of it all. At any rate, Steinberg's collage-drawings of this period take cues on visual sleight-of-hand not only from the forger's playbook, but from the brain-teasing complications of Cubist still life and from the clever, jubilantly lowbrow work of American "money" painters such as Otis Kaye—an art full of cons devised to leave the unwary viewer "holding the bag."

At the bottom-most layer of *Vichy Water Still Life* are two (or perhaps "two") drawings, an architectural scene and a bedroom farce, drawn in two styles and two ink colors. Glued atop them at lower right is a trompe-l'oeil

simulation of a chromolithograph postcard (a watercolor-on-paper Steinberg) which bears, in turn, an inscription in (false) script and a (real) postage stamp. The latter is canceled with a postmark, which proves on inspection to be a brush-and-ink imitation.[59] Also collaged into the scene are materials that call to mind Cubist contests between physical fact and fiction. These include a Steinberg drawing of a woman's profile, on a sheet of real memo pad paper; a real bottle label affixed to a drawn bottle of mineral water; and a sample chip of wood grain veneer, which is cast in the role of the wooden backdrop in a send-up of a trompe-l'oeil still-life painting. The mineral water label—to take all this punning on false fronts and representations to another level—invokes the name of Vichy, France's wartime puppet state under the Nazis.

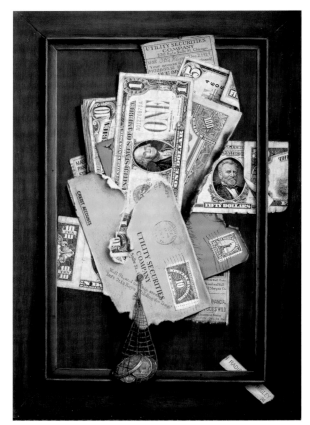

Otis Kaye, *Holding the Bag*, 1929. Oil on canvas, 16 x 11 in. (40.6 x 27.9 cm). Private collection.

26
Techniques at a Party

1953
Ink, colored pencil, and watercolor on paper, 14½ x 23 in. (36.8 x 58.4 cm)
The Saul Steinberg Foundation, New York, SSF 1990
Published: *The Discovery of America*, p. 84.

27
Group Photo

1953
Ink, thumbprints, and rubber stamp on paper, 14 x 11 in. (35.6 x 27.9 cm)
Collection of Richard and Ronay Menschel
Published: WMAA 1978, p. 179; *The Passport* (1979 ed.), back cover of dust jacket.

Increasingly, Steinberg's art addressed what he simply called "the identity problem"—that of differentiation from the group, and of identification with it. It was a problem much on the mind of the managerial class that constituted *The New Yorker*'s readership. World War II had been won on the strength of corporate conformity on a vast, national scale, and now the Cold War had been engaged on the same basis. And yet, theoretically, the hero of the American Dream was the Individual, and Soviet-style collectivization the enemy. In *The Organization Man* (1956), William H. Whyte, Jr., wrote that the social engineers of industrial park and suburb aimed for "an environment in which there is no restless wandering but rather the deep emotional security that comes from total integration with the group. Radical? It is like nothing so much as the Middle Ages."[60] Such a conclusion could only confirm the worst fears of a committed urbanite.

In a note to himself in late 1952, Steinberg suggested expanding on his existing meta-drawings, in which drawings drew themselves (fig. 27, p. 37), by drawing "drawings a bit annoyed for finding themselves in a drawing."[61] The premise he had hit upon—making his figures conscious of their status as (self-) representations, as "identity problems"—opened a rich vein, starting with two series he undertook the next year: cocktail-party typologies and portraits of Thumbprint Man. In each case, the marriage of theme to technique is so intuitive that it is easy to forget it needed inventing.

At a Steinberg party, everyone is a living self-portrait and character is style, whether one is retreating into dotty reverie or making a smudgy splash. (A question implicitly posed by his party scenes is whether, say, a dot-woman, smudge-woman, and hatching-man are likely to understand one another much, or at all.) *Group Photo* presents the antipodal situation—the very image, literally, of collective identity. One of Steinberg's neatly assembled clubmen (or graduating seniors or junior executives) has managed to make himself stand out, but only by resorting to an arrow (not drawn but rubber-stamped). Here, all are one—that is, one man's thumbprint, varied only by the incidental effects of pressure and inkiness.

In 1965, Steinberg came up with a subject that allowed him to merge these two conceits, the orgy of individualism and the group pose: namely, the family portrait (p. 6), in which each sitter in the group, though kin to the others, has developed a distinct technique for fitting into, and standing out from, the picture.[62] He had written to his friend Aldo Buzzi the year before, "I . . . like the old drawings in which I combined techniques to explain people's great differences in ideas," and noted that "Colette, speaking of dogs, explains that what we call breed is really style or character."[63]

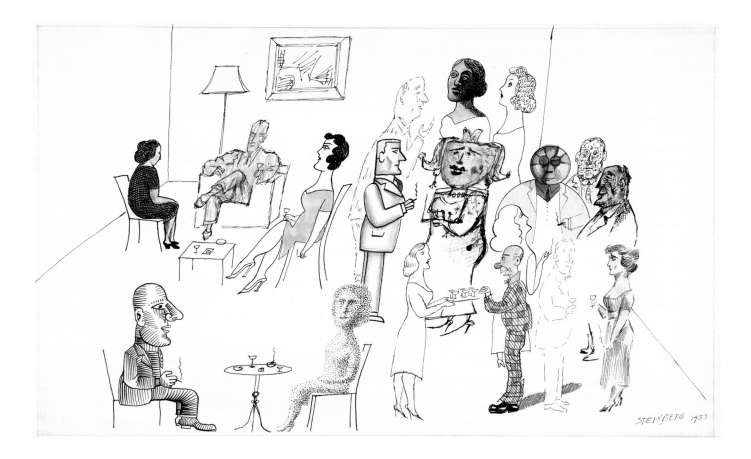

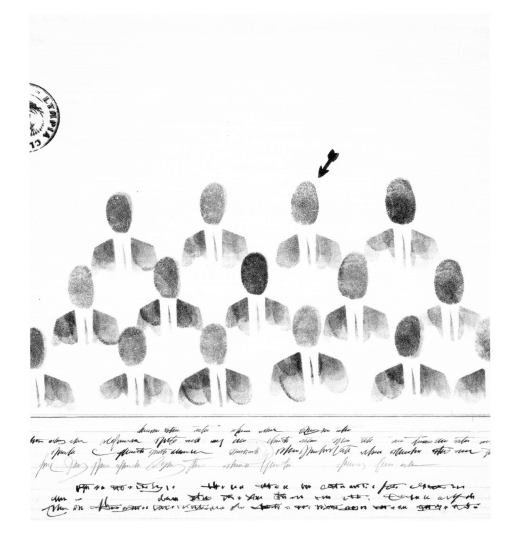

Untitled (Florida Types)

1952
Ink and collage on paper, 30 x 24 in. (76.2 x 61 cm)
The Saul Steinberg Foundation, New York, SSF 1960
Published: *The Passport*, p. 216.

Steinberg traveled as a gourmand eats—eagerly, any-where, grandly or on the cheap, alone or not, for a pur-pose or just to keep his senses alert, and always in search of the unforeseen. In September 1952, he and Sterne flew to São Paulo for the opening of joint solo exhibitions at the Museu de Arte. He later complained that after a month's travels in Brazil, people expected him to "talk about the social injustice of Brazil, about art, about cli-mate," to "speak like *Time* magazine, like whatever trash one reads that is considered to be reality." But on a remote beach there one day, he had seen a chicken that had just rubbed against a freshly painted fence, and "the green chicken was much more essential and beautiful for me than any other thing [in Brazil]."[64] Told in words, such details could only get him labeled an eccentric;

realized in drawings, they became definitive windows onto a locale.

The place and populace in *Florida Types* are compos-ites, pieced together like an anecdote assembled out of scattered memories. Steinberg was in Florida and the South in the winter of 1951–52, traveling at first on an assignment to draw Palm Beach for *Life* and then on a general research expedition for *The New Yorker*.[65] After-ward, he translated his sketchbook pencil studies of the seasoned locals into ink drawings. These he cut out, figure by figure, and arranged them on a large sheet, gluing them down when satisfied with the composition. Reproduced as a line-shot in *The Passport*, the piece looked as though it had been drawn on a single sheet.[66]

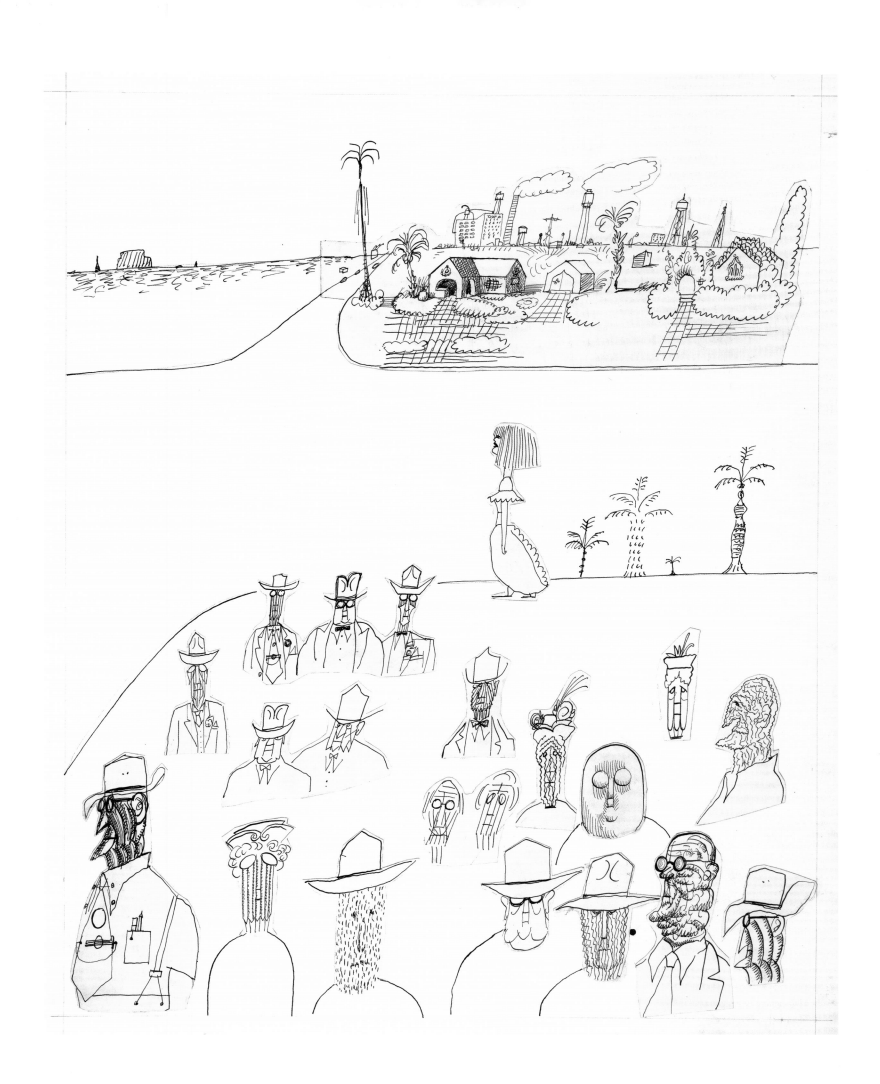

Untitled (Ironwork Pier)

c. 1952
Ink on paper, 23 x 29 in. (58.4 x 73.7 cm)
The Saul Steinberg Foundation, New York, SSF 170
Published: *The Passport*, p. 109.

Ironwork Pier is another pastiche derived from Steinberg's travels of 1952. While in England to see his show at London's Institute of Contemporary Arts, he rode the trains for days, making sketches of railway stations and other louche masterworks of Victorian architecture. The stately pleasure domes on this imaginary monument of oceanside Orientalism recall the Pavilion and Palace Pier at Brighton and Eugenius Birch's pier at Eastbourne (1865).[67]

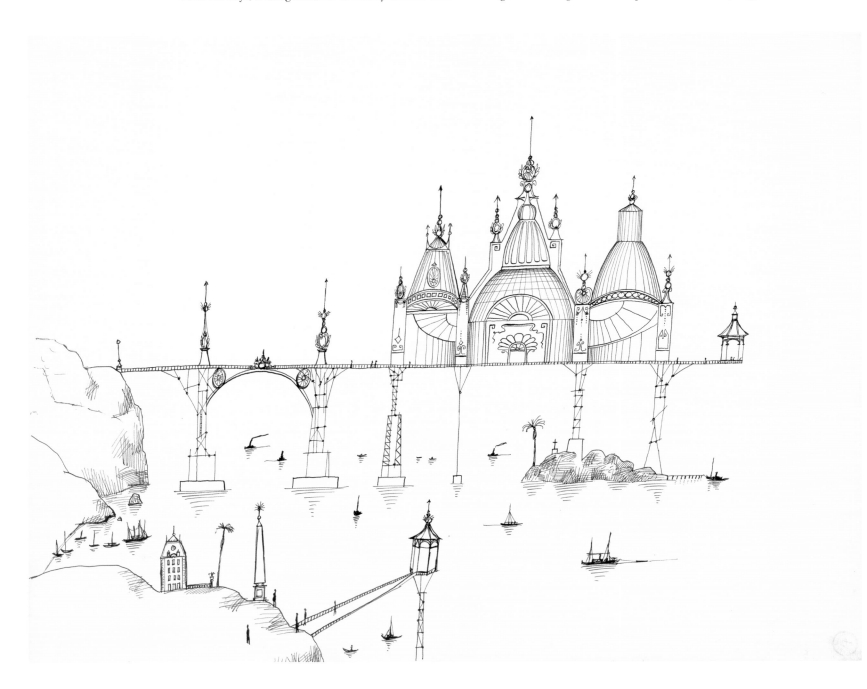

30
Diary

1954

Ink and watercolor on paper, 14¼ x 23 in. (37.5 x 58.4 cm)

Collection of Richard and Ronay Menschel

Published: *The Passport*, p. 7; "False Daguerreotypes, False Diary, False Diploma—True Steinberg," *Vogue* (October 15, 1954), p. 113.

"This is Rimbaud's diary—the lost diary," Steinberg told a visitor to his studio in 1954, and handed her one of a series of "spreads" such as this one.[68] He was alluding to the legendary manuscript rumored to have occupied poet Arthur Rimbaud during the years after he had thrown over poetry for the life of a trader in Africa.[69] Steinberg's interviewer gradually realized that the "writing" on the sheet was not going to surrender any secrets, and the artist admitted, "I wrote it myself. I antique the paper myself. It's in the same line as the passports and diplomas [cats. 20, 21]. You see, people who like relics . . . get excited not about the saint but about the saint's bones. What they want of Rimbaud is not the poetry but the button torn from his jacket."[70]

The *Diary* pages differ from Steinberg's false documents in their lavishly falsified histories. The overall discoloration, teacup stains, foxing, match burns, and moisture damage on *Diary* (all effects as fictional as the handwriting) invite a detective to go to work constructing a plausible life story for these pages, the better to titillate a fetishistic fan or a dealer in rare manuscripts.

The Line

1954
Ink on paper folded into twenty-nine sections, 18 x 404 in. (45.7 x 1026.2 cm)
The Saul Steinberg Foundation, New York, SSF 3749

In *The Line*, the sparest of formats serves to showcase the semiotic richness of Steinberg's fundamental tool of art, the nib-wide line of ink. The 33-foot-long drawing, which unfolds accordion fashion, demonstrates that the simplicity and the malleability of a line are one. The principle can serve as a manifesto for Steinberg's view of art as a realm for the mind's free play, where everything is what an artist, or an eye, makes of it: a (horizon) line is a (railway) line is a line (of laundry).

The Line is a product of Steinberg's fortieth year, by which time the line-shot cartoon on a magazine page accounted for but a small portion of his creative output. Indeed, *The Line* itself was created as part of his fifth and most ambitious mural yet, which opened to the public in late August 1954 at the 10th Triennial of Milan, a design and architecture fair (see p. 48). But, as if in tribute to what was still the home base of his art and his fame, he submitted a second, more concise version of *The Line* to *The New Yorker*, where it appeared as a two-page spread the next month.[71]

The mural was executed in *sgraffito* (incised plaster) on a spiraling trifolium of temporary walls (fig. 45, p. 49) which the fair's designers—the Milan firm of BBPR (Belgiojoso, Peressuti, and Rogers) conceived as a "children's labyrinth." *The Line* decorated one of the labyrinth's three leaves; the other two featured a satirical survey of world architecture (including America's headlong rush from log cabin to modernist cliff dwelling, below right) and a sailor's-eye-view of the Mediterranean coastline, home to the ruins and renaissances of successive civilizations, East and West.[72] In concert with these thematic treatments of architectural history, *The Line*—an all-points tour of reality, beginning and ending with a hand drawing it into being—tendered a vivid reminder that the whole of design was owed to the simplest, most potent graphic invention ever: the stick.

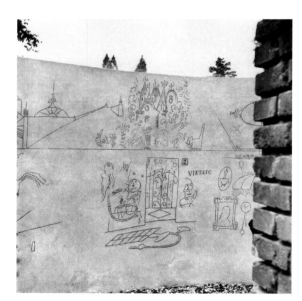

Children's Labyrinth, Milan, 1954.
Details of *The Line* and *History of Architecture* murals. Photographs by Leo Lionni. YCAL.

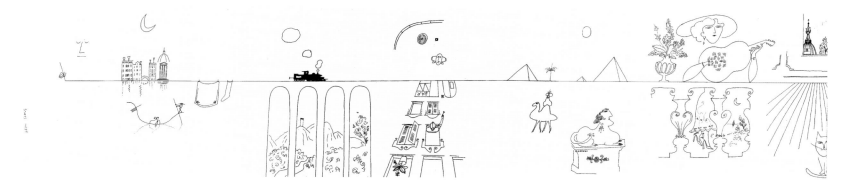

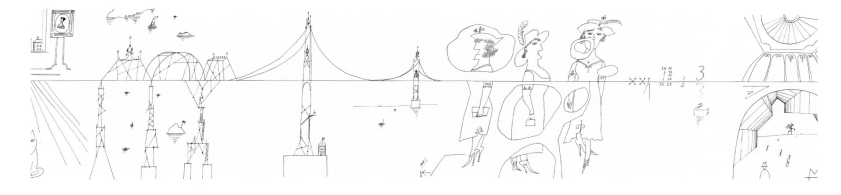

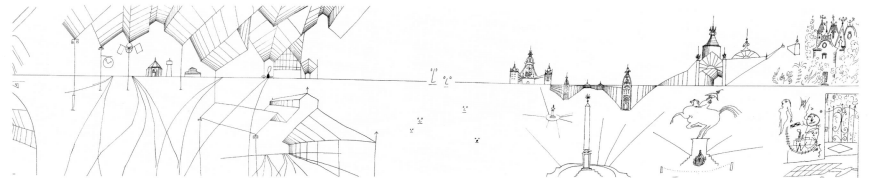

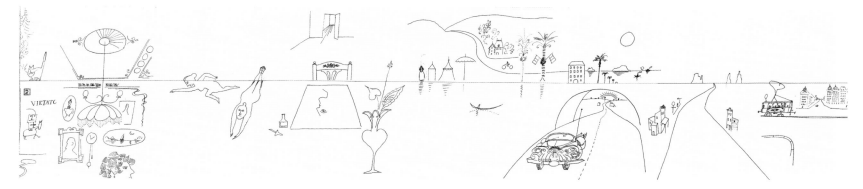

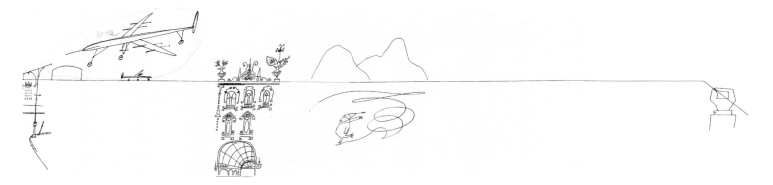

Elevated

1957

Ink, crayon, and watercolor on paper, 14¾ x 23¾ in. (37.5 x 60.3 cm)

The Saul Steinberg Foundation, New York, SSF 4552

This powerfully simple winter scene, drawn in brush over pen, pays tribute, perhaps, to a mourned neighbor: the Third Avenue El. Until 1951, Steinberg and Sterne had lived in a fourth-floor walk-up apartment-studio near the eastern end of 50th Street. The East River was one block east; two blocks south was the marathon demolition-construction spectacle of the United Nations complex (1948–52).[73] Two blocks west was Third Avenue and its El. In January 1952, the couple moved into a duplex on East 71st Street—about a hundred yards to the west of the same train line.

Then in May 1955, while Steinberg was away for a few months in Paris, service on the Third Avenue El ended and its dismantling began; it was the last of Manhattan's elevated lines to go. Here, he draws it in a bolt of memory, a memento of a friend from the old neighborhood, gone without a goodbye.

Stadium at Night (Ebbets Field)

1954
Ink, watercolor, and colored pencil on paper, 22⅞ x 29 in. (58.1 x 73.7 cm)
The Saul Steinberg Foundation, New York, SSF 2089
Published: "Steinberg at the Bat," *Life*, July 11, 1955, pp. 60–61; IVAM 2002, p. 59.

In May and June 1954, on commission from *Life* maga-
zine, Steinberg accompanied the Milwaukee Braves
baseball team to games in Philadelphia, Cincinnati,
Pittsburgh, Chicago, New York, and at their home field.[74]
He had not followed baseball before, but once immersed
in its subculture, he came to see it as an "allegorical play
about America," with keynotes of "courage, fear, good
luck, mistakes, patience about fate and sober self-esteem
(batting average)."[75] From the press box before a game,
he would sketch each of the stadiums. In their vast scale
and utilitarian dedication to mass pleasure, they embod-

ied the American orientation toward spectacle. "The
old stadiums," he later recalled, "especially the one in
Philadelphia, or Ebbets Field in New York, were fantastic
architectural structures of wood that gave you the feeling
you were seeing a naval disaster of the nineteenth cen-
tury, a collision of big riverboats."[76]

The electric-light-splotched night sky over the stad-
ium anticipates Steinberg's skyscapes of twenty years
later, rendered in oils and watercolor, sponges and eye-
droppers (fig. 71, p. 68; cats. 61, 68).

Baseball stadium, Philadelphia,
1954. Ballpoint pen. YCAL
sketchbook 4905.

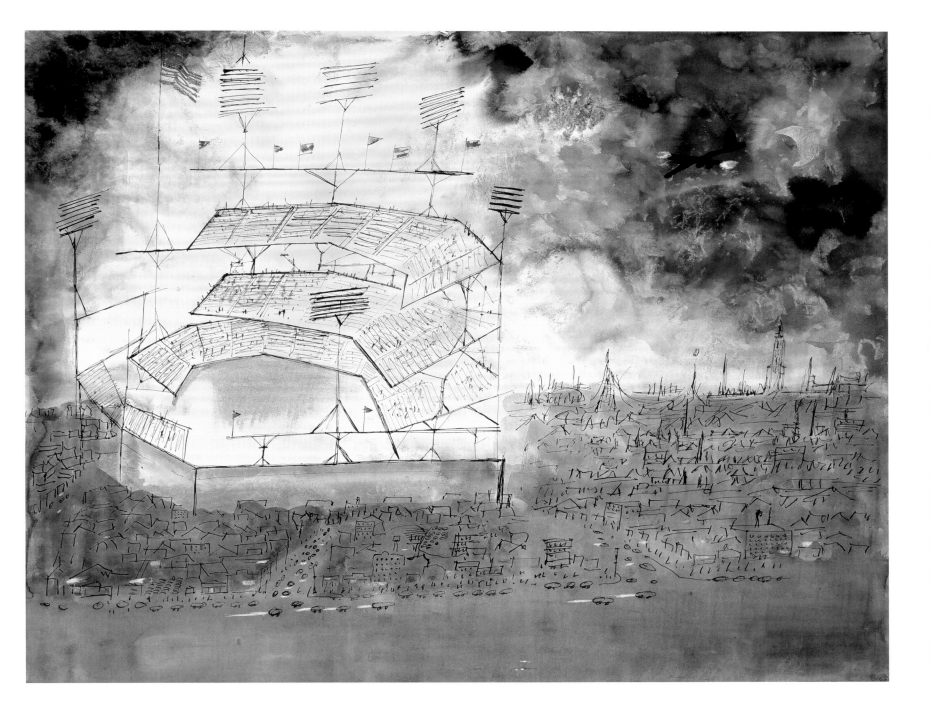

34
Untitled (Couple)

1955
Ink, colored pencil, and packing tape on paper, 17¾ x 13 in. (45.1 x 33 cm)
Private collection
Published: *The Discovery of America*, p. 105.

Following a visit to the South in January 1955, Steinberg used the physical language of collage to create this street-corner study that distinguishes two gradations of skin color. In a culture where race spoke louder than anything else, the difference between "high yellow" and "black" was not one of mere degree, but of substance, as between drawing paper and packing tape.

The culture of Jim Crow horrified and fascinated Steinberg, who saw in the political isolation of Southern blacks a direct analogy to the despair he had felt as a young Jew in Romania.[77] In planning his tour of white and black areas around Vicksburg and Oxford, Mississ-

ippi, and Memphis, Tennessee, he might have relied on travel tips from Walker Evans, with whom he had dinner two days before his departure.[78] He took regional buses and hired cabs, seeing back roads that the tourist literature avoided and sketching vignettes of a black America that remained as distant from white experience as the scenes Evans had photographed twenty years earlier.[79] On Memphis' Beale Street, he found a nighttime street life of frank sexual display and bluesy elegance that he registered in his sketchbook with the same keen-edged linear grammar that served him in Latin countries when portraying the eroticism of the tango.

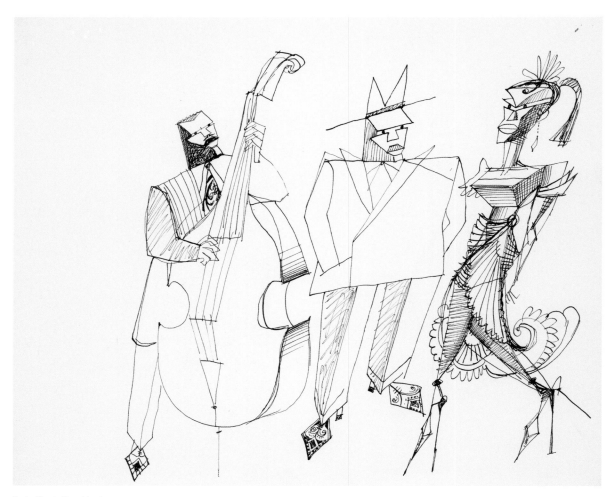

Beale Street, Memphis, January
1955. Ink. YCAL sketchbook
4848.

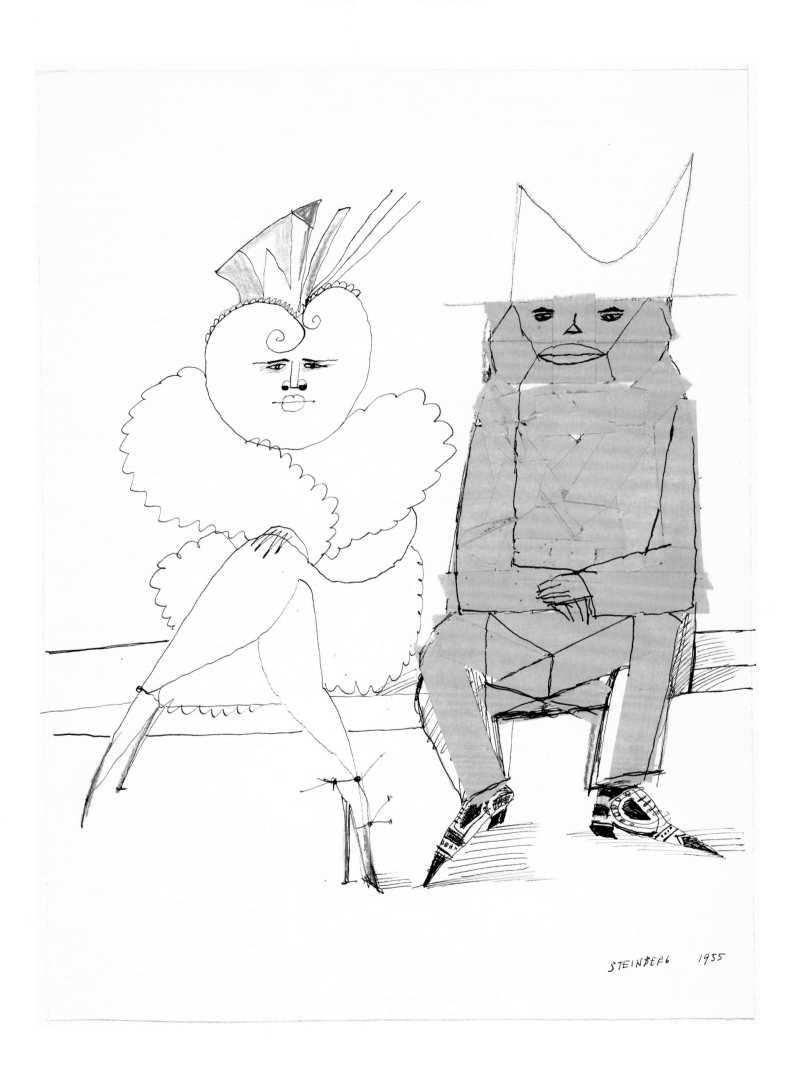

STEINBERG 1955

Road, Samarkand, USSR

1956
Ballpoint pen on paper, 19 x 24 in. (48.3 x 61 cm)
The Saul Steinberg Foundation, New York, SSF 267
Sketch for "Samarkand, U.S.S.R.," published in *The New Yorker*, May 12, 1956, p. 47.

The New Yorker arranged for Steinberg to make a three-week trip to the USSR in the winter of 1956, with stops in Moscow, Kiev, Odessa, Tashkent, Tbilisi, and Samarkand. The trip would result in two portfolios, published in May and June under the heading "A Reporter At Large."[80] Steinberg brought with him a camera with several dozen rolls of film, a diary, a thick stack of sketchbooks in all sizes from shirt-pocket to easel—and a collection of prodigiously leaky, blotting ballpoint pens, with which he made do.[81]

Though he had chosen to visit Samarkand on strictly romantic grounds—for its past glory and its remoteness on the map—Steinberg took his reportorial duty there seriously, photographing all day and writing and creating sketches in the evenings.[82] In this oversize sketch, the domes and minarets of the fifteenth-century tomb of

Tamarlane peek over the crest of the hill. What we are seeing, however, is an image in progress. Whether working out conceptual inventions or reconstructing scenes from observation, the artist was sanguine about the ever-gaping ratio between research and result: "Drawing is much like writing. A good writer is a good editor. You don't have to correct yourself constantly, but sometimes you have to decide to do this and not that."[83] In the drawing as it appeared in the "Samarkand" portfolio, Steinberg preserved elements from this sketch—the drainage ruts in the road, the tree and shops—and inserted among them a detail preserved in one of his travel photographs: a car, probably his guide's, in which he seated a driver and passenger. The entire scene was finally demoted to a background position, filling a couple of square inches on the printed page.

Road, Samarkand. Photograph
by Steinberg, March 1956.
YCAL.

The Labyrinth, 1960, p. 196.

Untitled (Racetrack Crowd)

c. 1958
Ink and colored pencil on paper, 14½ x 23 in. (36.8 x 58.4 cm)
The Saul Steinberg Foundation, New York, SSF 310

In several drawings of the late 1950s, Steinberg subjected the collective character of crowds to graphic caricature. As when drawing individuals, he adjusted his technique and style to suit the personas at hand, whether bettors at a racetrack after the starter's bell has rung, a Moscow audience at the Bolshoi Ballet, or the spectators at a bullfight.

It is tempting to read the three scenes as political allegory. The tight-packed Soviet audience is unified by rapt absorption in a staged event, whereas the spectacle of ritualized violence in Fascist Spain appears to have reduced each fan to a grim, lonely voyeur. In the American racetrack crowd, what looks at first like shared passion melting a mob into physical unity (faces cheek by jowl, all eyes fixed on the main event) proves to be a morass of warring self-interest. Each viewer, a stylized isolato, howls for his or her horse to defeat all the others. A few spectators, their ponies evidently out of the running, adopt an attitude of blank neutrality as they await the next race.[84]

Untitled (Ballet Audience), February 1956. Ballpoint pen on paper, 19 x 24 in. (48.3 x 61 cm). SSF 242.

Untitled (Bullfight), c. 1957. Ink on paper, 14½ x 23 in. (36.8 x 58.4 cm). SSF 270.

Small Town with Small Town Skyscraper

1958
Ink on paper, 30 x 22 in. (76.2 x 55.9 cm)
The Saul Steinberg Foundation, New York, SSF 4470

For his last public mural, *The Americans*, in the American pavilion at the 1958 Brussels World's Fair (pp. 50–52), Steinberg worked in two stages. From New York, he submitted a batch of large-scale line drawings, including this one, which would retain their clarity even when photographically enlarged to 10 feet high. The enlargements, mounted on freestanding wall panels, then served as backdrops upon which Steinberg pasted a cast of brown-paper collage figures that he created on site.

The backdrop scenes, highly finished drawings in themselves, portray archetypes of the American land-scape, assembled out of visual notes Steinberg had collected on his many trips around the country. For example, the billboard-topped building in the right foreground reincarnates a dubious-looking dive he had sketched from life in 1952 in Gary, Indiana. He had become a master of the banal small-town overview through his habit of staying in top-floor rooms in Main Street hotels. There, looking out a side or back window, he sketched views that any wise postcard maker would have shunned.

Small Town with Small Town Skyscraper as incorporated (center) in *The Americans* mural, 1958. Musées Royaux des Beaux-Arts de Belgique, Brussels.

Gary, Indiana, 1952. Pencil. YCAL sketchbook 4882.

View from hotel room, Hotel Selwyn, Charlotte, North Carolina, February 11, 1954. Pencil. YCAL sketchbook 4888.

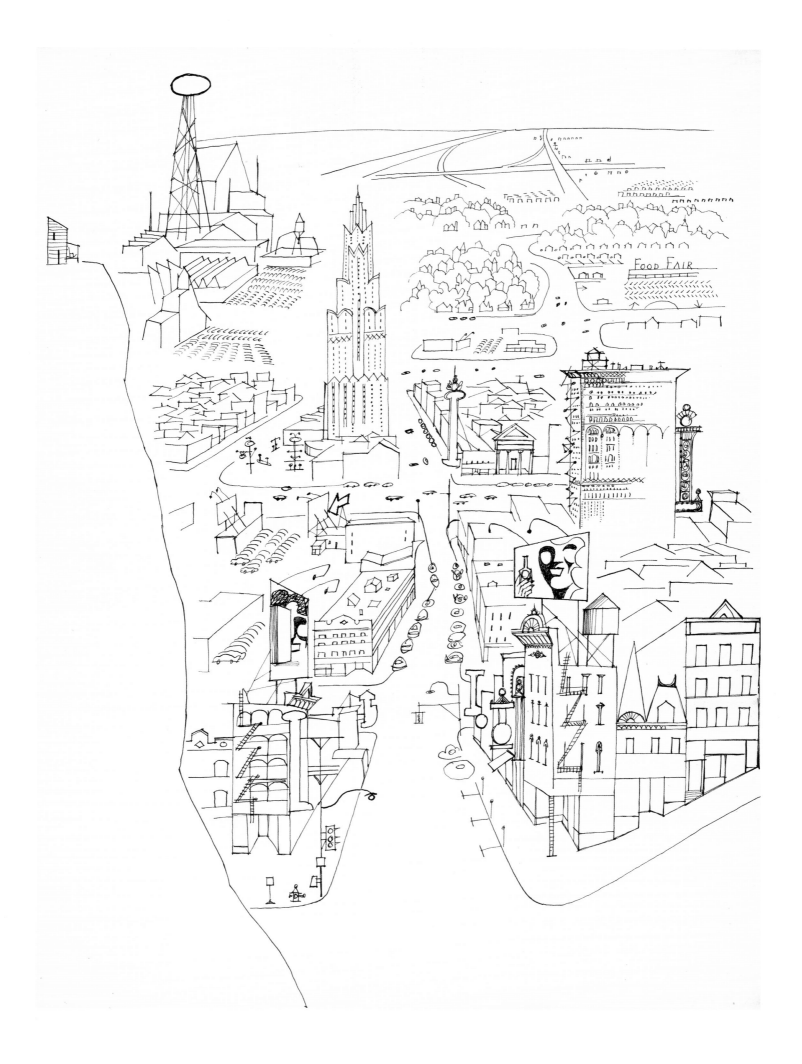

Curtain design for Rossini, *The Count Ory*

1958
Ink, watercolor, and colored pencil on paper, 14½ x 23 in. (36.8 x 58.4 cm)
The Saul Steinberg Foundation, New York, SSF 2061

Gioacchino Rossini's comic opera was performed with Steinberg's sets at the Juilliard Opera Theater, New York, in March 1959.[85] *The Count Ory* (1828) is set in a castle in France during the Crusades. Ory, in pursuit of the sister of a peer gone crusading, breaches the castle's defenses by disguising himself, first as a hermit, then as leader of an order of nuns. Steinberg drew several backdrops and props, which he tested for proportion in photographs with a group of clay figurines. The sets were then rendered at full scale by a team of painters.[86]

The opera's libretto, by Augustin Eugène Scribe,

spoofs the valiant conceits of piety and power, embodied by the less than impermeable Castle of Formoutiers. In the present design for the curtain of the production, or as the program has it, the "Visual Overture," Steinberg features the absent count and his Saracen foe, framed by a pastiche of medieval and Moorish elements. The playfully disjointed, cartoon-cubist space in Steinberg's designs may have been inspired in part by a seldom-recognized forerunner to the comic strip—namely, paper-doll stage kits of the early nineteenth century, uncut sheets for which the artist collected (below right).[87]

Set drawing for *The Count Ory* with clay figurines, used as a maquette. Photograph, c. 1958. YCAL.

J.K. Green (artist), J. Redington (publisher), backdrops for *Douglas: A Tragedy*, 1834, uncut hand-colored sheet from Steinberg's collection. YCAL.

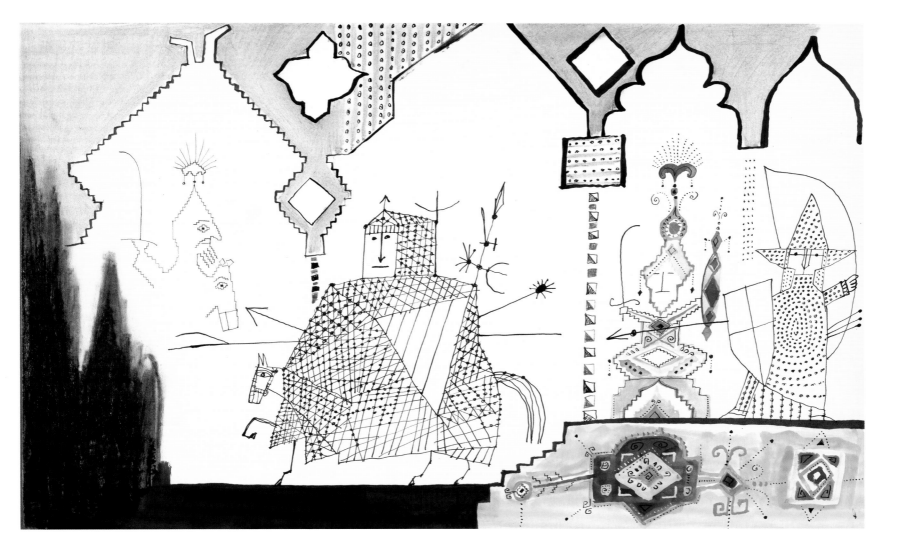

39
Motels and Highway

1959

Ink and ballpoint pen on paper, 22 x 30 in. (55.9 x 76.2 cm)

The Saul Steinberg Foundation, New York, SSF 1127

Published: "Steinberg in the West," *Encounter* 14 (April 1960), pp. 8–9; *The Labyrinth*, p. 129.

Steinberg's affinity for the profile view, which turns things into hieroglyphics of themselves, extended to his images of the open road; he typically portrayed roads not from a driver's perspective behind the wheel but, as here, from an imagined point of view off to the side, causing them to unscroll across his pages like a staff of music or a line of type (cats. 78, 85). The road in this case is a postwar superhighway of the American West, its nine lanes crawling with insect-cars, motel courts walling it off from the wilderness. Presiding over all is the artist's dragon figure, the remorseless and all-consuming crocodile. Much of the image is drawn in ballpoint pen, a medium that brought out Steinberg's doodling, space-filling impulse—a graphic equivalent to the geographic subject at hand.

Motels and Highway served as climax of a six-picture portfolio on the West in *Encounter*, solicited by its English editor, Stephen Spender.[88] In Steinberg, Spender identified the same quality that made the American photographs of (Swiss-born) Robert Frank so compelling to Europeans at this moment: they offered a spy's-eye view of a process for which Americans had no vocabulary, but which Europeans called Americanization. "We are all hypnotized by this America," Spender wrote, "because it is the image of what is happening to our civilization." An engine of "perpetual self-renewal" was at work, "acknowledging no debts to the past and no need to fit its bursting ubiquitous forms into the surrounding scenery which it tramples down to suit its purposes." Steinberg's subject, Spender concluded, is "the gulf between the American and the Universe; and this gulf is the Absurd . . . the gulf which the tourist sees when, having parked his car at the edge of the Grand Canyon, between the Palmist's Hut and the Motel, he peers down into the depths of a nature that seems encircled and tamed, and thinks that it is all America, that he has nothing to fear."[89]

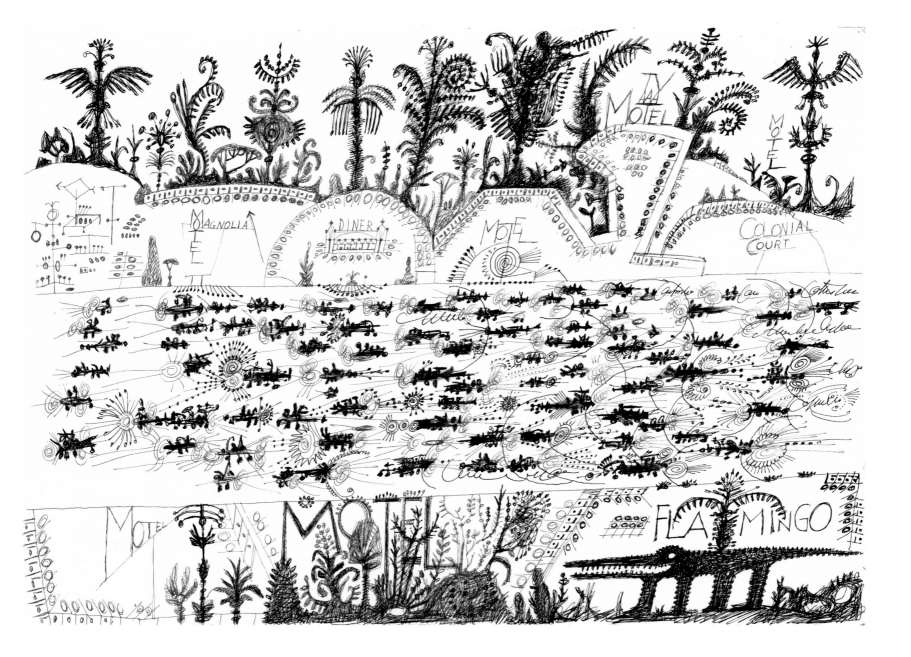

40
Six Masks

1959–65
Pencil, crayon, ink, rubber stamps, and colored pencil on cut brown paper bags, approx. 14½ x 7¾ in. (36.8 x 19.7 cm) each
The Saul Steinberg Foundation, New York, SSF 2024, 2029, 4039, 4056, 6503, 6510
Published: SSF 2024, *Saul Steinberg Masquerade*, p. 57 (before addition of teeth); SSF 2029, *Le Masque*, p. 163, *Saul Steinberg Masquerade*, pp. 38, 63, 71; SSF 6503,
Le Masque, p. 169 (variant), *Saul Steinberg Masquerade*, pp. 31, 61 (variant); SSF 6510, *Saul Steinberg Masquerade*, pp. 18, 34 (variant).

41
Summer Mask

c. 1961 (face), 1966 (body); misdated 1960
Crayon, colored pencil, pencil, and collage on cut paper, 32 x 22 in. (81.3 x 55.9 cm)
The Saul Steinberg Foundation, New York, SSF 11
Published: WMAA 1978, p. 209; mask of face, *Saul Steinberg Masquerade*, p. 68.

Brown craft paper, by suggestive contrast to white, initially intrigued Steinberg as a means of representing dark-skinned figures (cat. 34). Its subtle nap and sheen, as it turned out, made for a highly satisfying paper-world version of skin in general, and in his large mural *The Americans* (1958; p. 52) he introduced the schema he would put to use in his masks, where brown paper stands for personhood, white for the surrounding world.⁹⁰

Joining Steinberg's repertoire in 1959, masks quickly

assumed an important place in his work, his thought—and his public image, as he increasingly opted to don a mask when photographed for the press.⁹¹ Within a couple of years he made dozens of masks of a simple paper-bag type, associated in America with Halloween, in Europe with the mid-Lenten festival. The masks became widely known through photographs Inge Morath made at the "masquerades" she and Steinberg convoked at friends' houses.⁹²

The masks, in turn, grew bodies, first in a 1962 *New*

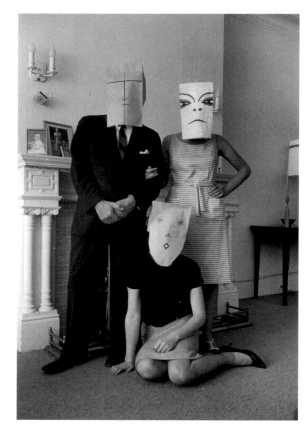

Inge Morath, *Untitled* (from the
Mask Series with Saul Steinberg),
1962.

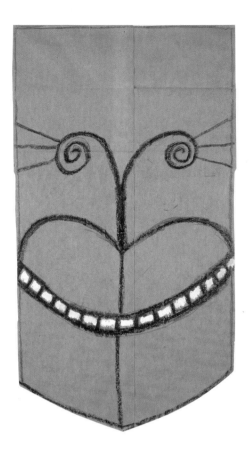

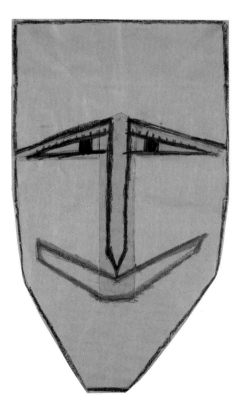
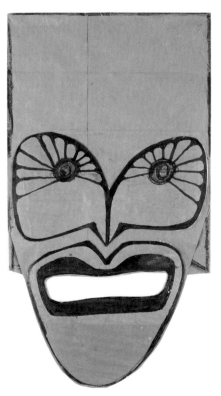

Yorker portfolio of pen-and-ink drawings of figures with fantastic heads, then—in Steinberg's 1966 Paris exhibition and full-color book *Le Masque*—as life-scale "idols" of brown craft paper.[93] (The diamond-mouthed face of *Summer Mask*, which figured among these, had formerly been a wearable mask; see p. 148.) The exhibition's centerpiece was a wall-size installation portraying the *masquerie* of the art world itself, featuring the avid art lovers Steinberg called "samurai," made of cut-out craft paper, linen, and canvas.

Steinberg's masqueraders—the militantly agreeable hostess, the all-business man whose features are rubber stamps, the blank-eyed ingenue—are not about to let down their masks. Masks are who they are. In notes toward an explanation of the series, Steinberg wrote, "The mask is a protection against revelation. . . . Only the primitive & the poet have the possibility to reveal their emotions and the truth in their own faces. The emotions are of an antisocial nature in an organized society [and are] attributed to various forms of insanity. Only the safest forms are permitted. The mask of perpetual happiness is the most common—sorrow is encouraged at sickness & funerals only. The mask of ecstasy in front of bonafide

natural phenomenons (Niagara Falls, the rainbow) or works of art in Museums & Famous Galleries. . . ."[94]

A characteristically far-ranging commentary on his icon-like mask figures came in 1967, when a German television interviewer asked whether Steinberg "exercised." "Of course I exorcise," he replied, sneaking in an unannounced respelling, and went on to trace his art to primitive idol-making, which turns "something incomprehensible that was frightening into something clear and visible. . . . People of society, they exorcise each other. In America there is the tradition of exorcizing the woman. The woman has traditionally been very scarce and very precious [since] the beginning, when the country was colonized. . . . Now in order to exorcise [this] apparition they transform her into a mask, into a goddess image. . . . And the women have cooperated with the men, they have invented these static qualities. . . . Now, corsets and girdles and all these things are sculpture, they are static. But the most extraordinary thing is that they transform their faces into static elements that will not express emotions. The eyes are painted, the mouths are shaped in a continuous smile, the smile of Greece, the smile of sorrow, the sadness of the Greek mask."[95]

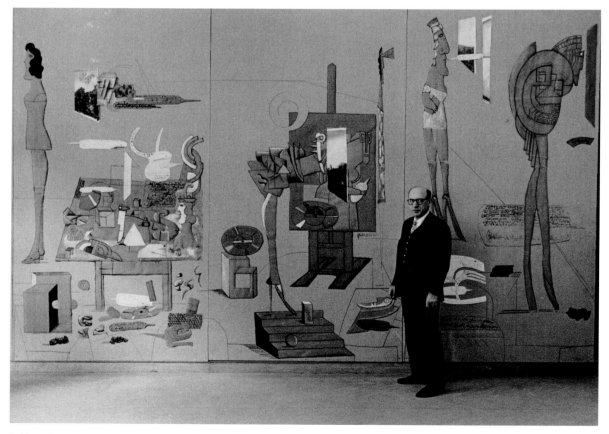

Steinberg with *Le Masque* mural,
Galerie Maeght, Paris, 1966.

41

Erotica 1

1961
Ink and colored pencil on paper, 14½ x 23 in. (36.8 x 58.4 cm)
The Saul Steinberg Foundation, New York, SSF 1216
Published: "Saul Steinberg," *Du Atlantis* 26 (August 1960), p. 602.

Steinberg called his 1961 drawings of couples in bed "a parody of pornography."[96] They double as visual puzzles. Like classic screwball comedies, they arrive at resolution when the mismatched protagonists are shown to have a deeper unsuspected bond. The more glaring the initial contradiction, the greater the confusion, and the more satisfying the final peace. What Steinberg is parodying, perhaps, is not pornography but sexual attraction itself. In *Erotica 1*, a **5** and a **?**—of irreconcilable clans, one would think—turn out to share so many curves, flairs, bulges, and points that they nearly become mirror images. Having shed the conventional layer of meaning that differentiates them as elements of writing, they prove to be, as drawings, secret soul mates.

One well-known precedent for treating writing as drawing was Italian Futurist art—the subject of a major 1961 exhibition at The Museum of Modern Art.[97] Closer to the artist's heart was the tradition of the rebus (p. 188). In the bed series, Steinberg built on these precedents by excavating the inner life of writing—the character of characters. Additionally, through his choice of titles, he found an artistic afterlife for the names of hotels he had patronized. In the *Hotel Modena*, a puffy cloud couples with an angular Art Deco ornament; two near-identical talk balloons (gay? long-married?) are interlocked at the *Hotel Plaka* in Athens; a vigorous black quill-pen signature romances a colorful set of concentric circles at the *Albergo Minerva*, Florence; and at the *Hotel Pont Royal*, Steinberg's regular Paris address, the question mark (predictably unmonogamous) has a tryst with a labeled Pythagorean triangle.[98]

Pasqualino Cangiullo, *Una Schiaffeggiata Futurista (A Futurist Scuffle)*, 1916. Ink on graph paper, 8¼ x 10½ in. (21 x 26.7 cm). Collection of Merrill C. Berman.

STEINBERG 1961

Abstinentia, Pietas, Sapientia, Dignitas

1961
Ink on paper, 23 x 14 in. (58.4 x 35.6 cm)
The Saul Steinberg Foundation, New York, SSF 5365
Published: *Think* 27 (March 1961), p. 22.

The eagle of Abstinence, Piety's knight, Wisdom's angel, and the gliding swan, Dignity, fly their respective banners and toot their horns. Under the noses of these proud paragons, a few faceless figures in a stranded boat pull some overboard comrades to safety. As an arch commentary on the vanity of noble intentions, this scene would not have been out of place among Steinberg's contemporaneous contributions to *The New Yorker*. His cartoons, which began increasing dramatically in number at this time, had ever less in common with the magazine's usual kind of situation-comedy drawing (p. 51). Instead they trafficked in moral philosophy, delivered—as here—in graphic terms derived from premodern models.

However, the present drawing appeared not as a stand-alone Steinberg in *The New Yorker* but as an illustration in *Think*, the corporate magazine of International Business Machines. It accompanied an article, "Alcoholics Anonymous Comes of Age," which highlighted the effectiveness of the group's mutual-aid principles, in contrast to older moralistic efforts to shame drinkers off liquor. When seen in that context, the drawing's center of gravity shifts from the fatuous allegories crowding the foreground to the unsung heroes in their bare-masted boat, pulling drowners from the drink.

Allegory

1963
Ink and watercolor on paper, 22¼ x 28¾ in. (56.5 x 73 cm)
Collection of Carol and B.J. Cutler
Published: "Saul Steinberg," *Du Atlantis* 26 (August 1960), p. 605; WMAA 1978, p. 120.

A little knowledge is a dangerous thing; so is too much information. Seen as a whole, *Allegory* announces its membership in the same self-assured image family as naïve hellfire picture-sermons (below) and election-day editorial cartoons, in which world-class conflicts are swept into tidy piles with a few broad graphic gestures. Only in such an abstract and visionary world, for example, do skyscrapers sprout from the clouds, or protesters emerge en masse from a feudal keep, cross a stone bridge, and pass through a heavenly gate.

Studying *Allegory* close up is just as reassuring: virtually every detail invites one-to-one symbolic translation, engendering a sense of familiarity that feels like understanding. A stork is birth; a skeleton, death; Uncle Sam climbing Jacob's ladder is some kind of progress. Art finds her ideal subject in the mirror, while Reason (a Pythagorean diagram) is caressed by voluptuous Beauty. An inaccessible date palm is Paradise; an old branching tree, History. Right of center is a monument to the Age of Revolutions; its Enlightenment foundation bears promise in the form of a rainbow, but the final upshot, after the Paris Commune of 1871, is just a toppled petty officer. Clear enough.

The difficulty arises when you try to make sense of the whole. Try connecting the macro to the micro—the armature of vast generality to the cast of trite truisms—and the willful absurdity of *Allegory* becomes clear. "Essentially," Steinberg said of his work as a whole, "what I am playing with is the voyage between perception and understanding."[99] *Allegory* portrays the landscape surrounding that voyage, cluttered with the officially sanctified detritus of received wisdom.

Das Neue Jerusalem, hand-colored Pennsylvania German fraktur woodcut, nineteenth century. Library of Congress, Washington, D.C.

45
Untitled (Paris/Sardinia)

1963
Ink, red ballpoint pen, crayon, watercolor, colored pencil, and pencil on paper, 23⅛ x 14⅜ in. (58.7 x 36.5 cm)
The Saul Steinberg Foundation, New York, SSF 7163
Study for *The New Yorker*, October 12, 1963, cover.

46
Untitled (Cat Garden)

1962
Ink, colored pencil, watercolor, and collage on paper, 17 x 15¼ in. (43.2 x 38.7 cm)
Collection of Carol and Douglas Cohen
Published: *The New Yorker*, May 16, 1964, cover; *The New World*, p. 154.

47
Untitled (Initials)

1964
Ink, colored inks, and colored pencil on paper, 19¾ x 14½ in. (50.2 x 36.8 cm)
The Saul Steinberg Foundation, New York, SSF 916
Study for *The New Yorker*, December 5, 1964, cover.

Study drawings reveal that Steinberg's *New Yorker* covers usually evolved out of busier-looking beginnings. In a draft for his twelfth cover, a hostess and her visitor (by unvarying cartoon convention, hatless and hatted) discuss travel, but each talks only of her preferred destination. Steinberg's innovation is to let his discussants speak in the notionally objective terms of the map. A dense social document—part image, part writing, and part measuring device—the map for all its professed factualism is full of implicit agendas and serves the unspoken chauvinism of place. For a Paris devotee, travel talk brachiates by the city's coordinates, from boulevard to stylish side street. The world falls together differently for a traveler to Sardinia, whose talk balloon—read frame of mind—is dotted at the edges with ports, but is essentially a self-contained island. In the finished cover, Steinberg combines comics and cartography with a third idiom: collage. By composing his speakers and their speech out of cut-out brown paper against white, he evokes the self-contained nature of their contest.

Summer 1964 saw the cover debut of Steinberg's trademark patchy white cat, who resembles both the artist himself and a real-life pet he had left to Hedda

Sterne's care since 1960. For publication, their cat was known as Pusskin; privately, its name was the kiss-sound one makes to get a cat's attention. Appropriate, perhaps, that an unspellable creature of nature should be the overseer of a typographic garden plot where, in one critic's words, Steinberg "notes the progressive fossilization of once-vegetal forms and their abasement into printers' clichés, and restores them, by dint of a horticultural setting, to botany."[100]

A cover published the following December treats another semiotic theme: acronyms and initials, abbreviated forms of language appropriate to an age of bureaucracy. In the study, so elegantly finished it makes the cover look like a "rough," the USA's surface is crammed with commercial and political triads. Tunneling below it are New York City's subway lines, the BMT, IRT, and IND. The CIA, too, lurks underground, only to be (literally) undermined by its Soviet counterpart, the MVD. Broadcasters and airlines ply the clouds. Even the stratosphere has been colonized by the Strategic Air Command, which would make it through the design's final cut, and other lofty entities (some just visible in faintest pencil) which would not: LSD, GOD, and ETC.

The New Yorker cover, October 12, 1963.

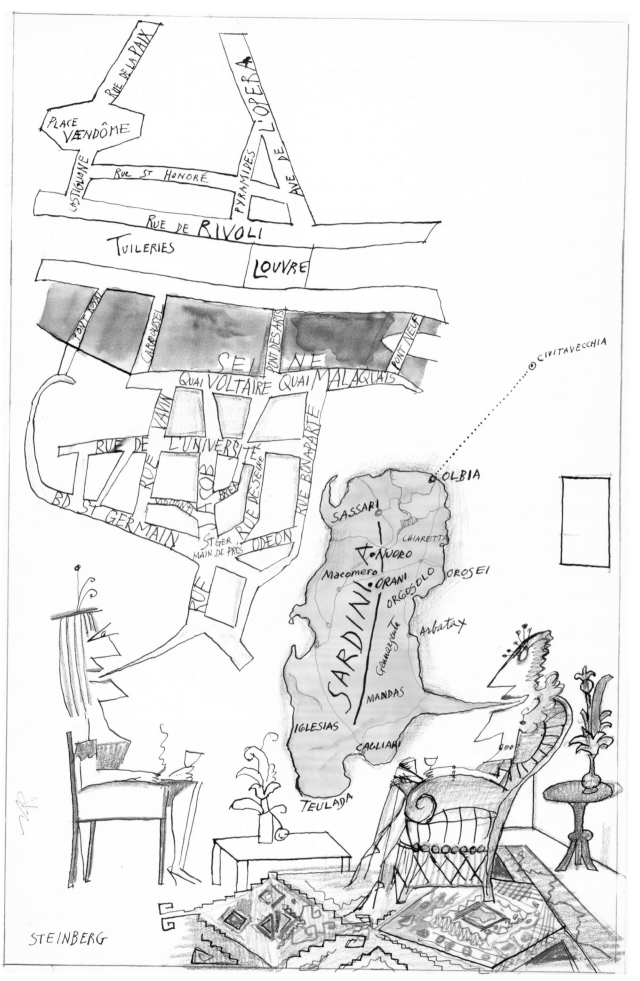

The New Yorker cover, May 16, 1964.

The New Yorker cover, December 5, 1964.

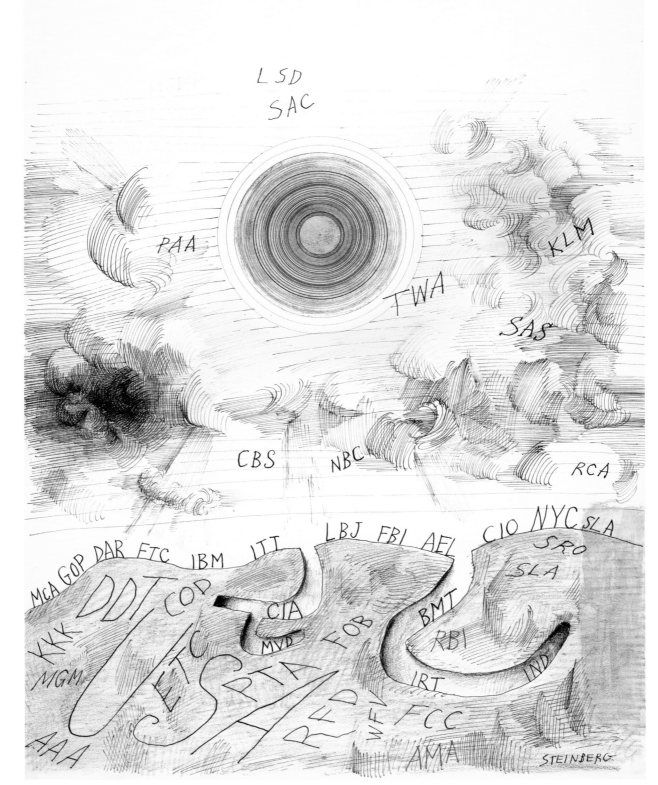

November 26, 1965

1965
Ink and colored pencil on paper, 14½ x 23 in. (36.8 x 58.4 cm)
The Saul Steinberg Foundation, New York, SSF 2241

In his art, Steinberg was constantly giving form to time, often as a map (fig. 32, p. 40; cat. 92). He also generated, as many people do, a non-art record of his passing days—the week-at-a-glance books in which he kept track of everything: deadlines, gallery openings, a travel agent's number, the night's poker-game address, a list of drawings shipped out on tour, checks deposited, and innumerable rendezvous with women.[101] Except when a day or week in those books gets buried under a lava-flow of doodling, the pages of Steinberg's life look much like anyone's. The chaos of life crowds the accidental order imposed by a calendar's structure. In *November 26, 1965*, the artist proposes that a daybook's mix of events, projections, and memories, in the zone between form and formlessness, is what time looks like.

Time moves, naturally, from left to right. Yesterday at 3 P.M. Steinberg arrived at his house in Springs, Long Island. News about Vietnam tinted the day's horizon red.[102] Last night, he read Shaw, tipped over into blue slumber at 10:30, woke in the night and read Thomas Mann's essay on Chekhov. Today he rose at 8:00; he remembers dreaming about Ada, his first love, in Milan.[103] The day's date—for Steinberg, a fact that always looms large—brings thoughts of last year and the year before (Thanksgivings, perhaps, with two sculptor friends, Wilfrid Zogbaum and Ibram Lassaw).[104] This afternoon, walking on the beach, he finds a wounded baby tern that the local animal hospital cannot save.

No grand lesson or revelations follow from this experimental portrait of a day, in which Steinberg takes artlessness for a lesser evil than artiness and finds out what art would look like if it looked like life.

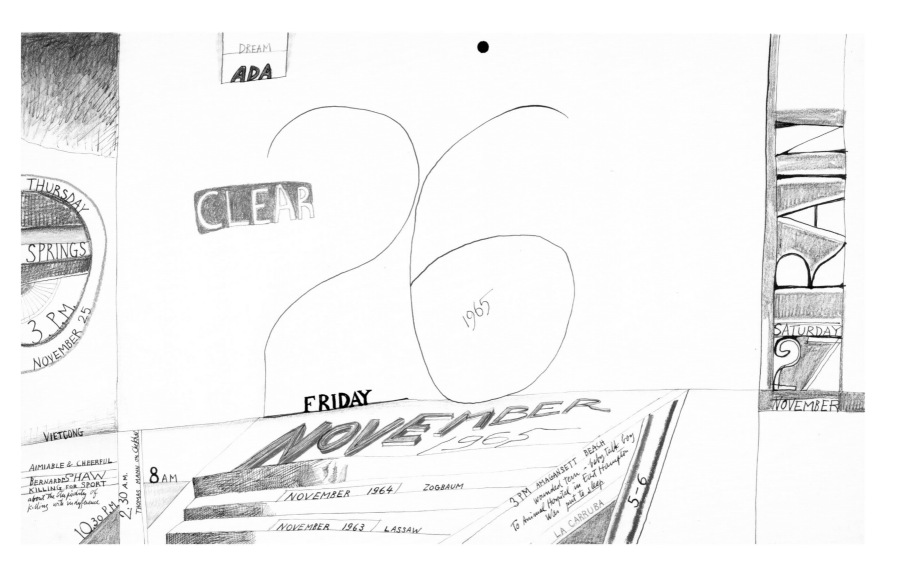

DREAM
ADA

●

CLEAR
26
1965

THURSDAY

SPRINGS

3 P.M.

NOVEMBER 25

R A I N

SATURDAY

27

NOVEMBER

FRIDAY
NOVEMBER 1965

VIETCONG

AIMIABLE & CHEERFUL
BERNARD SHAW
KILLING FOR SPORT
about the stupidity of
killing with indifference

10.30 P.M.

2.30 A.M.

THOMAS MANN IN CLERAC

8 AM

311

NOVEMBER 1964 ZOGBAUM

NOVEMBER 1963 LASSAW

3 PM AMAGANSETT BEACH
wounded tern - baby Talb boy
To Animal Hospital in East Hampton
Was put to sleep.

LA CARRUBA

5 - 6

Biography

1965
Watercolor, pencil, ink on paper, 22 x 15 in. (55.9 x 38.1 cm)
The Saul Steinberg Foundation, New York, SSF 2016
Published: Paul Tillich, *My Search for Absolutes*, 1967, p. 88; *The Inspector*, p. 189 (cropped).

The graphic motif known as the *Lebenstreppe* (Staircase of Life) is a paper monument to orderly notions about the Ages of Man, proceeding implacably from infancy to maturity to the grave. From the sixteenth century on, it figured in the imagery of many nations, serving didactic purposes from scriptural exegesis to political satire. Steinberg adopted the format as early as 1954 to point out, for one thing, that life was not the symmetrical affair it used to be, and for another, that the mutual bafflement of modern men and women should come as no surprise.

More than a decade later, the artist put the staircase theme through seven new variations in one of the three folios of drawings he contributed to *My Search for Absolutes*, the posthumously published credo of theologian Paul Tillich (1886–1965).[105] Steinberg's outlook was more nuanced and less glib at age fifty than it had been at thirty-nine. In *Biography*, he concedes the *Lebenstreppe*'s main implication, that life is all downhill after a certain point. But he adds a proviso: the worst error you can make is to achieve the wrong kind of success—the kind that begins melting you into a blob before you've even reached the peak, on your way to bouncing inertly back down to dust. As he verbalized it: "If man expresses himself only through society's means, he has wasted his life; and that is what society wants him to do."[106]

Theophilius Bloomer (publisher),
The Several Ages of Man Explained (detail), 1821–27.
Hand-colored engraved broadside,
15 x 20⅛ in. (38 x 51 cm).
Chatham's Library, Manchester,
England.

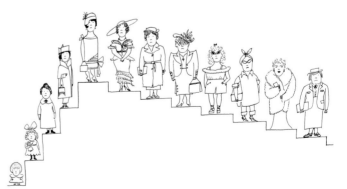

The Passport, 1954, p. 50.

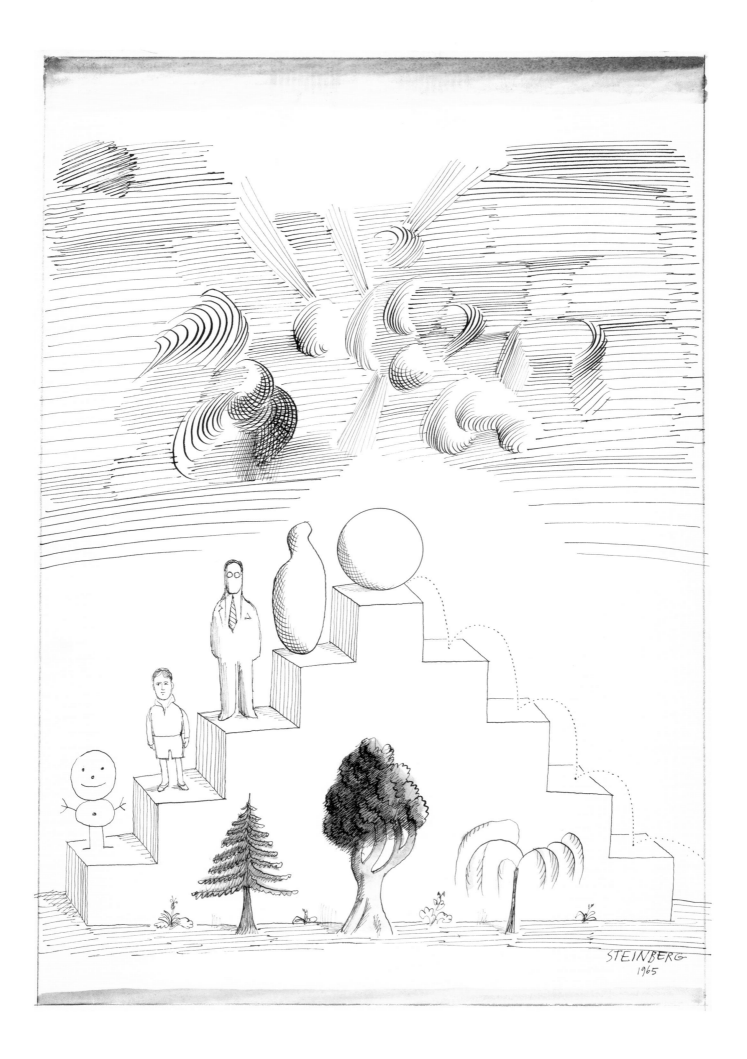

50
Two screen designs for Stravinsky, *The Soldier's Tale*

1967
Ink, colored pencil, marker pen, crayon, rubber stamp, pencil, and watercolor on paper, 14½ x 23 in. (36.8 x 58.4 cm) each
The Saul Steinberg Foundation, New York, SSF 2070, 2073

Steinberg spent the late winter through early spring of 1967 in Washington, D.C., as artist-in-residence at the Smithsonian Institution.[107] For what he described as "perhaps the strangest three months of my life," he lived in a stately Georgetown mansion and attended diplomatic black-tie functions in the evenings. He worked, however, much as he would have at home, explaining that his contract obliged him only "to beautify the city with my presence."[108] When a reporter expressed surprise that his "airy" drawings were created in the mansion's wood-paneled library, Steinberg countered, "Nothing is ever created in Washington, except in a political sense," then demurred: "Three weeks ago I designed some stage sets for a Stravinsky opera, which were painted in a car barn in Southeast. So my residency has had that effect—in the short time I've been in Washington something has been created here."[109]

The Soldier's Tale (*Histoire du Soldat*, 1918), a Faustian "camera opera" that draws upon Russian folk literature, had been selected by the Seattle Opera for a traveling production in "remote fishing, lumber, and farm communities."[110] Steinberg designed four screens for the Narrator to pull down to indicate changes of scene. The present two designs, representing the Soldier's home village and the Devil's palace, respectively, reflect Steinberg's own unlikely journey from backwater shtetl to the stronghold of earthly power. The village is reduced to one peasant's cabin, one tree, and one goat, perched atop a hill bearing the Ottoman patterns that were Steinberg's emblem of (Romanian-level) remoteness (see cats. 38, 63). The goat gazes across a chasm toward the realm of worldly wisdom and might.

As for the Devil's school of brutalist modern architecture, it is that of every hypertrophied hall of power from Moscow to Chicago. The debut of this style during Steinberg's Washington sojourn, however, suggests that his immediate models were what he called, in horror, "those buildings . . . on Constitution Avenue."[111] Later in the year, he revived the style in a portfolio for *Look* on "Our False-Front Culture." Of what he called "Rubber-Stamp Architecture," Steinberg commented: "Government, charity and bureaucracy live [in these halls], where boredom stands for dignity and symmetry equals beauty. This architecture is also the mark of the Totalitarians—it is amazing that it should flourish here."[112]

Merchandise Mart Building, 1930, Chicago. Postcard, c. 1950, from Steinberg's collection. YCAL.

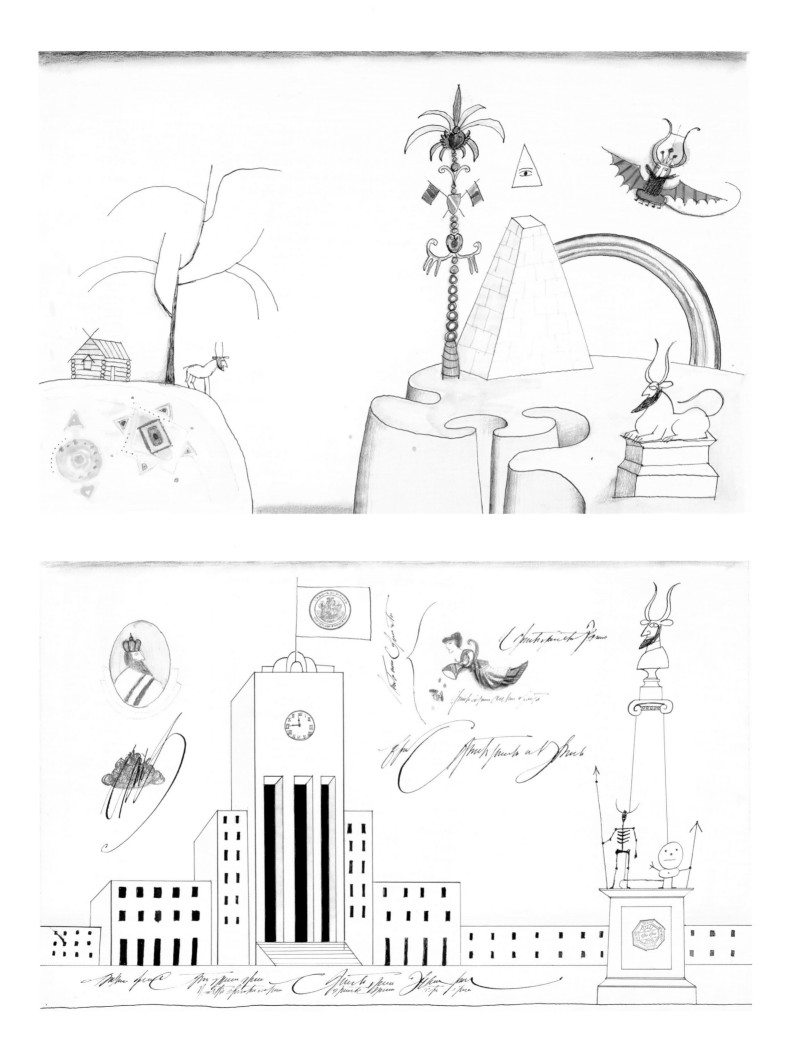

51
Spiral

1968
Pencil and colored pencil on paper, 19⅝ x 25½ in. (49.8 x 64.8 cm)
The Saul Steinberg Foundation, New York, SSF 1373

If only because of a shared dedication to line, Steinberg often found himself compared to Paul Klee.[113] Their affinity, he explained, was that between two "ex-children who never stopped drawing," and who drew like the primitives "who truly used the line in order to say something," as "a form of writing."[114] The spiral, an elemental motif that engaged them both, supplies an instructive point of comparison between the two artists' views on line as sign.

Klee believed in the communicative powers of pure form. A spiral's two possible vectors, outward and inward, signified to him "life and death . . . either a gradual liberation from the center through freer and freer motions, or an increasing dependence on an eventually destructive center."[115] Steinberg took an emotional step forward and an analytical one back from this intuitive level of reading. He regarded spirals as diagrams, and

components, of their inventors' realities. When he drew a little man stepping out of a coiling line and into a landscape, it meant, he said, "the past eats him up." But an inward-turning line, such as the one in *Spiral*, struck him as a symbol of its creator's "own time and space—his life; at the same time, it is his destruction. It gets narrower and narrower. This is a frightening drawing. It could be the life of the artist who lives by his own essence. He becomes the line itself and finally, when the spiral is closed, he becomes nature."[116] If for Klee drawing presented the most potent way of symbolizing ideas, for Steinberg it stood, more primally, for the human capacity to turn concepts and precepts into fact: "Just as words crystallize a philosophical system or promise, drawing defines the world of reality & creates this reality. There is no reality without drawing."[117]

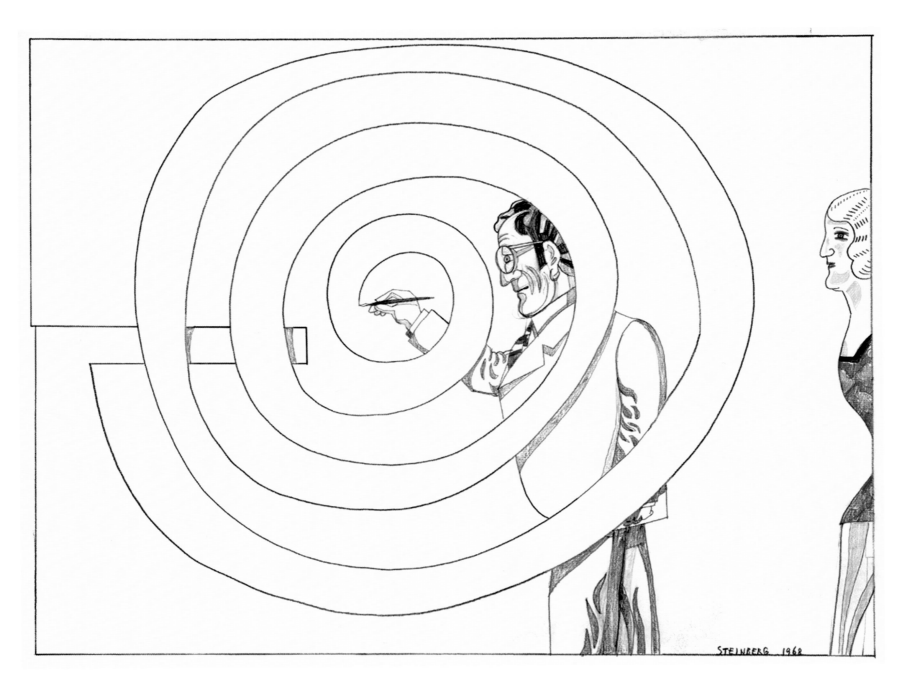

52

Indians, Cyclists, Artists

1968
Rubber stamps and ink on paper, 23¼ x 29 in. (60.3 x 73.7 cm)
The Saul Steinberg Foundation, New York, SSF 6358
Published: *The Inspector*, p. 46.

53

Artists and War

1969
Rubber stamps, pencil, and colored pencil on paper, 23 x 29 in. (58.4 x 73.7 cm)
The Saul Steinberg Foundation, New York, SSF 1105
Published: WMAA 1978, p. 159.

As early as 1951, Steinberg had begun accumulating stationer's rubber stamps to use in drawings ("RUSH," "ORIGINAL," a pointing hand, a bowl of fruit, wreaths, foliated borders, a hotel's coat of arms). They were his emblems, he said, of "having suffered so much with visas and documents."[118] These flea-market finds played only a minor, occasional part in his arsenal over the years.[119] But in 1966 he began having rubber stamps made after his own designs, starting with faux-official seals (regal flourish, censor's hexagon) accompanied by a mixed population of Mack Sennett stock characters (bicyclist, warpath Indian, flapper seated at easel) and the members of some lost Giacometti batallion.[120] Now he could compose whole scenes in what he called "a computerized form of art."[121] The rubber-stamp drawings, which predominated in his Parsons-Janis show of 1969, had little to do with the light rubber stamp entertainments of the preceding decades. In sensibility, their roots lay instead in a mode of collage he had practiced as an angry young cartoonist.

In the shop spirit of *Bertoldo* in the 1930s—midway between Dada and *Mad*—Steinberg had enlivened his cartoons by gluing in bits of clipped-out Victorian junk graphics (and, on one occasion, a photograph of his father's head, recast as the bust on a schoolroom wall).[122] As it turned out, just about any chunk of old printed matter, once it got transplanted into the fresh context of a cartoon, looked both corrupt and ridiculous—like an old crackpot trying to mix with a clever young crowd.

(Terry Gilliam made the same discovery in his clip-art animated shorts for *Monty Python's Flying Circus* thirty years later.) Steinberg went on to put this effect to good use in his wartime cartoons for *PM*. For example, he drew teenage Hitler posing in an oldtime photographer's studio, oafishly sticking his elbow in a collaged-in cuspidor; gave the dictator a glued-in meat-grinder to cram German soldiers into; and incarnated the Vichy regime as a fey Rococo ornament clipped out of a book.[123]

Steinberg graduated to subtler forms of collage-caricature in the postwar years; among other inventions, his paper skyscrapers (fig. 39, p. 43) politely lampoon the soulless glass boxes that began overtaking midtown in the 1950s. But as was true for many of his friends—including Ad Reinhardt, another former *PM* cartoonist—the Vietnam War gave Steinberg back his outrage, and he expressed it through rubber stamps as he had once done through collage.[124] *Artists and War* condemns the war on specific grounds—it spells disaster for culture. As the vast war machine of eagles, crocodiles, and armed lancers carries out its clockwork atrocities, a corps of artists seated at their easels prepares to crank out protest art, their lock-step reaction mirroring that of an army.[125] "The cliché, the rubber stamp, has a political meaning," Steinberg later commented, recalling with pride that in the Prague Spring of 1968, "when Czechoslovakia had its season of freedom, . . . they published my rubber stamp pictures as symbols of slavery and boredom inflicted by the State."[126]

<h1 style="text-align:center">54
Nine Postcards</h1>

<p style="text-align:center">1969

Rubber stamps and postcards mounted on board, 20 x 24⅝ in. (50.8 x 62.5 cm)

The Saul Steinberg Foundation, New York, SSF 6461

Published: Museum of Contemporary Art, North Miami, American Short Stories, 2003, fig. 15.</p>

<h1 style="text-align:center">55
Wyoming</h1>

<p style="text-align:center">1969

Ink, pencil, and watercolor on paper, 14½ x 23 in. (36.8 x 58.4 cm)

The Saul Steinberg Foundation, New York, SSF 704

Published: The New Yorker, April 12, 1969, p. 43; The Inspector, p. 175 (before color added).</p>

In Jean-François Millet's *Angelus* (1857–59; Musée d'Orsay, Paris), two peasants in a field at dusk thank the deity for blessing their humble corner of Creation. Steinberg had known the couple since childhood—not, at first, as figures from the history of art, but as lead characters in his father's collection of stock motifs to print on confectionery packaging. "Millet was ideal for chocolate boxes," the artist later remarked, "because he combined the classicism of the Renaissance with socialism, which at that time was not only popular but also virginal (no one yet knew of the horrors that might come, and did come)."[127]

In 1969 and 1970, the artist ordered rubber stamps of the praying couple in various sizes, together and singly, and put them to work repeatedly in his art—most prominently, a 1970 *New Yorker* cover in which an endless lineup of Angeluses is posing for a squad of plein-air artists (the same painters are at work in cat. 53).[128] He also used the stamps to lend a note of *bondieuserie* to tourist postcards in his collection.[129] In *Nine Postcards*, several American cards of the type collectors call "chromes," with their relentlessly banal compositions and electric-blue skies, are visited by two ambassadors from the landscape tradition's more pious past.

New and Old World notions of geography are still more explicitly weighed against each other in *Wyoming*. The arbitrarily vast (and incidentally postcard-shaped) western state, willed into existence on a map by surveyor's fiat, makes even New Jersey, with its river-and-coast outline, look like a natural expression of God-given topography.[130]

Untitled, 1969–70 (drawing for *The New Yorker* cover, June 6, 1970). Oil, ink, and rubber stamps on canvas, 22⅝ x 16¼ in. (57.6 x 41.3 cm). Private collection.

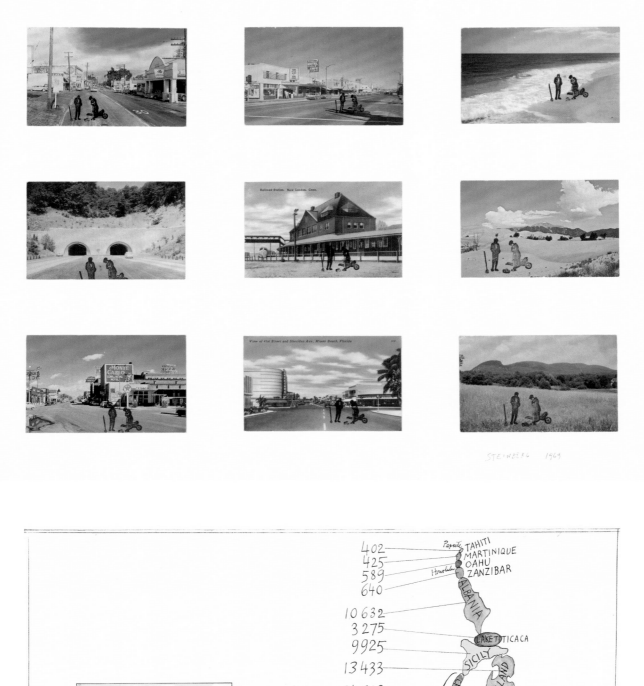

STEINBERG 1969

Five False Paintings

c. 1971
Mixed media on wood, maximum height 42⅜ in. (108.9 cm); assembled width 30 in. (76.2 cm)
The Saul Steinberg Foundation, New York
56. *Standing Man*, SSF 6179
57. *Marcel Duchamp*, SSF 5643
58. *Woman in Doorway*, SSF 5635
59. *Man in Doorway*, SSF 5637
60. *Mondrianerie*, SSF 5641

61

Louse Point

1969
Oil and rubber stamps on prepared board, 18 x 24 in. (45.7 x 61 cm)
The Saul Steinberg Foundation, New York, SSF 6141
Published: WMAA 1978, p. 138; Alec Wilkinson, *The Riverkeeper* (New York: Alfred A. Knopf, 1991), dust jacket.

Steinberg was a nettlesome resident of Flatland. He liked to make noises about emigrating to the third dimension someday, but he was having too much fun twisting the local laws of grammar to move away. A spread in one of his books combined two drawings that toy with the conventions of spatial foreshortening. Each portrays a group of standing figures viewed from eccentric angles. Seen from straight overhead, the people on the right-hand page turn into clutches of shoulders, shoe-tops, and upturned faces. At left, more uncannily, is a group seen as though turned on edge. Each figure has been rotated several degrees away from the plane of the page and revealed to be (as drawings are, of course) only paper-thin. The result is a misbegotten version of oblique perspective—the kind of thing you can get away with when speaking a foreign language, if the natives can't decide

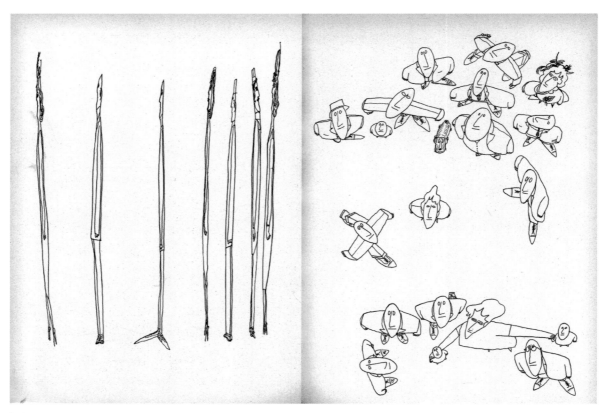

Steinberg's Umgang mit Menschen, 1954, pp. 62–63.

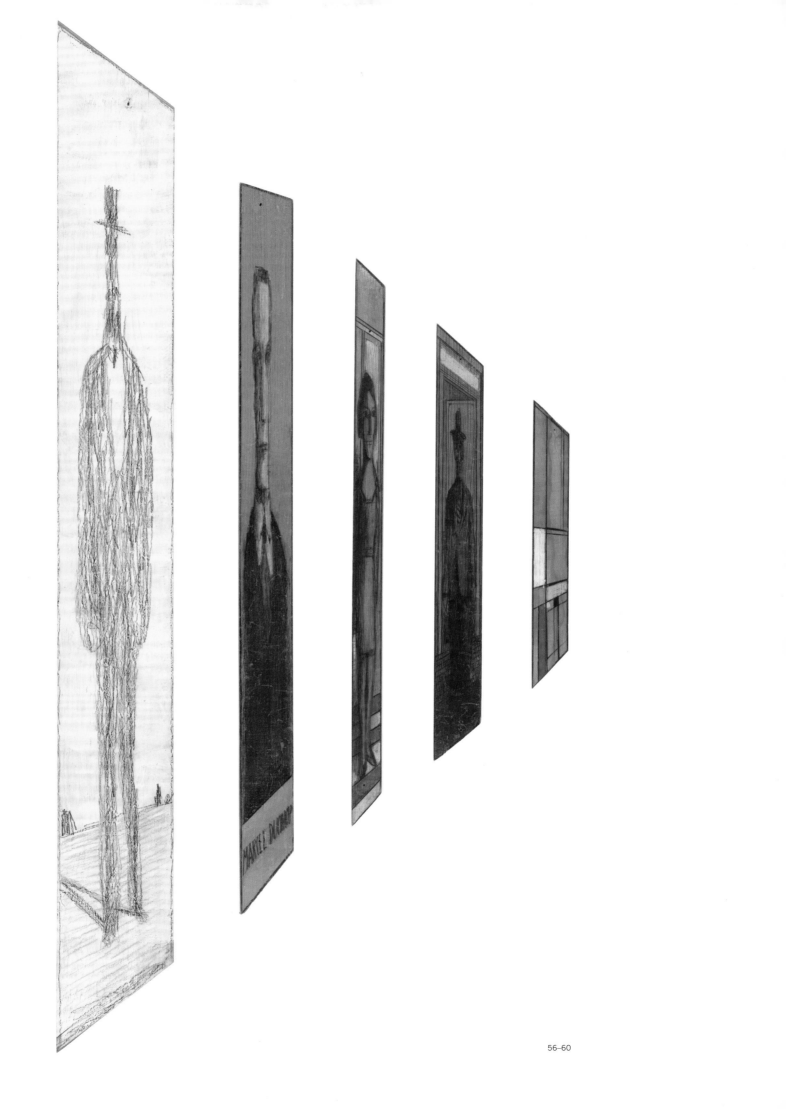

whether you've made an error or said something too smart for words.

Steinberg counted on enjoying just such an advantage when he was invited to show at the Carnegie International Exhibition of Painting and Sculpture in 1970. The summer before, he had taken up paint and brushes and begun creating *faux* canvases (painted on Masonite) such as *Louse Point*, named for a quiet beach on an inlet near Amagansett. The water, land, and sky in these scenes are brushed or sponged on in oil, but the people and paraphernalia in the foreground, who recall nineteenth-century figures posing for the camera at lonely colonial outposts, are rubber stamps. "Painting takes too much time," he explained, "it seduces me, it's much too beautiful . . . and the preparation of canvases, stretching and so on, in itself is the administration of enterprise." But "I have to try everything and right now I'm going to go through painting for a while. My work is about my evolution. . . . When I do a landscape, I use it in my own way. I don't think of it as being a true landscape, a part of nature. It's more like a collage of nature. It has to be done in oil because it fits my purpose. I use rubber stamps and drawing and whatever comes logically."[131]

The galleries, or collections, of "false paintings" in perspective Steinberg created in 1971—each painting executed on a trapezoidal slat of wood—pull painting deeper into the game of representing representation. These low-relief wall sculptures represent paintings in space which, in turn, represent scenes out of art or life, exemplifying Steinberg's preoccupation with "different degrees of reality."[132] At the right end—the "distant" end—of the present group is a pastiche after the modernist apostle of flatness, Piet Mondrian. The tribute, though flat as can be, beguiles us into seeing it as a square viewed obliquely, occupying volumetric space. Also here is a yardstick-skinny portrait of Marcel Duchamp, who had died in 1968, and whose gentle, persistent undermining of "retinal" art had opened the way for art about wit, and art about art.

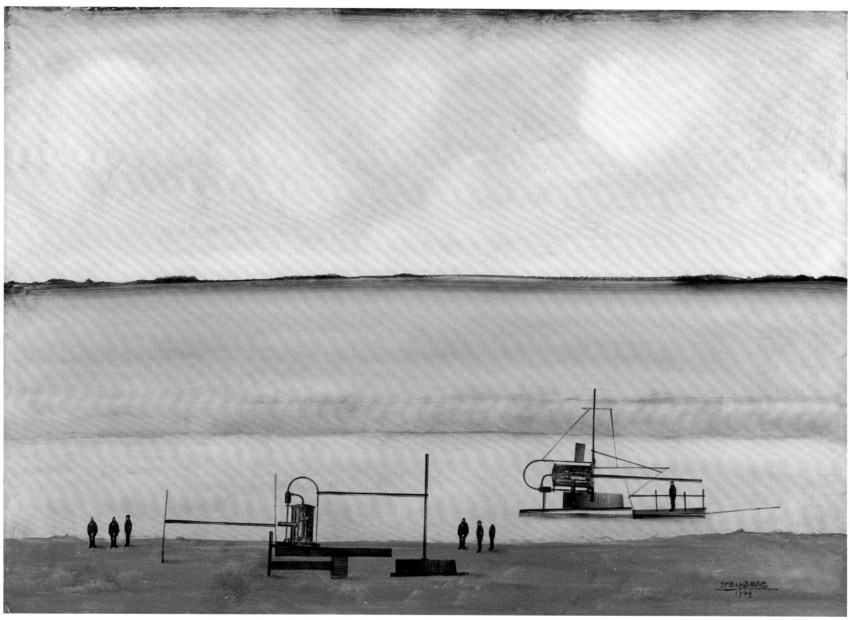

61

Artist

1970
Pencil, colored pencil, ink, and rubber stamps on paper, 22½ x 28½ in. (57.2 x 72.4 cm)
The Saul Steinberg Foundation, New York, SSF 6341
Published: *Saul Steinberg*, exh. cat. (London: Waddington Galleries, 1983), pl. 1.

Dispassion and horror merge in a group of vivid drawings Steinberg made in 1969–70, which look like illuminations for a field guide to hell. Their cursory narrative schemas, like those of Dante or Bosch, serve mostly to provide simple backdrops before which a diverse cast of characters performs. The richer story at hand is one of mental archaeology, as Steinberg goes rummaging around the roots of his imaginative world.[133]

The mountaintop allegorical figures in *Artist*—a flying missile and a flying fish, a crowned crocodile, a dog playing the Loyal Dog, a roaring housecat swelled to lion's size—have about them the plainspoken oddity of paper dolls, shadow puppets, or the paper-toy theater figures Steinberg collected. In the foreground, two females, a stoned-looking hippie chick and a skeleton-suited vixen in Minnie Mouse gear, have been laid out like tomb statuary. They clutch, respectively, a cross and a switchblade—stock emblems, in popular evangelical rhetoric of the time, for the options facing troubled youth.[134] The Artist of Steinberg's title is a debased Mickey Mouse in an honorary sash, who stands at the easel and tries to do his job. That his only company is a loose consortium of refried clichés hints at the professional doubts Steinberg confided to an interviewer around this time: "Had I not been an artist, I might have contributed more directly to society. I look at these important people. They make a mistake. They learn. They move on. I keep making the same mistakes. I live in another world."[135]

J. Redington (publisher), characters and props for *Baron Munchausen's Adventures*, c. 1835. Uncut sheet from Steinberg's collection. YCAL.

STEINBERG
1970 Copyright © 1970 Saul Steinberg

Bucharest in 1924

1970
Ink, pencil, and colored pencil on paper, 23⅛ x 29 in. (58.7 x 55.9 cm)
Private collection, New York
Published: Loria 1995, no. 15; Museum of Contemporary Art, North Miami, *American Short Stories*, 2003, pl. 20.

Bucharest in 1924 brings to life the tangle of Slavic, Ottoman, and Continental motives that defined the *"enfant-prodige* city" of the artist's youth.[136] On the horizon—in the pictorial role, one would think, of a palace—is Moritz Steinberg's printing and boxmaking shop, crowned by Peasant Liberty on a rainbow. In the foreground, ten-year-old Saul, dressed in his Prussian-modeled school uniform and bearing a Christmas candle, steps behind an army regiment in parade formation.[137] Behind him follow two street vendors, Muslim and peasant, the latter rendered as though in the needlework of his native costume. In the middle distance, in a soft grain suited to background memories, are some of the street figures which the artist had by now begun unearthing, via magnifying glass, out of period postcards. The hellhound in the foreground, too, has come slouching out of the background of a postcard illustrating Bucharest's central avenue, the Bulevardul Elisabeta (fig. 88, p. 79). Soon Steinberg would have this canine and several other bit players rendered as rubber stamps, which he drafted into service in picture after picture (cats. 65, 70, 71)—thus turning onetime figures of real life into recurring, symbolic types.

Page in a book of hand-colored photocopies made by Steinberg, c. 1984. YCAL. An enlarged detail of a postcard featuring a horse-drawn cart and (far right) the source for Steinberg's Walking Inspector stamp (see cat. 70).

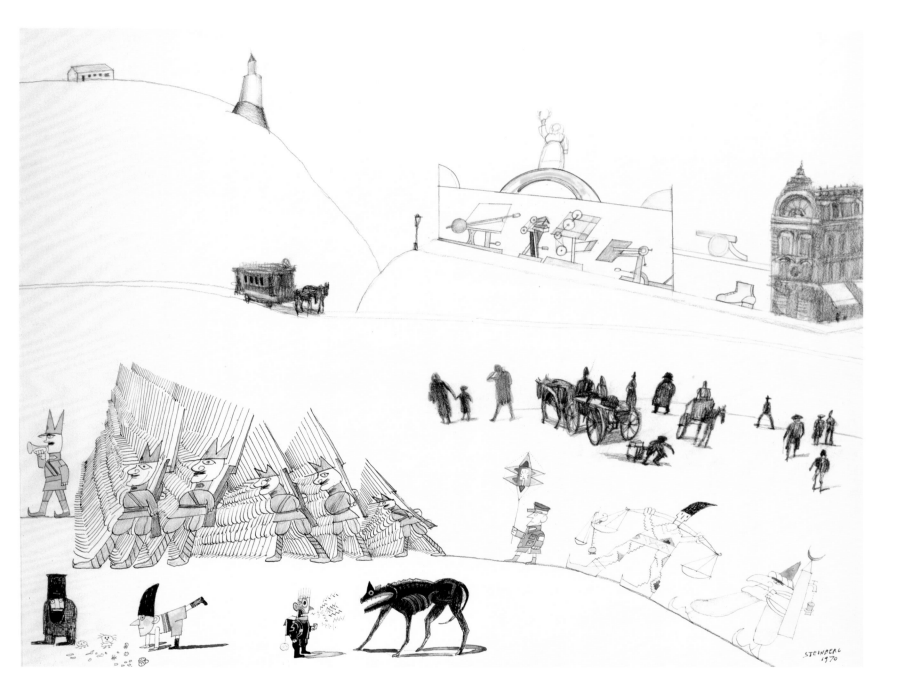

64
Konak

c. 1970
Colored pencil, pencil, rubber stamps, and collage on paper, 23 x 31½ in. (58.4 x 80 cm)
The Saul Steinberg Foundation, New York, SSF 6427

"I play with Cubism to find out what it means," Steinberg said of his frequent forays into the earliest, still-strangest invention in twentieth-century art.[138] Still lifes on desks and drawing tables predominate in his Cubist experiments, as they did in Picasso's and Braque's. Steinberg's centerpiece is typically an intimate piece of paper ephemera, such as an air mail envelope addressed to him by an old girlfriend, or—as in *Konak*—a Turkish hotel bill.[139] "Cubism belongs to the beginning of the century," he said. "It's impossible to re-do it. We are of our time. If I do Cubism now, it's obvious that I know too much. I'm not innocent the way they were. Mine is Cubism revisited."

To his eye, "innocent" Cubism was a poetic record of the way electric light had changed vision in the era of his childhood and just before. "[R]eflections in the windows, shadows on the walls, the superimposition of various sources of light, transparency: all these were the magic that suggested Cubism." By extrapolating a composition out of the row- and column-dividers in the Hotel Konak's invoice, Steinberg proposes another historical source for hard-edged, rectilinear abstraction—namely, the grids and rule-lines of mechanically prepared paperwork in an "organized society."

STEINBERG

65
Untitled (Pineapple)

c. 1970
Pencil, colored pencil, collage, watercolor, ink, and rubber stamps on lithographically imprinted paper, 23½ x 30 in. (59.7 x 76.2 cm)
The Saul Steinberg Foundation, New York, SSF 1397

In early summer 1970, Steinberg wrote that he was "working well in the big studio [at Union Square]—doing lithographs and would like to try a combination of litho and collage."[140] Here, through collage and other techniques, he transforms a lithograph in which Don Quixote tilts at a giant pineapple—a scenario first ventured in his March 4, 1967 cover for *The New Yorker*.[141] This time around, teams of rubber-stamped inspectors are on hand to watch the event, and the pineapple has been given a partner—a pyramid which bears on its flank a theater ticket dating from Steinberg's 1956 USSR trip.

The language of the art trade draws a distinction, deliberately blurred here, between a "multiple," such as a cast sculpture or a print, and unique objects, such as a drawing or collage. An altered lithographic print loses, so to speak, its status as a multiple and is promoted to the condition of originality—thus also of rarity and increased value. Steinberg would complicate matters further when he used impressions of his lithograph *The Tree* (1970) as the base for a series of collage-drawings, which he issued as a numbered "edition" titled *Nine Variations*.

Bestowing originality on a multiple—even if only by adding more multiples to it (like the stenciled French curves, rubber stamps, gummed label, and theater ticket in *Pineapple*)—was an act of alchemy that appealed to Steinberg's sense of metaphor. In human terms, the multiple corresponds to the undifferentiated masses—rubber-stamp man—while an "original," as the word is used in everyday language, describes a singular maverick. Steinberg was inclined to see the operations of art and reality as commentaries on each other. Thus a drawing in pencil of a pencil that draws itself—on the face of it, a hermetic art-about-art conceit—was, in his eyes, "a satire of autobiography."[142] By the same token, hearing a mockingbird sing reminded him of art—specifically, of his relationship to other artists. He pointed out that whereas "most birds have only one song," which they endlessly repeat, the mockingbird is an anthologist of techniques and identities—a meta-songbird and as such, an original among the multiples.[143]

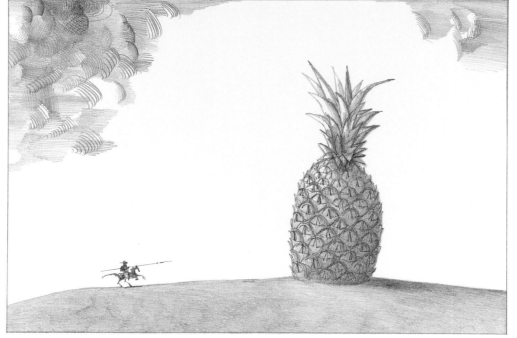

Knight and Pineapple, 1970.
Lithograph, 22¼ x 30 in.
(56.5 x 76.2 cm). SSF 3217.

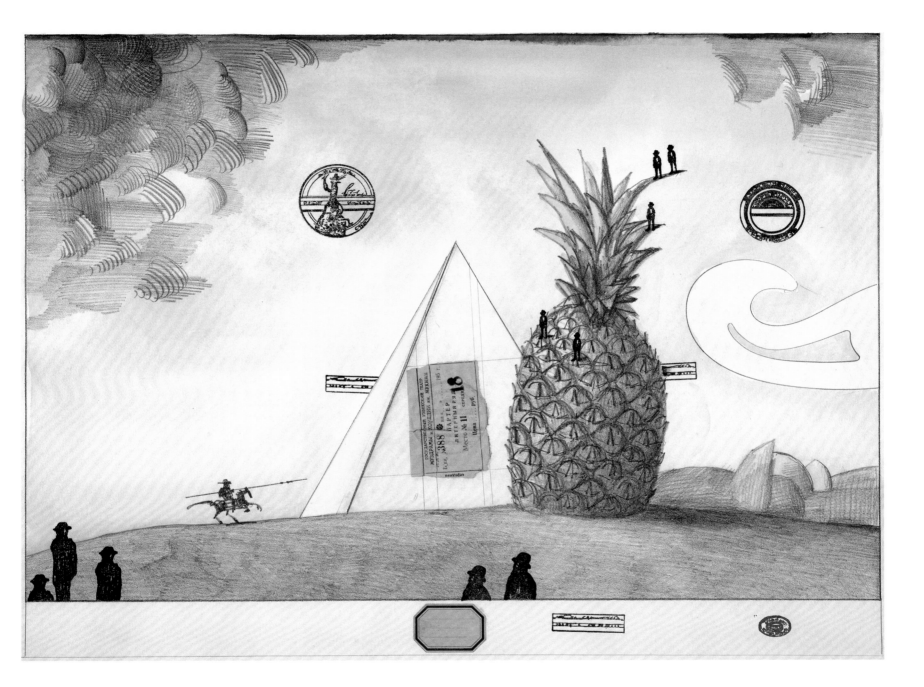

Bleecker Street

1970
Ink, pencil, colored pencil, and crayon on paper, 29⅜ x 22⅜ in. (74.6 x 56.8 cm)
Collection of Michael Ulick
Published: *The New Yorker*, January 16, 1971, cover; *The Inspector*, pp. 162–63 (details); *The Discovery of America*, p. 114.

The main street of Greenwich Village presents a portrait in microcosm of a nation spiraling down to inarticulate infanthood. Beneath store signs growling cartoon sound effects, a few denizens of the street have traded in their identities for central-casting getups as biker boy, bandito, and stormtrooper.[144] Others pull off childish imitations of adulthood, all stick-limbs-and-head, while the saddest cases fade away into scribble. The Law, reduced to a tin push-toy, speeds through the chaotic masquerade, past the garbage and free-range rats, roaches, and crocodiles, toward an unseen crisis.

What makes a place hell on earth? Weimar-era Berlin, in George Grosz's period street scenes, is sticky with moral decadence. In the America of late 1960s underground comix, the villain is political corruption, with the Vietnam War lending the pervasive note (p. 63). A related but shaggier malaise infests the world-gone-wrong in Philip Guston's late figural paintings, first exhibited at the Marlborough Galleries the month before Steinberg turned in this cover design for *The New Yorker*.[145]

Steinberg, for his part, was neither a moral nor a political critic in any usual sense. His ultimate reference point for the true, good, and reasonable—and their opposites—was style. His idea of Pandemonia, seen here, is the extinction of period style—the loss of that social and visual integrity that had made an intelligible fabric of public space in, for example, Italy (cat. 22) and even, strange to say, Manhattan as he had first known it (cat. 8). Steinberg's Bleecker Street is hell because it is a Babel of half-baked individualisms, where "freedom" has locked each figure up in a solitary life script, leading everyone to nowhere. The disaster that looms in such a world is not the cathartic, redemptive kind, but the comprehensive collapse announced, with bracing plainness, in the opening line of John Ashbery's landmark prose poem "The System" (1972): "The system was breaking down."[146]

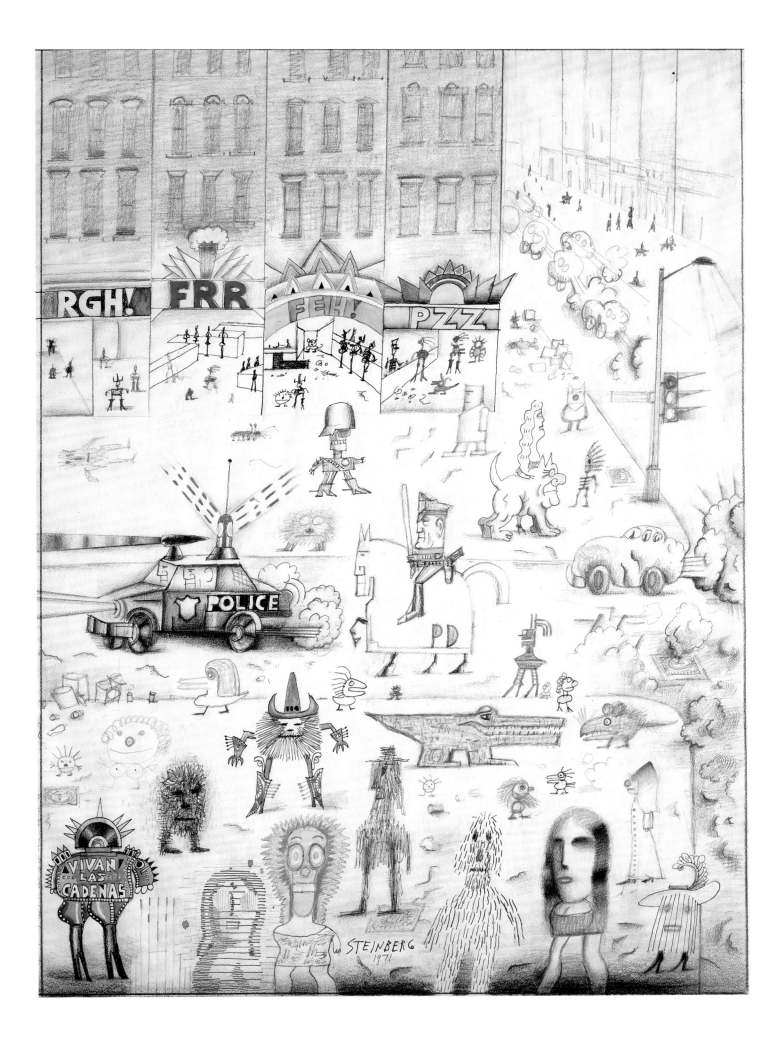

I Do, I Have, I Am

1971

Ink, marker pens, ballpoint pen, pencil, crayon, gouache, watercolor, and collage on paper, 22¾ x 14 in. (57.8 x 35.6 cm)

The Saul Steinberg Foundation, New York, SSF 912

Published: *The New Yorker*, July 31, 1971, cover; *The Inspector*, p. 199 (cropped).

Hybrids between word- and picture-logic suited Steinberg's border-oriented mind. He migrated to formats that combined the verbal, the visual, and the schematic: maps (cats. 45, 75, 76, 90), statistical diagrams (cat. 55), and for that matter the single-frame cartoon itself—which, even when captionless (as most of his are), remains in the business of embodying caption-like *aperçus* (cats. 11, 42).

The year-end issue of *The New Yorker* in 1970 included eight of Steinberg's rebus drawings, captioned upside-down with their solutions.[147] In these puzzle-pictures, the tidy child's-play rebus—in which each drawn motif stands for one sound or word and the visual syntax runs left to right, scriptlike—is joined with the freer-form visual riddles known as "Tom Swifties" and the accidental surrealism of the mid-nineteenth-century rebus *tableaux* of Théodore Maurisset.[148]

By their very nature as puzzles, Steinberg's rebuses flirted with obscurity. An earlier invention, the self-deleting *Not Yet*, fuses verbal sense with visual execution and winds up in a fog. By contrast, the message of *I Do, I Have, I Am* could not be clearer. This gentle testament against materialism is like a rebus turned inside out: whereas word and picture interrupt and complicate each other in the puzzles, here they collaborate.[149] The result is a pictorial equivalent to homiletic sermons, which translate a parable or image—in this case, the sun blazing in the sky over a shack on a bluff—into a spiritual lesson. To Do is exciting but ephemeral; to Have is but a form of poverty; the only bedrock is Being—character. When this design appeared on the cover of *The New Yorker* in July 1971, many readers (Christian, Buddhist, and Jewish) wrote fan letters, proposing a poster version—a marketing opportunity which, perhaps appropriately, the artist declined to pursue.

See you in Italy at the end of June.

Rebus in an untitled portfolio, *The New Yorker*, December 26, 1970, p. 27.

Théodore Maurisset, rebus (*Maintenant un homme qui bat des entrechats dans un bal est trouvé ridicule par chacun*), c. 1847–53. From an envelope of study photographs, c. 1970, of Maurisset's rebuses in Steinberg's papers. YCAL.

Not Yet, 1965–66. Ink, colored pencil, gouache, watercolor, and rubber stamp on paper, 14½ x 23 in. (36.8 x 58.4 cm). SSF 2286.

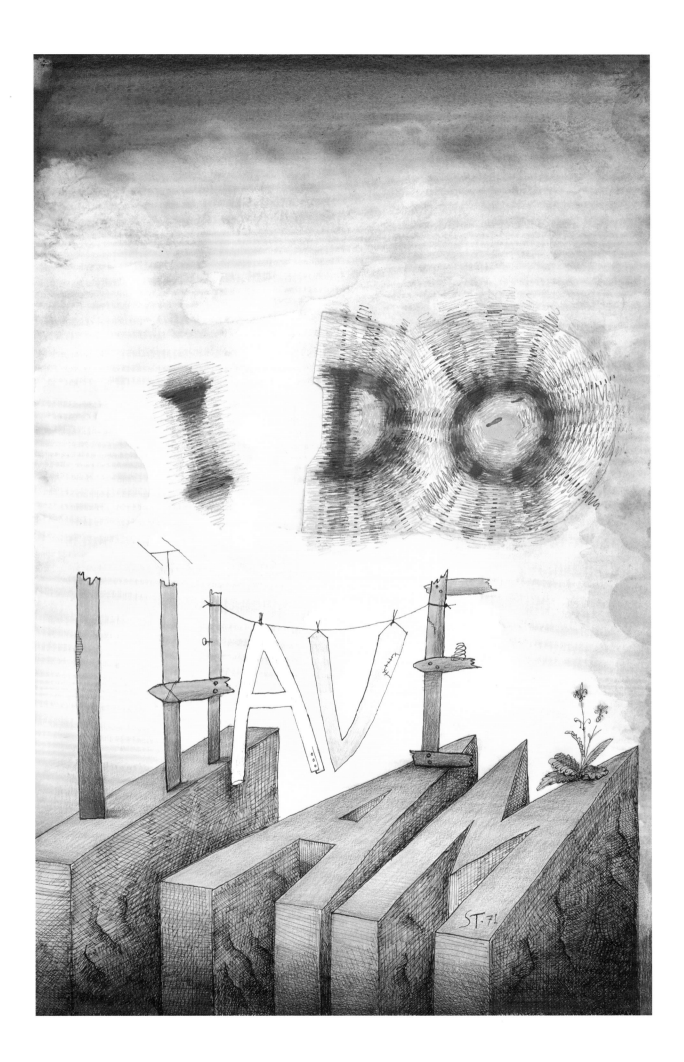

Sixteen Landscapes

1972 and 1979 or later
Oil and pencil on paper, 20 x 29 in. (50.8 x 73.7 cm)
The Saul Steinberg Foundation, New York, SSF 4194
Published: WMAA 1978, p. 173 (in earlier state, titled *Sixteen Horizons*).

When Steinberg signed and dated this drawing in 1972, its sixteen frames showed only bare prairie, as in the top and bottom tiers. The plains were still unsettled when the work appeared in the artist's traveling retrospective exhibition in 1978. At some point after it returned to his studio, pioneers came and, in the second row, made a start on what looks to be a network of suburban tract roads. One row below, bigger cities have sprung up, evidently connected by spaceship service.[150]

On a literal level, the empty horizons in what Steinberg called his "postcard" landscapes refer to the vast unexploited space he first saw in the New World—an exotic sight for someone arriving from the oversettled old one. Some of the postcard plains allude, by title, to his wider travels: *Anatolia*; *Kisumu* (on Lake Victoria, in Kenya); *Kunming* (where he was stationed in China in 1943); *African Postcards*; *Egyptian Landscape*.[151] His skies often bear the stamp of an Inspector who—himself a rubber stamp—appraises the vacant wilderness, alone or in surveying teams, as on his 1971 *New Yorker* cover.

A commentary on painting is also afoot here. As a genre, Steinberg's postcards derive from his 1969–70 pastiches of oil landscape (cat. 61), and his scapes of land and sky resemble no other art so much as the massive "floating plateaus of tint" painted by his lamented friend Mark Rothko, who committed suicide in February 1970.[152] But the painterly tradition of the Sublime, which is commonly seen as culminating in Rothko's work, is reduced by Steinberg to a school of assembly-line craft.[153] To create these sixteen scenes, he first laid down a border grid using narrow strips of drafting tape. The "land" was then rendered with four wide sweeps of a broad brush loaded with oil pigment, the cloud-dappled "skies" with thinned watercolor paint and an eyedropper.

The New Yorker cover,
September 25, 1971.

Street War (Cadavre Exquis)

c. 1972–74
Pencil, crayon, colored pencil, and ballpoint pen on two joined sheets of paper, 21 x 13½ in. (53.3 x 34.3 cm)
The Saul Steinberg Foundation, New York, SSF 737

In 1973, Steinberg moved out of his apartment in Washington Square Village and back to the relative tranquility of the Upper East Side. A duplex on 75th Street near Park Avenue became his city residence-studio for the last quarter century of his life. In the short term, however, the hurlyburly of downtown lived on in his work. Visions from his old neighborhood—of sidewalk life and of the street revolution propounded by the counterculture—filled his sketchbooks. He tore several dozen leaves out and pinned them to the high end wall of his newly expanded Amagansett studio. From this catalogue of characters in search of a scenario, he glued selected drawings into couplings, such as *Street War*, that give the appearance of disjointed narrative episodes. (In fig. 70, p. 67, the bottom half of *Street War* is at the right end of the top row; the top half is second from left in the second row.)[154] Steinberg called these jarring combination works *cadavres exquis* (exquisite corpses), after the Surrealist game in which players pass around a folded piece of paper, adding to a drawing or poem that is revealed in its entirety only when the page has been filled.[155]

Steinberg's premonitions of urban chaos invite comparison to the news photographs he had begun clipping as post-colonial turmoil spread in the Middle East and Africa.[156] His tommy-gun-toting terrorists often resemble Mickey Mouse, or, as here, some third-tier rock guitarist who happens to have picked up a deadly instrument instead of a noisy one. The world, in a timeless spectacle, was passing into the hands of those who could be trusted with it least—the reckless, the extreme, and the fierce. Steinberg remade himself as one of this cartoonish tribe, using grease pencils on old khakis to create desert camouflage gear in which he had himself photographed, wearing a mask of pop-eyed mania and clutching—in pruning gloves—a handmade machine gun.

Leftist gunmen celebrating in the lobby of the Holiday Inn in Beirut yesterday after seizing the building

Newspaper clipping, 1974, preserved with others between the pages of a sketchbook. SSF.

Steinberg in desert military mask and painted camouflage costume, Amagansett, 1981.

Machine gun, c. 1974. Crayon, pencil, and rubber stamp on carved wood, 7½ x 28¼ in. (19.1 x 71.8 cm). SSF 5625.

Milanese II

1973
Ink, pencil, colored pencil, and rubber stamps on paper, 18½ x 29¼ in. (47 x 74.3 cm)
The Saul Steinberg Foundation, New York, SSF 5184

In a series of 1973 drawings, Steinberg traveled back to his student years in 1930s Milan.[157] The building at the center of *Milanese II* is a double caricature: it is designed in an exaggerated version of the "Milanese Bauhaus" manner native to the drafting tables of the Reggio Politecnico and rendered in slightly cockeyed three-point perspective—the kind of grandiose conceit a student would use to dress up some just-OK homework.

The hopped-up, Deco-inflected mode of design practiced at the Politecnico, all portholes, roof-piercing slab-walls, and cantilevered pulpits in the sky, looked in hindsight like the perfect stylistic expression of a regime modernizing its nation by main force. But as Steinberg saw, the style had hardly died with Mussolini. It lived on, sobered up, in the roadside architecture that greeted him on his American rambles. He found it in motels, their signage geared to the attention-span of eyes passing at 90 mph (fig. 56, p. 57) and in razor-edged, klieg-lit diners and gas stations out on the plains. Steinberg's aptitude

for rendering the roadside kitsch of America was more than a matter of a foreign caricaturist's eye seizing upon gaucheries. At work, too, was a trained architect's hand, keeping up to date with the fevered strain of modernism from which his talent had sprung.

As Inspectors approach the edifice in *Milanese II*, a shady character, hat tugged down, slumps away, stage front. Several inches tall—the largest creature in Steinberg's rubber-stamp corps—the man originated as a jaywalker in a Bucharest postcard (fig. 88, p. 79).[158] Perhaps, making a furtive escape from the scene of design, he is the artist himself, who expressed relief in retrospect that none of his student projects had ever been built. In a captioned drawing, he recalled stopping in Ethiopia on a round-the-world journey in 1963–64. In Asmara, he had encountered "the architect's nightmare: his student projects built in concrete . . . more or less our own student works, Milanese or Neapolitan Bauhaus built during the Italian occupation of Ethiopia."

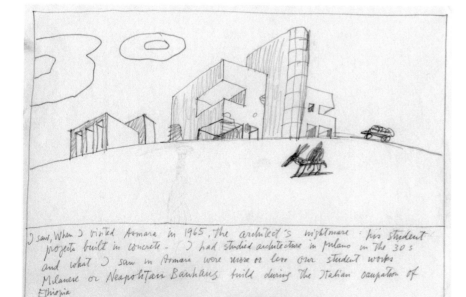

Ex-voto drawing, c. 1983. Pencil on paper, 11 x 14 in. (27.9 x 35.6 cm). YCAL 3343.

Greyhound Lines Bus depot,
Jackson, Mississippi, 1940s.
Postcard, c. 1950, from Steinberg's
collection. YCAL.

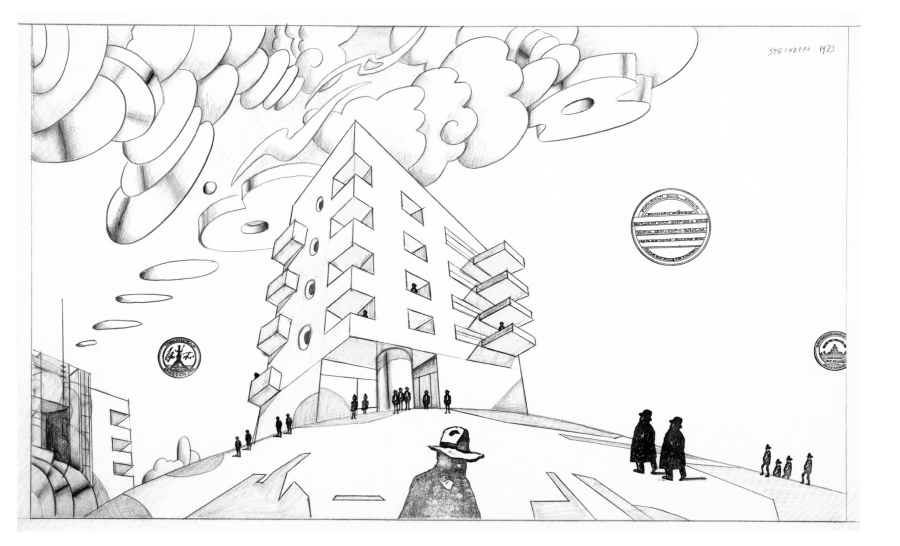

The Politecnico Table

1974
Mixed media assemblage on wood, 28¼ x 23¼ in. (71.8 x 59.1 cm)
Collection of Richard and Ronay Menschel

By 1971, Steinberg had begun replicating the common objects in his studio at 1:1 scale, in three dimensions—casual trompe-l'oeil sculptures created by (his word) "whittling," assembling, and painting simulacra of the objects all around him. His subjects included the tools of his trade (pencils, pens, erasers, brushes, T-squares, triangles, and rulers), as well as other desktop paraphernalia such as a pocket calendar, a key ring, even a plate of sliced halvah. The point of this strange mimetic game went beyond visual resemblance to invoke some more primal form of imitative magic. Once, handing a studio visitor one of his pink wooden "erasers," Steinberg pointed out that even with respect to weight, it uncannily resembled its original.[159]

Some of these works he offered as gifts, giving "cameras" to photographer friends, for example.[160] Others he incorporated into "drawing table" assemblages such as the *Politecnico*, which recreate the ordinariness and the mystery of the miniature stage upon which the world of his art daily came to life before him. The performers here include three simulated old photographs (quick-brushed Duco varnish on smooth paper), two receipt books (slabs of plywood, scored in pencil on the edges to imitate sandwiched sheets of carbon paper), a pen, a ruler, two pencils, and a printing plate engraved with a Bauhaus-style structure. The ghostly scene at the center, in which rubber-stamp figures face a seemingly empty landscape, might represent art as an artist most often sees it on his table: in a state of delicious *non finito*, awaiting completion by his hand.

Dog tag, c. 1988. String and metal, 1½ x 2¼ in. (3.8 x 5.7 cm). SSF 5674.

1971 Datebook, 1971. Mixed media on wood, 4⅛ x 2⅝ x ¼ in. (10.5 x 6.7 x .6 cm). SSF 6189.

Camera, 1974. Mixed media on wood block, 5⅛ x 3½ x 1⅛ in. (13 x 8.9 x 2.9 cm). SSF 5996.

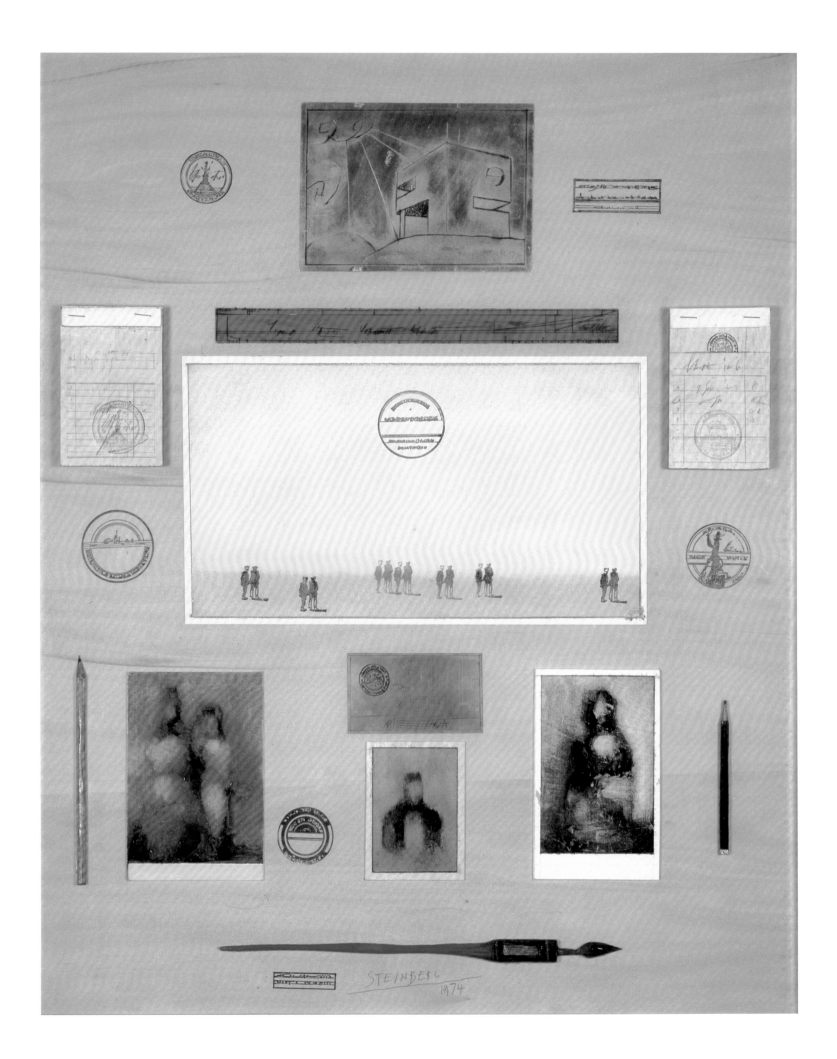

STEINBERG
1974

Breakfast Still Life

c. 1974

Pencil and colored pencil on paper, 23⅛ x 14⅞ in. (58.7 x 37.8 cm)

The Saul Steinberg Foundation, New York, SSF 4777

Periodically, Steinberg turned close attention to sketching in full color *dal vero* ("from life"—literally, "from the truth").[161] Such work combined pure research with sensory recreation, a break from what he called the "calisthenics" of cartoon or idea-drawing work.[162] In 1973, he had made additions to his house and studio in Amagansett, and in the following year he drew many light-drenched arrangements on a table facing the glass door onto the new deck, overlooking the backyard. *Breakfast Still Life*, elegantly unarranged and unfinished, conveys a sense of openness to possibilities, as when the mind ponders a fresh challenge. Its freshness, and its vertical format, recommend it as a precursor to four variants *The New Yorker* went on to publish as covers between 1976 and 1983.[163]

The clear light comes at us—through the glass of water, for example—at the oblique and ever-changing angles of direct morning sun, effecting a greater urgency than any deadline imposes.

The Empire State Building thermometer and Eiffel Tower souvenir at left were recurring players in Steinberg's tabletop theater, along with a pyramid, a Statue of Liberty, and a leaning tower of Pisa.[164] If they are muses of architecture, it is not the capitalized Architecture of a member of the profession. They are apt icons, rather, of architecture as a perspective on (and amid) the stuff of everyday experience: reminders that life as one knows it is a product of small acts of observation, rearrangement, and design.

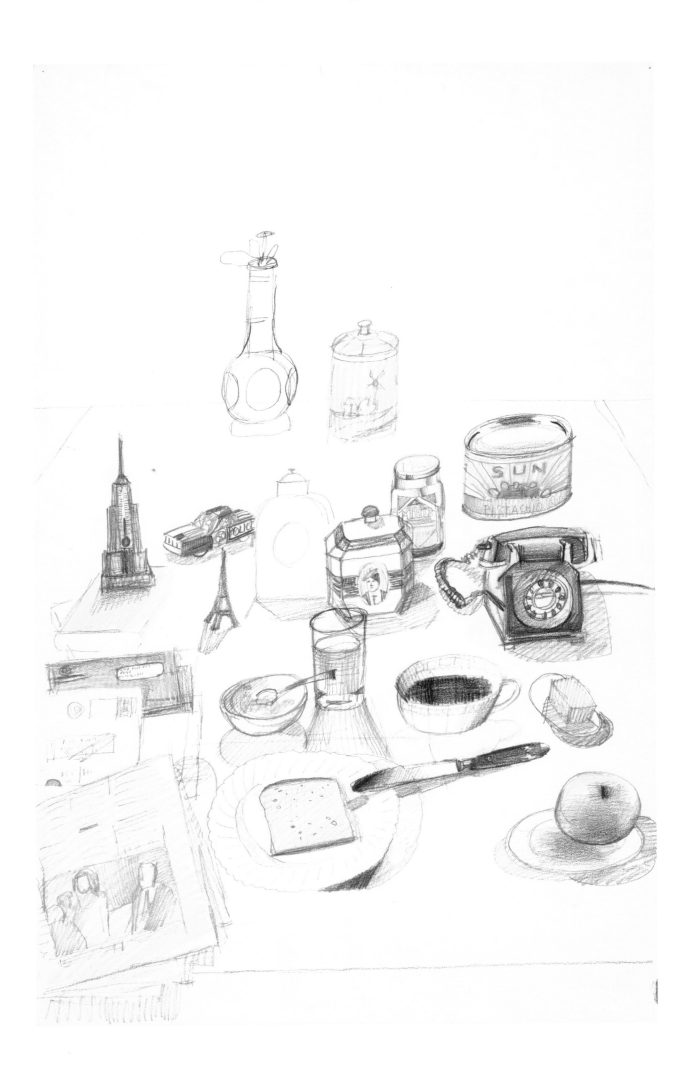

Dal Vero (Sigrid and Papoose), September 10, 1979

1979
Pencil and colored pencil on paper, 14 x 17 in. (35.6 x 43.2 cm)
The Saul Steinberg Foundation, New York, SSF 4202

The year 1979–80 was as busy a time for Steinberg's *dal vero* portraits as 1974 had been for still life. In a September 1979 sketch, Sigrid Spaeth sits at the table where Steinberg had drawn his unfinished breakfast a few years before. Behind her is the black cat, Papoose, who functions as an informal timepiece within many of the Amagansett portraits, showing up in two or three locations as he moves around the room.[165]

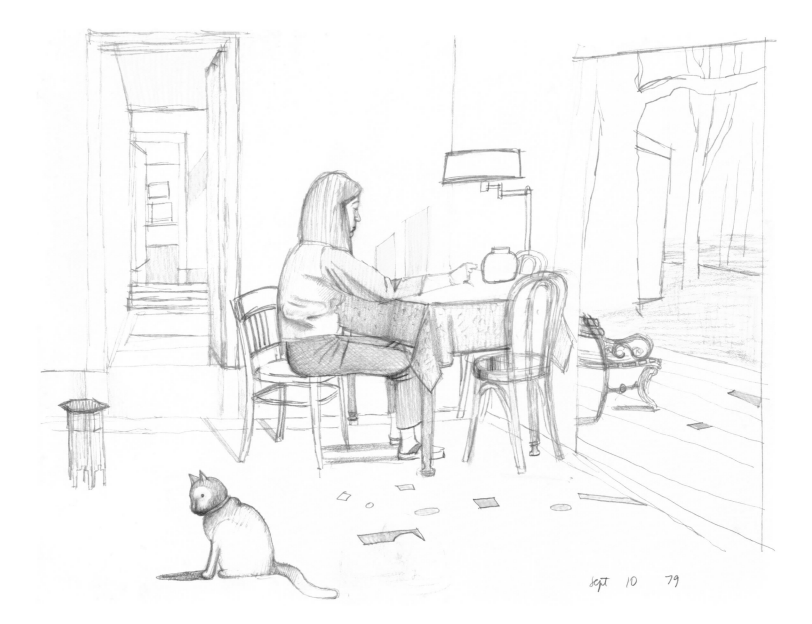

Untitled (Energy, Part 3)

1975
Ink over pencil on paper, 14½ x 23 in. (36.8 x 58.4 cm)
The Saul Steinberg Foundation, New York, SSF 699
Published: *The New Yorker*, February 16, 1976, p. 64.

This drawing appeared in *The New Yorker* with the third, closing chapter of Barry Commoner's series of articles on the energy crisis. Each installment was accompanied by a progressively more complex Steinberg drawing of a scene doubled by its reflection in water.[166] Reflection and symmetry, especially as translated into the spatially ambiguous language of line, were topics of long-enduring interest and comic possibility for the artist (fig. 2, p. 21).[167] Only recently, however, he had been struck by reading

Pascal's observation that whereas horizontal (left-right) symmetry is the general rule in animals and plants (and, Steinberg added, in architecture), "in nature at large, which is the scene of life, the nature of the earth and sky, there exists only a vertical symmetry, produced by water, nature's mirror."[168] A remarkable footnote to this rule is the 360-degree symmetry of heavenly bodies like the sun—ultimate source of all earthly energy, and the asterisk-like central figure in this vibrant scene.

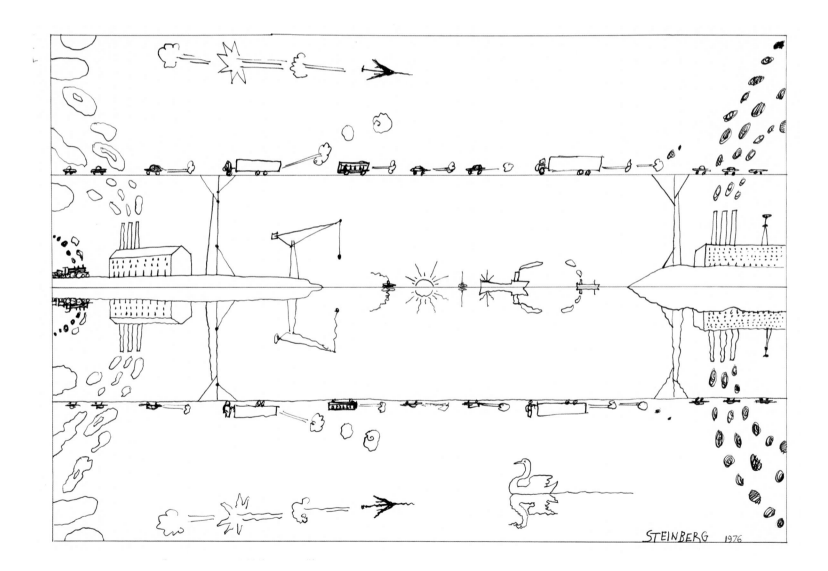

75
The West Side

1973
Ink and colored pencil on paper, 19 x 25 in. (48.3 x 63.5 cm)
The Saul Steinberg Foundation, New York, SSF 6506

76
View of the World from 9th Avenue

1976
Ink, pencil, colored pencil, and watercolor on paper, 28 x 19 in. (71.1 x 48.3 cm)
Private collection, New York
Published: *The New Yorker*, March 29, 1976, cover; Loria 1995, no. 23.

76A
View of the World from 9th Avenue

1975
Ink, wax crayon, and graphite on paper, 20 x 15 in. (50.8 x 38.1 cm)
Collection of Sivia Loria
Published: WMAA 1978, p. 79; Loria 1995, no. 21
Variant of cat. 76. Reproduced on p. 62.

In 1973, Steinberg ventured a first version of the idea which his most famous image would render immortal—or, at least, inescapable for the rest of his life. His initial drawing, titled *The West Side*, describes the continental United States as a sprawling outer-borough neighborhood beyond the range of cab service—more or less the Manhattanite's view. The decisive shift separating this first draft from its celebrated descendant is, of course, Steinberg's reversal of perspective, to that of a New Yorker facing west. That inspiration is foreshadowed, if subtly, by the Manhattan-centric orientation of the country's name and of most other place names on the map, from Nebraska (lower left, bordering the Yukon) to Honolulu, just visible on the far southeastern horizon (top right), out beyond southern Africa.

View of the World from 9th Avenue is a two-part invention, split at the middle by the Hudson River. The bottom of the image and the top speak in two different graphic languages. In the foreground—on the river's near bank—is a naturalistic view looking over the mundane western reaches of Manhattan's midtown. On the far side of the Hudson is an extremely schematized map of the world from New Jersey west, which is seen as though laid out on a tabletop, from the perspective of someone looking across the table. The image as a whole is lent visual logic by the fact that the city scene lies on a common ground plane with the map across the river. If *View of the World* prompts quick laughter, it is because one's

mind immediately perceives (even as the eye overlooks) the logical disconnect between view and map, and the dual mindsets they represent—a keen physical awareness of one's immediate environment and an airy abstraction about the outlying world.

Though couched in terms of New York, this drawing takes as its real subject a fundament of psychogeography. Try mapping in your mind a place you know well—the block you live on, say—and you are sure to envision it three-dimensionally and in detail—a living place seen by daylight, in terms more like a bird's-eye view than a flatland map. But beyond a certain distance from the ground zero of the self, this sensory space (where sidewalks have breadth, manhole covers give off steam, and cars move in the streets) gives way to abstract cartographic space (take Route 206 to the Interstate). Moving outward, the mind's map grows vaguer as its ignorance expands. Steinberg's succinct diagramming of this universal condition helps explain why, since appearing on the cover of *The New Yorker* in March 1976, *View of the World* has spawned innumerable imitations, custom-cribbed to fit locales on every continent and repurposed to commercial needs from winery souvenir mug to right-wing editorial cartoon to self-help mandala.[169]

The graphic ancestry of *The West Side* and *View of the World* can be traced back to a drawing Steinberg made in 1966, focused not on the egotism of New York but on the otherworldliness of Los Angeles (fig. 76, p. 70). Steinberg

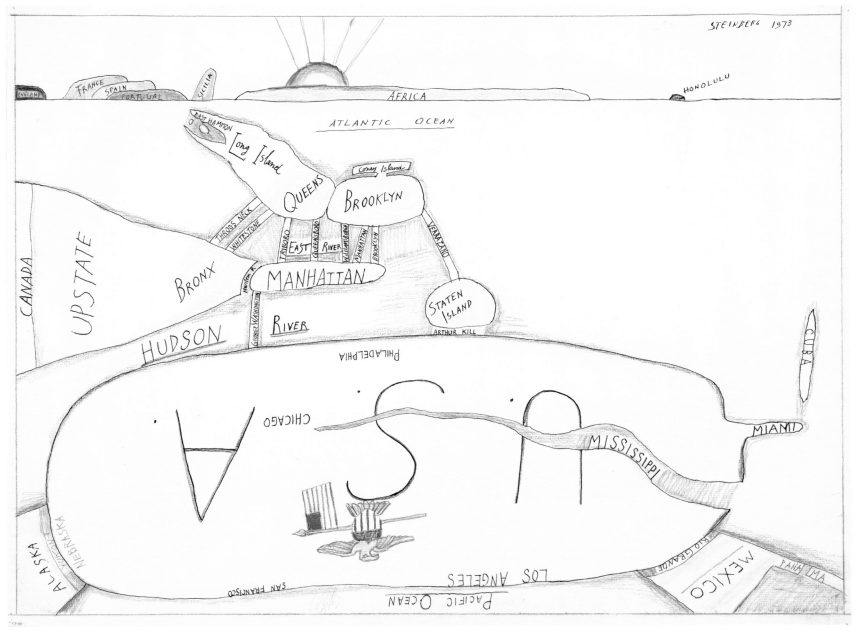

might have known, as well, an older precedent in graphic imagery of New York. John Bachman's popular, though non-comic, 1859 aerial view north from the tip of the Battery literalized the notion of Manhattan as a central, world-class continent, an effect achieved by combining a bird's-eye view with "fish-eye" perspective, which exaggerates the curvature of the earth and thus pushes Long Island, Paterson, and the Bronx to the horizon.[170]

Equally germane is the popular tradition of novelty maps—often issued as postcards—in which the whole country, or world, is envisioned as the outlying suburb of a star locality. One such map, which Daniel Wallingford

published in repeated updates throughout the 1930s, represented "A New Yorker's Idea of the United States of America."[171] This New Yorker's sense of geography is comical insofar as it is muddle-headed, locating the city of Pennsylvania in the state of Philadelphia and so on. Steinberg's New Yorker might be a little fuzzy on the details regarding the layout of the provinces, but his mental map is funny precisely because it is, for all its crudeness, accurate. After you cross through Jersey, Mexico's going to be on your left, Canada on your right. Japan? Keep going, straight; you can't miss it.

John Bachman (publisher), *New York & Environs*, 1859. Lithograph. Museum of the City of New York; Gift of James Duane Taylor, 31.24.

Daniel Wallingford, *A New Yorker's Idea of the United States of America*, c. 1939 version. University of Arizona, Tucson; Main Library, Map Collection.

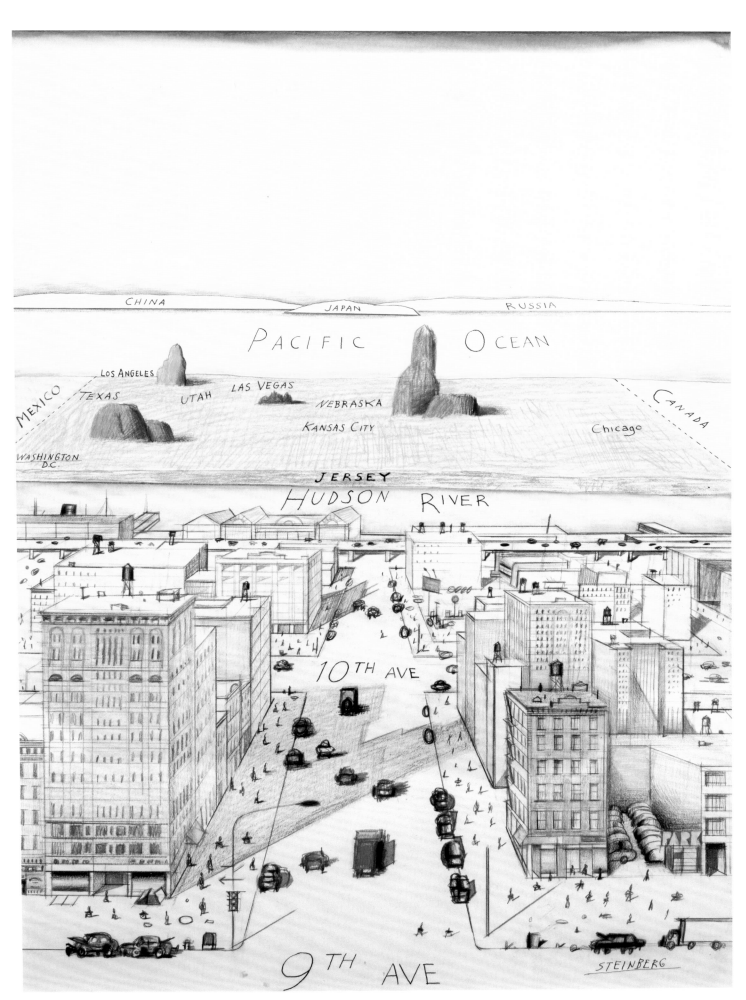

77

Papantla (Veracruz), Mexico

1977
Colored pencil and pencil on paper, 14¼ x 20½ in. (36.2 x 52.1 cm)
The Saul Steinberg Foundation, New York, SSF 6266
Published: "Postcards," *The New Yorker*, February 25, 1980, p. 39.

78

Manassas, Virginia

1978
Pencil, colored pencil, and marker pens on paper, 22¾ x 28¾ in. (57.8 x 73 cm)
Collection of Carol and Douglas Cohen
Published: *Steinberg: Still Life and Architecture*, exh. cat. (New York: The Pace Gallery, 1982), n.p.; *The Discovery of America*, p. 65.

After what he called the "Battle of Austerlitz" effort of assembling his 1978 Whitney Museum retrospective, Steinberg avoided the inertia of self-congratulation by pushing himself into new genres of work.[172] His contributions to *The New Yorker*—neglected for a few seasons—came back in a big way. He now drew almost exclusively covers and portfolios of half-page drawings—all rendered in color, even though features on the magazine's inside pages would continue to be printed in black-and-white until 1989.

Papantla (Veracruz) Mexico figured in the second of two *New Yorker* portfolios titled "Postcards," in which Steinberg dug through his lifetime of travels. He and Sigrid had visited Veracruz in 1968 for an intensive round of visits to archaeological sites.[173] Just as in an earlier stint as guest artist for NASA, when rocketry had turned out to interest him less than "the honky-tonks

around Cape Canaveral,"[174] Steinberg appears not to have drawn any main attractions such as the Pyramid of the Niches, outside Papantla. Still, at the center of this unprepossessing view, sandwiched between a sky full of wires and a rutted mud hillside, a stepped pyramid hides—demoted to a job as statuary base beneath a gesticulating local worthy.

Likewise, despite the somber resonance of the name "Manassas," Steinberg finds all trace of the Civil War battle long gone, trod under cookie-cutter architecture, toy traffic, and a sky full of clouds churned from a draftsman's stencil. This is, twenty years on, the cartoon world the American highway invented (cat. 39). Here all is "new," in the strictly technical sense that it lacks history, and yet everything is a stillborn cliché—clone of countless siblings up and down the road.

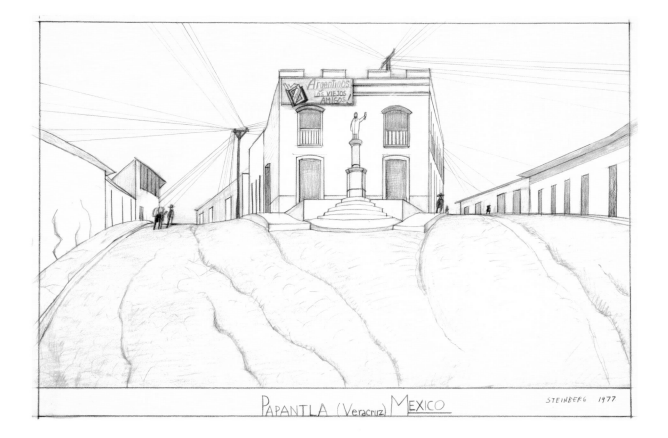

PAPANTLA (Veracruz) MEXICO STEINBERG 1977

MANASSAS VIRGINIA STEINBERG 1978

The American Corrida

c. 1981

Colored pencil and pencil on two sheets of paper, 21 x 16⅞ in. (53.3 x 42.9 cm)
The Saul Steinberg Foundation, New York, SSF 4184
Study for *The New Yorker*, November 30, 1992, cover.

For all his fascination with popular spectacle, not a single line on football or basketball comes down from Steinberg, who was averse to the sight of physical strain.[175] Nor did he draw either of those mainstays of *New Yorker* cartooning, golf and tennis. His idea of an absorbing sport was one long on ritual (horse racing), calculation (billiards), or better yet, both (baccarat). Then, on a higher level, there was the pageantry of national pastimes. He remarked that to understand the American character meant understanding baseball, "a philosophical sport, very silent most of the time," grounded in statistics and specialized role-playing.[176] In *The American Corrida*, baseball's Latin analogue, the bullfight, comes into service as a darker allegory for American history as bloodsport, with Uncle Sam as matador, his quarry a feathered Indian.[177]

The drawing, on two joined sheets of sketchpad paper, is the first conception of what would become, in 1992, Steinberg's second Thanksgiving cover for *The New Yorker*. (The figures in the stands, representing Easter, Halloween, and other holidays, are leftovers from his first, 1976 Thanksgiving cover, in which they sat at table waiting for dinner.[178]) Two other sketches dated 1981

show that the Indian was soon replaced by the turkey of the final design—clarifying the holiday reference, if at the cost of political punch.[179]

As originally conceived, *The American Corrida* draws upon two kinds of precedent, one found in older American editorial art and the other in Steinberg's own sketchwork. First, his commentary on the martyrdom of the Indians simply reverses the sentiment of Gilded Age patriotic imagery, such as an 1887 celebration of the Constitution's centennial, which equated a vanquished Red Man (below, center; lower left corner) with the health of the Republic. (Twenty years earlier, just after the Civil War, a Yankee artist would have paired the cringing Mohawk with a downcast soldier of the Confederacy.) Second, in using the ritualized scenario of a sport to diagram other conflicts, *The American Corrida* looks back to an unpublished 1954 series of baseball studies. There, by penciling in infield lines, a pitcher's mound, and home plate, Steinberg translated such showdowns as the Old West barroom shootout into the archetypal relations among pitcher and batter, catcher and umpire, first baseman and base runner.[180]

The New Yorker cover, November 30, 1992.

J. Keppler, "Our Constitution's Centennial," spread in *Puck*, July 1887.

Untitled (Baseball Showdown), c. 1954. Ink and pencil on paper, 14½ x 23 in. (36.8 x 58.4 cm). SSF 269.

80
November (Long Shadows)

1985
Pencil and crayon on paper, 19½ x 25⅝ in. (49.5 x 65.1 cm)
The Saul Steinberg Foundation, New York, SSF 2245

81
Ocean

1983
Ink, marker pens, colored pencil, ballpoint pen, and crayon on paper, 19⅝ x 25¾ in. (49.8 x 65.4 cm)
The Saul Steinberg Foundation, New York, SSF 4193
Published: *The New Yorker*, August 1, 1983, p. 38.

"Manmade situations" was Steinberg's summary of the territory covered by his art.[181] Nature won his heart on an intimate level each year at his Amagansett house; while there he became an avowed "country man," following seasonal cycles of birds, foliage, flowers, and light. He even tried his hand as a nature poet in *November*, an ode on aging, in which he walks his bicycle through the woods as late afternoon sun throws long shadows down the hill. Behind him, on a more Yeatsian note, the house assumes the form of a giant leonine sphinx. As an artist Steinberg seldom ventured much further than this past the backyard frontier, acknowledging that "[f]or nature and whatever is untouched by people, I use a series of clichés."[182]

In art, nature "untouched by people" finds its ultimate symbol in the face of the sea, a reminder of the Flood, God's willfulness, and the puniness of human priorities. Yet in its very capacity as a symbol, the ocean rejoins the fold of "manmade situations." So Steinberg seems to reflect in the seascapes he drew in 1983, when *The New Yorker* requested images to accompany William Wertenbaker's two articles on maritime law.[183] Here, tiny figures on a beach watch as a cartoon-operatic ocean rehearses its complete catalogue of graphic agitations. The scenario caricatures the stock formula of Claude-Joseph Vernet (1714–1789), painter of innumerable port scenes and seascapes suited to every mood from nocturne to storm-tossed fury. Steinberg might have detected a fellow lover of boilerplate cliché in Vernet, who had got his start in art as an apprentice to his father—a painter of coaches.

Claude-Joseph Vernet, *A Storm on a Mediterranean Coast*, 1767. Oil on canvas, 44½ x 57⅜ in. (113 x 145.7 cm). The J. Paul Getty Museum, Los Angeles, 2002.9.1.

Giacometti's Face

c. 1983
Colored pencil and pencil on paper, 11 x 14 in. (27.9 x 35.6 cm)
The Saul Steinberg Foundation, New York, SSF 3535
Published: IVAM 2002, p. 103.

In 1983, Steinberg revived the captioned-image format he had used three decades earlier in his so-called "ex-voto" drawings (cat. 19)—but with a difference. This time around, the captions were not false handwriting but the real thing. The new ex-votos mark his debut as author-illustrator of his life story. "My idea of the artist, poet, painter, composer, etc., is *the novelist*," he had commented a few years earlier.[184] Now he developed a writing voice that extended his monologue-prone speaking manner, freely blending memories, philosophical commentary, and diaristic observation in the proto-novelistic tradition of "confessions" (his working title for an earlier book of drawings).[185]

Steinberg created dozens of pencil sketches such as this one, which he submitted now and then to *The New Yorker* as "roughs" for a projected portfolio or series.[186] As his sketches multiplied, they built a momentum of their own, reaching into dimensions of his experience from childhood sense-memories to evocations, as here, of friends long gone, to more traditional ex-votos, in which he committed to paper dangers he had survived. Despite the immediate and ongoing enthusiasm of the editors, it was not until 1994 that Steinberg okayed for publication a group of seven completed drawings, which by then could be printed in color.[187]

Ex Voto, Monday, August 3, 5 pm, 1992. Colored pencil. YCAL sketchbook 3140.

Giacometti's face was rough creased by deep lines horizontal vertical
and diagonal - The color was often unhealthy.
The hairdo was exploding steel wool. In repose he looked angry.
 But when he liked something a smile of infinite kindness illuminated
and transformed his face
(He had also a unexpected ressemblance to Colette)

Broadway

1986

Ink, pencil, and collage on paper, 14½ x 23 in. (36.8 x 58.4 cm)

The Saul Steinberg Foundation, New York, SSF 6466

Published: *The New Yorker*, October 27, 1986, p. 45; *The New York Times*, October 24, 1992, p. 23; *The Discovery of America*, p. 200.

The hyperbole of theater posters is translated into architectural straight talk in one of four cartoons Steinberg published in *The New Yorker* in late 1986.[188] These marked his final essays in the single-frame comic drawing, which had long ceased to be his usual idiom; during the preceding decade, along with some seventy pages of thematic portfolios, he had published only eight cartoons.

In the 1990s, *The New Yorker* would publish two Steinberg covers in which letters figure as buildings in a city block. One of them, in which the block spells HERE and a passing taxi is NOW, appeared as a tribute to the artist just after his death in May 1999. The cover reproduction had to be made from a color photocopy on file, the original art having been returned to Steinberg. After it had come back to him, he altered the skyline by adding a prominent rooftop sign emblazoned DIE, partner to the store called DO.

Here and Now, 1981, altered after submission in the 1990s (drawing for *The New Yorker* cover, May 24, 1999). Pencil, colored pencil, and collage on paper, 14 x 11 in. (35.6 x 27.9 cm). Collection of Ian Frazier and Jacqueline Carey.

Library

1986–87
Pencil and mixed media on wood assemblage, 68½ x 31 x 23 in. (174 x 78.7 x 58.4 cm)
Collection of Carol and Douglas Cohen
Published: *Saul Steinberg: Recent Work*, exh. cat. (New York: The Pace Gallery, 1987), pp. 32–33.

Steinberg once had a carpenter cut out a few dozen doll-scale wooden chairs, wardrobes, beds, and tables from blocks of wood. He arranged them in tidy rows on a slab and dubbed the assemblage *Furniture as Biography.*[189] In its literalism and its muteness, the piece (later disassembled) subtly mocked the biographer's conceit of "documenting" a life—of understanding a man through his inventory of physical effects.

Library takes the absurd premise of *Furniture as Biography* to more serious, more mysterious ends. A minimal carpenter's sketch of a desk supports an accumulation of small lumber—book-shaped blocks bearing titles, authors, and cover art in pen and pencil. The selection of titles adds up to no boiled-down canon of anything, except Steinberg's idiosyncrasy. One sees, in cross-section, the gentle chaos of a lifetime's book-gathering—library as biography. (*Library*'s inventory, along with an assortment of Steinberg's many other book-sculptures, appears on pp. 218–19.)

Some of Steinberg's perpetual rereads are here (Tolstoy, Herzen, Flaubert, Saint-Simon), along with traces of his youth (Dostoevsky and Verne in Romanian translation, Kipling and London in Italian, the 1939

Larousse), cherished offbeat classics (Norman Douglas' *Old Calabria*, Aleksandr Kuprin's prostitution exposé *The Pit*, Richard Hughes' *In Hazard*), some books by real-life friends (Aldo Buzzi, Ennio Flaiano), and a few fetish-objects, such as the thin local telephone directories Steinberg brought home from his travels.

The Oxford, Mississippi, phone book—a kind of spy's concordance to Faulkner country—is a key to the imaginative spirit of *Library* as a whole. A library (like a work of art) represents an objectified version of the mind/body problem, a place where the world of real things shades into the virtual world of consciousness—just the kind of un/real place from which you might put in a phone call to the Snopes or Compson household. In a library, as in the mind, Harold Rosenberg can sit down next to Stendhal, Buber's mystic theology converse with the comics. But the magical quality of reading, which makes a book so much more than just another object, is undone by the raw physicality of *Library*. Here books are literally just so many chunks of tree—including a copy of *Carpentry & Cabinet Making* by the aptly named W.M. Oakwood.

Furniture as Biography (Grand Hotel), 1986. Wood assemblage with crayon and pencil, 42 x 42 x 31 in. (106.7 x 106.7 x 78.7 cm). Disassembled.

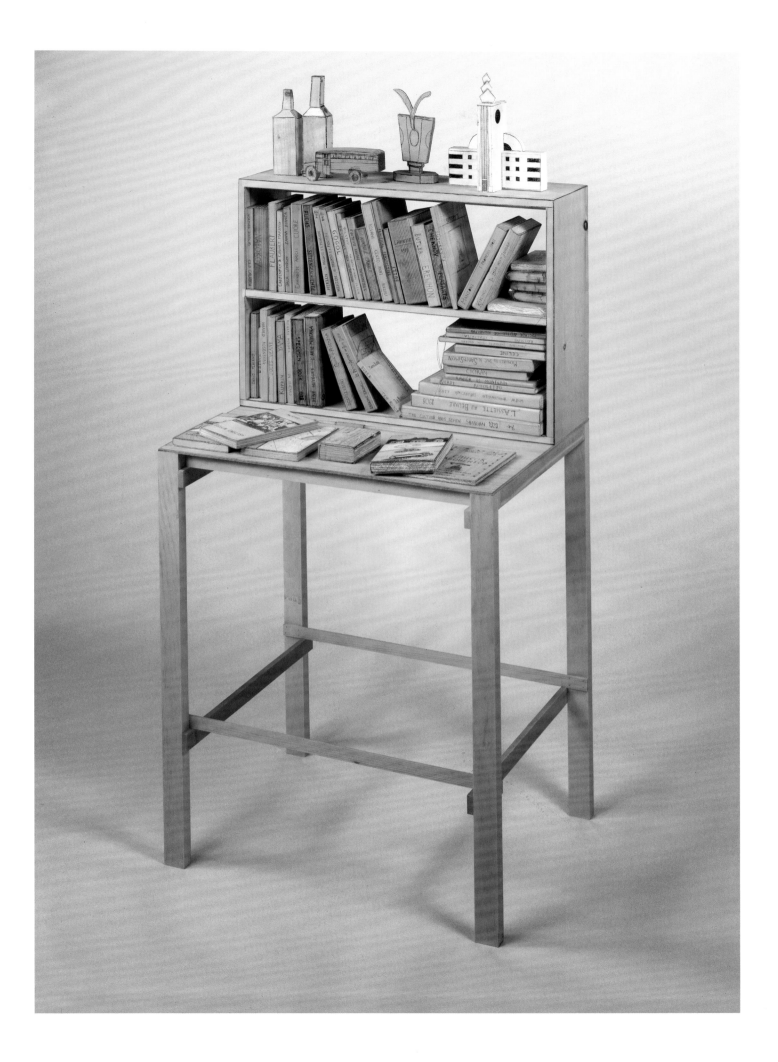

Books in *Library*

L'Assiette au Beurre, 1908

The Culture Arts Review, Shanghai, 1929

Johnson City, Tennessee Directory, 1911

Larousse 1939

Oxford, Mississippi Telephone Directory,
 November 1954

Practical Perspective 1933

РУССКОЕ ДЕРЕВЯННОЕ ЗОДЧЕСТВО
 (Russian Wooden Buildings)

САМАРКАНДСКАЯ ГОРОДАЯ
 ТЕЛЕФОННАЯ СТАНЦИЯ.
 СПИСОК АБОНЕНТОВ
 (Samarkand telephone directory
 1954)

Scott, *19th Century International Album*

Sotheby's, *Postage Stamps of the World
Specimen Book*, 1928

Edmondo de Amicis, *Cuore*

Bébèl-Jislè, *Kèk Prinsip Pou Ékri
 Kréyòl* (Creole grammar)

Buber, *Ten Rungs*

Butler, *Erewhon*

Buzzi, [*Piccolo Diario Americano*]

Erskine Caldwell, *Le Petit Arpent du Bon
 Dieu*

Celine

Chekhov, *Peasants*

Cioran

Daniel Defoe, *Robinson Crusoe*

Dostoievschi, *Crima si Pedeapsa*

Dubufe J. [Jean Dubuffet], *Ler Dla
 Canpane*

Norman Douglas, *Old Calabria*

Ennio Flaiano

Flaubert

Anatole France

Fuchs, *Sittengeschichte*

Gogol, *Nose*

Herzen, *Il Passato e I Pensieri*, vols. I
 and II

Richard Hughes, *In Hazard*

René Huygues, *L'Arte Moderna*

Kipling, *Il Libro della Jungla*

Kuprin, *YAMA*

D.H. Lawrence, *Sea and Sardinia*

Jack London, *Zanna Bianca*

Manzoni, *I Promessi Sposi*

Xavier de Montepin

Murphy, *Pidgin English*

Nabokov

W.M. Oakwood, *Carpentry & Cabinet
 Making*

Ovid, *Tristia*

Harold Rosenberg, *The Tradition of
 the New*

Rossini, *L'Italiana in Algeri*

Rovani, *Cento Anni*

Mémoires du Duc de Saint-Simon

Stendhal, *Vie de Henry Brulard*

Italo Svevo, *La Coscienza di Zeno*

Suetonius

[Swift], *Guliver* [*sic*]

Tacitus

Tolstoy, *The Death of Ivan Ilich*

Verdi, *Rigoletto*

Jules Verne, *Insula Misterioasa*

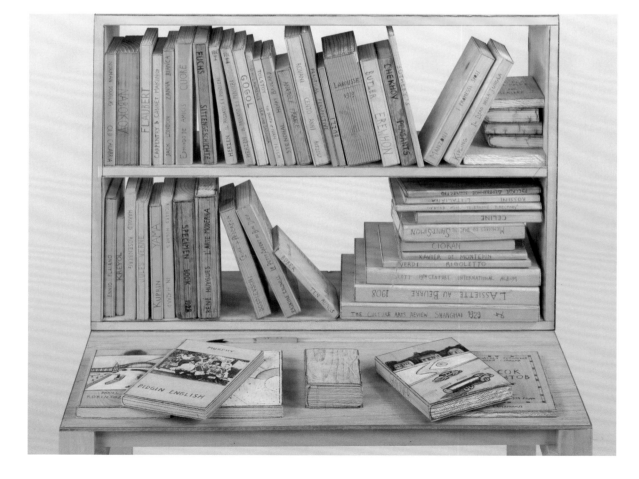

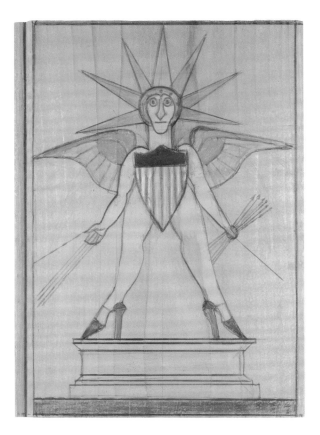

Liberty as Struwwelpeter, c. 1980. Mixed media on board, 9¾ x 7 x ⅝ in. (24.7 x 17.8 x 1.6 cm). SSF 5654.

Isaiah Berlin, c. 1988. Mixed media on wood, 6¾ x 4⅞ x 1⅛ in. (17.1 x 12.4 x 2.9 cm). SSF 6050.

Open book (Le ravisseur de la Jaconde and figures in a landscape), c. 1990. Mixed media on wood, 12⅞ x 5½ x ½ in. (32.7 x 14 x 1.3 cm). SSF 6055.

85
Untitled (Headlights)

1988
Pencil, watercolor, and colored pencil on paper, 18½ x 24 in. (47 x 61 cm)
The Saul Steinberg Foundation, New York, SSF 2239
Published: *The Discovery of America*, p. 181.

86
Untitled (Streetscape)

late 1980s
Black pencil and pencil on paper, 23 x 29 in. (58.4 x 73.7 cm)
The Saul Steinberg Foundation, New York, SSF 4832

In 1950, Steinberg had been invited to Hollywood to provide the lead character's painting hand in the film *An American in Paris*. Though that plan dissolved after a falling out on the set, he and Sterne stayed on for the summer, long enough to fix in his mind and art the car-window view of Los Angeles.[190] He found the "avant-garde city of parody in architecture . . . difficult to draw, a trap—like portraying clowns."[191] He saw the city again only occasionally until 1981, when he signed on to create prints at the Gemini G.E.L. press there.[192] A new Los Angeles would enter the bones of his work during the 1980s—a pastel-toned, scarily seductive parody of its eastern counterpart, New York (fig. 79, p. 73).

This is the world in *Streetscape*, where fleshy cartoon folk tool around in flimsy-bulbous cars amid pasteboard landscaping. But are we in Los Angeles? The same formula overtook his images of eastern Long Island in these years, as Reagan-era nouveaux riches turned onetime artists' enclaves in the Hamptons into pseudo-opulent mansionlands. *Streetscape* resembles contemporaneous Steinberg drawings featuring palm trees, Mission architecture, and California place names, and sketches titled *Sagaponack*—a town just a few minutes' drive from the artist's Amagansett studio.[193]

In the summer of 1981, a longtime Hamptons neighbor, Lee V. Eastman, asked on behalf of his daughter Linda and her husband, Paul McCartney, whether Steinberg would design a cover for an upcoming album with the working title *Cold Cuts*.[194] A pun took root in the artist's mind but, as seen in *Headlights*, it visually linked cold cuts to the composite surfaces of freeway road cuts, rather than verbally to cuts of music.[195] Another kind of cross-section is also brought to the table here: the light of high beams on the freeway, cross-cutting one another into colorfully refracted arcs.

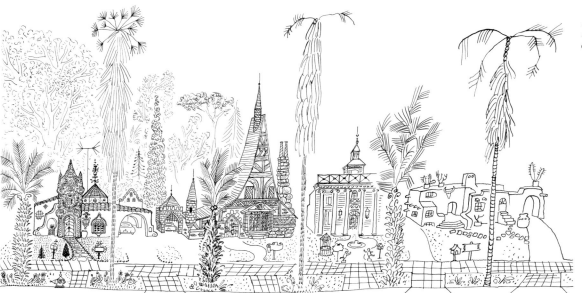

Beverly Hills, 1950. *The Passport*, 1954, p. 215. Original drawing, SSF 1083.

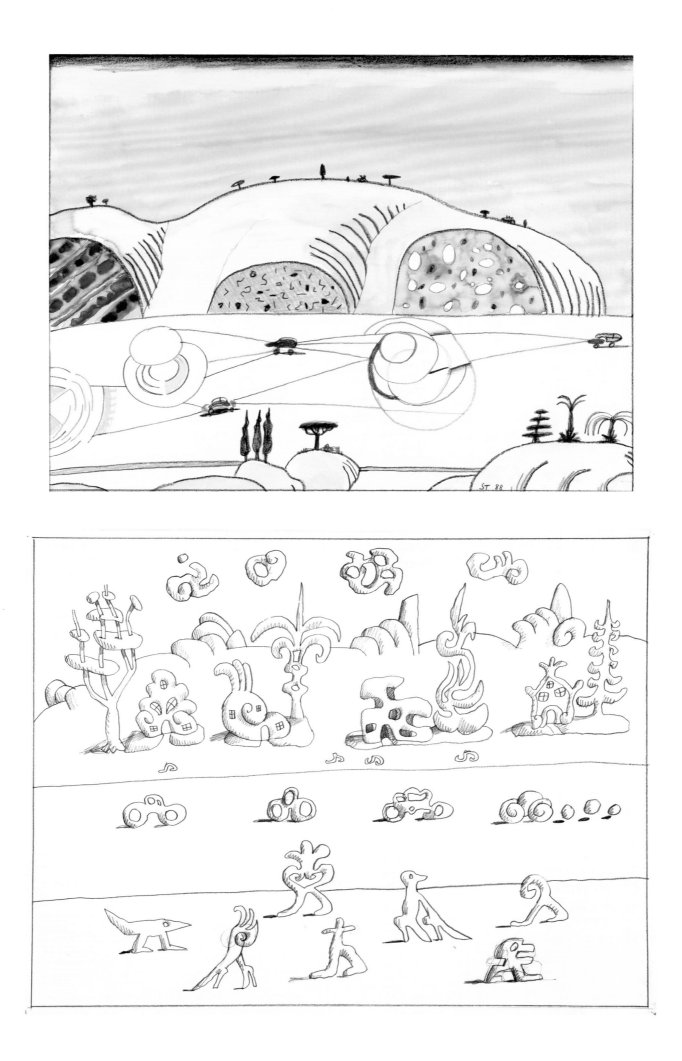

Untitled (Floral Still Life)

1989
Pencil, crayon, and colored pencil on paper, 19⅝ x 26⅞ in. (49.8 x 68.3 cm)
The Saul Steinberg Foundation, New York, SSF 4169

For Steinberg, drawing a still life presented an opportunity to travel through time and space via the senses. Here, a vase of summer wildflowers, a vivid tactile and olfactory presence, hosts two visitors from further afield. At left lies a sketchbook drawing in which a sphinx in a fez guards a pyramid.[196] To the right, selectively edited and colorized by the artist, is one of the hundreds of keepsakes he tacked up on the walls of his house and studio through the years—a photograph portraying his old friend Aldo Buzzi in a bar. Datable to the late 1940s, it was possibly

taken when the friends made a return visit to Il Grillo, the Milan saloon downstairs from the room where Steinberg had lived during their student years.[197] The vase throws turquoise glimmers, rendered as little desert pools, onto the surface of the drawing. Meanwhile, an aromatic theme links the flowers to the photograph: around Aldo's head float advertisements for two citrus-based drinks, the Milanese liqueur Amaro Ramazzotti and Chinotto Recoaro mineral water.

Aldo Buzzi, c. 1948. Photograph, printed 1960s, in Steinberg's papers. YCAL.

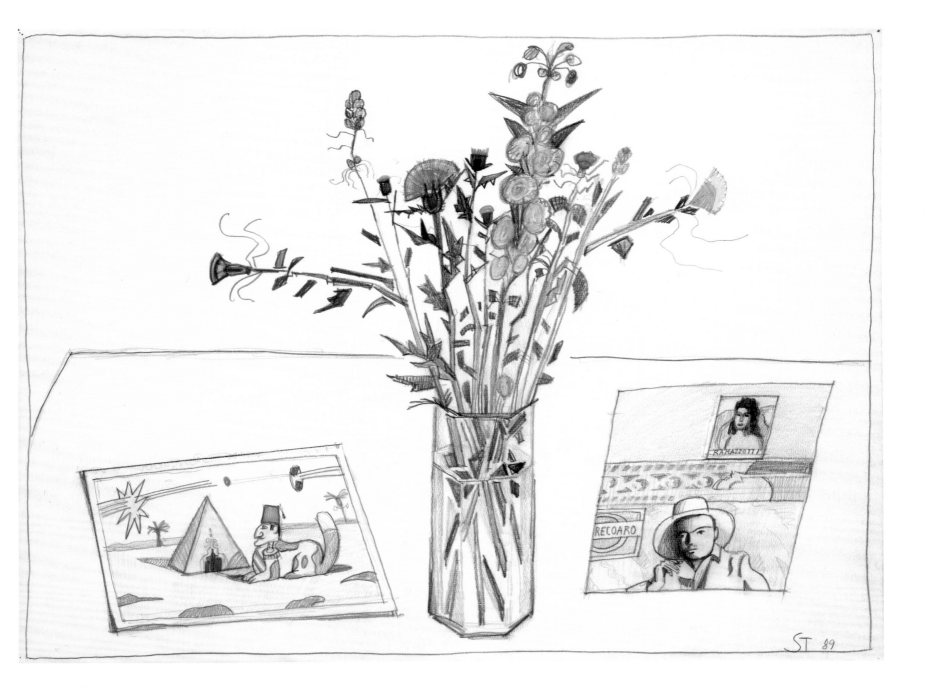

Untitled (Canal Street)

c. 1990
Marker pen on paper, 18 x 23¾ in. (45.7 x 60.3 cm)
The Saul Steinberg Foundation, New York, SSF 2111
Published: IVAM 2002, p. 124.

In his 1990 essay "Canal Street," Ian Frazier brings to life a jam-packed crosstown route where bridge-and-tunnel traffic shoves its way through Manhattan, while Manhattan does all it can to squeeze cash from the traffic before it gets away.[198] In Steinberg's drawings for a collaborative book version of the essay, all is in motion. "Down" lies off all four edges of this sheet of paper; competing vantage points, and laws of gravity, give the eye no purchase.

It looks as if Steinberg, with his artless, eager marker pen, might have just come from mustaching a poster in the subway or scrawling sale prices on a sidewalk bin full of wholesale goods. The leggy creature at the center of this unpublished outtake is a two-legged cousin to the "monopods" he drew in these years—exiles from the crude, vigorous graffiti universe that bloomed on every downtown wall.

Untitled (Two Monopods), c. 1990. Marker pen, colored pencil, and collage on paper, 14 x 11 in. (35.6 x 27.9 cm). YCAL 1765.

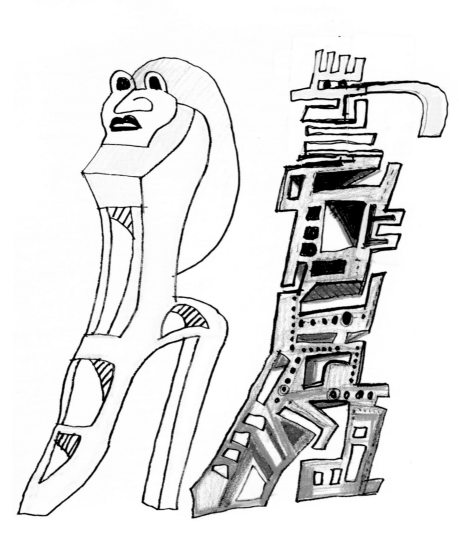

Untitled (The Blue Dog)

c. 1990
Oil pastel and pencil on paper, 17¾ x 23⅞ in. (45.1 x 60.6 cm)
The Saul Steinberg Foundation, New York, SSF 2302

From 1969 until his death—more than half of his career in America—Steinberg published only two features outside the pages of *The New Yorker*. Both appeared in *Grand Street* in the years after 1988, when long-time *New Yorker* editor William Shawn had been fired and the artist kept some distance from the magazine (pp. 73–74). The protagonists of the drawings in "3 Postcards & 9 Dogs," published in the summer 1990 *Grand Street*, have all been elevated from lowly supporting roles in postcards, press images, or real life. One of them, for example, is a corgi from a portrait of Queen Elizabeth; another is Rudy, the sad-eyed hound of Steinberg's friend and neighbor, Tino Nivola.[199] *The Blue Dog*, for its part, might have come

frolicking out of a hunting scene in the work of an Old Master such as Tiepolo or Callot.

The idea of granting these obscure sidekicks dog-stardom in their own right probably arose from Steinberg's travels by magnifying glass through his collection of old gravure postcards, where he met up with many miniature dogs his naked eye had missed (fig. 88, p. 79). In the *Grand Street* feature, photocopy-of-photocopy blowups of his postcard finds are paired with raw oil pastel drawings whose crude texture echoes the blobs and burrs of lo-tech enlargement. Morally, as physically, the series makes something big of littleness, paying tribute to the rough vulnerability of unseen underdogs.

The Flat Earth

1991

Pencil, crayon, and colored pencil on paper, 27 x 35 in. (68.6 x 88.9 cm)

The Saul Steinberg Foundation, New York, SSF 400

Published: *The Discovery of America*, p. 147.

The cosmological map, a favorite Steinberg conceit, renders mental schemas as geographic facts. Here, the parsimonious worldview of the Flat Earther—the epitome of stubborn, simple-minded backwardness—is brought nearer perfection through two fittingly severe innovations. First (the mapmaker commands), let us have no more fancy shapes on the land masses; from now on, nothing but 90-degree corners are allowed. Second, do Asia, Europe, and North America really warrant different floor plans? Let's just assign three southern peninsulas to each one, plus an offshore island (Ceylon, Sicily, and Cuba, respectively), and a niche on the east or west coast—the better to accommodate one of the world's four island nations: Japan, England, New York, and Hollywood.

One of Steinberg's sketchbooks features notes on parody, which he saw as a naturally occurring facet of reality. Among his findings: the nose is a parody of the face; relatives present one with one's "vulgar versions: weak, fat, primitive, despondent"; an architectural style is the enduring self-parody of the period that produced it.[200] These riffs never added up to a full-blown project;

perhaps the artist ultimately concluded that "parody parodied" sounded dangerously like his nightmare—having "dreams about dream analysis."[201] But amid his notes, *The Flat Earth* is foreshadowed in a section headed "Geography as Parody," which displays a crackpot's genius for system:

Europe is duplicated in Asia & America:

ASIA—*Arabia (Spain), India (Italy), Indochina (Greece), Caspian Sea (England) [!], Persia (France), Tibet (Switzerland), China (Germany), Siberia (Russia). Australia plays the part of Africa.*

AMERICA—*Baja (Spain), Central America (Italy), Florida (Greece), Japan (England), Alaska (Scandinavia), Canada & Atlantic Ocean (Russia), Vermont (Czechoslovakia) . . . South America plays the part of Africa.*

91
Delacroix (after Nadar)

1994
Pencil and colored pencil on paper, 14¾ x 13⅛ in. (37.5 x 33.3 cm)
The Saul Steinberg Foundation, New York, SSF 6435

Most of Steinberg's longest, closest attachments were to creative friends whose artistry inspired and enriched his life—and whom, in most cases, he outlived.[202] Each loss grieved him personally and, as his generation passed away, diminished his sense of the world's shared intelligence. In 1993–94, he conjured in his sketchbooks a durable circle of comrades by drawing the early modern writers and artists who were never far from his thoughts: Turgenev, Chekhov, Courbet, Mayakovsky, Van Gogh, and others.[203] The present drawing is after the work of Nadar (Gaspard-Félix Tournachon, 1820–1910), whose photographs conferred immortality on the literary, artistic, and political pantheon of the Second Empire.

After moderate success as a graphic caricaturist, Nadar had found his true calling as a photographer. He worked like an attentive listener, granting each sitter just enough theatrical space to make a dramatic, yet credible, event of himself. Nadar's portraits fascinated Steinberg, who denied any distinction between an artist's work and appearance. "There's always great equivalence between an artist and his work," he asserted; "there is a correspondence between my doings, my looks, my talking, my moving around. . . . And I occasionally see artists who are manqué, who should be something else, because they are not built for what they are doing. Sculptors, especially, should look like sculptors, and often they look like watercolorists."[204] The hardened Napoleonic mien of the sinewy Romantic painter Eugène Delacroix expresses the intensity that yielded canvases full of battle, rapture, and animal frenzy.

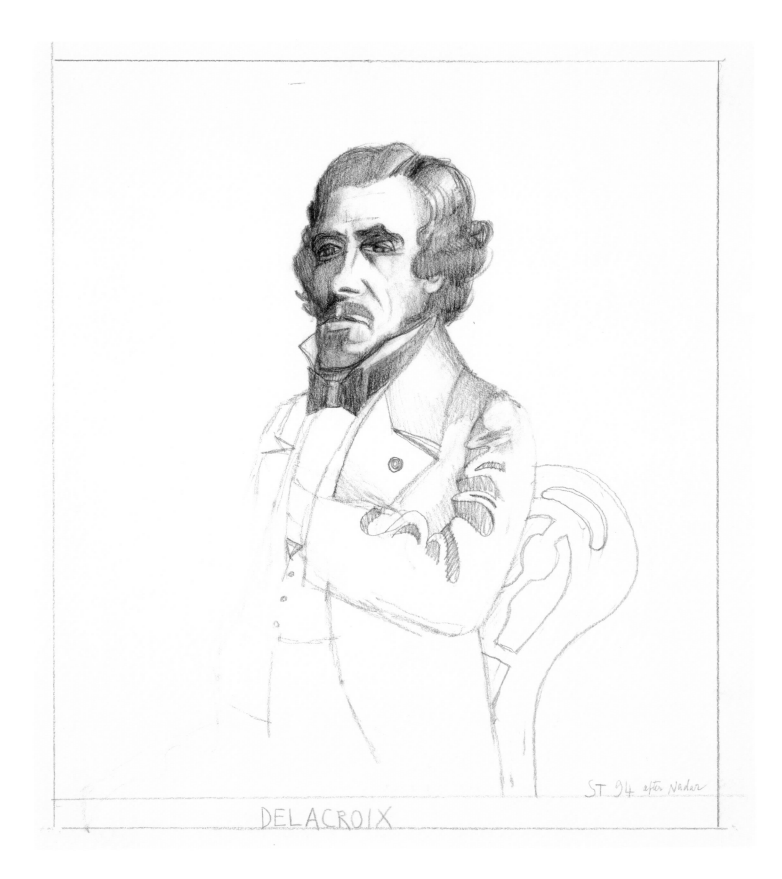

ST 94 *after Nadar*

DELACROIX

2000

1996
Pencil, ink, watercolor, crayon, and collage on paper, 21½ x 14⅛ in. (54.6 x 35.9 cm)
The Saul Steinberg Foundation, New York, SSF 924
Published: *The New Yorker*, January 6, 1997, cover.

Though the British writer Angela Carter remarked as early as 1980 that "the *fin* has come a little early this *siècle*," many citizens of the twentieth century found it impossible to conceive of the close of the millennium—and, as a matter of daily habit, the end of years beginning with "19"—until the change was upon them. Steinberg had made his first sketches pondering the impossible in 1979.[205] At that time, he had visualized the twenty-one years ahead as a broad highway plowing straight ahead to the horizon, annual mile-markers spaced along the way and the monumental "2000" peeking over (as here) from the far side. By the artist's later years, as the horizon grew closer, the final approach began looking dodgier. This *New Yorker* cover drawing for New Year's, 1997, hints at some doubt about whether he was going to make it over the last hill. Born just in time for the onset of the Great War, he died in May 1999—a creature of the short twentieth century. "The news of the world," he remarked in 1990, "makes me think that for many years we've been the victims of an immense prank, which has lasted perhaps since the year of my birth, 1914."[206]

93
Ten Women

1983 and 1996
Color proof, etching on paper, 20⅞ x 29⅝ in. (53 x 75.2 cm)
The Saul Steinberg Foundation, New York, SSF 2691

"These days," Steinberg wrote in 1994, "I think only of etchings, drypoint, aquatint, and even lithographs. The *New Yorker*, the magazines, are finished."[207] Through good and bad times at the magazine, printmaking provided him with a separate means of publishing his work, more intimate and controlled than mass-market printing. This proof in colors of an etching that would finally be printed in black-and-white, thirteen years after it was begun, demonstrates the room for experiment that attracted him to print media. The subject is a survey of feminine types

from the back catalogue of his art, laid out as though for a police lineup or the unspooling filmstrip of memory. They include, in the bottom row, a leggy walker (compare fig. 63, p. 61), a bright-eyed, literally disarmed listener (compare cat. 41), and three variants on the cross-legged sitter (compare cat. 34), including a TV-screen woman (compare fig. 66, p. 63). Directly above her stands a woman whose crown has evolved—as earlier proofs of the print reveal—from a pair of mouse ears (compare fig. 67, p. 64; cat. 62).[208]

94
The Signature

1991
Marker pen, carved and stained wood glued to paper, 20¾ x 29½ in. (52.7 x 74.9 cm)
The Saul Steinberg Foundation, New York, SSF 6439
Published: IVAM 2002, p. 8.

The large form seen here recalls the artist's characteristic "ST" signature abstractly—roughly the way a Franz Kline painting recalls the steam locomotive or factory after which it is named. Glued to the page below the flourish is a whittled approximation of an Asian calligraphy brush, bearing an actual "ST" and the date.

An autograph is, as the word indicates, a self-representation. It is more ideographic than alphabetical: whether it is legible matters less than whether it is recognizably your own, like your voice or thumbprint. *The Signature* is Steinberg's wordless credo, in which writing, self-portrait, and art are one.

Notes

Illuminations, or The Dog in the Postcard

1. Gustave Flaubert to Louise Colet, March 1852. The cited passage is one of several that Steinberg marked in his copy of Herbert Lottman, *Flaubert: A Biography* (Boston: Little, Brown, 1989), p. 108, StL.

2. Among books on the subject in Steinberg's library was one for which he created a jacket of his own design: Émile-A. van Moé, *La Lettre Ornée dans les manuscrits du VIIIe au XIIe siècle* (Paris: Éditions du Chêne, 1943), StL.

3. Steinberg, notes for remarks on the occasion of David Levine's Gold Medal award from the American Academy and Institute of Arts and Letters, courtesy of Prudence Crowther.

4. Quoted in Rosalind Constable, "Saul Steinberg: A Profile," *Art Digest* 28 (February 1, 1954), p. 29.

5. "Who is American? It's a foreigner who came here and said, *tiens!* what a country. Let's go west. That is the tradition of the American. As a matter of fact, this is the tradition of the artist—to become someone else. An artist who doesn't become someone else remains the next-door girl or boy"; Steinberg, quoted in Glueck 1970, p. 117. Steinberg's formula recalls not only Rimbaud's example, but his most famous statement, "Je est un autre." The artist's earliest published images of Rimbaud—as a sun-baked exile surveying his lonely empire—appear in "Monsieur Steinberg's French Notebook," *Harper's Bazaar* 80 (May 15, 1947), p. 85. On Steinberg and Rimbaud, see also cat. 30.

Paul Verlaine's claim that the title *Illuminations* expressed Rimbaud's affinity for cheap popular illustration, in preference to the corrupt aesthetic standards of the official French Academy, could only have encouraged Steinberg's fixation. For Verlaine, see Enid Starkie, *Arthur Rimbaud* (1938; 3rd ed. London: Faber & Faber, 1961), p. 214. Another author associates the title with "the brightly colored cheap popular prints or '*images d'Epinal*' of the period, which [Rimbaud] lists in *Alchimie du Verbe* among the things that delighted him at the time when he 'held in derision the celebrities of modern painting and poetry'"; Louise Varèse, introduction to Arthur Rimbaud, *Illuminations* (New York: New Directions, 1957), p. xi.

6. The note appears in YCAL sketchbook 3178 (1987–90).

7. See Smith 2005.

8. Quoted in Robert Long, *De Kooning's Bicycle: Artists and Writers in the Hamptons* (New York: Farrar, Straus and Giroux, 2005), p. 198.

9. Two alternatives to "museum art" surveys deserve mention here. Tom Phillips, *The Postcard Century: 2000 Cards and Their Messages* (London: Thames and Hudson, 2000), though Steinberg did not live to see it, is a cross-grain history of modernism as well as a monumental apologia for his main collecting focus; see cats. 54, 77, 78. Steinberg did know and treasure Eduard Fuchs, *Illustrierte Sinngeschichte vom Mittelalter bis zum Gegenwart*, 6 vols. (Munich: Langen, 1909–12), which uses a status-blind array of art and craft to explore the history of everyday life; see cat. 84, p. 218.

10. Iain Topliss made the same point in his recent book, *The Comic Worlds of Peter Arno, William Steig, Charles Addams, and Saul Steinberg* (Baltimore and London: The Johns Hopkins University Press, 2005), p. 181 and note 5. The few minor exceptions to the rule include Peter Selz, *Art in Our Times: A Pictorial History, 1890–1980* (New York: Harry N. Abrams, 1980). Steinberg's work makes a small appearance in Kirk Varnedoe and Adam Gopnik, *High & Low: Modern Art and Popular Culture*, exh. cat. (New York: The Museum of Modern Art, 1990) but none in Kassandra Nakas et al., *Funny Cuts: Cartoons and Comics in Contemporary Art*, exh. cat. (Stuttgart: Staatsgalerie Stuttgart, 2004) or in John Karlin, Paul Karasik, and Brian Walker, eds., *Masters of American Comics*, exh. cat. (Los Angeles: UCLA Hammer Museum and The Museum of Contemporary Art, 2005).

11. Steinberg and other immigrants from southern Europe, having been oppressed by the wrong dictator, unfortunately did not qualify for inclusion in Stephanie Barron with Sabine Eckmann, eds., *Exiles and Emigrés: The Flight of European Artists from Hitler*, exh. cat. (Los Angeles: Los Angeles County Museum of Art, 1997).

12. See Brooke Kamin Rapaport and Kevin L. Stayton, eds., *Vital Forms: American Art and Design in the Atomic Age, 1940–1960*, exh. cat. (New York: Brooklyn Museum of Art, 2002).

13. Sources for the epigraphs: Willem de Kooning, "What Abstract Art Means to Me," paper for a symposium of the same title at The Museum of Modern Art, New York, February 2, 1951, in Herschel B. Chipp, ed., *Theories of Modern Art: A Sourcebook for Artists and Critics* (Berkeley: University of California Press, 1968), p. 558; Steinberg, Gopnik interview, p. 7; Geoffrey Keynes and Brian Hill, eds., *Samuel Butler's Notebooks* (New York: E.P. Dutton, 1951), p. 86.

14. Meera E. Agarwal (Thompson), "Steinberg's Treatment of the Theme of the Artist: A Collage of Conversations," unpublished paper, Vassar College, December 1972, p. 23, YCAL, box 78, folder "Meera Agarwal on ST."

15. Glueck 1970, p. 115.

16. Dore Ashton, "A Victorian Dialogue with Saul Steinberg," unsigned typescript, c. 1954, p. 4, YCAL, box 8.

17. Roger Angell, quoted by Hedda Sterne in conversation with the author, July 17, 2005.

18. Steinberg, text of ex-voto drawing, early 1980s, YCAL 3570.

19. *Reflections*, pp. 3–21.

20. "Examples of radar with Mother" is a fragmentary note in Steinberg's 1960 diary, January 7, YCAL, box 3.

21. 1991 diary, May 19, YCAL, box 75; Marbella diary, May 1993, YCAL, box 95.

22. 1991 diary, May 22, YCAL, box 75. The note continues, in bitter marvel: "(To the end we thought, They can't kill the Jews, America will not allow it.) We even thought Russia, SOCIALISM, cannot allow it. Yes."

23. Ibid., June 15.

24. Steinberg, "Chronology," in WMAA 1978, p. 235.

25. Steinberg's first meeting with Giovannino Guareschi, editor-in-chief of *Bertoldo*, is recounted in Carlo Manzoni, *Gli anni verdi del Bertoldo* (Milan: Rizzoli, 1964), p. 28.

26. Reproduced in Cinzia Mangini and Paola Pallottino, *Bertoldo e i suoi illustratori* (Nuoro: Ilisso Edizioni, 1994), p. 95, fig. 138. Regarding "Xavier," see p. 103.

27. Steinberg, "Chronology," in WMAA 1978, p. 235.

28. De Chirico was a ubiquitous presence in the Italian art press of the 1930s. He lived and worked in Milan in 1933–34, and Steinberg would have seen his 1933 mural at the Palazzo dell'Arte, *La Cultura Italiana* (no longer extant), for the 5th Milan Triennial. Steinberg knew also the magic realism of Gianfilippo Usellini, a popular and critical favorite in the 1930s whose (tipped-up) Belle Époque world— a blend of De Chirico, Magritte, Ernst, and naïve painting—finds echoes in Steinberg's early gouache scenes (cat. 3). Steinberg owned Arnaldo Beccaria's monograph *Gianfilippo Usellini* (Milan: Ulrico Hoepli, [1940]), StL. He saw Usellini often in the spring of 1948, when the latter visited New York; Steinberg to Buzzi, May 13, 1948, *Lettere*, p. 30.

29. In 1945, in a possibly inflated professional summary, Steinberg wrote that in Milan, "1938 to 1941," as an "Architect/Designer . . . [o]ccasionally I made designs for interior decorations"; see United States Naval Officer Qualifications Questionnaire, May 29, 1945, YCAL, box 20, folder "Navy." Steinberg's friend from the Reggio Politecnico, architect Sandro Angelini, mailed him color photographs of this gouache and a related rendering in 1987; YCAL, box 64, folder "Correspondence 1987."

30. Piervaleriano Angelini, "L'attività italiana di Saul Steinberg" (thesis, Università degli Studi di Pavia, 1981–82) details all of Steinberg's signed drawings in *Bertoldo* (ending March 18, 1938) and *Settebello* (ending September 10, 1938). Steinberg's unsigned work in *Bertoldo* (ending April 1941) is documented in Mangini and Pallottino, *Bertoldo e i suoi illustratori*, pp. 93–94 and figs. 139, 140; Carlotta and Alberto Guareschi, *Milano 1936–1943: Guareschi e il Bertoldo* (Milan: Rizzoli, 1994), pp. 333–70 and appendix, pp. 487–91. Drawings Steinberg left with *Bertoldo* when he fled Italy in 1941 (including fig. 14, p. 28 and p. 82, as well as unpublished works) are in the collection of the Guareschi Foundation in Roncole Verdi.

31. See, for example, his account to Primo Levi, July 18, 1985, YCAL, box 64, folder "Correspondence 1985–87."

32. The legend is perpetuated, for example, by Rosenberg, in WMAA 1978, p. 14. Steinberg's (undoctored) Romanian passport, filled with Spanish and Portuguese transit visas and a travel affidavit from the United States Consul in Milan, is in YCAL, box 89, folder "Tortoreto."

33. See Steinberg's intermittent diary pages, beginning December 7, 1940, YCAL, box 20, folders "Tortoreto 1940–42" and "Miscellaneous 1940–42."

34. "Persiflage from Paris," *Harper's Bazaar* 73 (March 15, 1940), pp. 60–61; "Life in the 'Guatavir' Line," *Life*, May 27, 1940, pp. 14–15, 17; "Steinberg Desenhos," *Sombra* 1, no. 1 (December 1940–January 1941), cover and pp. 49–50, 72–73, 88–89. Civita placed work by Steinberg in the Argentine magazine *Cascabel* (1941–42), which has yet to be documented; see Gertrude Einstein to Steinberg, March 3 and n.d. [mid-May], 1942, YCAL, box 1, folder "1942 Correspondence." On the role of the New York branch of the family in Steinberg's immigration, see Lawrence Danson, "An Heroic Decision," *Ontario Review* 53 (Winter 2000–01), pp. 57–68.

35. The precise nature of the disaster in September 1940—sometimes said to involve the artist being unable to prove he was not a Communist or criminal who shared his name (Danson, "An Heroic Decision," p. 61)—is not clear, but it loomed in memory as his darkest hour. At a later turn in his immigration labyrinth, Civita's assistant in New York, who was on the American end of the effort, wrote to assure him: "As to your documents, please believe that they are now in perfect order, and that there is not the slightest danger that the events of Lisbon will again take place"; Gertrude Einstein to Steinberg, May 25, 1942, YCAL, box 1, folder "1942 Correspondence." Steinberg himself indicated that the snag involved a missing Italian stamp in his dossier, which he obtained by being arrested; *Reflections*, p. 32.

36. On Steinberg's arrest and internment, see *Reflections*, pp. 26–39, from which these quotations are taken, and the loose diary pages in YCAL, box 20, folders "Tortoreto 1940–42" and "Miscellaneous 1940–42."

37. Tally book of numbered packets of drawings sent from Ciudad Trujillo, YCAL, box 1, folder "Santo Domingo."

38. Steinberg and Einstein used a system of numbered letters and responses, the numbers corresponding to his running list of packets of drawings, which were in turn individually numbered. Several of Einstein's letters are in YCAL, box 1, folder "Correspondence 1942."

39. In the *Bertoldo* cartoon, titled "Perplessità" and published in the December 18, 1936 issue (Angelini, "L'attività italiana di Saul Steinberg," no. 14), the reversed centaur is a work of sculpture, contemplated by its maker.

40. Diary, December 7, 1941, YCAL, box 20, folder "Miscellaneous 1940–42."

41. "To Our Artists," mimeograph circular from the Editors, *The New Yorker*, July 2, 1942, YCAL, box 1, folder "1942 Correspondence." Einstein's earlier letters to Ciudad Trujillo imply that Steinberg had been receiving prior topic bulletins from the editors, but these do not survive. The July 1942 memo would have been the first one that reached him after his arrival in New York.

42. On Ross and Donovan, see note 52 below. Harold Ross wrote to Elmer Davis, November 5, 1942, recommending Steinberg for propaganda work; Thomas Kunkel, ed., *Letters from the Editor: The New Yorker's Harold Ross* (New York: Modern Library, 2000), p. 191.
 The medical files in Steinberg's Navy records (copy at SSF) indicate that he was disqualified on the basis of "visual defect" after his first physical examination on January 21, 1943. Various Navy personnel continued to disqualify him for the next few days, until some unrecorded pressure was exerted. A handwritten, unsigned comment dated February 3 in a document in Steinberg's Officer Personnel File reads: "This applicant has about everything disqualifying that could exist. However, an officer went from here to New York to get him. He is physically disqualified and is not a citizen. Is urgently wanted by VCNO [Vice Chief of Naval Operations] for special duty in conjunction with activities of schizophrenist and, being the pick of New York, is eminently qualified for duties for which wanted. . . . Capt. Calhoun and Capt. Metzel know reason for which wanted. Recommend waive, appt, certify, and order to VCNO." On February 15, he received a "waiver of physical defects" and, four days later, his certificate of naturalization.

43. "Cartoons Against the Axis," organized by the Art Students League; correspondence and clippings, YCAL, box 1, folder "1942 Correspondence"; Edward Alden Jewell, "Cartoons on View at Art Museum," *The New York Times*, May 2, 1943, p. 11. Steinberg was represented by two works, one of which, "Aryan Family," described as a watercolor (possibly a colored version of the drawing in *All in Line*, p. 50, top), won an honorable mention and was purchased for $25 by fellow exhibitor Dave Breger, creator of the "Private Breger" cartoons that were the first popular cartoon hit of the war; see *BRUSH reMARKS*, mimeographed circular of The American Society of Magazine Cartoonists, n.d., YCAL, box 1, folder "1942 Correspondence."

44. On Nivola, see Micaela Martegani, *Costantino Nivola in Springs*, exh. cat. (Southampton, New York: The Parrish Art Museum, 2003). Leo Lionni, another Milan acquaintance of Steinberg's, was based in Philadelphia with Curtis Publications; on his professional contact with Steinberg and on the scene at Del Pezzo, see Lionni, *Between Worlds: The Autobiography of Leo Lionni* (New York: Alfred A. Knopf, 1997), pp. 198–202.

45. Hedda Sterne, in conversation with the author, May 6, 2002.

46. For the train trip, see YCAL sketchbook 3200 (which includes fig. 32). The only sign that Steinberg visited the movie studios is a series of sketches (YCAL sketchbook 3186) of the composer Mario Castelnuovo-Tedesco, inscribed "Hollywood January 1943." The latter had fled Milan in 1938 and was working for MGM. Steinberg later told friends, including Sterne and Ian Frazier, that immediately upon arriving in New York in summer 1942, he had taken a train west in order to see the Pacific Ocean. What Sterne calls his "strong geographic sense" makes the story plausible, but to date nothing in his papers has substantiated it. The January 1943 trip might have evolved over time into an exaggerated memory.

47. Gertrude Einstein to Steinberg at General Delivery, Los Angeles, January 11, 1943, YCAL, box 1, folder "1943 Correspondence." Steinberg needed to report for the draft at 7:30 a.m., January 20. Atypically, Einstein wrote this letter in Italian (to ensure precise comprehension?) on stationery that advertises Cesar Civita's role as Disney's New York representative for South America.

48. "Drawings in Color by Steinberg, Paintings by Nivola," April 12–24, Wakefield Gallery, 64 East 55th Street; announcement card, YCAL, box 2, folder "Exhibitions."

49. Steinberg described his position as "Psychological Warfare Artist" in an Officer Qualifications Questionnaire, May 29, 1945, YCAL, box 20, folder "Navy." On the Happy Valley outpost, see Milton Miles, *A Different Kind of War: The Little-Known Story of the Combined Guerilla Forces Created in China by the U.S. Navy and the Chinese During World War II* (New York: Doubleday, 1967), and illustrations section, pp. 8–9, for drawings by Steinberg, dated August 1943.

50. *China Theater: An Informal Notebook of Useful Information for Military Men in China* (Reproduction Branch of the Office of Strategic Services, 1943). Copy on file with SSF and StL. See also Jane Kramer, "Mission to China," *The New Yorker*, July 10, 2000, p. 59.

51. Captain Frank Gleason, email to Sheila Schwartz, SSF, November 29, 2005.

52. Written orders from M.E. Miles, Office of the U.S. Naval Observer, American Embassy, Chungking, China, dated December 6, 1943, direct Steinberg to proceed from Kunming to Algiers via India and report to the Chief of the Office of Strategic Services for temporary duty; YCAL, box 57. The next year, when Harold Ross wrote to Donovan to request Steinberg's release to inactive service, he commented: "You—personally, I believe—picked [Steinberg] up there [China] and took him to North Africa"; Ross to Donovan, October 13, 1944, TNYR, box 62.

53. See Smith 2005, pp. 50–57. Steinberg's ten wartime portfolios in *The New Yorker*: "Fourteenth Air Force, China Theatre," January 15, 1944, pp. 18–19; "Fourteenth Air Force, China Theatre," February 5, 1944, pp. 20–21; "North Africa," April 15, 1944, pp. 24–25; "North Africa," April 29, 1944, pp. 22–23; "Italy," June 10, 1944, pp. 20–21; "Italy," July 8, 1944, pp. 18–19; "Italy," July 29, 1944, pp. 18–19; "India," February 24, 1945, pp. 22–23; "China," March 24, 1945, pp. 28–29; and "India," April 28, 1945, pp. 20–21.

54. Some of Steinberg's drawings, including fig. 18, appear as photostats in the papers of his OSS comrade Hermann Broch de Rothermann, YCAL, Uncat. ZG MS 27, box 1; in a 59-drawing portfolio in the OSS files at the National Archives in Washington, D.C.,

RG 226, OSS E139, box 140, folder 1900, labeled "MO-OP-64. Production-ETO. Steinberg (Cartoons)"; and in a portfolio of drawings and clippings, possibly compiled by Steinberg himself, labeled "MO: Collection of Cartoons Produced by MO Artist, LT. (jg) Saul Steinberg. Target—Germany. For OWI, PWB, and MO/US, MTO & ETO, 1941–1945," National Archives, RG 226, entry 99, box 40, folder 6; copies of the latter two compilations at SSF. To date, published contexts (if any) have been identified for only a few of the drawings.

55. *Das Neue Deutschland* was one of many propaganda schemes. For another that involved Steinberg, code-named Operation Sauerkraut, see Elizabeth McIntosh, *Sisterhood of Spies: The Women of the OSS* (New York: Random House, 1998), pp. 60–70.

56. June 1986 interview, p. 1.

57. Carleton S. Coon, Major, AUS, "Interview with Lt. (j.g.) Steinberg of MO, 8 November 1944," National Archives, RG 226, entry 99, box 48, folder 2, "Medto-Nato Anthology"; copy at SSF.

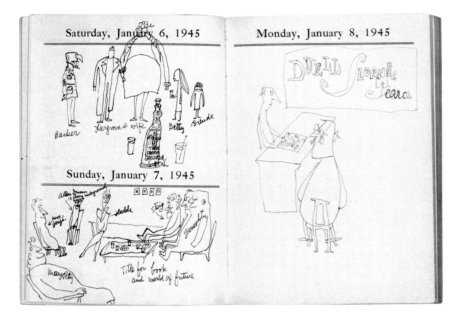

Saturday, January 6, 1945

Sunday, January 7, 1945

Monday, January 8, 1945

DUELL SLOANE Pearce

January 6–8 in Steinberg's 1945 appointment book (see note 58).

58. 1945 appointment book, January 7, 1945 (above), YCAL sketchbook 3074. Clockwise from bottom left: Mary Petty, Eva Geraghty, Alan Dunn (described, inscrutably, as "12 floors underground"), Hedda Sterne, William Steig, Steinberg, James Geraghty. Petty and Dunn were a *New Yorker* cartooning couple.

59. Ibid., April 26–May 2. Steinberg's OSS activity is not reflected in his military records, nor does any document in the OSS files in the National Archives record his resignation. He was released from active to inactive duty in the US Naval Reserve in December 1945 and received an Honorable Discharge in July 1954.

60. The sole reproduction of *Hiroshima* is in Aline B. Louchheim, "The Favored Few," *Art News* 45 (September 1946), review of "Fourteen Americans," p. 51. In the same week that issue appeared, John Hersey's "Hiroshima" filled the entire August 31, 1946 issue of *The New Yorker*. Steinberg wrote to Geraghty from Paris on September 7, "Everybody here talking about Hiroshima issue of the N. Yorker. I haven't seen it yet. I have some stuff in a show at the Museum of Modern Art. How is it?"; TNYR, box 62.

61. "My mind is always filled with a lot of separate 'art problems.' Hokinson needs ideas. Barlow needs ideas. Darrow needs time. Hoff needs patience. Steinberg needs excitement. Macdonald needs energy. Decker needs money. Dove needs help. Day needs a vacation. Steig needs a new editor. So does Arno. Garrett Price needs common sense"; Harold Ross to Hawley Truax, January 31, 1945, quoting James Geraghty, TNYR, box 28.

62. Quoted in Brendan Gill, "Steinberg's Surprise," *Horizon* 21 (April 1978), p. 68.

63. Steinberg recalls Lindner's proto-Pop color sense in his notes for a tribute delivered January 24, 1979 for the American Academy and Institute of Arts and Letters, YCAL, box 75, folders "Notes About Dreams" and "SS Tribute to Richard Lindner."

64. For Steinberg's magazine features, see Bibliography, pp. 269–72. For other types of works, see figs. 40, 41, pp. 44–45, and p. 102, center; cats. 8, 10, 23, 31, 33, 37, 38.

65. For example, see Mary F. Corey, *The World Through a Monocle: The New Yorker at Midcentury* (Cambridge, Massachusetts: Harvard University Press, 1999); Topliss, *The Comic Worlds of Peter Arno, William Steig, Charles Addams, and Saul Steinberg*; and David Remnick's introduction in Robert Mankoff, ed., *The Complete Cartoons of The New Yorker* (New York: Black Dog & Leventhal, 2004), pp. 8–9.

66. On artist ratings at *The New Yorker*, see Lee Lorenz, *The Art of The New Yorker, 1925–1995* (New York: Alfred A. Knopf, 1995), pp. 122–23; on Steinberg's pay scale, see Mason to Harold Ross, September 2, 1947, TNYR, box 62.

67. For the phrase "barnacle on the ship," see Walt Kelly, *Positively Pogo* (New York: Simon and Schuster, 1957), p. 14.

68. "I appeal to the complicity of my reader who will transform [my] line into meaning by using our common background of culture, history, poetry. Contemporaneity in this sense is a complicity;" quoted in Jean vanden Heuvel (Jean Stein), "Straight from the Hand and Mouth of Steinberg," *Life*, December 10, 1965, p. 59.

69. Quoted in "The Job of Being Absurd," *Newsweek*, July 9, 1945, p. 97.

70. Steig, at least, saw it that way. Jane Filstrup wrote to Steinberg in 1978 requesting an interview for *Cats* magazine. She had interviewed Steig, who, she said, "mentioned to me then that he and Saul Steinberg were the two artists who could do cartoons for the magazine which didn't have to be funny, have gags in them"; July 5, 1978, YCAL, box 22, folder "Fan mail."

A roster of middlebrow avant-gardists in the graphic arts should include Steinberg and Steig (magazine cartoons), Edward Gorey (illustrated books), Robert Frank (press photography and photography books), and Walt Kelly (newspaper comics). The defining relationship in all their careers was with publication, as a business and as a creative process. They all changed the possibilities of art in their respective trades—for themselves, at least (Kelly), and in some cases for the whole field (Frank, Gorey).

71. See Heinz Politzer, "The World of Saul Steinberg: A Mirror Reflecting the Forlornness of Modern Man," *Commentary* 4 (October 1947), pp. 319–24.

72. Film footage of the inside of Steinberg's and Sterne's house, made in 1954 or slightly later, records a wall-size pin-up collage of paper ephemera in Steinberg's studio. The footage is preserved on video at SSF.

73. June 1986 interview, p. 1.

74. In a reprint of this cartoon—though not in its original *New Yorker* appearance—the vertical join between the walls is aligned along the gutter; "Saul Steinberg, Visual Historian," *Design and Paper*, no. 30 (c. 1950), n.p., copy at SSF. *Design and Paper* was a series of booklets published by Marquardt & Co., New York, a paper manufacturer. This issue is devoted to Steinberg.

75. *I Remember That: An Exhibition of Interiors of a Generation Ago*, exh. brochure (New York: The Metropolitan Museum of Art/Index of American Design Publications, 1942), copy at SSF. A note (inside cover) explains that Harnly's renderings, and others in the show, were part of "the Index of American Design compiled by the New York City Art Project of the Work Projects Administration." The Index of American Design, housed at The Metropolitan Museum from 1942 to 1944, is now at the National Gallery of Art, Washington, D.C.

76. Notable Steinberg picture essays on American environments and places include a survey of five decades of style, "Change of Mind, 1900–1950," *Vogue* (January 1950), pp. 96–101; the drawings accompanying Cleveland Amory, "Palm Beach," *Life*, January 21, 1952, pp. 88–92, 95, 96, 101; Amory, "Saratoga: Swan Song for a Spa," *Harper's* 205 (October 1952), pp. 69, 71–72, 74, 76–77, 79; and—a rare combination of written and visual comment—Steinberg, "Built in U.S.A.: Postwar Architecture, 1945–52," *Art News* 52 (February 1953), pp. 16–19.

77. Steinberg, interview with André Parinaud, *Arts et Loisir* (Paris), March 16–22, 1966; reprinted in *Saul Steinberg: Collagen und Zeichnungen*, exh. cat. (Hamburg: Hamburger Kunsthalle, 1968), p. 13.

78. Steinberg's cash flowed swiftly. He and Sterne had no children, but—mindful of the help to which he owed his own survival—he sup-

ported many people with his income. After the war, he began sending monthly care packages of cash and goods to his friend in Milan, Aldo Buzzi, and to his girlfriend during the Milan years, Ada Ongari, both of whom had helped him escape Italy. His support for Ongari (who called him "my American uncle") continued until her death in the early 1990s. He supported his family with regular payments, too, and arranged for his parents' move from Bucharest to Nice in 1950 and for that of his sister, her husband, and their two children to Paris in 1958. He continued to send them money regularly thereafter, as he did to his aunts and cousins in Israel.

79. "I have been rather too busy in the last months, [creating] unedited drawings for fashion or literary magazines, illustrations for books I didn't read and other rush things that made me feel like a bookkeeper. I hope I'll do some good cartoons in Mexico, that's relaxing work"; Steinberg (in transit to Mexico) to Ross, April 8, 1947, TNYR, box 62.

80. Hedda Sterne, conversation with the author, July 17, 2005.

81. For example, see "Eight Drawings," *Wake* 10 (1951), pp. 5–12; cover, *Paris Review*, no. 19 (Summer 1958); "Steinberg U.S.A.," *Harper's* 221 (September 1960), pp. 49–54.

82. Steinberg to Aldo Buzzi from East Jamaica, Vermont, July 23, 1947, *Lettere*, p. 27: "I've designed a mural for a department store in New York. . . . But I'm not executing it myself. There's an army of hooligans who crane their necks on the scaffolding, in this heat, copying it on the wall." He refers to visiting New York to supervise the work in a letter of August 4 (ibid.). To date, the only known visual record of the mural is a small perspective view in a Bonwit Teller ad, *The New Yorker*, January 24, 1948, p. 3. Steinberg's original drawing is in the collection of Carol and Douglas Cohen. Tino Nivola, who had created hand-decorated holiday cards for Bonwit Teller, might have recommended Steinberg for the mural; see Martegani, *Costantino Nivola in Springs*, p. 15.

83. Steinberg to Buzzi, August 4, 1947 and February 24, 1948, *Lettere*, pp. 27–29. Steinberg's Navy friend Ben Baldwin, an interior architect with Skidmore, Owings & Merrill, the Terrace Plaza's designers, had precipitated the Cincinnati commission. For photographs of the restaurant, see *Benjamin Baldwin: An Autobiography in Design* (New York: W.W. Norton, 1995), p. 123. Steinberg installed the panels with the assistance of Nivola in March 1948; see YCAL, box 57, folders "1947" and "1948." In 1965, after the hotel had been sold to the Hilton chain, the mural was taken down and accessioned by the Cincinnati Museum of Art. The mural's panels, now undergoing restoration, are to be exhibited in conjunction with the Cincinnati stop of the present exhibition. Segments of the mural are reproduced in [Gjon Mili], "The Walls Have Laughs," *'48 The Magazine of the Year* 2 (June 1948), pp. 114–17; "Cincinnati's Terrace Plaza," *Architectural Forum* 89 (December 1948), p. 85; "Murals by Modern Masters," *Design* 54 (November 1954), p. 39; and *The Cincinnati Art Museum Bulletin* 8 (January 1968), p. 47, and (October 1968), p. 19.

84. Steinberg-Henry Dreyfuss correspondence, 1948, YCAL, box 57, folder "1948." Bernard Rudofsky, "For the Honor of the Fleet: Murals for American Export Lines," *Interiors* 108 (December 1948), n.p., includes a foldout illustrating five panels of the Export Line mural. The photographic prints that composed the murals were printed in negative on Varlar, a stain-resistant vinyl material. An installation view of one of the murals appears in "Modern Art Goes to Sea," *Fortune* 39 (May 1949), p. 97, where the lace curtain effect of the tonal reversal can be seen. The "Four Aces" were recommissioned merchant marine vessels, among them, coincidentally, the *Excalibur*, on which Steinberg had sailed from Lisbon in 1941.

85. Steinberg to Buzzi, June 1, 1949, *Lettere*, p. 34.

86. Steinberg to Alexander Girard, February 12, 1949, describing the project as "noble and interesting work," for which he was willing to accept "what I consider a token fee"; copies of correspondence at SSF. The catalogue was published by The Detroit Institute of Arts as *An Exhibition for Modern Living*, eds. A.H. Girard and W.D. Laurie, Jr. The twenty-two drawings for the mural are in the collection of The Detroit Institute.

87. "Saul Steinberg: Drawings," Betty Parsons Gallery and Sidney Janis Gallery, January 28–February 16, 1952. Installation views of the Parsons-Janis shows are in YCAL, box 50, folder "Betty Parsons Gallery 1969 show"; checklists are in YCAL, box 40, folder "Shows."

88. *Habitat* (*Revista das Artes no Brasil*), no. 9 (1952) has features on Steinberg's and Sterne's shows, pp. 17–20 and 21–26, respectively.

89. Ernesto N. Rogers-Steinberg correspondence, July–August 1954, YCAL, box 8, folder 7 of 9, "1954 correspondence." See "Il labirinto alla Triennale," *Domus*, no. 300 (November 1954), pp. 2–5; "XT: The Shapes to Come," *Fortune* 50 (December 1954), pp. 123–25; "Labirinto Steinberg [*sic*]," *Linea Grafica* (September–October 1954), pp. 262–63, containing an interview with Steinberg; *Casabella*, no. 203 (November–December 1954), "Il labirinto dei ragazzi," pp. 50–53. Photographs: YCAL, box 2, folder "Graffito Triennale, photographs."

90. The drawings are preserved at The Saul Steinberg Foundation: SSF 3479 (*The Line*); SSF 3750 and 3751 (*Shores of the Mediterranean* and *Cities of Italy*); and SSF 3752 (*Types of Architecture*).

91. Betty Pepis, "Children's House Steals Milan Fair," *The New York Times*, August 31, 1954, p. 24. The labyrinth's open-air format and placement recall the experimental structures Tino Nivola and Bernard Rudofsky created in Nivola's garden in Springs, Long Island, which Ernesto N. Rogers knew at first hand. See Rudofsky, "The Bread of Architecture" (1952), reprinted in Barbara Goldstein, ed., *Arts & Architecture: The Entenza Years* (Cambridge, Massachusetts: The MIT Press, 1990) and Alistair Gordon, "The Nivola Garden," in Martegani, *Costantino Nivola in Springs*, pp. 35–44.

92. Steinberg's undated note "Readers—myopes/presbytes" appears in his 1952 diary; on introspection, in his 1952 year book, March 11 (both YCAL, box 3); and on the transition from peasant to middle class, in a telephone memo pad (YCAL sketchbook 3090, p. 10), c. early 1960s.

93. In an April 8 telegram to the Hotel Cortez, Shawn offered to send the text and photographs of the architect, to arrive by April 12, if Steinberg could send a drawing by the 15th. Steinberg submitted the art April 12, apologizing that he "wasn't able to do something more brilliant about Le Corbusier. My drawing represents him as he is in New York: lonesome, and as he is usually—bitter looking—And as I saw him more often—in Italian restaurants"; TNYR, box 455. The portrait—the first drawing Steinberg made on graph paper ("because it looks like [Le Corbusier's] architecture, neat, orderly, transparent, logical"), appeared in *The New Yorker*, May 3, 1947, p. 36. On Steinberg and Le Corbusier, see also pp. 243–44, note 73, below.

94. Steinberg's running job tally and scrapbook of *New Yorker* tearsheets are preserved in *The New Yorker* library.

95. See Manuel Gasser, "Steinberg as an Advertising Artist," *Graphis*, no. 67 (1956), pp. 376–85. For Steinberg's one venture into animation, a Jell-O television commercial for Young & Rubicam, see *Graphis Annual 1955*, no. 670, p. 190.

96. James Geraghty to Steinberg, November 10, 1954, YCAL, box 8, folder 4 of 6, "Correspondence 1954."

97. Harold Ross called Steinberg shortly after his portfolio of Los Angeles drawings, "The Coast," had appeared in the January 27, 1951 issue. In a follow-up memo, Ross told Geraghty that Steinberg "says he still regards a Los Vegas [*sic*] layout as a good possibility for the future, world conditions permitting, and that he'd like to do a layout on the South—gracious living down there, etc. The South has been in his mind since he first arrived in this country, at Miami, nine years ago, and made the trip to New York by bus"; TNYR, box 62.

 For the watercolor in fig. 48, added at a later date, see pp. 242–43, note 38, below.

98. Steinberg, USSR diary, February 14–March 24, 1956, YCAL, box 3.

99. The titles come from the checklist in *Steinberg: The Americans, Panneaux de l'Exposition universelle de Bruxelles, 1958; et Aquarelles, dessins, et collages, 1955–1967*, exh. cat. (Brussels: Musées Royaux des Beaux-Arts, 1967), n.p.

100. Bernard Rudofsky oversaw details of the pavilion's interior design and installation for Peter G. Harnden Associates. His letters to Steinberg on details of the mural job, February–March 1958, are at YCAL, box 8, folders 1–3, "Correspondence 1958."

101. Peter Harnden, quoted in "Steinberg at Brussels," *Newsweek—International Edition*, April 28, 1958, p. 39.

102. "Americans at Brussels: Soft Sell, Range & Controversy," *Time*, June 16, 1958, pp. 70–75.

103. On Lionni's pavilion, commissioned by *Fortune* magazine, see "Fair Exhibits to Symbolize U.S. Problems," *The New York Times*, March 11, 1958, p. 12. Race went unaddressed in Steinberg's mural, even though he had written upon taking the last-minute job: "I'm in

trouble . . . I must use my cabeza, think (the subject is *people* in U.S. How do you draw the blacks?)"; Steinberg to Buzzi, January 20, 1958, *Lettere*, p. 48, the word *people* in English. Lionni wrote Steinberg from Brussels in May to say that the artist's "screens" were "the best thing since Guernica—I hope that they will be housed properly after the expo—I'll raise bloody hell if they [aren't]. I am here to fix up all sorts of trouble in connection with my small pavilion"; Lionni to Steinberg, May 15, 1958, YCAL, box 8, folder 3 of 3, "Correspondence 1958." As it turned out, the panels of *The Americans* went unclaimed by the American commission after the fair. They are preserved at the Musées Royaux des Beaux-Arts de Belgique.

104. Caption in Hans Curjel, "Expo '58," *Graphis*, no. 78 (1958), p. 290.

105. Ibid., p. 292.

106. Mortgage for Springs house, May 22, 1959, YCAL, box 40, folder "Contracts, old."

107. 1959 Year Book, May 26–27, YCAL, box 3.

108. Steinberg to Buzzi, August 7, 1960, *Lettere*, pp. 53–54.

109. YCAL, box 14, folder "Jaguar correspondence."

110. "Dear Saul—Here is a card and drawing by the beautiful young German girl who was so dying to talk to you the other night and who is adorable.—Please send it back as it's the only drawing of hers I have. Would you like to be re-introduced? She is ignored by all these ¼ men I introduce her to"; "Barbara" to Steinberg, undated letter (possibly spring 1960), YCAL, box 14, folder 2 of 2, "Correspondence 1959–61."

111. The clean shave postdated his meeting Sigrid. In an undated letter to Steinberg (c. late 1960), Paul Rand passes Steinberg a contact telephone number to aid in Sigrid's job search and remarks, "It was good to see you without your moustache"; YCAL, box 14, folder 1 of 2, "Correspondence 1959–61."

112. See Smith 2005, pp. 34–38.

113. See p. 22 above for the full quotation.

114. José Ortega y Gasset, *The Revolt of the Masses* [*La Rebelión de las Masas*, 1932] (New York: Mentor Books, 1950), p. 80, chap. 12, "The Barbarism of Specialization."

115. Untitled typed statement, c. 1950–52, YCAL, box [45], blue folder "1952."

116. Steinberg's fullest explanation of the crocodile as a figure in his art and speech is in Glueck 1970, pp. 115–17.

117. By "normalcy," Steinberg meant being guided by one's own urges and curiosities, instead of by crowds or critics. "One has a special relationship with the loved artists. One is kept honest by them and sometimes works to amaze them. They are the real witnesses and reassuring examples of normalcy in a world where normalcy in reality or in novels is not attractive or even credible"; quoted in Margaret Staats and Lucas Matthiessen, "The Genetics of Art, part II," *Quest* 1 (July–August 1977), p. 38.

118. For reports on Steinberg's visits to locales throughout Europe and the Americas, see the clippings from newspapers in the folders and scrapbooks of clippings in YCAL, box 132.

119. Steinberg to Edmund Wilson, April 27, 1961, Edmund Wilson Papers, YCAL, box 64. Steinberg wrote that *The Labyrinth* "with one or 2 exceptions was received by stupid silence or worse." He enclosed a "better review" (from the Columbus, Ohio *Post-Dispatch*, April 1961) that recommends the book if "you understand or appreciate Steinberg's work (we can't and don't)." Steinberg's allusion to Stendhal might refer to the "First Preface" (1826) to *On Love* (1822), which begins, "This book has had no success," then enumerates the many varieties of readers who will fail to understand it.

120. Max Kozloff, "Art" (review of Steinberg exhibitions at the Sidney Janis and Betty Parsons galleries), *The Nation*, December 19, 1966, p. 683.

121. Steinberg, "The Nose Problem," *Location* 1 (Spring 1963), p. 37. Harold Rosenberg was a co-founder and editor of this journal.

122. A fourth general class worked its way into this schema in the 1960s: the highbrow yet "culture"-oriented review (such as *The Paris Review*) that resembled *The New Yorker* in putting art on its cover, but kept the art black-and-white. On the echelons of middlebrow identity,

see Russell Lynes, *The Tastemakers* (New York: Harper and Brothers, 1955), pp. 310–33; see also cat. 12.

123. Gopnik interview, p. 7, for all quotations in this paragraph.

124. Steinberg used this shorthand method to refer to the abstract and figural phases of Philip Guston's art, as when he called the later work of De Chirico "The main influence on Guston II"; 1991 diary, May 9, YCAL, box 75.

125. "I've finally seen *I Vitelloni*, very good, one of the rare times when I'm sorry not to have gone into cinema"; Steinberg to Buzzi, November 1956, *Lettere*, p. 44. "I've finally seen—it's arrived here with an awful title: *The Sound of Trumpets*—[Olmi's] film *Il posto*, which they could have translated properly as 'The Job' or even 'Il Giobbe' [a cross-lingual pun on the biblical Job]. . . . Beautiful film—what a pleasure, I'll see it again soon—what true compassion by not exaggerating. I should have made this film"; Steinberg to Buzzi, November 2, 1963, partially published, *Lettere*, p. 59. All of Steinberg's letters to Buzzi are at SSF.

126. Steinberg, "Chronology," in WMAA 1978, p. 241.

127. Tullio Kezzich speaking with Antonio Monda in *Vitellonismo*, a documentary feature on *I Vitelloni* (Criterion Collection DVD, 2004).

128. 1993 looseleaf journal entry, YCAL, box 75, folder "SS Tribute to Richard Lindner."

129. The phrase is quoted in Ashton, "A Victorian Dialogue with Saul Steinberg," p. 4.

130. Quoted in Aline B. Louchheim, "Steinberg: Artist and Humorist," *The New York Times*, February 3, 1952, Arts section, p. X9.

131. This sketch could have been spurred by conversations with Vladimir Nabokov about *Lolita*, which had occupied the author for years and would be published in Paris in 1955.

132. On a photocopied article on Nikolai Gogol, with whose writing he deeply identified, Steinberg took note of a description of Gogol's idiom as "satirical, but not in the ordinary sense. It was not objective, but subjective, satire. His characters were not realistic caricatures of the world without, but *introspective caricatures* of the fauns of his own mind"; Prince D.S. Mirsky, quoted in Donald Fanger, "With Gogolized Eyes," *Times Literary Supplement*, November 27, 1992, p. 18, Steinberg's underlining, YCAL, box 121. A marked paperback copy of Vladimir Nabokov, *Nikolai Gogol* (1944; ed. New York: New Directions, 1961), which Steinberg first read in the 1940s and reread many times, is preserved at SSF. Steinberg's sense of identification with Gogol is discussed at length in Dore Ashton, "'What I Draw Is Drawing,'" in IVAM 2002, pp. 152–58.

133. Steinberg first mentions taking mescaline on November 24, 1955; 1955 year book, YCAL, box 3. In June of that year, an entry indicates that he had seen, in Paris, artist-poet Henri Michaux, the proponent of mescaline whom he had known since 1948, who possibly supplied the drug.

134. June 1986 interview, p. 4. See cat. 66.

135. Issues of mainstream and underground comic books and tabloids Steinberg saved are housed in YCAL, boxes 91 and 92, and at StL.

136. On the dynamics of comix artists and editors within the underground press in this period, see Patrick Rosenkranz, *Rebel Visions: The Underground Comix Revolution, 1963–1975* (Seattle: Fantagraphic Books, 2002), pp. 123–70.

137. See, in Steinberg's collection of underground comix, *East Village Other*, June 4, 1969, folded open to Deitch, "Off th' Wall"; *Other Scenes*, August 1, 1969, folded open to Richard Sherman, "Kim's Comic Strip" (on Deitch); *East Village Other*, September 3, 1969, folded open to Deitch, "Uncle Ed, Rewritin' th' Unwritten Law"; Deitch, *Laugh in the Dark* (comic book, 1971); Deitch and Art Spiegelman, *Swift Comics* (comic book, 1971). The first three are YCAL, box 92; the next two, YCAL, box 91, folder 1. Deitch was the editor of *Gothic Blimp Works* for most of 1969; Rosenkranz, *Rebel Visions*, pp. 150–53.

138. John Ashbery, "Saul Steinberg: The Stamp of Genius," *Art News* 68 (November 1969), p. 45.

139. See, for example, Steinberg's portfolio "The City," *The New Yorker*, February 24, 1973, partially reproduced in Smith 2005, pp. 156–57.

140. Medical records (Bircher Benner Clinic, Zurich) in YCAL, box 6, folder "1971 Maeght opening."

141. Sterne, conversation with the author, May 6, 2002.

142. Receipts for book orders through Books & Co. appear throughout Steinberg's papers from this time onward. See also his cover drawing for Lynne Tillman, preface by Woody Allen, *Bookstore: The Life and Times of Jeanette Watson and Books & Co.* (New York: Harcourt Brace, 1999).

143. The final drawing, in which Los Angeles is figured as a giant pair of initials, appeared in *The New Yorker*, October 1, 1966, p. 56.

144. For the series of sketches and drafts, as well as a group of larger works on the theme executed in 1986, see *Saul Steinberg: Fifty Works from the Collection of Sivia and Jeffrey Loria* (New York: Jeffrey H. Loria, 1995), nos. 18–23.

145. For sales and reprint records on the poster for 1977 and 1978 and correspondence from *The New Yorker* regarding publication requests for the image from advertisers, see YCAL, box 49, folder "Fan 78."

146. Prudence Crowther, email to the author, January 4, 2004.

147. For one response, see Louis Foye's card to Steinberg, October 25, 1987, YCAL, box 43.

148. "*Libro d'Arte.*" Steinberg wrote to Buzzi, July 19, 1977, *Lettere*, p. 98, referring to the catalogue for the upcoming Whitney Museum exhibition and underlining the phrase for emphasis. "These museums," he explained, "are ferocious to make money and I'm afraid that what I thought was a show and simple catalogue is becoming a big show and *Art Book*. which I've been trying to avoid for many years, a heavy, expensive, vulgar book, which is the stuff on which museums feed. I'll surely try to defend myself and make the best of this situation." For his contention that such publications transform the artist into a "work of art," see Appendix, p. 249.

149. Rosenberg, in WMAA 1978, p. 36.

150. Steinberg likened his conversations with Rosenberg—"talking about things without any plan, without anything in mind"—to the ascent of flying cranes on warm air currents and called it "free speech"; Elaine O'Brien interview with Steinberg about Harold Rosenberg, March 1993, transcript pp. 2, 6, copy at SSF. The passage concerning the "non-professional" model is quoted in full on p. 22 above.

151. Among the other early losses in a long line, Richard Lindner died in 1978. Roland Barthes and Italo Calvino, two revered Steinberg collaborators, died in 1980 and 1985, respectively. Barthes had provided the texts and Steinberg the images for *all except you* (Paris: Repères, 1983), Calvino had written the by now oft-reprinted essay, "Drawing in the First Person," which introduced *Derrière le Miroir*, no. 224, an issue devoted to Steinberg's 1977 exhibition at the Galerie Maeght.

152. Steinberg reported his change of gallery representation to Buzzi, April 5, 1982, *Lettere*, p. 121.

153. Steinberg, "Postcards," *The New Yorker*, January 16, 1978 and February 25, 1980; "Dreams," February 1, 1988; "Architecture: Villas," September 26, 1983; "Lexington Avenue," July 4, 1983; "Cousins," May 28, 1979; "Kiss," December 2, 1985. See Smith 2005, p. 43.

154. The caption appears below a drawing of a bed and a tree, YCAL 3323. On the late ex-votos, see cat. 82 and Smith 2005, pp. 44–45.

155. June 1986 interview, p. 2.

156. For Steinberg's term "political," see Rosenberg, in WMAA 1978, p. 20.

In a sketchbook note on parody, Steinberg included "epigonic art" and "*neo*- etc. in art" in his list of "intentional parodies"; YCAL sketchbook 4953, c. 1985. Elsewhere, he wrote that Robert Rauschenberg "was interesting as long as he was a revolutionary. His pictures against the abstract expressionists—brushstrokes and drippings over real objects (a bed a goat) were truly exciting. He operated within art history and when his revolution was over he was left with very little. . . . Similar heroes are the student Princip of Sarajevo—Oswald of Dallas" (assassins of the Archduke Franz Ferdinand and John F. Kennedy, respectively); YCAL 3325, c. 1983, a loose sheet whose text is framed at bottom.

157. June 1986 interview, p. 1.

158. Steinberg to Buzzi, January 26, 1946, *Lettere*, pp. 21–22.

159. Undated diary page [1993], YCAL, box 48, envelope "St. Barth travels."

160. Sterne, conversation with the author, July 17, 2005.

161. Marbella Diary, April–May 1993, YCAL, box 95.

162. Ibid. Fasting on Yom Kippur was Steinberg's only religious observance.

163. Ian Frazier and Saul Steinberg, *Canal Street* (New York: The Library Fellows of the Whitney Museum of American Art, 1990); Steinberg, "3 Postcards & 9 Dogs," *Grand Street*, no. 36 (Summer 1990), pp. 51–64; Steinberg, "13 Drawings," *Grand Street*, no. 48 (Winter 1994), pp. 65–79; Steinberg, *The Discovery of America*, with an introduction by Arthur C. Danto (New York: Alfred A. Knopf, 1992). Drawings in *The New York Review of Books* were published in the following issues: December 22, 1994, cover; March 23, 1995, p. 21; February 1, 1996, p. 35; June 20, 1996, p. 59; August 8, 1996, p. 11; November 14, 1996, p. 4.

164. Two of Steinberg's three appearances in *The New Yorker* under Gottlieb had been in color. One was an illustration for Frazier, "Canal Street," April 30, 1990, the other an extremely small reproduction of a drawing, October 19, 1992, that appeared in *The Discovery of America*, p. 198.

165. On Steinberg's attitude to *The New Yorker* in the nineties, see Steinberg to Buzzi, January 9, 1993, *Lettere*, pp. 222–23: "I'm suffering over the corruption of the *New Yorker*, which you'll observe in the next few issues. . . . It's much worse than I had feared, a magazine for clever idiots. Having studied the tastes and wishes of its new audience (14-year-olds), this magazine dedicated to making money will become more and more . . . I'll stop now. But I can't, it's my magazine, I played a major role in creating it. Must I divorce my wife because she has a serious illness? I'm paralyzed." March 9, 1993, *Lettere*, p. 227: "The *New Yorker* is better, but still resembles those publicity magazines that you find in the seat pocket on the airplane." But, January 27, 1994, *Lettere*, p. 246: "Now that I've decided to return to the *New Yorker*, it seems better to me."

166. 1995 appointment book, February 8, YCAL, box 82.

167. Steinberg to Buzzi, February 11, 1996, *Lettere*, pp. 286–87. The letter is written on a sheet of *New Yorker* stationery turned upside down, "in order to avoid a sight that I used to love." Steinberg's Librium prescription is listed in the admission questionnaire for his biopsy at Memorial Hospital for Cancer and Allied Diseases, where he also indicates that he has considered or made preparations for suicide, December 5, 1995, YCAL, box 71, folder "Überlingen and Lenox Hill 1995 Fall."

168. Gopnik interview, pp. 10–11.

169. Quoted in John Gruen, transcript of recorded interview with Steinberg, with handwritten emendations by the artist, dated January 19, 1978, p. 14, YCAL, box [67], now possibly box 78, folder "SS Interviews, 1978–99."

170. June 1986 interview, p. 2.

171. Steinberg's description of his time-travel via postcard enlargements supplied the departure point for Aldo Buzzi's prose piece "Chekhov in Sondrio," which the artist in turn helped bring to the pages of *The New Yorker*, September 24, 1992. Buzzi's essay, accompanied by a reproduction of one of Steinberg's postcards (a street in Rybinsk), opens with a sentence from a letter Steinberg had written him on April 11, 1988 (*Lettere*, p. 171): "I have enlarged some early Russian postcards, and looking at them one enters into that world—just before our birth—a most attractive and comprehensible time, with people in uniform, military or school workers, dogs, horses, a *chainaya*, a printer's on the second floor, a man in a long overcoat walking with hands clasped behind him." In a letter to Buzzi of November 23, 1995 (*Lettere*, p. 284), Steinberg describes looking through a magnifying glass at some newly acquired Romanian postcards from the same historical period.

172. "3 Postcards & 9 Dogs," *Grand Street*, no. 36 (Summer 1990), pp. 51–64.

173. The portfolio of photocopies is in YCAL, box 121.

Catalogue

1. Gopnik interview, p. 9.

2. On *Bertoldo*, its artists, and Steinberg's contribution, see Carlo Manzoni, *Gli anni verdi del Bertoldo* (Milan: Rizzoli, 1964); Cinzia Mangini and Paola Pallottino, *Bertoldo e i suoi illustratori* (Nuoro: Ilisso Edizioni, 1994); and Carlotta and Alberto Guareschi, *Milano 1936–1943: Guareschi e il Bertoldo* (Milan: Rizzoli, 1994). A copy of Piervaleriano Angelini's thesis, "L'attività italiana di Saul Steinberg" (University of Pavia, 1981–82) is on file at SSF.

3. For one proposal and Steinberg's rejection, see Augusto Marcelli to Steinberg, May 26, 1961 and November 28, 1962, YCAL, box 14, folder "Correspondence 1961–62."

4. For Mosca, see Mangini and Pallottino, *Bertoldo e i suoi illustratori*, pp. 82–91.

5. Brendan Gill, "Saul Steinberg's Surprise," *Horizon* 21 (April 1978), p. 71.

6. Steinberg to Henrietta and Harold Danson, March 16, 1942, quoted in Lawrence Danson, "An Heroic Decision," *Ontario Review* 53 (Winter 2000–01), p. 64. Ciudad Trujillo's first school of fine arts, subsequently the national academy of the Dominican Republic, took shape only in the season after Steinberg's departure, under the impetus of a group of émigré artists whom he had evidently known there, including Manolo Pascual and Vela Zanetti; see Don V. Catlett to Steinberg, October 19, 1942, YCAL, box 1, folder "1942 Correspondence."

7. Now YCAL 2853; reproduced in IVAM 2002, frontispiece.

8. See the sketch in Steinberg's letter to Henrietta Danson, August 25, 1941, reproduced in Danson, "An Heroic Decision," p. 56.

9. The photograph is reproduced in Steinberg, "Chronology," in WMAA 1978, p. 234.

10. See, for example, *All in Line*, p. 49 bottom; Margaret C. Scoggin, ed., *Chucklebait: Funny Stories for Everyone* (New York: Alfred A. Knopf, 1945), cover.

11. *Reflections*, p. 3.

12. Ibid., pp. 16, 21.

13. "Drawings in Color by Steinberg, Paintings by Nivola," April 12–24, 1943, Wakefield Gallery, 64 East 55th Street, New York.

14. Some drawings from the Wakefield show remain with The Saul Steinberg Foundation, SSF 1893–1897, 1899–1900, all drawn on tablet sheets matching this one. The top right verso corners bear prices in pencil, ranging from $35 to $45. The factory view is SSF 1895, the crime scene 1896. SSF 1898 is a kind of reverse-angle partner to *Strada Palas*: a penciled but uncolored view of the Steinberg house from the courtyard. It bears no gallery price.

15. Steinberg to Geraghty, June 14, 1944, TNYR box 62.

16. In addition to *Cassino*, five other drawings in this group are at SSF: *South Pacific* (SSF 1223, *Fourteen Americans*, no. 150), *Nuremberg* (SSF 1949, ibid., no. 151), *China* (SSF 1948, ibid., no. 143), and two titled *Germany* (SSF 1222, 1950).

17. *Fourteen Americans*, nos. 131, 135. Steinberg donated the exhibited impression of *Head* (on green paper) to The Museum of Modern Art. A second impression of it (on beige paper) and one of *Monuments* (on turquoise paper) that he gave to curator Dorothy C. Miller were sold at Christie's, New York, Dorothy Miller sale, November 12, 2003, lots 172, 174. The printer was Richard Haas.

18. Book covers and prints by José Guadalupe Posada are at YCAL, box 37, folder "José Guadalupe Posada book covers."

19. For *Movie Palace*, *Drugstore*, and *Doubling Up*, see *The Art of Living*, pp. 25, 33, 41.

20. Steinberg to Buzzi, May 29 and July 23, 1947, *Lettere*, pp. 26–27.

21. "Your Perfume According to the Stars," *Harper's Bazaar* 81 (October 1947), p. 186; Gian-Carlo Menotti, *The Telephone* (New York: G. Schirmer, 1947); *The Art of Living*, p. 142.

22. Fleur Cowles to Steinberg, October 26, 1951, YCAL, box 1, folder "1943 Correspondence." In 1950 Cowles had commissioned Steinberg's two photographic features for *Flair*, "Portraits" and "The City" (see Bibliography, p. 270). On Cowles as impresario, see *Fleur*

on *Flair: A Magazine and Its Legacy*, exh. brochure (New York: Pratt Manhattan Gallery, 2003) and S.J. Perelman, "The Hand that Cradles the Rock," *The Most of S.J. Perelman* (New York: Simon and Schuster, 1958), pp. 439–44.

23. Quoted in Robert Hughes, "The Fantastic World of Steinberg," *Time*, April 17, 1978, p. 94.

24. Steinberg discusses chairs in Dore Ashton, "A Victorian Dialogue with Saul Steinberg," unsigned typescript, c. 1954, pp. 7–8, YCAL, box 8.

25. Steinberg and unknown author, "Psychoanalyze Your Furniture," *House Beautiful* 85 (January 1943), pp. 32–33; *The New Yorker*, November 10 and 24, 1945, April 13, 1946, and October 12, 1946; "Furniture News from France by Steinberg, humoriste américain," *Interiors* 106 (February 1947), pp. 87–89; *The Art of Living*, pp. 2–9, 12.

26. See John A. Kouwenhoven, "The Background of Modern Design," in *An Exhibition for Modern Living*, exh. cat. (Detroit: The Detroit Institute of Arts, 1949), pp. 10–26.

27. Ibid. Kouwenhoven's argument echoes that of Siegfried Giedion, *Mechanization Takes Command: A Contribution to Anonymous History* (Oxford: Oxford University Press, 1948). Steinberg had read Giedion's book in Paris in the summer of 1948; Steinberg to Buzzi, June 10, 1948, *Lettere*, p. 31.

28. Kouwenhoven, *An Exhibition for Modern Living*, p. 26.

29. On this theme (ubiquitous in Steinberg's work) as expressed through the topic of art, see Smith 2005, pp. 88–93.

30. Russell Lynes, "The Taste-Makers," *Harper's* 194 (June 1947), pp. 482–91; Lynes, "Highbrow, Lowbrow, Middlebrow," *Harper's* 198 (February 1949), pp. 19–28. Reprinted—without Steinberg's drawings—as chapters in Lynes, *The Tastemakers* (New York: Harper & Brothers, 1955). The quotation is taken from the book's cover blurb.

31. Charles C. Cunningham (curator of the exhibition), "Painting Paintings of Paintings," *Art News* 48 (November 1949), pp. 32–35, 67.

32. S.N. Behrman, *Duveen* (New York: Random House, 1952); *The New Yorker*, September 29–October 27, 1951.

33. "I have my first camera and that, together with the bullfight I'm going to see tomorrow, make me a perfect tourist"; Steinberg in Mexico to William Shawn, April 12, 1947, TNYR, box 455.

34. For Duco lacquer works, see "False Daguerreotypes, False Diary, False Diploma—True Steinberg," *Vogue* (October 15, 1954), p. 113; *The Passport*, pp. 18, 20–21. For photography-related cartoons, see Smith 2005, pp. 76, 148.

35. The photographers with whom he collaborated on these works included Paul Nodler, Hans Namuth, Louis Faurer, and Werner Wolff. See Bibliography, p. 270, for the 1950 photographic features in *Flair*. Faurer's collaboration with Steinberg is discussed in Anne Wilkes Tucker et al., *Louis Faurer*, exh. cat. (Houston: The Museum of Fine Arts, 2000), p. 33. Wolff's credit stamp appears on the verso of cat. 13.

36. For advertising art in which Steinberg's drawing is partnered with photography, see ads in *The New Yorker* for Miron Woolens (January–April 1950 and January 27, 1951), Emerson Radios, Simplicity Patterns, and Noilly Prat Vermouth (September 17 and 24, October 8 and 22, and December 3, 1955). In 1955, Steinberg's ad content in *The New Yorker* outweighed and outpayed his thin editorial contributions. If this was a subtle form of strike, its point was not lost on art editor James Geraghty; see p. 50.
Steinberg's photo-drawing composites extended to advertising work published in markets beyond *The New Yorker*. See, for example, his art in ads for Lewin-Mathes copper products and Wasco ventilators. A series of ads for Lewin-Mathes appeared, 1955–57, in *Fortune*, *Newsweek*, *Time*, *Business Week*, and architectural magazines, including *Progressive Architecture* and *Architectural Record*. One of the Wasco ventilator ads was published in *Progressive Architecture* 36 (April 1955), p. 66.
For an example of direct appropriation of his combination of line art, assemblage, and photography, compare the 1955 campaign for Nettleton loafers (*The New Yorker*, October 29, 1955, p. 3) to "Portraits by Steinberg," *Flair* 1 (March 1950), pp. 89–90.

37. YCAL, box 1, folder "Souvenirs."

38. Both of these drawings may have been exhibited in Steinberg's double exhibition at the Parsons and Janis galleries in New York in early 1952. (Extant records, typically featuring a one-word descriptive

title for each work, do not allow for a thorough reconstruction of the checklist.) Some works in that show went on to his summer exhibition at the Institute of Contemporary Arts in London and the Museu de Arte in São Paulo, and the cited reproductions of these two works accompany reviews of the latter two shows. The watercolor in *Three Liberties* (and in fig. 48) postdates the ink drawing, perhaps by as much as forty years. Anton van Dalen, Steinberg's studio assistant from 1969 onward, recalls seeing the artist applying color to his early works in the studio in the early 1990s; van Dalen, conversation with Sheila Schwartz, SSF, September 3, 2003.

39. *The Passport*, pp. 26–39; *The Inspector*, pp. 1–15; *The Discovery of America*, pp. 3–6. The parade drawings in *The Inspector* were originally published as a six-page spread in *The New Yorker*, May 25, 1968, pp. 36–41.

40. Quoted in "The End Is Not in Sight," sidebar to "Steinberg and Sterne," *Life*, August 27, 1951, n.p.

41. Ibid.; The Metropolitan Museum of Art, New York, acc. 1952.3 a–k; Betty Parsons Gallery installation photographs, YCAL, box 83, folder 2 of 8, "Unsorted, unidentified photographs."

42. For drawings in this series, see Steinberg and Ogden Nash, "Living Dangerously," *Vogue* (February 1, 1952), pp. 180–81, and *The Passport*, pp. 130–32. Several ex-voto drawings are preserved at YCAL: a parade float rammed by a moving truck (2890); the FBI at the door (2891); a birthday-cake-bearing mother tripping on the wire of an electric train set (2892). A marquee sign-hanger tumbling off his ladder (*The Passport*, p. 131) is YCAL 2889; a variant of the Calder mobile disaster (*The Passport*, p. 132) is YCAL 2893.

43. Aline B. Louchheim, "Steinberg: Artist and Humorist," *The New York Times*, February 3, 1952, p. X9.

44. Recipients of Steinberg diplomas include: Igor Stravinsky, Carl Dreyer, Billy Wilder, Charles Eames, Hedda Sterne, Le Corbusier, Vladimir Nabokov, Dick ("Riccardo") Blow, Alfred H. Barr, Jr., Thomas B. Hess, Betty Parsons, Heinrich Ledig-Rowohlt, and Josef Albers.

45. Quoted in Margaret Staats and Lucas Matthiessen, "The Genetics of Art, part II," *Quest* 1 (July–August 1977), p. 38.

46. June E. Downey, *Graphology and the Psychology of Handwriting* (Baltimore: Warwick & York, 1919), p. 2.

47. Quotations in this paragraph are from Glueck 1970, p. 114.

48. Invitation card, "Saul Steinberg: Drawings," Betty Parsons and Sidney Janis galleries, 1952. The same drawing was reproduced in *Habitat* (Brazil), no. 7 (1952), p. 81.

49. Janis to Steinberg, December 9, 1953, YCAL, box 8, folder "Correspondence 1953."

50. Alexander Calder, *Three Young Rats and Other Rhymes*, edited and with introduction by James Johnson Sweeney; limited edition (New York: Curt Valentin, 1944); popular edition (New York: The Museum of Modern Art, 1946).

51. Ibid., p. v.

52. Steinberg produced one or two holiday card designs a year for MoMA through 1952. After that time, a contract with Hallmark put an end to this arrangement, but as late as 1962 the museum was still reprinting his designs as they sold out. See royalty receipts and June 1952 correspondence between Raymond Hall of Hallmark, Steinberg, and Monroe Wheeler of The Museum of Modern Art, YCAL, box [45], folders "1950" and "1952"; box 14, folder "Sports Illustrated correspondence."

53. Raymond Hall wrote to Steinberg on February 6, 1952, enclosing $5,000 for one wrapping paper design (not realized), six Christmas card designs and a box design for a 1952 set, and one Valentine's Day card design for 1953; YCAL, box [45], folder "1952."

54. Twenty-three of Steinberg's Hallmark cards are in YCAL, box 2, folder "Christmas cards." For a selection of Steinberg Christmas cards, see L. Fritz Gruber, "Christmas and New Year's Cards," *Graphis*, no. 32 (1950), pp. 342–43; "Santa Takes a Holiday," *Design: For Arts in Education* 57 (November–December 1955), p. 60; *Literary Cavalcade* 8 (December 1955), cover and p. 3.

55. Steinberg spent July 3–11 and July 20–25 in Chicago; 1952 year book, YCAL, box 3. See also his (unused) convention press passes, YCAL, box 39, folder "Travel related items," and the letter of intro-

duction from Harding T. Mason (associate editor, *The New Yorker*), July 1, 1952, YCAL, box [45], folder "1952."

56. YCAL sketchbook 4882 features largely architectural details and views, including indications of locales on the New York-Chicago route.

57. Steinberg called Evans "an important pointing finger whose early discoveries nourished generations of abstract painters and cinema people"; quoted in Grace Glueck, "The 20th-Century Artists Most Admired by Other Artists," *Art News* 76 (November 1977), p. 101. Evans was a model for Steinberg, too, in his insistence on artistic freedom in the context of a magazine. *Fortune*, Evans remarked in 1971, "had the sense to know . . . I'd be better for them, even, if they left me alone. And I was"; quoted in Douglas Eklund, "'The Harassed Man's Haven of Detachment': Walker Evans and the *Fortune* Portfolio," in Maria Morris Hambourg et al., *Walker Evans*, exh. cat. (New York: The Metropolitan Museum of Art, 2000), p. 124.

58. Yorick, "Running Commentary" (column), *Evening News* (Yorkshire), May 10, 1952, n.p., YCAL, box 132, clippings scrapbook.

59. Steinberg occasionally posted such imitation postcards. In the Lee Miller Archive, East Sussex, England, is one similar to this, signed by Miller, Steinberg, and Sterne and mailed from New York to Roland Penrose, dated October 22, 1954.

60. William H. Whyte, Jr., "Belongingness," chap. 2 in *The Organization Man* (New York: Simon and Schuster, 1956).

61. 1952 year book, December 13, YCAL, box 3.

62. Though this drawing did not appear on the cover of *The New Yorker* until November 23, 1968, Steinberg had been paid for it nearly four years earlier, on February 6, 1965; YCAL, box 9, deposit book. The tall central figure does not appear on the cover, and must have been added after the art was photographed, probably in fall 1968. See also a study that includes the added figure in *Le Masque*, p. 106.

63. Steinberg to Buzzi, April 29, 1964, *Lettere*, p. 60.

64. Interview with Rolf Karrer-Kharberg, 1967, transcript, pp. 1, 6, YCAL, box 100, folder "Correspondence 1968–69."

65. See Steinberg's drawings in Cleveland Amory, "Palm Beach," *Life*, January 21, 1952. The letter of introduction from *New Yorker* editor Harold Ross that Steinberg carried on this trip is typical of those he took on his travels over the years: "November 28, 1951. To Whom It May Concern: The man presenting this letter is Saul Steinberg, artist for The New Yorker Magazine. He is travelling throughout the United States on the hunt for material for drawings. Any help you can give him will be greatly appreciated by the undersigned"; YCAL, box [45], folder "1952 Letters."

66. For other products of this collage procedure, see the related sidewalk scenes in *The Passport*, pp. 178–79 and 184–85. The collage illustrated on p. 179 is SSF 866; some of the cutout figures on p. 184, now detached from their backing, are in miscellaneous boxes at YCAL.

67. Sketches from the summer 1952 trip, including studies of the pier at Brighton, appear in YCAL sketchbook 4862.

68. Related works include *Harrar Diary*, 1951, reproduced in *The Passport*, pp. 8–9, and *Rimbaud Document*, 1953 (SSF 1049), reproduced in WMAA 1978, p. 65 (detail) and IVAM 2002, p. 58.

69. Though Steinberg owned other books on Rimbaud, his main source was Enid Starkie, *Arthur Rimbaud* (1938; rev. ed. New York: W.W. Norton, 1947; 3rd ed., London: Faber & Faber, 1961). On a "reading menu" he wrote for friends in the early 1970s, Steinberg included the Starkie biography among the "entrées"; YCAL, box 64, folder "Correspondence 1985–87."

70. Ashton, "A Victorian Dialogue with Saul Steinberg," pp. 7–8.

71. *The New Yorker*, September 18, 1954, pp. 30–31, SSF 3748. Reproduced in E.H. Gombrich, *Art and Illusion: A Study in the Psychology of Pictorial Representation* (New York: Pantheon Books, 1960), pp. 203–04. A third iteration of *The Line* (1959 or 1960), intermediate in length but the most polished and graphically elaborate, introduces Steinberg's fourth American book, *The Labyrinth*, pp. 1–7, published in 1960; SSF 3802–3808.

72. For these two drawings, see p. 239, note 90.

73. The mammoth UN project deepened Steinberg's friendship with Le Corbusier, who "used Nivola's [8th Street] studio as his own for nearly two years" while the project dragged on, to the architect's

misery; Micaela Martegani, *Constantino Nivola in Springs*, exh. cat. (Southampton, New York: The Parrish Art Museum, 2003), p. 16. Social plans with Le Corbusier in Paris and New York appear throughout Steinberg's 1946–58 appointment books, YCAL, box 3. On April 23, 1958, Le Corbusier wrote a solemn letter of gratitude for a birthday album that included one of the artist's diplomas. Le Corbusier's wife had died one day before the gift arrived. He addressed the givers as "Saul Steinberg Walter Gropius Breuer Paul Lester Wiener Papadaki Chermayef [*sic*] Albers Wells Coates Mies Van der Rohe Nivola"; YCAL, box 5, folder "Special letters 1957–60." A street postcard portrait of Steinberg, Sterne, and Le Corbusier (YCAL, box 4, folder "Photos including woman/tub") became the basis for a later sketch by Steinberg of himself and Le Corbusier, SSF 2203, late 1980s.

74. 1954 Chicago Cubs Program, YCAL, box 1, folder "Menus"; press pass, Milwaukee County Stadium, YCAL, box 2, folder "Steinberg's Christmas cards"; 1954 year book, YCAL, box 3; travel receipts, YCAL, box 8, folder "Correspondence 1953." It was the former Boston Braves' second season in Milwaukee, and right fielder Hank Aaron's first appearance with a major league team.

75. Steinberg, "Chronology," in WMAA 1978, p. 240, and Stefan Kanfer, "Art May Be Long, Says Saul Steinberg, But It Should Be Worth Laughing At Too," *People*, May 29, 1978, p. 80.

76. *Reflections*, pp. 51–52.

77. "My childhood, my adolescence in Romania were a little like being a black in the state of Mississippi"; *Reflections*, p. 3.

78. 1955 year book, January 8–13, YCAL, box 3. At Evans' on January 6, the other guest was George Orwell's widow, Sonia Brownell; Lee Miller—a mutual friend—had urged Steinberg to befriend; YCAL, box 8, folder "Correspondence 1952." See Belinda Rathbone, *Walker Evans: A Biography* (Boston: Houghton Mifflin, 1995), pp. 228–29.

79. Compare sketches in YCAL sketchbook 4848 (Mississippi, January 1955) and sketchbook 4888 (North Carolina, February 1954) to Hambourg et al., *Walker Evans*, cats. 74–76 (*Mississippi Town Negro Street* and *Vicksburg*, 1936) and 77–78 (*Church* and *Negro Church, Beaufort, South Carolina*, 1936).

80. "Samarkand, U.S.S.R.," *The New Yorker*, May 12, 1956, pp. 44–48, and "Moscow in Winter," June 9, 1956, pp. 31–34.

81. Sketchbooks and notebooks from the 1956 USSR trip include YCAL 199, 200, 202b, 3173, 3176, 3191, 4860, 4869; see also National Diary 1956 (small), YCAL, box 3.

82. Steinberg described his motivation for going to Samarkand to both Hedda Sterne and Ian Frazier; conversations with the author, May 6, 2002, and March 11, 2004, respectively.

83. June 1986 interview, p. 2. Steinberg's final drawing was published in two "edits," first closely cropped in "Samarkand, U.S.S.R.," p. 47, and later in its entirety in *The Labyrinth*, p. 196.

84. In a Steinberg cartoon for *Bertoldo* titled "At the Races" ("Alle Corse," December 15, 1936, p. 2, Angelini, "L'attività italiana di Saul Steinberg," no. 12), one viewer asks another: "But if only the first horse wins, what's the point of the others running?" Steinberg's involvement in the racetrack led to an eight-page color portfolio, "Steinberg at the Races," in *Sports Illustrated*, November 11, 1963, pp. 40–47. Other race drawings appear in *The Passport*, pp. 70–73, and *The Labyrinth*, pp. 161–65.

85. Juilliard Opera Theater Program, YCAL, box 6, folder "Correspondence 1959." The production was also staged at Spoleto in the summer of 1962. The present drawing can be dated to late 1958 by the crayon cypresses at left, a match for those in Steinberg's third *New Yorker* cover, January 17, 1959. Ory-like knights on horseback appear in an accordion sketchbook datable to the same year (YCAL sketchbook 3073). Costantino Nivola's young daughter, Claire, gave the artist three drawings, dated 1958, of knights that appear to be modeled on Steinberg's; YCAL, box 8, folder "Correspondence 1958."

86. Photographs: YCAL, box 2, folders "Count Ory: photographic prints" and "Stats or photos of drawings sold or lost"; box 50, folder "Photographs, unsorted." Program notes indicate that Steinberg designed a poster (whereabouts unknown) for the Juilliard production; YCAL, box 5, folder "Correspondence chiefly 1960."

87. YCAL, box 38, folders "Pollock's Juvenile Romance" et seq.

88. 1959 year book, November 19, YCAL, box 3; Spender to Steinberg, December 7, 1959, YCAL, box 6, folder "Correspondence 1959"; Spender to Steinberg, December 16, 1959, YCAL, box 10, folder "Special letters."

89. Stephen Spender, "Steinberg in the West," *Encounter* 14 (April 1960), p. 4.

90. Steinberg used two-paper schemas to represent figure and ground in two published projects of around this time: illustrations for Stuart Chase, "How to Read an Annual Report," *The Lamp* (Standard Oil of New Jersey) 39 (Winter 1957–58), p. 20 (a brochure version of the article includes more examples), and a direct mail brochure for the 1959 Lincoln Continental, "A Brief Message About Your Motoring Comfort"; copy at SSF.

91. "Vingt masques sinistres de mi-carême: le dernier gag de Steinberg," *Paris Match*, March 14, 1959, pp. 18–19. The book-jacket author portrait by Inge Morath for Steinberg's *The Labyrinth* is of the same moment as the photographs in this feature. See also "The Faces of Steinberg," *Harper's Bazaar* 93 (December 1959), pp. 118–19. Steinberg appeared masked on the cover of *The New York Times Magazine*, November 13, 1966, in connection with a feature by Harold C. Schonberg, "Artist Behind the Steinbergian Mask," pp. 48–51, 162–69; in a photograph by Irving Penn, *Vogue* (January 1, 1967), p. 96, in connection with Harold Rosenberg, "Steinberg: A Unique Artist—A Specialist in the Riddles of Identity," pp. 96–99, 137–38, 146; and on the cover of *Frankfurter Allgemeine Magazin*, May 30, 1986, in connection with Erwin Leiser, "Saul Steinberg," pp. 14–22. Steinberg remarked, "I was able to relax inside the masks and show a constant public image of myself to the camera. . . . So I used photography in a way that defeated its purpose. Instead of catching that famous fleeting moment, that peculiar expression on my face, I gave them something steady that I made"; quoted in Jean vanden Heuvel, "Straight from the Hand and Mouth of Steinberg," *Life*, December 10, 1965, p. 70.

92. See *Saul Steinberg Masquerade*, photographs by Inge Morath (New York: Viking Studio, 2000). Among the participants in the 1961 group shoots on Long Island were Steinberg, Sigrid Spaeth, Morath's husband Arthur Miller, and writer Norman Rosten. See Rosten to Steinberg, November 1962 and undated, YCAL, box 14, folders 1–2 of 5, "Correspondence 1961–63."

93. Untitled portfolio, *The New Yorker*, May 5, 1962, reproduced in part in Smith 2005, p. 150; *Steinberg: Le Masque*, texts by Michel Butor and Harold Rosenberg, photographs by Inge Morath (Paris: Maeght Editeur, 1966), pp. 146–55. Rosenberg's text appeared in English as "Saul Steinberg's Art World," *Art News* 65 (March 1966), pp. 51–54, 67.

94. Red ink handwritten notes, 1965(?), on three loose leaves of *New Yorker* stationery, YCAL, box [58].

95. Interview with Rolf Karrer-Kharberg, 1967, transcript, p. 4, YCAL, box 100, folder "Correspondence 1968–69."

96. Quoted in Rosenberg, in WMAA 1978, p. 13, note 3.

97. Joshua C. Taylor, *Futurism*, exh. cat. (New York: The Museum of Modern Art, 1961).

98. *Hotel Plaka, Hotel Pont Royal*, and *Albergo Minerva* are reproduced in WMAA 1978, pp. 13 and 128; *Hotel Modena* in *Saul Steinberg: Drawing into Being*, exh. cat. (New York: PaceWildenstein, 1999), p. 43.

99. Quoted in vanden Heuvel, "Straight from the Hand and Mouth of Steinberg," p. 66.

100. Leo Steinberg, "The Glorious Company," in Jean Lipman and Richard Marshall, *Art About Art*, exh. cat. (New York: Whitney Museum of American Art, 1978), p. 20.

101. 1945–77 appointment diaries, pocket diaries, and year books, YCAL, box 3; 1959 National Diary, box 4; 1963 year book and 1975, 1977–78, 1980–1992, 1994 *New Yorker* Diaries and 1993–99 appointment diaries, box 82.

102. The first major battle between the American and North Vietnamese forces in the South, at Ia Drang Valley, November 14–16, 1965, had been followed by an ambush of the US 7th Cavalry on November 17. At the time of Steinberg's day-in-the-life, American troops in Vietnam numbered over two hundred thousand. Two days later, on November 27, thirty-five thousand protesters would encircle the White House and march on the Washington Monument.

103. Correspondence from Ada Ongari and bank records of Steinberg's ongoing periodic transfers into her account are scattered throughout Steinberg's papers. Photographs of Ada, some with Steinberg, taken from the 1930s to the 1950s, are at YCAL, box 40, folder "Family 1910–20, photographs of Ada."

104. Zogbaum (born 1915) had died January 7, 1965; Ibram Lassaw (born 1913) died in 2003.

105. Published by Simon and Schuster, 1967. Copies of Tillich's May 1961 contract for the book, which changes the title from *My Encounter with God* to *Who Am I?*, and Steinberg's contract with the publisher, September 1, 1966, are at YCAL, box 1, folder "Contracts 1944–67." Steinberg met Tillich (a colleague of Harold Rosenberg's at the University of Chicago, 1962–65), to discuss the project. After Tillich's death, he met with the book's editor, Ruth Nanda Anshen, in January 1966 and on several subsequent occasions; 1966 year book, YCAL, box 3. Steinberg told a reporter in April 1967 that he had "assented to Tillich's request to illustrate his *credo*, 'but I hoped to get out of it. Now that he is dead I look on it as an obligation'"; quoted in Mary M. Krug, "Enigmatic Steinberg Discusses Residency," *The Torch* (Smithsonian Institution) 12 (April 1967), p. 3.

106. Quoted in Pierre Schneider, "Steinberg at the Louvre," *Art in America* 55 (July–August 1967), p. 85. The *Lebenstreppe* in Steinberg's *New Yorker* cover, November 11, 1967, makes the same point; see Smith 2005, pp. 146, 149, and the original drawing reproduced in WMAA 1978, p. 125.

107. For Steinberg's contract with the Smithsonian Institution, January 10–May 10, 1967, see YCAL, box 10, folder "Contracts, old."

108. The first quotation is from *Reflections*, p. 45, the second from Mary M. Krug, "Enigmatic Steinberg Discusses Residency," p. 3.

109. Krug, ibid.

110. Glynn Ross of The Seattle Opera Association to Steinberg, November 21, 1966, YCAL, box 16, folder "Correspondence 1966–67." In the Seattle Opera's production, the opera's title was rendered *Story of a Soldier*. Cary Grant was an early prospect to play the Narrator. Steinberg oversaw but did not participate in the painting of the screens, which were discarded when the production concluded, March 9, 1967. Steinberg's proposed follow-up for the 1969 season, Mozart's *The Magic Flute*, did not materialize; see Glynn Ross to Steinberg, February 28, 1967, YCAL, box 16, folder "Correspondence 1967."

111. Quoted in Krug, "Enigmatic Steinberg Discusses Residency," p. 3. "Those buildings" then appear in a Steinberg drawing in *The New Yorker*, August 5, 1967, p. 32, and in drawings in Tillich, *My Search for Absolutes*, pp. 115 and 117.

112. Steinberg, "Our False-Front Culture," *Look*, January 9, 1968, p. 48.

113. The artists were paired in the exhibition "Saul Steinberg and Paul Klee: An Exhibition of Drawings," The Art Gallery, University of California, Santa Barbara, November 20–December 16, 1962; see letters from David Gebhard, director of the gallery, August–October 1962, YCAL, box 14, folder 1 of 5, "Correspondence 1961–63." Among similar comparisons, see Max Egly, "Klee, Steinberg, MacLaren," *Image et Son: Revue de Cinéma*, no. 182 (March 1965), pp. 58–62, and Schonberg, "Artist Behind the Steinbergian Mask," p. 165.

114. Quoted in Glueck 1970, p. 114.

115. Paul Klee, *Pedagogical Sketchbook*, trans. Sibyl Moholy-Nagy (1925; ed. New York: Praeger, 1953), section 4.33, p. 53.

116. Quoted in vanden Heuvel, "Straight from the Hand and Mouth of Steinberg," p. 62.

117. 1965 year book, November 13, YCAL, box 3.

118. Steinberg to Buzzi, October 26, 1951, *Lettere*, p. 40. Three hundred fifty-four rubber stamps, found and commissioned, are in YCAL, boxes 52, 53, and 55.

119. See *The Passport*, endpapers and p. 28; "Saul Steinberg Stamp Collection," *Harper's Bazaar* 90 (June 1959), pp. 70–73; *The Labyrinth*, p. 111. (Steinberg had drawn/stamped the works in the *Harper's Bazaar* feature on the pages of a 1954 appointment book, YCAL sketchbook 3128; in the magazine plates, headings from a 1958 appointment book are substituted.) On the false documents Steinberg made from the 1940s to the 1960s, the seals, stamps, and cancellations are either hand-drawn imitations (as in cat. 20) or found stamps (e.g., that of the Lympia Club, in cat. 27).

120. "Rubber Stamps," *The New Yorker*, December 3, 1966, pp. 56–61. Steinberg's rubber stamps were made from his drawings by William Cypel at the Union Stamp Works and Printing Co., 817–819 Broadway (later 48 East 12th Street); invoices for thirty-three stamps, with test proofs, are in YCAL, box 8, folder "Correspondence 1969–70."

121. Quoted in Grace Glueck, "A Way to Stamp Out Art," *The New York Times*, November 9, 1969, p. D28.

122. See, for example, Mangini and Pallottino, *Bertoldo e i suoi illustratori*, figs. 152–53 and 255 (all 1937).

123. See *PM*, December 13, 1942 (reproduced in *All in Line*, p. 51) and March 9 and 23, 1943. A photocopied set of Steinberg's *PM* work is at SSF.

124. Reinhardt wrote to Steinberg in Washington, D.C., in early 1967: "I have a feeling I should do something about the dirty war. What? Aren't we now like all the Germans who said they didn't know what was going on? You think there are some images, pictures, lettering, ideas (visual), tricks, shenanigans, symbols, figurations (flat), anything one can do as a naïve artist? One artist's five-year-old made a drawing of a five-year-old saying [in a talk balloon] Don't Kill Me! You think that's any good? I know a sixty-three year old artist who would make a drawing of a 63 yr-old child saying [in a talk balloon] Don't Kill Me! Is that a better idea?"; undated letter, YCAL, box 20, folder "Primo L."

125. Steinberg regularly donated art to fundraisers against the war, for example, in 1967, to the group exhibition "Protest and Hope: An Exhibition of Contemporary Art" at the New School Art Center, New York. In 1970, a number of art galleries in New York and elsewhere staged simultaneous "Art for Peace" exhibitions. The shows culminated in a benefit auction for Referendum 70, a national organization supporting anti-war Congressional candidates. Steinberg contributed the art for the auction's poster, featuring the spiral-drawing artist motif in cat. 51 and entitled *Preferendum 70*.

He also saved many flyers and circulars received from artist groups organizing protest events and exhibitions. In December 1966, as he was preparing to take up residence in Washington, Max Kozloff and Dore Ashton, of Artists and Writers Protest, invited him to help create a collective "Collage of Indignation" during a "Week of the Angry Arts," January 29–February 4, 1967; see YCAL, box 16, folder 3 of 5, "Correspondence 1966–67."

126. June 1986 interview, p. 1.

127. *Reflections*, p. 12.

128. Invoices for three Angelus stamps, with test proofs, February 16, 1970, YCAL, box 8, folder "Correspondence 1969–70." See, among many appearances of the Angelus in Steinberg's art, the lithograph *Millet*, in the portfolio *Six Drawing Tables* (Abrams Original Editions, 1970) and *La Vie de Millet*, 1969, reproduced in John Ashbery, "Saul Steinberg: Callibiography," *Art News Annual* 36 (1970), p. 59. In an ex-voto drawing, c. 1983, YCAL 3322, Steinberg remembers seeing the painting in person at a Millet exhibition at the Grand Palais, Paris (October 17, 1975–January 5, 1976).

129. Two such postcards are reproduced in *The Inspector*, pp. 52–53. Steinberg's 1971 exhibition at Galerie Maeght, Zurich, included *Travel*, a different set of nine postcards stamped with the Angelus; YCAL, box 20, folder "Exhibition Maeght Zurich 1971." Four loose postcards bearing Angelus rubber stamps are interfiled with Steinberg's postcard collection in YCAL, box 44.

130. Installation photographs show that this drawing was colored some time after it was exhibited in "Steinberg Cartoons," at the Parsons and Janis galleries in 1976; YCAL, box 83, folder "Installation, Doubles, 1976."

131. Quoted in Glueck 1970, p. 112.

132. *Reflections*, p. 82, where the phrase refers to a drawing of a scene and its reflection in water, as in cat. 74 or fig. 2, p. 21.

133. Related images include *Cultural Revolution*, 1970, in *Steinberg*, exh. cat. (Zurich: Galerie Maeght, 1971), no. 41; *Lex Pax Lux*, 1969, in WMAA 1978, p. 131, and Loria 1995, no. 14; *Allegory II* and *Street War*, both 1970, in WMAA 1978, pp. 105 and 126, respectively; and the drawing that accompanies John Newhouse, "SALT," part II, *The New Yorker*, May 12, 1973, p. 79.

134. The title of Reverend David Wilkerson's novel about a ghetto minister, *The Cross and the Switchblade* (New York: Bernard Geis

Associates, 1963), had become a boilerplate phrase in editorials pre-scribing fear of God as a cure for juvenile delinquency. In 1970 the book was turned into a film starring Pat Boone and Erik Estrada.

135. Quoted in Meera E. Agarwal (Thompson), "Steinberg's Treatment of the Theme of the Artist: A Collage of Conversations," unpublished paper, Vassar College, December 1972, p. 6, YCAL, box 78, folder "Meera Agarwal on ST."

136. *Reflections*, p. 13. Steinberg consistently dated his embittered consciousness of Romanian anti-Semitism to 1924. The pogroms that spread throughout Romania in the 1920s might underlie his fixation on this date. More concretely, it was the year he moved from elemen-tary school to the Liceul Matei Basarab, which he called an "over-crowded, tough school, devoted mostly to Latin"; Steinberg, "Chronol-ogy," in WMAA 1978, p. 234. On Bucharest in 1924 and Steinberg's loss of childhood patriotism, see his letters to Buzzi, July 1, 1967, October 16, 1985, and January 4, 1990; *Lettere*, pp. 70, 144, 188.

137. A stationer uncle of Steinberg's sold German-made metal toys and ornaments such as this one at the shop where Saul worked at Christmastime; *Reflections*, p. 17.

138. The quotations in this paragraph are from the June 1986 inter-view, p. 4.

139. Airmail envelopes mailed from Erba, home of Ada Ongari, figure in *Erba Still Life*, c. 1986, SSF 6315, and on the cover of *The New Yorker*, January 12, 1987 (SSF 14). The invoice in *Konak* records Steinberg's stay at the Hotel Konak, Istanbul, May 24–28, 1953; 1953 year book, YCAL, box 3. Steinberg's first self-described Cubist col-lages date to 1963: "I'm not working well and so to divert myself I do collages of 1912 that I even sign Braque etc."; Steinberg to Buzzi, June 17, 1963, *Lettere*, p. 59. For examples of these, see *The New Yorker*, March 20, 1965, cover; *Le Masque*, pp. 144–63; and at SSF–to name only two works that reference Cubism explicitly–6162 (signed "Avignon 1914") and 6163 (signed "G. Braque"). The artist noted with satisfaction that "The 2 important Cubists Pic[asso] & Gris came out of cartoon"; 1992 appointment book, August 22, YCAL, box 82.

140. Steinberg to Buzzi, May 15, 1970, *Lettere*, p. 76. Both the present lithograph and *The Tree* (p. 184) are probably by-products of the artist's work toward what became the lithographic portfolio *Six Drawing Tables*, published by Abrams Original Editions in 1970. In April, Steinberg had signed a contract to turn in the completed portfolio by November; YCAL, box 40, folder "Contracts, old."

141. For Steinberg's account of the origin of the pineapple in the role of Don Quixote's windmill, see Smith 2005, p. 136.

142. Steinberg, undated typescript, YCAL, box 67. For examples of the "self-made" motif, see Smith 2005, pp. 182–85.

143. Quoted in Agarwal, "Steinberg's Treatment of the Theme of the Artist," p. 9.

144. Steinberg stressed that "[T]hose people on Bleecker Street . . . those 'zombies' dressed like killers, are not real people. They are impersonators. Hookers looking for a kick. I wouldn't worry about them"; June 1986 interview, p. 4.

145. Steinberg deposited *The New Yorker*'s check for delivery of this drawing on December 6, 1970; check record deposit book, YCAL, box 9. Philip Guston's solo exhibition was seen at Marlborough Galleries, New York, in October 1970. Steinberg clipped Hilton Kramer's scathing attack on the Guston exhibition, circling the conclusion (without recording whether it prompted a laugh or tension between Guston and himself): "As it happens, we already have a living master who has given us a whole new view of the socioesthetic terrain that Mr. Guston pretends to have illuminated in these paintings–I mean Saul Steinberg. But Mr. Steinberg has succeeded because . . . he never pretends to be an innocent. Mr. Steinberg is an intellectual, and he has no interest in donning the mask of the stumblebum when he takes up his brush or pencil or rubber stamps. He knows very well that the mileage has long ago run out on that particular charade. To have retained the belief that an artist must nowadays come on as if he were a great big lovable dope is perhaps Mr. Guston's last attachment to the old 10th Street ideology, and it proves to be a fatal one"; *The New York Times*, October 25, 1970, p. D27, YCAL, box 39, folder "Articles and clippings."

146. John Ashbery, "The System," in *Three Poems* (1972), reprinted in Ashbery, *Selected Poems* (New York: Penguin, 1985), p. 123.

147. *The New Yorker*, December 26, 1970, pp. 24–27.

148. Steinberg's set of study photographs of the plates in Maurisset's *Album des Rébus Illustrés* (Paris: [c. 1847–53]), is at YCAL, box 25, folder "Photographs of drawings."

149. See also the *New Yorker* covers for January 31 and March 7, 1970, and December 4, 1971; *The Inspector*, pp. 203, 202, 198.

150. A photograph in the archives of the Galerie Maeght, Paris (no. 16827) shows the work in its unpopulated state. It may have been included in Steinberg's 1973 show at the gallery, possibly as no. 37, *Sixteen Postcards* (unillustrated) in the checklist of *Derrière le Miroir*, no. 205.

151. WMAA 1978, pp. 136, 142, 143, 148, 151.

152. The description of Rothko's work is from Rosenberg, in WMAA 1978, p. 16.

153. On Rothko and the Sublime, see Robert Rosenblum, *Modern Painting and the Northern Romantic Tradition: Friedrich to Rothko* (New York: Harper & Row, 1975) and Kynaston McShine, ed., *The Natural Paradise: Painting in America, 1800–1950*, exh. cat. (New York: The Museum of Modern Art, 1976).

154. The bottom half of *Street War* serves as the basis for the left half of an unpublished lithograph, known only in a test proof, SSF 2678. The sheet dimensions, 15 by 22 7/8 inches, match those of a spread in *Derrière le Miroir*, the series of unbound portfolios published by the Galerie Maeght, Paris, for their one-artist shows. SSF 2678 was proba-bly made, but never used, for *Derrière le Miroir*, no. 205 (September 1973), where related works appear.

155. "Cadavre Exquis" works make their earliest appearance in the exhibition brochure for Steinberg's 1966 exhibition at the Sidney Janis Gallery, no. 6 (illustrated); also reproduced in WMAA 1978, p. 193. Steinberg played the conventional version of *cadavre exquis* with Pablo Picasso during a visit to the latter's studio in Nice, May 16, 1958. Two of their collaborative drawings survive, one at YCAL, the other in the Steinberg estate.

156. Many news clippings and photocopies, dating from the 1960s through the 1990s, are in YCAL, box 126, labeled "Objects from table in studio #582," meaning Steinberg's 75th Street studio.

157. Six of these drawings make up the portfolio "Italy–1938," *The New Yorker*, October 7, 1974, pp. 36–38. One of them (SSF 2267) is a variant of *Milanese II*, featuring parading blackshirts; reproduced in color in Smith 2005, p. 192.

158. The rubber-stamp figure can be seen full-length in *The Inspector*, p. 43 (SSF 6367).

159. Agarwal, "Steinberg's Treatment of the Theme of the Artist," p. 19.

160. Recipients of cameras included Sigrid Spaeth (p. 196), Henri Cartier-Bresson (Collection Fondation Cartier-Bresson, Paris), and Helen Levitt.

161. *Dal Vero* was the title Steinberg gave to a book of his portrait drawings, with text by John Hollander, published by the Library Fellows of the Whitney Museum of American Art, New York, in 1983.

162. Quoted in John Gruen, transcript of recorded interview with Steinberg, with handwritten emendations by the artist, dated January 19, 1978, p. 14, YCAL, box [67], now possibly box 78, folder "SS Interviews, 1978–99."

163. The dates of the still life covers are September 20, 1976; January 7, 1980; April 20, 1981; and January 17, 1983. See also WMAA 1978, pp. 168–71, for 1973–74 still lifes, some featuring motifs seen here.

164. See WMAA 1978, p. 245.

165. Two double Papooses appear, for example, in *Dal Vero*, n.p., SSF 821, dated 1976, and SSF 6280, dated August 1980; another example is SSF 823, dated August 12, 1979.

166. Barry Commoner, "A Reporter at Large: Energy," *The New Yorker*, February 2, 9, and 16, 1975. The three "Energy" illustrations may have been selected from a batch of drawings that included a closely related reflection-themed cartoon, published November 10, 1975, p. 42.

167. For early instances of symmetry on inside pages of *The New Yorker*, see June 11, 1949, Goings on About Town, p. 2 and July 7, 1956, p. 27, a drawing accompanying the first part of Mary McCarthy's profile on Venice. Vertical symmetry plays a part in the covers of

August 29, 1964 and July 23, 1966, horizontal symmetry, in the end-papers for *The Art of Living*.

168. Steinberg's wording appears in *Reflections*, p. 75, where he notes that he had read Pascal's commentary in W.H. Auden, *A Certain World: A Commonplace Book* (New York: Viking, 1970).

169. See Marc Treib, "Maps of the Mind," *Print* 41 (March–April 1987), pp. 112–17. In 1984, the appropriation of the work in a poster for the movie *Moscow on the Hudson* spurred a lawsuit from the artist (*Steinberg v. Columbia Pictures Industries Inc.*), which was decided in Steinberg's favor; see Smith 2005, p. 43.

170. Steinberg would have known Bachman's lithograph from its reproduction in John Kouwenhoven, *The Columbia Historical Portrait of New York* (Garden City, New York: Doubleday, 1953), p. 287. Steinberg's drawing *Doubling Up* (1946; *The Art of Living*, p. 41) also appears in the book, p. 521.

171. A friend mailed Steinberg a 1936 edition of Wallingford's novelty map after the *View of the World* cover had been published; YCAL, box 9, folder "Correspondence 1971–1976."

172. "As for me: the same old catalog, the never-ending show. . . . And this week the interviews and photo sessions for the magazines are already getting underway, plus there's the poster, the invitation, stuff from headquarters, the general staff, the Battle of Austerlitz"; Steinberg to Buzzi, January 17, 1978, *Lettere*, p. 100.

173. YCAL, box 1, folder "Mexico 1968."

174. Steinberg, "Chronology," in WMAA 1978, p. 244.

175. A suggestive paper trail hints that Steinberg may have created football pictures that do not survive. In the week spanning New Year's, 1962, he and Spaeth flew to Los Angeles to see the Rose Bowl, courtesy of *Sports Illustrated*. On January 25, 1962, he was reimbursed $15,000 by the magazine's parent company, Time, Inc., for unidentified "lost paintings"; YCAL, box 3, 1961 year book; box 14, folders "Sports Illustrated Correspondence" and "Bills, Receipts, Correspondence, n.d."

176. Interview with Rolf Karrer-Kharberg, 1967, transcript, p. 8, YCAL, box 100, folder "Correspondence 1968–69."

177. The dancing figure's costume resembles that in a postcard, "Pueblo Indian doing Eagle Dance," n.d., YCAL, box 42.

178. *The New Yorker*, November 29, 1976; reproduced in Smith 2005, p. 204.

179. For the 1981 sketches, as well as a 1989 version and the final cover drawing, see Loria 1995, nos. 45–48.

180. For more sketches of baseball metamorphosed, see YCAL sketchbook 3128 (1954 desk calendar), November 19 (gunfight), 21 (bullfight), 23 (knight and dragon), and 25 (hoary editorial cartoon clichés). For a direct forerunner to the fight between Uncle Sam and an Indian/turkey, see "Rubber Stamps," *The New Yorker*, December 3, 1966, p. 61, YCAL 1214. A bird again deflects the literal meaning of the image, as a mounted Indian faces off against the American flying eagle before a coliseum crowd composed of George Washington heads.

181. Quoted in vanden Heuvel, "Straight from the Hand and Mouth of Steinberg," p. 68.

182. Ibid. Close variants on *November* include a smaller version torn from a sketchbook, reproduced in *Steinberg: 4. Internationale Triennale der Zeichnung*, exh. cat. (Nuremberg: Kunsthalle Nürnberg, 1988), cover and p. 171, and YCAL 6284, reproduced in IVAM 2002, p. 110.

183. William Wertenbacker, "A Reporter at Large: The Law of the Sea," *The New Yorker*, August 1 and August 8, 1983, reporting on the concluding sessions of the Third UN Conference on the Law of the Sea.

184. Steinberg, "Chronology," in WMAA 1978, p. 243.

185. The book was published as *The New World* (1965). For the original title, see the contract between Steinberg and Harper & Row, March 31, 1965, YCAL, box 1, folder "Contracts 1944–67"; Termination Agreement between Steinberg and Harper & Row, May 12, 1978, box 40, folder "Contracts, old."

186. Surviving ex-votos include YCAL 3313–3330, 3337–3350, and 3526–3545.

187. "Notebook," *The New Yorker*, August 22–29, 1994, pp. 98–101; see Smith 2005, pp. 44–45.

188. The other three were published on November 24, December 1, and December 29, 1986.

189. From the late 1960s onward, Steinberg occasionally hired a carpenter to help construct his wood sculptures. He reminisces about carpenter Sig Lomaky in *Reflections*, pp. 90–94.

190. From this stay resulted the drawings for the six-page portfolio "The Coast," *The New Yorker*, January 27, 1951, reproduced in part in Smith 2005, pp. 78–79; for an expanded view, see *The Passport*, pp. 200–19.

191. Steinberg, "Chronology," in WMAA 1978, p. 238.

192. Contract between Gemini G.E.L. and Steinberg dated January 20, 1981, YCAL, box 10, folder "Special letters." The artist agreed to come to Los Angeles to create the prints; Steinberg to Sidney Felsen, February 5, 1981, YCAL, box 40, folder "Contracts, old."

193. The California drawings include *Pasadena, CA* (1989), in *The Discovery of America*, p. 184. YCAL 1729 and 6464, both dated 1984, are labeled "Sagaponack." Two Long Island landscapes (SSF 4111 and 4112, 1980s) highlight the Hamptons combination of potato fields and waterfront McMansions.

194. Lee V. Eastman to Steinberg, June 1, 1981, YCAL, box 58, folder "Show to Pat Willis For Archive." A postcard in the same folder from the McCartneys, postmarked August 21, 1981, does not mention the cover question, which Steinberg had probably put to rest by a note expressing his regrets. The album, retitled *Tug of War*, was released the next year.

195. A variant of this drawing (SSF 4185, 1988) adds to the road cut/cold cut pun a (visually further-fetched) parallel between Swiss cheese and clouds; reproduced in *The New Yorker*, August 9–16, 2004, p. 55.

196. The sketch is YCAL 3928.

197. The photograph is at YCAL, box 127, folder "Material removed from frames." There is a tack-hole at the top of it; an affixed note explains that it was hanging in the living room in Amagansett at the time of Steinberg's death.

198. Ian Frazier, "Canal Street," *The New Yorker*, April 30, 1990; Frazier and Steinberg, *Canal Street* (New York: The Library Fellows of the Whitney Museum of American Art, 1990); the essay is reprinted in Frazier, *Gone to New York: Adventures in the City* (New York: Farrar, Straus and Giroux, 2005), pp. 17–52.

199. SSF 6321. Steinberg's letters (June and July 1963) to the writer Nicola Chiaromonte in the literary voice of Rudy are in the Yale Collection of American Literature, Nicola Chiaromonte Papers, box 3, folder 79. One of the letters is written on roughly torn scrap paper in a deliberately childish hand (paw?)—a match, notably, for the writing style Steinberg had used twenty years before in a letter to Santa from Adolf and Benito; reproduced in *All in Line*, p. 51.

200. YCAL sketchbook 4953.

201. In statement for "The Visual Arts Today" issue of *Daedalus* 89 (Winter 1960), pp. 124–26.

202. Some of the most important losses: Ad Reinhardt (1967), Steinberg's sister Lica Roman (1975), Alexander Calder (1976), Vladimir Nabokov (1977), Harold Rosenberg and Richard Lindner (1978), S.J. Perelman (1979), Charles Addams, Bernard Rudofsky, and Costantino Nivola (1988), Willem de Kooning (rendered incommunicado by dementia in the 1980s), William Shawn (1993); and in a special case, Sigrid Spaeth, who committed suicide in 1996. Remaining close friends of his generation were, overseas, Henri Cartier-Bresson and Aldo Buzzi; in New York, Hedda Sterne; and in Amagansett—until the final months of the artist's own life—William Gaddis.

203. Portraits of Van Gogh are SSF 953 and 4141; Courbet, SSF 6433; Puvis de Chavannes, SSF 6434; Mayakovsky, YCAL 1761.

204. Glueck 1970, p. 114.

205. The early version of *2000* is in YCAL sketchbook 4851, which also includes sketches based on the number 1980, probably preparatory for a *New Yorker* New Year's cover.

206. Steinberg to Buzzi, February 5, 1990, *Lettere*, pp. 189–90.

207. Steinberg to Buzzi, May 27, 1994, *Lettere*, p. 255.

208. SSF 2784 and 2814 are impressions of this earlier state.

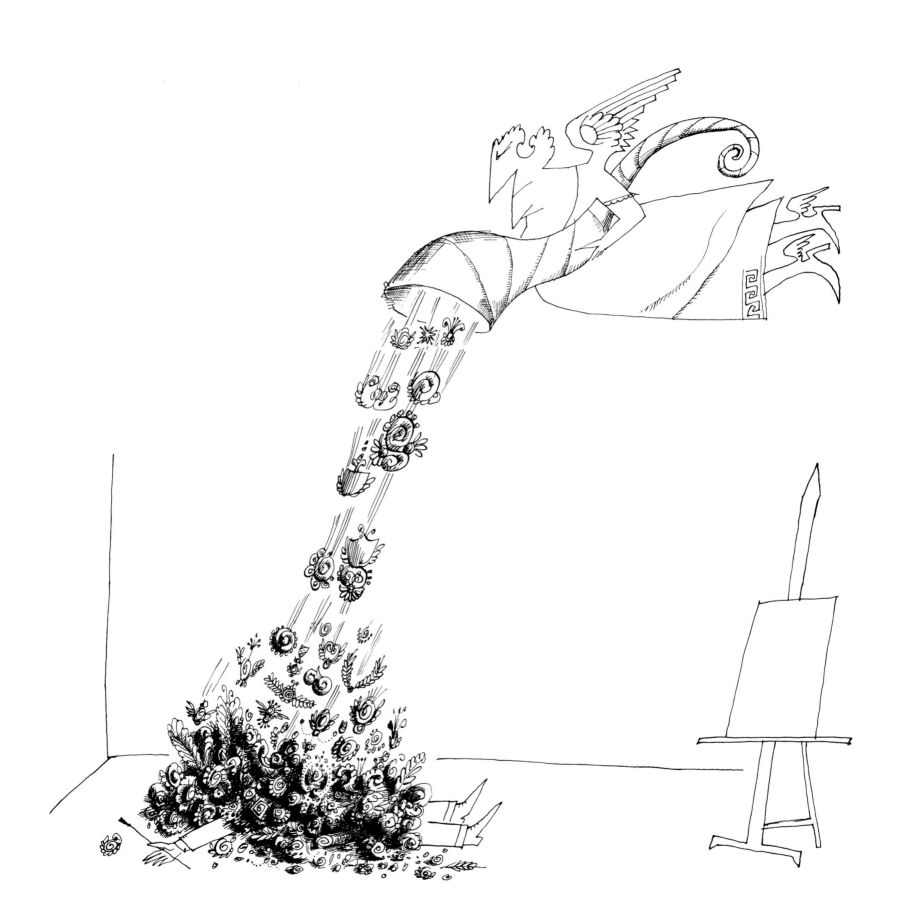

Appendix
Saul Steinberg to Katherine Kuh, 1961

Typed letter, dated November 9, 1961, on New Yorker *stationery, with Steinberg's home address rubber-stamped at the top. YCAL, Katherine Kuh Papers, box 2, folder 28.*

Art historian and curator Katherine Kuh had recently met with Steinberg as part of a campaign of interviews of American artists for publication and preservation in the Archives of American Art.

Dear Katherine,

You probably understood that I wouldn't come back for the continuation of the interview.

Here is the explanation that I owe you for the sake of courtesy and to myself so that I will not be poisoned by unfinished business.

After talking to you for about one hour I realized that I was doing nothing but questioning your questions. This sounded to me like the tradition of Dada, Surrealism, pranks and other devices of desperation and I felt suddenly tired. This was no way to spend an afternoon. I was spending your time and my time without purpose, because, I understood, I was not collaborating. There was, then, a necessity to collaborate? In other words, to create a complicity in which I would play my part according to popular expectations.

I don't question your faithfulness [in] recording the statements of the artist of distinction. There are comical aspects that become interesting with time. I question the position of the artist. This situation implies the collaboration of the artist in the manufacture of history and this sort of instant history is traditionally made to resemble the textbook and the popular version. In other words, fiction. This planting of artistic ruins for present and future archeologists results per force in predictable originality and the faults of documentaries, lifelike situations and other catch-the-fleeting-moment arts.

(This exercise is dangerous too. The man involved in his own history becomes himself a work of art. And a work of art doesn't permit changes and it doesn't paint or write.)

I consider then this business of answering questions as being fiction, in our case theatre, complete with script, ad-libs and audience.

If I follow my instinct, which is non-fiction, I would greet your questions with grunts, sighs, silence. You would not print that. If I decide to cooperate with you I would give you fiction, entertainment and for this performance I want to be paid. The money will clarify our positions and certainly make me take this project seriously.

My fee, for the interview and several drawings to go with it, will not be extravagant and I hope that you and your publisher will agree with my moral and money reservations.

In any case you are welcome to print this letter as a conclusion to my unfinished interview. This for free of course. It's a personal letter written out of my own desire to clarify my mind and the situation. With affection and best wishes

[signed]

The New World, p. 109, detail in *The New Yorker*, September 15, 1962.

Adult Comics, c. 1990. Pencil on
two sheets of paper, 14¾ x 23 in.
each (37.5 x 58.4 cm). SSF
4179.

Chronology and
Selected Exhibition History

The "ingredients lists" for Steinberg's books are taken
from the Chronology he wrote for his 1978 Whitney
Museum exhibition catalogue (WMAA 1978), pp. 234–45.
Quotations are from the same source or, when indicated,
from Steinberg's letters to Aldo Buzzi (see Bibliography,
p. 268).

1914–19

Born June 15 (Julian calendar), 1914, Râmnicul Sărat,
Romania. When he is six months old, the family (father
Moritz, mother Rosa Iacobson, older sister Lica) moves
to Bucharest. As an adult, he will often celebrate his
birthday either on June 16, the Bloomsday of James
Joyce's *Ulysses*, or on his birthday's new-calendar equiva-
lent, June 28. On the day he is born, Archduke Franz
Ferdinand is assassinated in Sarajevo, precipitating World
War I; the Treaty of Versailles will be signed on the same
day five years later.

Moritz Steinberg serves in an artillery regiment during
the war, returning home in 1919. Saul later writes to Aldo
Buzzi: "He was a printer and binder of books, and then,
prodded by his wife, he bought machinery and became a
manufacturer—Victoria, *Fabrica de Cartonaje*. He made
cardboard boxes, a profession he didn't like, near the
flower market on Strada Soarelui (the street of the sun),
a narrow, rat-infested lane, disastrous for horses in the
winter."

Amid postwar financial upheavals, the family benefits
from American government aid and care packages from
cousins who have immigrated to America.

1920–24

In the early 1920s, Romania's chronic anti-Semitism is
enflamed by violent demonstrations and pogroms, led by
popular and proto-Fascist university organizations.

Following elementary school, matriculates in 1924 at the
Liceul Matei Basarab, an "overcrowded, tough school,
devoted mostly to Latin." Later comments that bi- or
tricultural Jewish children, living in a state of perpetual

Memory drawing of Strada Palas,
1978, with Steinberg family
home in center background. Black
pencil on paper, 11 x 14 in.
(27.9 x 35.6 cm). YCAL 1784.

translation, were held to a higher standard: "we were
all *Wunderkinder*." Often thought to be scowling, he is
merely nearsighted, but he will not wear glasses until age
twenty-one.

At a family get-together in Buzau, 1924, Saul meets
New York-branch Steinbergs, uncle Harry (his father's
brother), and cousin Henrietta.

1932

Graduates from high school, attends the University of
Bucharest, "frequenting the courses of Philosophy and
Letters."

University of Bucharest class,
March 30, 1932. Steinberg is
standing at the far left, front row.
YCAL.

1933

Enters Milan's Reggio Politecnico, Facoltà di Architettura.
Director Piero Portaluppi and Steinberg's drawing
teacher Tommaso Buzzi, though traditionalists, are aware
of current trends; instructor Giò Ponti is involved in
organizing the Milan Triennial cultural fairs of 1933, 1936,

and 1939. Ernesto Rogers, a graduate in the generation before Steinberg, has left a "rationalist" influence; Le Corbusier's work is of most interest to the students.

Resides first in the Casa dello Studente, later in shared apartments, and finally in a room over a bar, Il Grillo, at 64 via Pascoli.

Forms a lifetime friendship with classmate Aldo Buzzi.

1934–35

Draws architecture *dal vero* in Milan and on field trips to other places. Throughout his years in Milan, returns to Romania for summer vacations, sketching as he travels "by tramp steamer from Genoa to Naples, Catania, Piraeus, several Greek islands, Istanbul and Costanza."

1936

October 27, first cartoon appears in *Bertoldo*, a new twice-weekly humor tabloid edited by Giovannino Guareschi.

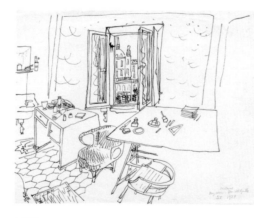

1938

April, work first appears in *Settebello*, a *Bertoldo* competitor. His regular feature is titled "Il Milione: Viaggi, Avventure, Usi e Costumi."

September–November, first of the anti-Semitic racial laws are passed in Fascist Italy. Jewish children and teachers banned from all schools; foreign Jews ordered to leave the country (the latter mandate haphazardly enforced).

1939

June, another racial law bans Jews from the skilled professions. Milan associates immigrate—Leo Lionni to Philadelphia, Costantino Nivola and his wife, Ruth Guggenheim, to New York City.

Agent Cesar Civita, with bureaus in New York and Buenos Aires, promotes Steinberg's work to magazines in the Americas.

1940

A selection of Steinberg's cartoons appears in the March *Harper's Bazaar*—his first American publication; a feature in *Life* follows in May.

A doctorate in architecture is issued to "Saul Steinberg of the Hebrew Race." Decades later, he proposes trading diplomas with Primo Levi, who has a similarly worded one from the University of Turin.

Cesar Civita and Steinberg's relatives in New York, having failed to get him a US visa, arrange a visa for the Dominican Republic and transport from Lisbon, but in September the Portuguese authorities send him back to Italy.

November, his Romanian passport expires, leaving him stateless.

1941

Hides in Milan at the homes of friends and his girlfriend, Ada Ongari. In April, his last cartoons run in *Bertoldo*. Arrested, then interned at Tortoreto-Teramo, a detention camp in the Abruzzi, May 2–June 8. After release, proceeds to Milan, then Rome; flies to Lisbon via Barcelona. Arrives June 16; departs June 20 on the S.S. *Excalibur*.

July, arrives Ciudad Trujillo (Santo Domingo), Dominican Republic, via Ellis Island. Begins applying for entry to the United States on the quota system.

Resides at Moises Garcia 46. Mails regular packets of drawings to Civita offices in Buenos Aires and New York. Publishes in *La Nacion* (Ciudad Trujillo) and *Cascabel* (Buenos Aires).

October 25, his first cartoon published in *The New Yorker*. Executive editor Ik Shuman writes a testimonial letter for Steinberg's immigration dossier at the Department of State.

Begins submitting political cartoons lampooning the Axis powers after the Japanese attack on Pearl Harbor, December 7, and US entry into World War II against Germany, Italy, and Japan.

1942

Beginning January 11, his editorial cartoons appear each Sunday in the liberal newspaper *PM*. By April, *Liberty* and *The American Mercury* are also publishing his political cartoons.

February 17, included in "Cartoons Against the Axis," a traveling exhibition organized by the Art Students League, which concludes at The Metropolitan Museum of Art as "Cartoons of Today."

Spring, exhibits three paintings in a juried exhibition in Ciudad Trujillo. Moves to Gabino Puello 9, home of Paul Rossin, an architect from Bucharest, his wife Tina, and brother Pierre.

By May, receives US visa, but transports are in short supply. May 14, signs a first-look contract with *The New Yorker*. May 24, *PM* begins running his weekly, untitled cartoon strip on Hitler.

June 12, flies to Miami and boards a bus to New York City. Intent on qualifying for citizenship, registers for the draft.

July 1, signs a two-year contract (renewed in 1944) giving 40 percent of his publication proceeds to Civita. Continues his weekly editorial cartoons for *PM*; also sells *The New Yorker* drawings that will appear as late as December 1944. Does drawings for advertisements commissioned by the Young & Rubicam agency, illustrations for *Fortune*, and pamphlet covers for the Bureau of Latin American Research, an anti-Axis organization employing writer Niccolò Tucci.

August 24, is classified 1-A (available for immediate military service).

By late November, is employed at the Office of War Information, Graphics Division, at 224 West 57th Street, New York.

1943

In early January, travels by train via Chicago to Los Angeles, either to see the MGM and Disney movie studios in operation (as he tells *New Yorker* editor Harold Ross) or to see the Pacific Ocean (as he tells friends later). While in California, receives notice to report to the draft board on January 20; returns east via a southern route, seeing the desert of the American Southwest for the first time.

February 19–20, obtains US citizenship and is commissioned as an ensign in the US Naval Reserve. Now rooming at the Hotel Lafayette, 9th Street at University Place, New York.

Hedda Sterne, a Romanian-born artist who arrived in New York in November 1941, admires Steinberg's drawings in *Mademoiselle* and invites him to tea. In immediate rapport, they will correspond throughout his tour of duty, in the course of which she will divorce her estranged husband.

February 28, reports for Naval Intelligence training in Washington, D.C., as a Psychological Warfare artist.

Betty Parsons organizes "Drawings in Color by Steinberg, Paintings by Nivola," April 12–24, Wakefield Gallery, 64 East 55th Street, New York.

May, departs San Francisco on troopship *Nieuw Amsterdam* to Wellington (New Zealand), Perth (Australia), Colombo (Ceylon). July 16, flies from Calcutta to Kunming, China. Stationed with the Sino-American Cooperative Organization in a training center called Happy Valley, near Kunming.

By Navy courier service, submits packets of drawings to *The New Yorker*, where the first of his ten wartime portfolios will appear on January 15, 1944. Plans his first book of drawings.

Reassigned to the Morale Operations (propaganda) Section of the Office of Strategic Services (OSS) in North Africa. Departs Kunming December 18; flies to Calcutta and on to Algiers.

1944

Stationed with the OSS in Naples through late May, thereafter in Rome, planning and drawing propaganda material.

September, ordered to return via North Africa to Washington, D.C., for reassignment to the director, OSS.

October 11, marries Hedda Sterne in New York.

Commutes between Washington and New York until the end of 1945, when his active duty ends. Befriends fellow *New Yorker* contributor Geoffrey Hellman, also on military assignment in Washington. In New York, he and Sterne live in her small top-floor apartment-studio at 410 East 50th Street until 1952.

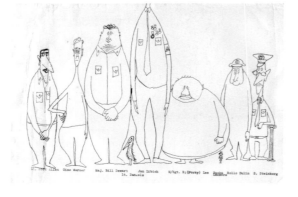

Flies to Bucharest in uniform in late 1944 to see his family. Though photographs corroborate the trip, in later years he will say he has not visited Romania since the 1930s.

1945

All in Line, his first book of drawings, published in June. A Book-of-the-Month-Club selection, it sells over 20,000 copies. Features drawings published in American magazines and newspapers, 1941–45, including wartime drawings of China, India, North Africa, and Italy.

June, solo exhibition at Young Books, Inc., New York, of drawings from *All in Line*.

Resumes contact with Aldo Buzzi in Milan. Will send money and care packages to Buzzi and Ada Ongari throughout Italy's long postwar recovery. Buzzi will work as a writer and set designer with film directors, including Alberto Lattuada and Federico Fellini; later, with Steinberg's encouragement, he becomes a full-time literary author, publishing books and articles on travel and gastronomy.

Designs Christmas cards for The Museum of Modern Art, as he will do every year until 1952.

1946

Impressed by exhibitions on Papua New Guinea and the South Pacific, the art of Marc Chagall and Matta. Judges a children's art contest for the Carnegie Institute in Pittsburgh, awarding top prize to "a little boy who did a very good painting of an old woman being decapitated."

Belongs to a regular crowd of artists, designers, writers, and architects who socialize at Del Pezzo, a midtown Manhattan restaurant, including Tino Nivola, Alexander

Calder, Bernard Rudofsky, Leo Lionni, Niccolò Tucci, Marcel Breuer, and, when in America, Le Corbusier.

With Sterne, spends June in Provincetown, Massachusetts.

July and August, travels to England, France, and Italy; is reunited with friends, including Buzzi, in Milan. Attends the Nuremberg trials as a pictorial reporter for *The New Yorker*. Travels throughout Germany. Drawings of postwar desolation and poverty there will appear in "Berlin" portfolios in *The New Yorker* (March 29 and April 12, 1947).

Spends the fall in Paris, forming close friendships with *New Yorker* Paris correspondent Janet Flanner and photographer Henri Cartier-Bresson, who introduce him to French artists and intellectuals. Draws Jean-Paul Sartre and Simone de Beauvoir. Gambles in Monte Carlo.

Included in "Fourteen Americans," The Museum of Modern Art, September 10–December 8. Among fellow exhibitors are Arshile Gorky, David Hare, Loren MacIver, Robert Motherwell, Theodore Roszak, Honoré Sharrer, Mark Tobey, and—an unannounced fifteenth—George Tooker. Steinberg's section features *The City*, a panoramic drawing that scrolls through a frame at the push of a button.

1947

Acquires first camera. In addition to a studio at 38 West 59th Street, rents an office space at 107 East 60th Street.

With film curator Iris Barry of MoMA, plans a (never-realized) documentary film festival, in part a pretense for bringing Buzzi to New York. Though forever considering major film projects, Steinberg never undertakes one.

March, violinist Alexander (Sasha) Schneider invites Steinberg, Sterne, and Vladimir Nabokov to dinner. Nabokov will become a friend, and Steinberg will reread his study *Nikolai Gogol* (1944) countless times, treating it as a guide to the labyrinthine twists of his own imagination.

April, travels to Mexico City, joining Hedda Sterne, who has been traveling with Miguel Covarrubias and others. On return journey, stops in Cincinnati, Ohio, to sketch the city for a projected mural commission.

Buys a 1941 Cadillac convertible, in which he and Sterne will make many long road trips. Spends summer with Sterne in East Jamaica, Vermont. Visitors include Tino and Ruth Nivola and Henri Cartier-Bresson.

Designs murals for Bonwit Teller department store and for the Skyline restaurant at the Terrace Plaza Hotel in Cincinnati. Executes the latter mural himself in paint on linen, using the Lower East Side studio of his friend

Gjon Mili, a photographer at *Life.* Art handlers from MoMA pack the mural for delivery to Cincinnati.

1948

Solo exhibition at the Institute of Design (New Bauhaus), Chicago.

March, with Nivola, travels to Cincinnati and installs mural at the Terrace Plaza Hotel.

April 22, composer Gian-Carlo Menotti telegrams Steinberg in Paris, asking him to come to London to design and execute scenery for a production of *The Telephone* opening April 29; Steinberg accepts.

Designs bar murals for the "Four Aces" ships of the American Export Lines. The interior decoration plan, coordinated by Henry Dreyfuss, puts contemporary art before a popular audience; other contributing artists are Loren MacIver, Miné Okubo, Oronzio Maldarelli, Mitzi Solomon.

Spends three months in Switzerland, Italy, and France.

His parents, on an extended but temporary visa, are housed in Paris with Sterne's brother, orchestra conductor Edward Lindenberg.

1949

Produces designs for Patterson Fabrics silks and wallpapers. Through the mid-1950s, draws designs on a fee-and-royalty basis for the firms Patterson, Stehli, and Greeff. Designs include *Views of Paris, Horses, Paris Opera, Wedding, Aviary, Trains, Cowboys,* and *Gendarmes.*

Creates drawings for photographic enlargement in a mural at "An Exhibition for Modern Living," Alexander Girard's landmark exhibition at The Detroit Institute of Arts and the J.L. Hudson Department Store, September 11–November 20. October, solo exhibition at Girard Gallery, Grosse Pointe, Michigan.

July, sails on the *Queen Elizabeth* to Europe. Based in Paris, he meets Saul Bellow, the beginning of a close and enduring friendship.

The Art of Living published, October.
Contents: CHAIRS, SUBWAYS, TAXIS, SALOONS, SIDEWALKS, DERELICTS, PERSPECTIVE, BIRDS, CATS, HORSES, ART AND WOMEN

1950

Arranges his parents' permanent move to Nice. Most years, will combine filial visits with gambling in French casinos, drawings of which figure in *The Passport.* Aunts and uncles reside in Israel.

March and September, publishes influential portfolios in *Flair* that combine photographs and drawing.

April–May, solo exhibition, Museum of Art, Rhode Island School of Design.

Summer, his painting-hand is hired to play that of Gene Kelly in the film *An American in Paris.* Though he quits on the first day, he and Sterne spend July–September in Brentwood, renting the house of Annabella Power, 139 North Saltair Avenue, and socializing with Kelly, Billy Wilder, Oscar Levant, Igor Stravinsky, Christopher Isherwood, and Charles and Ray Eames, among others. Charles Eames proposes making a "movie of the drawing of the town" (possibly *The City;* see 1946) with a

soundtrack. Returns by bus and train to New York via Las Vegas and across the Midwest plains states.

1951

January, portfolio "The Coast" (on Los Angeles) published in *The New Yorker*. Sterne is included in *Life* story on "the Irascibles," the New York School of painters.

Designs Neiman-Marcus store catalogue cover and wrapping paper; unhappy with the results, and with the thought of his drawings being torn apart. Throughout the 1950s, will field many proposals for products (coasters, ties, ashtrays, dinnerware, wrapping paper, etc.), which he declines outright, and mural and interior decoration projects (Corning Glass Works, 1951; Beverly Hilton, 1953; United Airlines, 1955), which he evades by asking exorbitant fees.

Late March, based in Palermo, travels through southern Italy on local transportation such as trolleys and ferries.

April, with Sterne, stays at Piazza Calda, unused Florence palazzo of friend and patron Richard Blow. Frequents the casinos of Nice, Monte Carlo, Ostende, and San Remo.

Travels in England, Scotland, and Ireland. In Paris through late summer.

Solo exhibition at Galleria L'Obelisco, Rome.

Invited by New York City Ballet impresario Lincoln Kirstein to design sets for a ballet to be choreographed by Georges Balanchine. Attends many ballet performances.

December–January, travels in Florida and the South, collecting material for features in *Life* and *The New Yorker*.

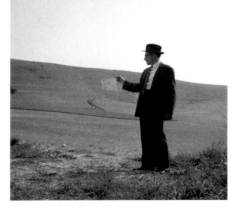

Steinberg drawing the Long Man of Wilmington, East Sussex, England, 1952. Photograph by Lee Miller.

1952

Designs Christmas and Valentine's Day cards for Hallmark Cards for the first time. Each January, beginning 1953 and until 1962, he receives $10,000 for the year's batch of designs, including a box design for the set.

January 28–February 16, his first dual-gallery solo exhibition at Betty Parsons and Sidney Janis galleries, 15 East 57th Street, New York.

End of January, moves with Sterne into a duplex on East 71st Street with a backyard, billiard room, two studios, and room to entertain guests. Frequent visitors include curator friends at MoMA; *New Yorker* writers and artists; French, Italian, and American artists; and actors connected with Herbert Berghof and Uta Hagen. Friends seen most frequently include critic Harold Rosenberg; sculptors Alexander Calder and David Hare; violinist Alexander Schneider; writers Joseph Mitchell and Niccolò Tucci; painters Willem de Kooning, Ad Reinhardt, Mark Rothko, and Richard Lindner; architect Marcel Breuer; *New Yorker* art editor James Geraghty; and MoMA film curator Iris Barry.

Spring, Steinberg and Sterne have simultaneous solo exhibitions at Gump's Gallery, San Francisco.

April 23–June 5, sails to London on Cunard White Star line for May 1 opening of an 85-drawing solo exhibition at the Institute of Contemporary Arts. Rides trains for several days, sketching Victorian industrial architecture, railway stations, and holiday pavilions.

July, in Chicago for Democratic and Republican party conventions. Sees, he claims, two hundred films this summer to escape the heat of New York City.

Fall, travels with Sterne to Brazil for their concurrent solo exhibitions at the Museu de Arte, São Paulo. Visits museum director Pietro Maria Bardi and his wife, architect Lina Bo Bardi, an acquaintance from Steinberg's student years, in their glass house overlooking the jungle (its walls the scene of a nightly "insect massacre"). Visits Manaus, Bahia, Buenos Aires, and Rio de Janeiro—a "tropical Bucharest," with "open trams, with two trailers; thousands of equestrian monuments; vultures that circle over the sidewalk in search of carrion."

December–January, solo exhibition at Frank Perls Gallery, Beverly Hills, California.

1953

January, travels in Mississippi.

Supplies drawings for a television commercial for Jell-O, his only venture into animation.

April–May, solo exhibition, Arts Club of Chicago.

April, first exhibition at the Galerie Maeght, Paris. Through January 1955, it travels to Stedelijk Museum, Amsterdam; Galerie Blanche, Stockholm; Museum

in Ostwall, Dortmund; Kupferstichkabinett in Kunstmuseum, Basel; Leopold Hoesch Museum, Düren; Kestner-Gesellschaft, Hannover; Kunst- und Museumverein, Wuppertal-Elberfeld; Overbeck-Gesellschaft in Lübeck; Frankfurter Kunstkabinett, Frankfurt.

Railway Station, c. 1953. Ink on paper, 23 x 29 in. (58.4 x 73.7 cm). Collection of Richard and Ronay Menschel.

Based in Paris; travels in Italy and Turkey.

October 28, note to himself: "Make rubber stamp of thumbprint." His art and humor increasingly focus on contradictions between mass society and the cult of individualism.

November, solo exhibition "Drawings by Steinberg" opens at the Virginia Museum of Fine Arts, Richmond; show travels through June 1956 to other venues, including the Corcoran Gallery of Art, Washington, D.C., and the Dallas Museum of Fine Arts. Late November, lends thirty-five drawings to solo exhibition at Santa Barbara Museum, California.

December, in Paris.

1954

February, travels with Aldo Buzzi to towns in the Carolinas and Virginia.

Invited by producer Arnold Saint Subber to create sets for Broadway production of Harold Arlen and Truman Capote's *House of Flowers*, but is rejected by the Scenic Painters' Union.

May and June, travels with the Milwaukee Braves baseball team on assignment from *Life*; drawings are published the next summer as "Steinberg at the Bat."

July, stays with New York City Ballet choreographer Jerome Robbins in Stonington, Connecticut. From scenarios collaboratively developed out of themes in Steinberg's art, Robbins will create *The Concert* (debut 1956, revised 1958), a ballet with a backdrop by Steinberg.

Invited by architect Ernesto Rogers, designs *sgraffito* (incised plaster) murals for the open-air "children's labyrinth" at the 10th Milan Triennial.

August 21, flies to Paris. In Milan, completes mural. Director Alberto Lattuada enlists Steinberg as an extra in a scene shot at the Milan Galleria for his film *Elementary School*. September, visits Nice, Cannes, and London.

The Passport published, October.
Contents: FALSE DOCUMENTS, PASSPORTS, DIPLOMAS, CERTIFICATES, FALSE PHOTOGRAPHS (WITH FALSE AUTO-GRAPHS), FALSE ETCHINGS, FALSE WINE LABELS, LETTERS, DIARIES, MANUSCRIPTS, FALSE EX-VOTOS, CALLIGRAPHY AND CACOGRAPHY.
FINGERPRINTS, PARADES, COCKTAIL PARTIES, BALLET, BILLIARDS, COWBOYS, PITCHERS, PALM TREES, CATS, DOG WALKERS, HORSEWOMEN, GUITAR PLAYERS, AUTOMOBILES, LOCOMOTIVES, RAILWAY STATIONS, BRIDGES, SUMMER AND WINTER, FASHIONS, SPHINXES, VICTORIAN ARCHITECTURE, ART NOUVEAU, RUBBER-STAMP ARCHITECTURE, SLUMS, SKY-SCRAPERS, TRAVEL NOTES FROM WESTERN EUROPE, MID-DLE EAST, MIDDLE WEST, PALM BEACH, ISTANBUL, MANAUS AND HOLLYWOOD.

State Line Motel. Postcard, c. 1950, from Steinberg's collection. YCAL.

Steinberg's Umgang mit Menschen published, a German compilation, largely from three previous books of drawings.

1955

January 8–13, visits Vicksburg and Oxford, Mississippi; Memphis, Tennessee; Birmingham, Alabama; and St. Petersburg and Tampa, Florida.

Creates panoramic drawing for title sequence in Alfred Hitchcock's film *The Trouble with Harry*.

March 7–25, exhibition of his architecture and false handwriting drawings at the Harvard Graduate School of Design, organized by José Luis Sert.

Lives in Paris early March to early August; August–September, with Sterne in Wellfleet, Massachusetts.

Begins seeking a location for a second home. During the next three years, considers Paris, small French and Italian towns, and Genoa, and rents summer houses with Sterne at various locations in Connecticut; on Cape Cod, Massachusetts; and on the eastern tip of Long Island, where many artist friends have acquired houses.

1956

Dessins published, a French compilation, largely from three previous books of drawings.

February–March, travels to Moscow, Tashkent, Tbilisi, Kiev, and Samarkand; drawings are published in *The New Yorker* in May and June as "A Reporter at Large" portfolios: "Samarkand, U.S.S.R." and "Moscow in Winter."

March 7–April 7, solo exhibition "Saul Steinberg: Drawings from Six Years," Allan Frumkin Gallery, Chicago.

Summer, road trip around the country with Sterne. July, they fly to Alaska, visiting Anchorage, Ketchikan, Juneau, and Fairbanks, where he photographs totem poles at the outskirts of town.

1957

Second solo exhibition at Institute of Contemporary Arts, London.

Summer, travels in Spain with Sterne.

August–September in Wellfleet, Massachusetts. Informed by telegram that sister Lica, her husband Ilie Roman, and two children are at last being allowed to leave Romania. Meets them in Genoa, takes them to Nice. Later buys a house for them in Paris.

1958

January–March, executes mural *The Americans* for American Pavilion at Brussels World's Fair. Publisher Robert Delpire commissions color photographs of the mural's panels for publication in book form, a plan abandoned when Steinberg rejects the color proofs. Delpire puts one of Steinberg's drawings of graph-paper

architecture on the cover of Robert Frank's book of photographs, *Les Américains*.

May, to Italy and France. In Nice, visits Pablo Picasso at La Californie. They execute collaborative "exquisite corpse" drawings. Years later, speaking to Adam Gopnik, he will recall Picasso as "an old Jewish man in the Florida sun—all torso and shorts. The voice of a cigar smoker . . . the falsetto of a cello. A Godfather's voice; he talked softly, in a very effective whisper."

June, Jerome Robbins' ballet *The Concert*, with Steinberg's backdrop, is part of the first Festival dei Due Mondi, Spoleto, directed by Gian-Carlo Menotti.

Bikers, c. 1958. Pencil. YCAL sketchbook 4891.

July, a typical driving tour, its highlights outlined in a travel sketchbook: "Aberdeen MD, South Hill VA, Greensboro NC, Greensville SC, Chattanooga Ten, Athens GA, Motel 119 Toler KY, Middlesboro KY, Belfry—near Williamson W Va, Uniontown PA."

Through Alexander Schneider, meets Inge Morath, a photographer recently arrived in New York, with whom he will collaborate (1959–62) on photographs of people wearing Steinberg masks.

December, in Copenhagen. Mathematician Piet Hein introduces him to Danish film director Carl Theodore Dreyer, for whom Steinberg will make a diploma the next year. Agrees to contact William Faulkner with Dreyer's proposal to adapt several Faulkner novels to film.

1959

January 17, Steinberg's third *New Yorker* cover, *The Pursuit of Happiness*, marks the beginning of his years as a regular cover contributor. In the 1960s, will increasingly concentrate his publishing activity on *The New Yorker*.

March 13–15, *The Count Ory*, an opera by Gioacchino Rossini, performed at Juilliard Opera Theater, New York, with sets by Steinberg. The opera will be revived at Spoleto in summer 1962.

First appearance in print in a self-made mask, *Paris Match*, March 14.

Signs mortgage, May 22, on a house on Old Stone Highway, near Amagansett. The Nivolas live across the way.

August, travels by bus in the American West.

1960

February, is the focus of an episode of the experimental CBS television program *Camera Three*. Panning shots of drawings in his books are accompanied by distorted recordings of music and Ionesco-like dramatic recitations (imitating love scenes, political speeches, etc.) of boilerplate clauses from contracts. A tuxedoed "announcer" (comedian Al Kelly) then delivers a brief tribute, its key words replaced by nonsense syllables. The film is screened at MoMA soon after its broadcast. *Camera Three* is canceled shortly thereafter.

Meets and becomes involved with Sigrid Spaeth, a German photography and design student working in New York; born August 1936, the year Steinberg published his first cartoons in *Bertoldo*.

Separates from Hedda Sterne, moving out of their East 71st Street house and into an apartment in Washington Square Village. Sterne and Steinberg remain close friends the rest of his life.

The Labyrinth published, late December.
Contents: ILLUSION, TALKS, WOMEN, CATS, DOGS, BIRDS, THE CUBE, THE CROCODILE, THE MUSEUM, MOSCOW AND SAMARKAND (WINTER 1956), OTHER EASTERN COUNTRIES, AMERICA, MOTELS, BASEBALL, HORSE RACING, BULLFIGHTS, ART, FROZEN MUSIC, WORDS, GEOMETRY, HEROES, HARPIES, ETC.

Mural detail, Palazzina Mayer, Milan, December 1961.

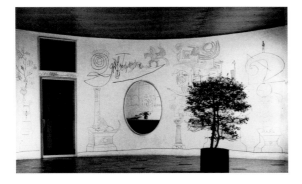

1961

June, in Italy.

Mother dies in October.

November, justifies to an interviewer why he resists cooperating in the chronicling of contemporary art (see Appendix, p. 249). Goes to Milan, where he executes a *sgraffito* mural in the entryway of the Palazzina Mayer, a private house on the Via Bigli (mural destroyed, c. 1997).

Inge Morath, *Untitled* (from the Mask Series with Saul Steinberg), 1962.

1962

June, travels to Appleton, Wisconsin, to accept his first honorary degree, from Lawrence College. In a case of life imitating art, will gradually build a sizable collection of honorary diplomas and proclamations.

June 26, writes to Buzzi: "I admire more and more people's literary qualities, I mean the possibility of recounting a fact or making a true and proper observation. Most people transform things that happen to them into things read in the newspaper. Those who don't know how to tell things are scary."

Renegotiates agreements with Hallmark Cards. Will no longer design cards, but only the full-color desk calendars called "Sketchbooks," which he had begun to make in 1960. Continues to produce Hallmark calendars through 1969.

October, first visit to Israel, where he has been invited to consider executing a mural on an ocean liner. Moved by an unforeseen feeling of emotional attachment and affinity with a nation of Jews.

November 20–December 16, "Saul Steinberg and Paul Klee: An Exhibition of Drawings," The Art Gallery, University of California at Santa Barbara.

1963

Increasingly close to Harold Rosenberg, who begins writing for *The New Yorker* this year. Will try several times to make sound recordings of their long, discursive conversations, but self-consciousness (or technical difficulty) always ends the experiment.

January 10, writes to Buzzi: "I work my 2–3 hours a day, and looking at what I've done, I can see that I rid myself of terrors etc. by drawing them in a comic way—in the manner of savages—and so what I draw is part of a diary."

February, in Key West with Sigrid.

The Catalogue is published, an American compilation of material from earlier books that have gone out of print.

December, commences solo round-the-world trip with stopovers in Paris and Italy. Continues to Athens, then Asmara and Cairo by Christmas; Gondar and Addis Ababa, Ethiopia; Kenya; and Bombay for New Year's.

Will return to Africa, with Sigrid and alone, several times through the early 1970s; Sigrid continues making long trips to Africa until the 1980s.

1964

January 4, in Bangkok. Continues to Hong Kong and Kowloon. Spends two weeks in Japan—Tokyo, where he stays at the Imperial Hotel, then Osaka, Nagasaki, Beppu, Kobe, Kyoto, and back to Tokyo—before flying to New York.

Steinberg's Paperback published in Germany, a compilation from previous books.

August, makes circuitous road trip with Sigrid to Wyoming and back.

1965

Spring, as official guest of NASA, spends two weeks at Cape Kennedy and watches launch of Gemini rocket; compares its slow ascent to the levitation of figures in Chagall paintings.

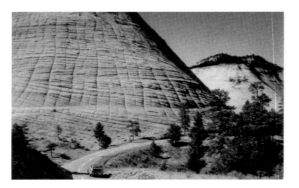

July, takes LSD. Tells Buzzi that he "spent a day of such happiness that the memory of this possibility existing in me makes everything else unimportant, reduces miseries to their proper scale. It's something very important that can change the meaning of life."

Unable to decide whether to move from Greenwich Village, he tells Buzzi on September 6, "I don't have a clear idea of what I am or want to be. Husband? Painter? Old, young, uptown, downtown, man about town, hermit? Also: rich or poor?"

Intends titling his next book *Confessions*. By the time of its publication in December, has opted for *The New World*.

Contents: NUMBERS, CONCENTRIC CIRCLES, SPEECH, GEOMETRY, PARODIES OF PARODIES, DESCARTES, NEWTON, QUESTION MARKS, GIUSEPPE VERDI, DRAWING TABLES, THE DISASTERS OF FAME, MARKS AND ALLEGORIES.

1966

March–April, solo exhibition, "Steinberg: Le Masque," at Galerie Maeght, Paris, and Fondation Maeght, Saint-Paul-de Vence.

Le Masque published.

Contents: SELF-DRAWN ARTISTS, ANACHRONISTIC LAND-SCAPES, ART LOVERS, TREES, STILL LIVES OF ILLUSIONS, AIRMAIL VARIATIONS, LABEL COLLAGES, RECORDS, NAVA-JOS, DUTCHMEN, SPHINXES AND HARPIES, COUPLES, THE NOSE, QUASI DAL VERO, PAPER-BAG MASKS AS COLLAGES OR PHOTOGRAPHED ON REAL PEOPLE BY INGE MORATH.

Begins having rubber stamps made after his own designs and after motifs appropriated from art and old postcards.

Spends more and more of each year in Amagansett. Increasingly, his annual trips to Europe follow routine patterns connected to exhibitions at Maeght and visits to his sister in Paris or to Buzzi in Milan.

September, awarded medal of Chevalier de l'Ordre des Arts et Lettres by French government.

December, "Saul Steinberg: Recent Work," Betty Parsons and Sidney Janis galleries, New York.

1967

Spends January–April, in Washington, D.C., as artist-in-residence at the Smithsonian Institution.

March 10–April 30, "Steinberg: 'The Americans'; Aquarelles, Dessins et Collages 1955–67," Musées Royaux des Beaux-Arts de Belgique, Brussels. Show travels through August 1968 to Museum Boymans-van Beuningen, Rotterdam, and Hamburger Kunsthalle.

Completes drawings for Paul Tillich, *My Search for Absolutes*. Designs and oversees execution of four screens for a Seattle Opera Company traveling production of Stravinsky's *The Soldier's Tale*.

Ad Reinhardt, who had become a close friend in recent years, dies.

1968

With Sigrid, travels to Merida, Veracruz, and Oaxaca, Mexico, in February; goes snorkeling, climbs the great pyramid at Chichen Itza. In April, they visit her home-town, Trier, Germany, and Paris. The visit to Paris coincides with the beginning of the student and worker riots in May, "in time," as he tells Buzzi, "for a dose of tear gas."

September, leases the entire eleventh floor of 33 Union Square for his studio. Andy Warhol's Factory is three floors below, Max's Kansas City a convenient lunch spot nearby. Begins reading underground comix, which will exert a deep influence on his work of the 1970s and beyond.

December, "Steinberg: Dibujos y Acuarelas," Museo de Bellas Artes de Caracas, Venezuela.

1969

February 25–March 18, "Saul Steinberg: Watercolors and Drawings," J.L. Hudson Gallery, Detroit.

Artist Anton van Dalen becomes his studio assistant. Until the end of Steinberg's life, "Saint Anthony" will do everything from packing works for travel to gluing together sculptural assemblages to shooting rolls of research photographs of taxi cabs or the statues of Union Square.

November, solo exhibition at Betty Parsons and Sidney Janis galleries, New York. Feels ambivalence about the growing difference between his gallery art and his publication work, telling Buzzi on November 16: "I've found

refuge in working for the *New Yorker . . .* obviously [it] is my refuge, *patria*, and safety net. I have the feeling I'm sabotaging the show and art with a capital A, maybe so as to free myself from that commercial world."

This year and the next, donates art and designs posters for politically motivated collectives, galleries, and auctions to raise funds for anti–Vietnam War campaigns.

1970

February, travels to Paris, Milan, Jerusalem, Tel Aviv, then to Africa. In Nairobi, runs into Saul Bellow, and they travel together to Murchison Falls. Goes to Ghana and Ethiopia; in Ethiopia stops at Addis Ababa, then visits Lalibella with architecture school friend Sandro Angelini.

Spring, solo exhibition, Kiko Galleries, Houston.

Paints one of his largest canvases, *The Tree* (altered 1978), based on the plateau scenery around Lalibella.

Fall, exhibits oil paintings in the Carnegie International Exhibition of Painting and Sculpture, Pittsburgh.

December 7–January 9, 1971, "Saul Steinberg: Paintings and Drawings," Felix Landau Gallery, Los Angeles.

1971

January, makes first visit to the "lovely prison" of the Bircher-Benner private clinic in Überlingen, Switzerland. Will return in subsequent winters for multi-day fasts—an activity suited only to Switzerland, "as in other places hunger would not be reassuring."

February, travels to Oaxaca, Mexico, and the Caribbean island of St. Martin with Sigrid.

June–July, solo exhibition, Galerie Maeght, Paris, includes large all-rubber-stamp drawings, oil paintings, two full walls of watercolor "postcards," and a trompe-l'oeil gallery of false perspective paintings. Show travels to Galerie Maeght, Zurich, in the fall. Steinberg attends the Zurich opening—now preferring, when possible, to avoid Paris, which has become a "garage," better suited to traffic than people.

1972

Winter, visits Überlingen clinic, where, following Nabokov's example, he quits smoking. Will later describe the resulting shift in his body chemistry as the beginning of his "slide into melancholy."

February–mid-March, travels to Cairo and Luxor, Kenya, Uganda, and Tanzania. Tells Buzzi on March 3 that he "came back like Candide ready for the garden—enough

of these absurd trips in a world ruined by the damned race of tourists."

1973

The Inspector published. Its working title had been *Homework*.
Contents: PARADES, BIOGRAPHIES, MASKS, STREETS AND AVENUES, TIME AND SPACE, MUSIC-WRITING, RUBBER-STAMP ARCHITECTURE AND SOCIETY, THE PROFESSIONAL AVANT-GARDE, THE LAW OF GRAVITY, URBAN WAR, CLOUD FORMATIONS, WORDS AND LETTERS, CROCODILES, COW-BOYS, GIRLS AND DINERS.

February 7–March 3, "Steinberg: New Work," Betty Parsons and Sidney Janis galleries, New York.

August–September, moves from his apartment in Washington Square Village into a duplex at 103 East 75th Street. Will relocate his studio there in 1975 and remain at this address for the rest of his life.

November, solo exhibition at Galerie Maeght, Paris.

November–December, solo exhibition at Galleria Mario Tazzoli, Milan.

December 21–February 10, 1974. "Steinberg at the Smithsonian," National Collection of Fine Arts, Smithsonian Institution, Washington, D.C.

1974

Awarded gold medal for Eminence in Graphic Art by the National Institute of Arts and Letters.

Sigrid's black cat, Papoose, whose behavior Steinberg observes closely, becomes a cherished companion.

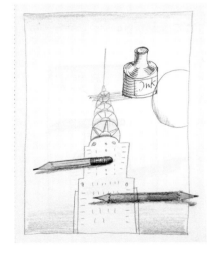

Drawing table with Chrysler Building, c. 1974. Ink, pencil, and colored pencil. YCAL sketchbook 4873.

May, solo exhibition, Galleria dell'Oca, Rome.

November, visits his ailing sister Lica in Paris.

November 14–December 31, "Saul Steinberg: Zeichnungen, Aquarelle, Collagen, Gemälde, Reliefs, 1963–1974." Kölnischer Kunstverein, Cologne. Show travels through August 1975 to Württembergischer Kunstverein, Stuttgart; Kestner-Gesellschaft, Hannover; Kulturhaus der Stadt Graz; Museum des 20. Jahrhunderts, Vienna.

1975

May, brings Lica to Amagansett for a month's visit; she dies July 15 in Paris after a lung operation.

1976

View of the World from 9th Avenue is on the cover of *The New Yorker*, March 29. The magazine will sell 25,000 over-size posters of the cover by 1980; imitations and plagia-rized products multiply.

June, receives honorary doctorate from Harvard University, made out to "reverendis Inspectoribus Saul Steinberg."

Alexander Calder dies in early November, soon after a retrospective of his career opens at the Whitney Museum of American Art. Steinberg speaks at the memorial serv-ice. Anxious about his own impending Whitney retro-spective and increasingly prone to depression.

November 17, "Steinberg Cartoons," opens at Betty Parsons (through December 4) and Sidney Janis (through December 11) galleries.

1977

In April, to Tel Aviv and then to Paris for opening of May–June solo exhibition, Galerie Maeght. Show travels through December 1977 to Galerie Maeght, Zurich, and Galeria Trece, Barcelona.

July, Vladimir Nabokov dies.

Installation view, Saul Steinberg retrospective, Whitney Museum of American Art, 1978. YCAL.

1978

Retrospective, "Saul Steinberg." Whitney Museum of American Art, April 14–July 9. Show travels to Hirshhorn

Museum and Sculpture Garden, Smithsonian Institution, Washington, D.C., October 13–November 26; Arts Council of Great Britain, Serpentine Gallery, London, January 17–February 15, 1979; Fondation Maeght, Saint-Paul-de-Vence, France, March 15–April 30, 1979.

Richard Lindner dies in April, Harold Rosenberg in July. Writes a tribute to Lindner that is read at January 1979 meeting of the American Academy and Institute of Arts and Letters. Speaks at tributes to Rosenberg at the New York Public Library (April 1979) and at the University of Chicago (October 1979).

April 17, *Time* magazine cover story on the retrospective brings old friends and relatives to light. Receives a letter from a cousin he has never met, Phil Steinberg, a plain-spoken electronics repairman and motorcyclist living in Arizona, and they begin to correspond. Is pleased to find a relative with an artist's quality of having "saved himself"; he will write to Buzzi in October 1979 that visiting Phil in Tucson gave him "an idea of what I'd be like without education, without success. . . . the visit left me with an exquisite taste of an authentic person," whereas his relatives had always struck him as "rich peasants like Tolstoy's, fake & boring, saying what one should say to one another & discovering new territories of boredom."

Draws the series "Uncles" and "Cousins," which appear as portfolios in *The New Yorker* in December 1978 and May 1979. From this time forward, often works in thematic series, such as "Postcards" and "Dreams," which function as chapters of pictorial autobiography.

Ian Frazier's "Dating Your Mom" appears in *The New Yorker*, July 3. A few months later, Steinberg mails the twenty-seven-year-old Frazier a fan letter, inviting him to lunch; they develop a close friendship.

1979

For several years, draws many portraits from life of Sigrid and visitors to the house in Amagansett.

Death of *New Yorker* writer S.J. Perelman, a friend from his earliest days in America, whose meticulous use of language to outrageous effect was a major inspiration for Steinberg.

Revised edition of *The Passport* published.

Late in the year, resumes playing the violin, which he had played as a child and occasionally went back to over the years. Takes lessons which, as he recounts to Buzzi on December 9, "miraculously bring back the pieces I did with the *liceo* orchestra. . . . I have an excellent violin, a gift from Sasha [Schneider], and playing it loudly, out in the country, with no neighbors nearby, is a pleasure." By November 1982, however, he has "completely abandoned the violin, convinced that I have a tin ear. On the other hand I have an excellent nose, but no intelligent or systematic way to use it."

1980

January 9–February 9, solo exhibition, Margo Leavin Gallery, Los Angeles.

February, with Sigrid to Guadeloupe, where they return in the winters of 1986 and 1989.

Devotes increasing attention to building and studying his collection of early-twentieth-century European gravure postcards. "A few years ago," he writes to Buzzi in May, "I discovered that this collection, with its groupings of railroads, monuments, etc., harbored a whole additional collection of reflections in water and in mirrors (nude women). Now I've discovered yet another aspect, never before examined: the text, the stamps, the postmarks."

October, "Saul Steinberg/Richard Lindner," Galerie Maeght, Paris.

1981

February, the first of several trips to Los Angeles to make prints at Gemini G.E.L. studio. Visits Ensenada, Baja, California; travels with his violin.

July, Marcel Breuer dies; Steinberg attends the memorial service at the Whitney Museum of American Art in September.

1982

Meets novelist William Gaddis, partner of friend and Hamptons neighbor Muriel Oxenburg Murphy. Feels assured of his own "normalcy" in the presence of the encyclopedically curious novelist, whose difficult and unclassifiable writing he admires. Their friendship will deepen throughout the 1980s and 1990s.

Ends thirty-year representation by Betty Parsons and Sidney Janis galleries to join the Pace Gallery, where he debuts with "Steinberg: Still Life and Architecture," April 3–May 5.

November 13–December 15, "Saul Steinberg: Mixed Media Works on Paper and Wood," Richard Gray Gallery, Chicago.

Designs the label for Château Mouton Rothschild 1983. Receives cases of wine in payment, which he will distribute among his friends.

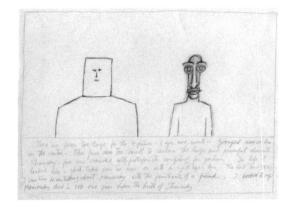

1983

July, spends three days at a Zen retreat in the Hudson Valley region of New York State. His ongoing search for peace is occasioned, among other things, by Sigrid's erratic mental health and by pressure to pursue further retrospective projects—which, this year, he swears off.

November 2–26, "Saul Steinberg: An Exhibition of Sculpture, Collages, and Drawings, 1970–1982," Waddington Galleries, London.

Dal Vero, with text by John Hollander, published in limited edition.

1984

Brings suit against Columbia Pictures Industries, Inc., for appropriation of *View of the World from 9th Avenue* in a movie poster.

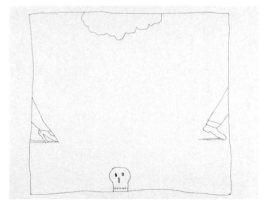

August, probably on the recommendation of Saul Bellow, participates in a Great Books conference led by Allan Bloom at the John M. Olin Center for Inquiry into the Theory and Practice of Democracy, University of Chicago.

1985

Corresponds and has telephone conversations with Primo Levi.

April, tells Buzzi of "a visit with de Kooning, a sad one, because he no longer seems to be present (constant smile and whispery voice—he appears to be deaf, but he's not). He was surrounded by 3–4 widows bickering about the future."

October, the last relative of his parents' generation, Aunt Sali, his mother's sister, dies in Israel, age ninety-one.

1986

Adam Gopnik begins a series of interviews with Steinberg, intended for publication in *The New York Review of Books*. They edit and rewrite the transcripts over several years, but the sessions are never published in English; excerpts published in French in the magazine *Egoïste*, December 1992.

October, "Saul Steinberg: Dessins, Aquarelles et Objets," Galerie Maeght Lelong, Paris.

November 9–January 4, 1987, solo exhibition, Elisabeth Franck Gallery, Knokke-le-Zoute, Belgium.

1987

January, *New Yorker* owner S.I. Newhouse dismisses longtime editor William Shawn, replacing him with Robert Gottlieb, an editor at Random House books. Steinberg will withhold work from the magazine for the next several years.

Prudence Crowther contacts Steinberg while compiling a volume of S.J. Perelman's letters; she will become an important friend to both Steinberg and Sterne.

June, Judge Louis L. Stanton hands down a twenty-five-page decision on *Steinberg v. Columbia Pictures*, in favor of Steinberg's suit against the illegal use of *View of the World from 9th Avenue*. Steinberg savors the intelligently written decision as "a true, primitive pleasure, the glorious dream of every humble individual persecuted by invincible forces (*I promessi sposi*, Dickens, Hugo)." When substantial punitive damages are awarded a year later, he makes no public announcement, "to avoid the vulgarity and annoyance of publicity."

October 13–November 28, "Steinberg: Recent Work," The Pace Gallery, New York.

1988

Deaths of Bernard Rudofsky (March 11), Tino Nivola (May 5), Charles Addams (September 29), and, also in September, Gertrude Einstein, who had managed the New York office of Steinberg's agent, Cesar Civita, and who had been Steinberg's lifeline during his year in the Dominican Republic.

Begins making photocopy enlargements, up to a meter wide, of old gravure postcards from Russia and Europe; considers issuing a book of blowups of cards featuring dogs.

Letters to Aldo Buzzi grow in frequency. As his only regular outlet for Italian, they become, in their idiosyncrasy and concision, an annex of his art. On April 11, he explains: "Italian has become my literary style, that is, my method for thinking in words. . . . Sometimes the very *paucity* [written in English] of my vocabulary forces a certain ingenuity on me, too." On May 3: "More and more I miss my sister Lica: I discover things about the past and have nobody to discuss them with. . . . So much knowledge is lost with every life. And this is the most important reason to write."

June 16–October 2, "Steinberg: 4. Internationale Triennale der Zeichnung," Kunsthalle Nürnberg, Nuremberg.

Summer, solo exhibition, Galerie Adrien Maeght, Paris. Show travels, February–March, 1989, to Galerie Maeght, Barcelona.

1989

February, buys a video camcorder, which he uses to experiment with extreme close-up self-portraiture (his nose, his lips, an eye).

After contemplating a visit to Romania to see his childhood house, writes to Buzzi, April 15: "I learned some frightening news from Bucharest: my old neighborhood, Antem and Uranus, has already been destroyed, razed to the ground! by the Monster [Ceaucescu]. So my plan to unburden myself of the past has already been resolved, in a drastic manner, and I have no desire to visit the imbecilic future."

In June, Papoose the cat, now aged, disappears—a deep personal loss for Steinberg. Will tell Sterne some years later that, of all the friends he has outlived, he misses his sister and Papoose most.

December, obsessively watches television news as the regime of Nicolai Ceaucescu is violently overthrown in Romania.

1990

Canal Street, collaboration with Ian Frazier, published in limited edition.

October 10–November 10, "Saul Steinberg: Tables and Works on Paper," John Berggruen Gallery, San Francisco.

Early 1990s, in a sensual dialogue with the past, begins adding color to some of his pen-and-ink drawings of the 1940s and 1950s. The distinguishing qualities of his current drawings are what he gladly calls "clumsiness" ("the best clumsy ones are Cézanne and Matisse") and a sometimes-crude simplicity; his eloquent pen-and-ink line has given way to oil pastel and marker pen.

Approach and Entrance to Holland Tunnel. Postcard, 1930s, from Steinberg's collection. YCAL.

1991

Encouraged by Sterne, practices meditation and yoga, studies Zen, and keeps a diary. Since the 1960s, has spoken on the phone with Sterne virtually every day. May 6, writes in his diary, "I ask Hedda—How come I have this urge to call you—She says: because we have something in common—What is it? I say. We both love you, she answers."

1992

The Discovery of America published, with introduction by Arthur C. Danto.

Sends William Shawn an inscribed copy of *The Discovery of America*, with a note saying he is considering contributing to *The New Yorker* again. Shawn, ailing, pens an encouraging response on the day he dies.

A beloved object of daily communion—a graceful tree growing from the sidewalk beside a tailor's awning at 115 East 75th Street—is sawed down to a stump by the building's owner.

Jerome Robbins' ballet *The Concert* performed by New York City Ballet with Steinberg's backdrop.

Aldo Buzzi's "Chekhov in Sondrio," a literary version of Steinberg's travels by magnifying glass through old postcards, appears in the September 24 issue of *The New Yorker*.

December 5–January 9, 1993, "Saul Steinberg: The Discovery of America," The Pace Gallery at Greene Street, New York.

1993

April, visits the Buchinger clinic in Marbella, Spain.

May 8–June 13, solo exhibition, Guild Hall Museum, East Hampton, New York.

Though still distraught at the demise of *The New Yorker* he loved, is gradually convinced by new editor Tina Brown and her art editor, Françoise Mouly, to contribute covers and color features. Will contribute a combination of new work and old but unpublished drawings, the latter excavated from sketchbooks and portfolios.

1994

February, with Sigrid to St. Bart's in the French Caribbean.

March 1–April 20, "Saul Steinberg: Major Works," Adam Baumgold Gallery, New York.

April 29–June 11, "Saul Steinberg on Art," Pace Drawing, New York.

June 28, writes in his diary, "Today I'm *80!* With delayed reflexes I now seem kinder, having missed the occasion for an instant nasty retort."

December 1994–November 1996, black-and-white drawings appear as occasional illustrations in *The New York Review of Books*, reprising the integral role his art once served at *The New Yorker*.

1995

February, returns to St. Bart's with Sigrid. On the third day, she suffers a mental collapse, and he brings her back to New York for hospitalization.

Diagnosed with thyroid cancer. It is "indolent"; no intervention is recommended. Makes arrangements for posthumous disposition of his art and papers and tells Buzzi that he is destroying many old drawings, being in a "funereal" mood.

Though drawing less often, remains a hungry collector and vivid reporter of details. April 30, to Buzzi: "After years of avoiding the cinema, saw a good, brutal film,

Pulp Fiction, in a lugubrious building with six theaters on six floors, connected by escalators. . . . The black cashier told me how to get to the 6th floor, to the right, Theater Number 6, addressing me as if I were a deaf Chinaman, the words staccato, in a loud voice. Good film, earsplitting. I'll buy the videotape in order to figure out what they were saying. And so I left before the end, alone on the escalator, with only one man who left behind me, at a constant distance of 2 floors. A scene out of Hitchcock (at that hour we were the only ones on the escalator). But he got off on the 4th floor to watch part of another film for free."

December, begins taking Librium for extreme depression.

1996

February 2–March 20, "Saul Steinberg: Drawings and Tables," Adam Baumgold Gallery, New York.

"Saul Steinberg: About America 1948–1995. Fifty Drawings from the Collection of Sivia and Jeffrey Loria," Arthur Ross Gallery, University of Pennsylvania, Philadelphia, October 20–January 21, 1996. Show travels to Yale University Art Gallery, New Haven, March 23–June 9, 1996.

Sigrid Spaeth commits suicide, September 24. Steinberg seeks comfort from the moral support of friends; he stays at home in Amagansett, spending the greater part of his days in telephone conversation.

1997

February, joins Prudence Crowther, who has rented a small house and guest cabin in Key West. William Gaddis is also there.

"This tree looks too much like Art," Key West, 1997. Black pencil. YCAL sketchbook 4846.

February 22, to Buzzi: "I open my eyes in the morning: great light, and on the ceiling, the enormous, silent fan, almost as big as the ceiling itself. If it falls, I'll be chopped to bits. I try to remember my ugly dreams—lost

on the Romanian railways—but then [I'm] happy, because I'm staying in this paradise for another 2 weeks (and perhaps longer): its strangeness, more than anything else, helps me to forget almost everything. Tiny houses, miniature temples of unpainted wood, dwellings for castaways. Mornings, a 2-km round trip on foot to buy the *NY Times*, with its list of deceased celebrities *du jour*. Nabokov feared his encounters with [Edmund] Wilson and Dostoevsky in Paradise."

September 13–November 8, "Saul Steinberg: Sammlung Sigrid Spaeth," Galerie Bartsch & Chariau, Munich.

December–January 1998, solo exhibition, Adam Baumgold Gallery, New York.

1998

January, returns to Key West with Crowther, Aldo Buzzi, and Buzzi's companion, Bianca Lattuada.

From August onward, often mails Buzzi old gravure postcards from his collection, annotated with commentary on visual details or with his salutation added to that of the card's original sender.

December, after long deliberation, begins a month of shock therapy for depression. The day after his first treatment, is devastated to learn that William Gaddis has died.

1999

January 24, to Buzzi: "The annus mirabilis of 1999. The year of my death—I would guess, calmly."

Bucharest street map and drawing on Steinberg's New York desk at the time of his death. Photograph, July 1999, by Evelyn Hofer.

March, travels to St. Bart's with Prudence Crowther for rest and recovery.

April, from a library map of Bucharest, redraws the streets he knew as a boy.

Early May, diagnosed with advanced pancreatic cancer; dies May 19, New York City.

Steinberg's will provides for the creation of The Saul Steinberg Foundation and the bequest of his papers to the Beinecke Rare Book and Manuscript Library, Yale University.

September 24–November 28, "Remembering Saul Steinberg," The Menil Collection, Houston.

October 1–30, "Saul Steinberg: Drawing into Being," PaceWildenstein Gallery, New York.

October 13–December 18, "Saul Steinberg: Works from the '50s–'80s," Adam Baumgold Gallery, New York.

2000

Saul Steinberg Masquerade, with photographs by Inge Morath, published; a selection of the photographs Morath took in 1959–62.

2001

November 17–January 13, 2002, "Saul Steinberg: Works from the '50s–'80s," Adam Baumgold Gallery, New York.

2002

February 7–April 7, solo exhibition, Institut Valencià d'Art Modern, Spain.

March 7–April 3, "Saul Steinberg: Selected Prints, Drawings, and Books, '60's–'90's," Adam Baumgold Gallery, New York.

Reflections and Shadows published. Edited by Buzzi, the book is based on oral memoirs Steinberg recorded in 1974 and 1977.

Lettere a Aldo Buzzi 1945–1999 published in Milan.

2003

September 19–November 15, "American Short Stories: Saul Steinberg/Raymond Pettibon," Museum of Contemporary Art, North Miami

December 4–January 31, 2004, "Saul Steinberg: Works from the '50s–'80s," Adam Baumgold Gallery, New York.

2004

February–March, "Steinberg: An Intimate View of His Art and World," organized by Anton van Dalen, Visual Arts Museum at the School of Visual Arts, New York.

2005

February 11–March 5, "Steinberg at *The New Yorker*," PaceWildenstein Gallery, New York.

Selected Bibliography

This bibliography is intended as a window onto Steinberg's career. Citations in each section are ordered chronologically. The compilation is selective, including primarily those publications most relevant for further research. A more extensive listing of journalistic book and exhibition reviews can be found in the 1978 Whitney Museum retrospective catalogue.

By Steinberg

BOOKS

All in Line. New York: Duell, Sloan & Pearce, 1945.

The Art of Living. New York: Harper & Brothers, 1949.

The Passport. New York: Harper & Brothers, 1954. Revised ed., with an introduction by John Hollander, New York: Vintage Books, 1979.

Steinberg's Umgang mit Menschen. Hamburg: Rowohlt Verlag, 1954.

Dessins. Paris: Gallimard, 1956.

Steinberg. Munich: R. Piper Verlag, 1959

The Labyrinth. New York: Harper & Brothers, 1960.

The Catalogue. Cleveland: Meridian Books/World Publishing, 1962.

Steinberg's Paperback. Munich: Rowohlt Verlag, 1964.

The New World. New York: Harper & Row, 1965.

Le Masque. Texts by Michel Butor and Harold Rosenberg; photographs by Inge Morath. Paris: Maeght Éditeur, 1966.

The Inspector. New York: The Viking Press, 1973.

all except you. With Roland Barthes. Paris: Repères, 1983.

Dal Vero. With John Hollander. New York: The Library Fellows of the Whitney Museum of American Art, 1983.

Canal Street. With Ian Frazier. New York: The Library Fellows of the Whitney Museum of American Art, 1990.

The Discovery of America. Introduction by Arthur C. Danto. New York: Alfred A. Knopf, 1992.

Saul Steinberg: Masquerade. Photographs by Inge Morath. New York: Viking Studio, 2000.

Lettere a Aldo Buzzi, 1945–1999. Edited by Aldo Buzzi. Milan: Adelphi Edizioni, 2002.

Reflections and Shadows. With Aldo Buzzi. Translated by John Shepley. New York: Random House: 2002.

"Steinberg as Contributing Artist" and "Periodicals": Most citations in these sections refer to the first appearance of a given body of work. Exceptions are labeled "reprints." Steinberg's art—in particular, his line drawings—has always had a wide secondary market in anthologies and thematic picture books, among other publications. Reprints are cited here only in cases where the new context was of special relevance to Steinberg's career or reception, or where new and recycled work appear in print together (denoted "some reprints").

Steinberg as Contributing Artist

Steinberg, Saul (?). *China Theater: An Informal Notebook of Useful Information for Military Men in China.* Washington, D.C.: Reproduction Branch of the Office of Strategic Services, 1943. Illustrations.

Scoggin, Margaret C., ed. *Chucklebait: Funny Stories for Everyone.* New York: Alfred A. Knopf, 1945. Dust jacket, cover, and illustrations.

Feldkamp, Fred, ed. *Mixture for Men.* Garden City, New York: Doubleday, 1946. Two illustrations.

Cohn, David L. *This Is the Story.* Boston: Houghton Mifflin Company, 1947. Dust jacket, cover, and illustrations (reprints).

Lieberson, Goddard. *Three for Bedroom C.* Garden City, New York: Doubleday, 1947. Dust jacket.

Taylor, Robert Lewis. *Adrift in a Boneyard.* Garden City, New York: Doubleday, 1947. Dust jacket and title page.

Hellman, Geoffrey. *How to Disappear for an Hour.* New York: Dodd, Mead, 1947. Dust jacket and decorations.

MacLiesh, A. Fleming, and Robert de San Marzano. *Infernal Machine.* Boston: Houghton Mifflin, 1947. Decorations, cover, and dust jacket.

Scoggin, Margaret C., ed., *More Chucklebait: Funny Stories for Everyone.* New York: Alfred A. Knopf, 1949. Dust jacket, cover, and decorations.

Gruber, Ruth. *Israel Without Tears.* New York: Current Books, 1950. Dust jacket and endpapers.

Behrman, S.N. *Duveen.* New York: Random House, 1952. Dust jacket, title page, and illustrations.

Liebling, A.J. *Chicago: The Second City.* New York: Alfred A. Knopf, 1952. Dust jacket, cover, and illustrations.

Baur, John I.H. *ABC for Collectors of American Contemporary Art.* New York: Princeton Press, 1954. Cover and illustrations (reprints).

CIAM (Congressi Internazionali di Architettura Moderna). *Il Cuore della città per una vita più umana delle comunità.* Milan: Hoepli Editore, 1954. Endpapers and one illustration.

Mitchell, Joseph. *The Bottom of the Harbor.* Boston: Little, Brown, 1959. Dust jacket and title page.

Tabak, May Natalie. *But Not for Love.* New York: Horizon, 1960. Endpapers.

Kuby, Erich. *The Sitzkrieg of Private Stefan.* New York: Farrar, Straus and Cudahy, 1962. Dust jacket.

Meyerson, Martin, et al. *Housing, People, and Cities.* New York: McGraw-Hill, 1962. Dust jacket and title page (reprints).

Friedman, Bruce Jay. *Stern.* New York: The New American Library, first paperback edition, 1963. Cover.

Chermayeff, Serge, and Christopher Alexander. *Community and Privacy: Toward a New Architecture of Humanism.* Garden City, New York: Doubleday, 1963. Illustrations (reprints).

Rosenberg, Harold. *The Anxious Object: Art Today and Its Audience.* New York: Horizon Press, 1964. Back leaf of dust jacket.

Miles, Milton. *A Different Kind of War: The Little-Known Story of the Combined Guerilla Forces Created in China by the U.S. Navy and the Chinese During World War II.* New York: Doubleday, 1967. Four wartime drawings.

Tillich, Paul. *My Search for Absolutes.* New York: Simon and Schuster, 1967. Three portfolios of drawings.

Heinrich Maria Ledig-Rowohlt zu liebe: Festschrift zu seinem 60. Geburtstag. Hamburg: Rowohlt Verlag, 1968. Cover.

Rudofsky, Bernard. *Streets for People: A Primer for Americans.* Garden City, New York: Doubleday, 1969. Three drawings (reprints).

Aronson, Elliot. *The Social Animal.* New York: Viking Press, 1972. Illustrations (reprints).

Buzzi, Aldo. *Quando la pantera rugge: Memorie interrotte dall'indignazione.* Milan: All'insegna del Pesce d'Oro, 1972. Rubber-stamp drawings.

Rosenberg, Harold. *Discovering the Present: Three Decades in Art, Culture, and Politics.* Chicago: University of Chicago Press, 1973. Endpapers.

Buzzi, Aldo. *Piccolo diario americano.* Milan: All'insegna del Pesce d'Oro, 1974. Dust jacket and illustrations.

Dubé, Anthony, et al. *Structure and Meaning: An Introduction to Literature.* Boston: Houghton Mifflin, 1976. Cover, title page, and illustrations.

Appel, Alfred, ed. *Vladimir Nabokov: A Tribute.* London: Weidenfeld and Nicolson, 1979. Illustration.

Buzzi, Aldo. *L'uovo alla kok: Ricette curiosità, segreti di alta e bassa cucina.* Milan: Adelphi Edizioni, 1979. Translated as *The Perfect Egg and Other Secrets.* London: Bloomsbury Publishing, 2005. Illustrations.

Fanger, Donald. *The Creation of Nikolai Gogol.* Belknap Press, 1979. Frontispiece (reprint).

Borsody, Stephen. *The Tragedy of Central Europe: Nazi and Soviet Conquest and Aftermath.* Revised edition, New Haven: Yale Concilium on International and Area Studies, 1980. Cover and frontispiece.

Krementz, Jill, ed. *Happy Birthday, Kurt Vonnegut: A Festschrift for Kurt Vonnegut on His Sixtieth Birthday.* New York: Delacorte Press, 1982. Illustration.

Buzzi, Aldo. *Andata & ritorno: Viaggi a Djakarta, Gorgonzola, Lambrate, Londra, Como, Baggio, Vienna, Leichlingen, Springs, Brunate.* Milan: All'insegna del Pesce d'Oro, 1984. Illustration.

Tillman, Lynne, with preface by Woody Allen. *Bookstore: The Life and Times of Jeanette Watson and Books & Co.* New York: Harcourt Brace, 1999. Dust jacket.

Herman Cherry: Paintings on Paper—Martha's Vineyard 1956. Exhibition catalogue. Springs, New York: Pollock-Krasner House & Study Center; New York: Gary Snyder Fine Art, 2002. Back cover.

PERIODICALS

Regular Contributions

Bertoldo (Milan): July 1936–April 1941. 256 cartoons (published without attribution after March 18, 1938).

Settebello (Milan): April 23–September 10, 1938. 60 drawings, including regular feature "Il Milione: Viaggi, Avventure, Usi e Costumi."

Cascabel (Buenos Aires): 1941–42. Cartoons, start and end date unknown.

PM: January 11, 1942–March 23, 1943. 48 anti-Fascist editorial cartoons and strips.

La Nacion (Ciudad Trujillo): early 1942. Contributions uncatalogued.

Liberty: 1942. Occasional war-related cartoons.

The American Mercury: April 1942–December 1946. 37 cartoons and illustrations.

The New Yorker: October 1941–May 1999, 87 covers, 17 captioned and 316 uncaptioned cartoons, 93 spots and "spot-pluses," 124 illustrations, and 71 portfolios containing 469 drawings.

The New York Review of Books: December 1994–November 1996. 1 cover, 6 illustrations.

Features and Illustrations

An asterisk (*) denotes a Steinberg contribution that is titled as a distinct feature but paired with a written feature on the same topic. "History of a Howitzer" (*Fortune*, October 1942), for example, shares pages with an article on the armaments industry.

"Persiflage from Paris." *Harper's Bazaar* 73 (March 15, 1940), pp. 60–61.

"Life in the 'Guatavir' Line." *Life*, May 27, 1940, pp. 14–15, 17.

Wainwright, Oliver. "The Shot Heard Round the County." *Town & Country* 95 (October 1940). Steinberg ill., p. 50.

Cover and "Steinberg Desenhos." *Sombra* (Rio de Janeiro) 1, no. 1 (December 1940–January 1941), pp. 49, 50, 72, 73, 88.

"Mademoiselle's Christmas Sleighride." *Mademoiselle* (December 1941), pp. 114–15.

"Don't Ever Marry These Guys." *Mademoiselle* (February 1942), pp. 88–89.

* "History of a Howitzer." *Fortune* 26 (October 1942), pp. 108–12.

Author unknown. "Who'll Be Drafted When?" *Fortune* 26 (November 1942). Steinberg ill., p. 97.

Author unknown. "Psychoanalyze Your Furniture." *House Beautiful* 85 (January 1943), pp. 32–33.

Author unknown. "The New World Belongs to Risk." *Fortune* 27 (January 1943). Steinberg ill., p. 110.

"The Bizarre Little Creations of Steinberg." *Life*, August 13, 1945, pp. 8–10 (cartoons from *All in Line*).

Tyler, Poyntz. "The Corporal Who Played Santa Claus." *Town & Country* 100 (December 1945). Steinberg ill., pp. 110–11.

Architectural Forum 84 (1946): "Drugstore," February, p. 70; "Movie Palace," March, p. 120; "Doubling Up," April, p. 102; "Underground," May, p. 114.

"People Are Talking About—In Washington." *Vogue* (February 1, 1946), pp. 132–37.

Author unknown. "Soap Opera." *Fortune* 33 (March 1946). Steinberg ill., pp. 118–19.

Cover. *Interiors* 105 (April 1946).

"Mottoes Illustrated." *Harper's Magazine* 193 (August 1946), pp. 107–10.

"Furniture News from France by Steinberg, humoriste américain." *Interiors* 106 (February 1947), pp. 87–89.

Iglauer, Edith. "Housekeeping for the Family of Nations." *Harper's Magazine* 194 (April 1947). Pictorial comment by Steinberg, pp. 297, 299, 300, 303, 304, 306.

Author unknown, "Nine Household Appliances." *House & Garden* 92 (April 1947). Steinberg ill., p. 118.

Cover and "Monsieur Steinberg's French Notebook." *Harper's Bazaar* 80 (May 15, 1947), pp. 82–85.

Author unknown. "The Whiskey Rebellion." *Fortune* 35 (June 1947). Steinberg ill., pp. 140–41.

Lynes, Russell. "The Taste-Makers." *Harper's Magazine* 194 (June 1947). Pictorial comment by Steinberg, pp. 483, 485, 487, 489, 491.

"People: Three Aspects by Steinberg." *'47 The Magazine of the Year* (August 1947), pp. 130–35.

"Your Perfume According to the Stars." *Harper's Bazaar* 81 (October 1947), pp. 186–87.

* "Steinberg: Five Drawings." *Commentary* 4 (October 1947), pp. 325–28 (some reprints).

Porter, Katherine Anne. "Gertrude Stein: A Self-Portrait." *Harper's Magazine* 195 (December 1947). Steinberg ill., p. 525.

"Man's Burden: Theme with Variations (Slight) by Steinberg, an artist gently lethal." *Vogue* (March 1, 1948), pp. 212–13. Reprinted as "L'Homme et son fardeau." *Vogue* (France) (May 1948), p. 83.

Lynes, Russell. "Highbrow, Lowbrow, Middlebrow." *Harper's Magazine* 198 (February 1949). Steinberg ill., p. 24.

Smith, Stevie. "Books." *Vogue* (London) 105 (December 1949). Steinberg ill., pp. 98–101.

"Change of Mind 1900–1950." *Vogue* (January 1950), pp. 96–101.

"Portraits by Steinberg." *Flair* 1 (April 1950), pp. 81–98.

Author unknown. "The Unembarrassed Mind." *Vogue* (April 15, 1950). Steinberg ill., p. 70.

"The City by Steinberg." *Flair* 1 (September 1950), pp. 74–91.

Architectural Review (London) 108 (December 1950), special issue, "Man Made America." Cover and pp. 344, 360, 371–75 (some reprints).

Untitled portfolio, *Portfolio* (Cincinnati) 1 (Winter 1950), eight pages (some reprints).

Cover (wraparound). *American Fabrics* 13 (Spring 1950).

"Eight Drawings." *Wake* 10 (1951), pp. 5–12.

Cover. *Holiday* 9 (April 1951).

* "Gare de Paris." *Harper's Bazaar* 85 (April 1951), pp. 108–09.

* "Paris, Noted by Saul Steinberg, Master of the Finely Etched Eccentricity." *Vogue* (May 15, 1951), pp. 81–82.

* "Jukebox." *Harper's Bazaar* 86 (August 1951), p. 146.

"Steinberg and Sterne." *Life*, August 27, 1951, n.p. Includes Steinberg feature, "The End Is Not in Sight," a spread on his multipaneled drawing *Parade*.

" . . . and Europe." *Look*, January 1, 1952, pp. 54–57.

Amory, Cleveland. "Palm Beach." *Life*, January 21, 1952. Steinberg ill., pp. 88–92, 95, 96, 101.

* "Italy." *Harper's Magazine* 204 (February 1952), pp. 61–64.

"Living Dangerously." *Vogue* (February 1, 1952). With verses by Ogden Nash, pp. 180–81.

Nash, Ogden. "Everybody loves a bride . . . even the groom." *House & Garden*, 102 (May 1952). Steinberg ill., pp. 120–21.

Amory, Cleveland. "Saratoga: Swan Song for a Spa." *Harper's Magazine* 205 (October 1952). Pictorial comment by Steinberg, pp. 69, 71–72, 74, 76–77, 79.

Steinberg, Saul. "Built in U.S.A.: Postwar Architecture, 1945–52." *Art News*, 52 (February 1953), pp. 16–19.

Stanton, John. "The Battle of the City Streets." *Life*, March 30, 1953. Steinberg ill., pp. 134–36, 139, 140, 142, 145.

"Steinberg à Paris." *Vogue* (France) (May 1953), pp. 51–53.

Rodman, Selden. "Drawings of This Hemisphere." *New World Writing* 4 (October 1953). Steinberg ill., p. 164.

"Livres d'or of Paris." *The Paris Review* 5 (Spring 1954). Steinberg ill., pp. 98–99.

"Saul Steinberg's View of 'The Threepenny Opera,' Revived." *Vogue* (May 15, 1954), pp. 81–82.

Constable, Rosalind. "Seven Painters and a Machine." *Fortune* 49 (June 1954). Steinberg ill., p. 131.

De Voto, Bernard. "Heavy, Heavy, What Hangs Over?" *Holiday* 19 (June 1954). Steinberg ill., p. 36.

Author unknown. "The 9-Day Wonder Diet Plus Follow-up Program." *Harper's Bazaar* 87 (June 1954). Steinberg ill., pp. 46–47.

Steinbeck, John. "Jalopies I Cursed and Loved." *Holiday* 19 (July 1954). Steinberg ill., p. 44.

"Steinberg's America." *Harper's Magazine* 209 (August 1954), pp. 48–52.

"False Daguerreotypes, False Diary, False Diploma—True Steinberg." *Vogue* (October 15, 1954), pp. 112–15.

Hall, Edward T., Jr. "The Anthropology of Manners." *Scientific American* 192 (April 1955). Steinberg ill., pp. 85, 86, 88.

"Zeichnungen aus *Passport*." *Texte und Zeichen: Eine literarische Zeitschrift* (July 1955), pp. 290, 317, 354, 372–373, 375, 376 (reprints).

"Steinberg at the Bat." *Life*, July 11, 1955, pp. 56–61.

Du 16 (January 1956), "Humoristische Photos, Humoristische Zeichnungen" issue. Cover and pp. 34, 35 (includes foldout page).

* "A Mozart Opera—As Seen by Steinberg." *Harper's Bazaar* 89 (January 1956), p. 99.

Steinbeck, John. "The Yank in Europe." *Holiday* 24 (January 1956). Steinberg ill., pp. 24, 25.

* "Drawings of Athens . . . by Steinberg." *Harper's Magazine* 212 (February 1956), pp. 46–47.

* "Steinberg Field." *Fortune* 53 (February 1956), pp. 96–99.

Ionesco, Eugene. "The Bald Soprano." *New World Writing* 9 (1956). Steinberg ill., pp. 200, 210, 224. Drawings reprinted in "La tragédie du langage," *Spectacles* (Paris) 2 (July 1958), pp. 3–5.

Mallet, Jacqueline, and Claude Romain. "Fumez-Vous?" *Femina-Illustration* 25 (May 1956). Steinberg ill., pp. 75, 77, 79.

Chase, Stuart. "How to Read an Annual Report." *The Lamp* (Standard Oil Company) 39 (Winter 1957–58), pp. 18–23.

Mitchell, Maurice B. "A Forward Look at Communications." In *The Britannica Book of the Year 1958*. Chicago: Encyclopedia Britannica, 1958. Illustrations, pp. 49–64.

Small, Verna. "Haphazards of the City." *Mademoiselle* (June 1958), pp. 80–81.

Cover. *The Paris Review*, no. 19 (Summer 1958).

"Saul Steinberg Stamp Collection." *Harper's Bazaar* 90 (June 1959), pp. 70–73.

* "Saul Steinberg Stops for the Night." *Fortune* 53 (June 1959), pp. 120–21.

Daedalus 89 (Winter 1960), "The Visual Arts Today" issue; Steinberg, pp. 124–26, is among thirteen contributors of "Statements and Documents."

"Steinberg in the West." *Encounter* 14 (April 1960), pp. 5–9, introduction by Stephen Spender.

"Steinberg U.S.A." *Harper's Magazine* 221 (September 1960), pp. 49–54.

"Steinberg's Perfume-Association Pictures." *Vogue* (December 1960), pp. 114–17.

Cover. *Art in America* 49, no. 2 (1961). Detail of cover on masthead page (reprint).

Small, Connie. "Alcoholics Anonymous Comes of Age." *Think* 27 (March 1961). Steinberg ill., p. 22

Olson, Jack. "The Pool Hustlers." *Sports Illustrated*, March 20, 1961. Steinberg ill., pp. 70, 76–77.

Cover. *Opera News*, 25 (April 29, 1961).

Journal of the American Institute of Planners 27 (August 1961), "Steinberg on the City: Part Two." Special all-Steinberg issue edited by Jesse Reichek (reprints).

Toffler, Alvin. "A Quantity of Culture." *Fortune* 64 (November 1961). Steinberg ill., pp. 124–25.

Haberler, Gottfried. "Why Depressions Are Extinct." *Think* 28 (April 1962). Steinberg ill., p. 2.

"The Nose Problem." *Location* 1 (Spring 1963), pp. 37–40.

"Steinberg at the Races." *Sports Illustrated*, November 11, 1963, pp. 40–47.

Cover. *Time*, May 14, 1965.

Vanden Heuvel, Jean. "Straight from the Hand and Mouth of Steinberg" (drawings from *The New World* with artist's commentary), *Life*, December 10, 1965, pp. 59–70.

G[asser], M[anuel]. "Saul Steinberg." Photographs by Franco Cianetti. *Du Atlantis* 26 (August 1966), pp. 592–613.

Steinberg, Saul. "Our False-Front Culture." *Look*, January 9, 1968, pp. 46–49.

Cover. *Art News Annual* (1970), "Narrative Art."

Birmingham, Stephen. "The Talk Industry." *Holiday* 47 (February 1970). Steinberg ill., p. 60.

Cover. *The New York Times Magazine*, August 23, 1985.

"Interiors/Exteriors." *Audience* 2 (May–June 1972), pp. 15–23.

Cover. *Derrière le Miroir*, no. 250, *Hommage à Aimé et Marguérite Maeght*, 1982.

"Album." *Arts* 62 (November 1987), pp. 96–97.

Cover and "3 Postcards & 9 Dogs." *Grand Street*, no. 36 (Summer 1990), pp. 51–64. Text by Walter Hopps.

Gopnik, Adam. "Steinberg's New York." *The New York Times*, October 25, 1992, p. 23.

Cover and "13 Drawings." *Grand Street*, no. 48 (Winter 1994), pp. 65–79.

"Las Vegas." *Grand Street*, no. 52 (Spring 1995), pp. 136–37.

OTHER

Christmas cards for The Museum of Modern Art, 1945–52.

Cover. *Jean-Paul Sartre présente Gjon Mili*. Paris: Galerie du Bac, 1946. Exhibition brochure.

Sheet music cover. Gian-Carlo Menotti, *The Telephone, or L'amour à trois: Opera Buffa in One Act*. New York: G. Schirmer, 1947.

Sheet music cover. Vittorio Rieti, *Second Avenue Waltzes* (1942). New York: Associated Music Publishers, 1949.

Christmas cards for Brentano's Books, 1950–52.

Record jacket. Saint-Saëns, *Carnaval des Animaux*, Edward Lindenberg, conductor. Paris: Odéon, 1950.

Christmas, Valentine's Day, and greeting cards for Hallmark Cards, 1952–c. 1958.

Desk calendars for Hallmark Cards, 1960–69.

"Documents et notes sur la vie d'Hélion." *Hélion: Les Marches*. Exhibition catalogue. Paris: Musée d'Art Moderne de la Ville de Paris, 1977, n.p.

About Steinberg
EXHIBITION CATALOGUES

Solo Exhibitions

Steinberg 1953. Paris: Galerie Maeght. *Derrière le miroir*, nos. 53–54, March–April 1953.

Saul Steinberg. Amsterdam: Stedelijk Museum, 1953.

Steinberg. Hannover: Kestner-Gesellschaft, 1954. Text by Alfred Hentzen.

Steinberg. Paris: Galerie Maeght. *Derrière le miroir*, no. 157, March 1966.

Saul Steinberg. New York: Sidney Janis Gallery, 1966.

Steinberg: "The Americans," Panneaux de l'exposition universelle de Bruxelles, 1958; et Aquarelles, Dessins et Collages 1955–1967. Brussels: Musées Royaux des Beaux-Arts, 1967. Foreword by P. Robert-Jones, text by Pierre Baudson.

Steinberg. Rotterdam: Museum Boymans-van Beuningen, 1967. Foreword by H.R. Hoetink, text by Pierre Baudson.

Steinberg: Zeichnungen und Collagen. Hamburg: Hamburger Kunsthalle, 1968. Foreword by Helmut R. Leppien, texts by Pierre Baudson and Manuel Gasser, interview by André Parinaud.

Drawings by Saul Steinberg. New York: Sidney Janis Gallery, 1969.

Steinberg 1971. Paris: Galerie Maeght. *Derrière le miroir*, no. 192, June 1971. Text by Jacques Dupin.

Steinberg: Ölbilder, Gouachen, Zeichnungen. Zurich: Galerie Maeght, 1971. Text by Manuel Gasser.

Saul Steinberg. Milan: Galleria Mario Tazzoli, 1973. Text by Giorgio Soavi. Reprinted in Soavi, *Tenero e il Mostro*. Milan: Rizzoli, 1977.

Saul Steinberg. New York: Sidney Janis Gallery, 1973.

Steinberg 1973. Paris: Galerie Maeght, 1973. *Derrière le miroir*, no. 205, September 1973. Text by Hubert Damisch.

Steinberg at the Smithsonian: The Metamorphosis of an Emblem. Washington, D.C.: National Collection of Fine Arts, Smithsonian Institution, 1973. Text by John Hollander.

Saul Steinberg: Zeichnungen, Aquarelle, Collagen, Gemälde, Reliefs 1963–1974. Cologne: Kölnischer Kunstverein, 1974. Texts by Tilman Osterwald, Wilhelm Salber, and Gertrud Textor.

Steinberg Drawings. New York: Sidney Janis Gallery, 1976.

Steinberg. Paris: Galerie Maeght, 1977. *Derrière le miroir*, no. 224, May 1977. Text by Italo Calvino.

Saul Steinberg. New York: Whitney Museum of American Art, 1978. Text by Harold Rosenberg, chronology by Saul Steinberg.

Drawings by Saul Steinberg. Brussels: The Belgo-American Association and the American Library, 1978.

Saul Steinberg, Richard Lindner. Paris: Galerie Maeght, 1980. *Derrière le miroir*, no. 241, October 1980. Text by Eugene Ionesco.

Saul Steinberg: Still Life and Architecture. New York: The Pace Gallery, 1982. Text by Italo Calvino.

Saul Steinberg: Mixed Media on Paper and Wood. Chicago: Richard Gray Gallery, 1982.

Saul Steinberg. London: Waddington Galleries, 1983.

Steinberg. Paris: Galerie Maeght Lelong, 1986. *Repères: Cahiers d'Art Contemporain*, no. 30, 1986. Interview by Jean Frémon.

Saul Steinberg: Recent Work. New York: The Pace Gallery, 1987. Text by Adam Gopnik.

Steinberg. Paris: Galerie Adrien Maeght, 1988. Text by Eugene Ionesco.

Steinberg: 4. Internationale Triennale der Zeichnung. Nuremberg: Kunsthalle Nürnberg, 1988. Texts by Italo Calvino and Curt Heigl.

Saul Steinberg: Fifty Works from the Collection of Sivia and Jeffrey Loria. New York: Jeffrey H. Loria, 1995. Texts by John Updike and Jean Leymarie. Catalogue for an exhibition at Arthur Ross Gallery, University of Pennsylvania, Philadelphia; Yale University Art Gallery, New Haven, 1995–96.

Steinberg: Drawing into Being. New York: PaceWildenstein, 1999. Texts by Arne Glimcher and Bernice Rose.

Saul Steinberg. Valencia: Institut Valencià d'Art Modern (IVAM), 2002. Forewords by Kosme de Barañano and

Valerio Adami, texts by Dore Ashton and Colin Eisler (new), Roland Barthes and Italo Calvino (reprints).

American Short Stories: Saul Steinberg/Raymond Pettibon. North Miami, Florida: Museum of Contemporary Art, 2003.

Steinberg: An Intimate View of His Art and World. Visual Arts Museum at the School of Visual Arts, New York, 2004. Interview with Anton van Dalen by Steven Heller.

Group Exhibitions

Fourteen Americans. New York: The Museum of Modern Art, 1946.

An Exhibition for Modern Living. Detroit: The Detroit Institute of Arts, 1949. Edited by Alexander Girard and W.D. Laurie, Jr. Essays by John A. Kouwenhoven and Edgar Kaufmann, Jr.

Golden Years of American Drawings 1905–1956. Brooklyn, New York: The Brooklyn Museum, 1957.

Wallpaper: A Picture-Book of Examples in the Collection of the Cooper Union Museum. New York: Cooper Union Museum, 1961.

A Selection of Paintings, Drawings, Collages and Sculptures from the Collection of Mr. and Mrs. Billy Wilder. Santa Barbara: The Art Gallery, University of California, Santa Barbara, 1966.

Protest and Hope: An Exhibition of Contemporary Art. New York: New School Art Center, 1967.

An American Collection: Paintings, Drawings, and Sculpture (The Neuberger Collection). Providence: Museum of Art, Rhode Island School of Design, and Annmary Brown Memorial, Brown University; Washington, D.C.: National Collection of Fine Arts, Smithsonian Institution, 1968.

Images of an Era: The American Poster 1945–1975. Washington, D.C.: National Collection of Fine Arts, Smithsonian Institution, 1975.

Documenta 6. Kassel, Germany: Documenta Gesellschaft, 1977. Exhibited in the section "Handzeichnungen: Utopisches Design."

Art About Art. New York: Whitney Museum of American Art, 1978. Catalogue by Jean Lipman and Richard Marshall, introduction by Leo Steinberg.

Drawing Acquisitions 1978–1981. New York: Whitney Museum of American Art, 1981. Catalogue by Paul Cummings.

Bild als Waffe: Mittel und Motive der Karikatur in fünf Jahrhunderten. Hannover, Germany: Wilhelm-Busch-Museum, 1984. See especially Gertrud Vowinckel-Textor, "Der New Yorker und seine Bedeutung für die moderne humoristische Zeichnung, den Cartoon," pp. 441–49.

Modern American Realism: The Sara Roby Foundation Collection. Washington, D.C.: National Museum of American Art, 1987. Essay by William Kloss.

Drawn to Excellence: Masters of Cartoon Art. San Francisco: Cartoon Art Museum, 1988. Foreword by Wayne Thiebaud, essay by Kenneth K. Kriste.

Artists at Gemini G.E.L. Celebrating the 25th Year. Newport Beach, California: Newport Harbor Art Museum, 1992. Text by Mark Rosenthal, introduction by Michael Botwinick.

Proof Positive: Forty Years of Contemporary American Printmaking at ULAE, 1957–1997. Washington, D.C.: The Corcoran Gallery of Art, 1997.

Großstadtfieber: 75 Jahre The New Yorker. Hannover, Germany: Wilhelm-Busch-Museum, 2000. Edited by Gisela Vetter-Liebenow, essays by Charles Saxon, Françoise Mouly, Lee Lorenz, and Lothar Müller.

DESIGN AND ADVERTISING ANNUALS

During the period 1946–71, Steinberg's art for advertising, greeting cards, posters, and fabrics appeared regularly in the *Annual of Advertising and Editorial Art* published by the Art Directors' Club of New York and in its international counterpart, *Graphis Annual.* (Steinberg's work, in published form, was also incorporated in the annual Art Directors' Club exhibitions, held variously at Grand Central Station, The Museum of Modern Art, and other venues in New York.) Among other commercial art annuals that included Steinberg, see the following.

Ninth Graphic Arts Production Yearbook. New York: Colton Press, 1950. Steinberg featured in "Thirteen Designers on One Theme."

International Poster Annual 1951. New York, Pellegrini & Cudahy, 1951.

BOOKS AND THESES

Craven, Thomas, ed., *Cartoon Cavalcade.* New York: Simon and Schuster, 1943.

Sachs, Paul J. *Modern Prints and Drawings: A Guide to Better Understanding of Modern Draughtsmanship.* New York: Alfred A. Knopf, 1954.

Gombrich, E.H. *Art and Illusion: A Study in the Psychology of Pictorial Representation.* New York: Pantheon, 1960.

Rodman, Selden. *The Insiders: Rejection and Rediscovery of Man in the Arts of Our Time.* Baton Rouge: Louisiana State University Press, 1960.

Manzoni, Carlo. *Gli anni verdi del Bertoldo.* Milan: Rizzoli, 1964.

Chaet, Bernard. *The Art of Drawing.* New York: Holt, Rinehart, and Winston, 1970.

Adhemar, Jean. *Twentieth-Century Graphics.* Translated by Eveline Hart. New York and Washington, D.C.: Praeger Publishers, 1971.

Wittkamp, Franz. *Saul Steinberg oder Philosophie der Zeichnung.* Mainz: Gesellschaft für Bildende Kunst, 1971.

Gill, Brendan. *Here at the New Yorker.* New York: Random House, 1975.

Cummings, Paul. *American Drawings: The 20th Century.* New York: Viking Press, 1976.

Reynolds, Nancy. *Repertory in Review: 40 Years of the New York City Ballet.* New York: The Dial Press, 1977.

Angelini, Piervaleriano. "L'attività italiana di Saul Steinberg." Thesis. Università degli Studi di Pavia, 1981–82. Copy at SSF.

Hadermann, Paul. "Les phylactères de Saul Steinberg ou les plaisirs de la conversation." In *Communicating and Translating: Essays in Honour of Jean Dierickx*, ed. J.P. van Noppen and G. Debusscher. Brussels: Éditions de l'Université de Bruxelles, 1985, pp. 119–30.

Eisenstein, Sergei. "The Kangaroo." In *Nonindifferent Nature*. Translated by Herbert Marshall. Cambridge: Cambridge University Press, 1987.

Hall, Lee. *Betty Parsons: Artist, Dealer, Collector*. New York: Harry N. Abrams, 1991.

Hapgood, Marilyn Oliver. *Wallpaper and the Artist: From Dürer to Warhol*. New York: Abbeville Press, 1992.

Mangini, Cinzia, and Paola Pallottino, *Bertoldo e i suoi illustratori*. Nuoro: Ilisso Edizioni, 1994.

Guareschi, Carlotta, and Alberto Guareschi. *Milano 1936–1943: Guareschi e il Bertoldo*. Milan: Rizzoli, 1994.

Mitchell, W.J.T. "Metapictures." In *Picture Theory: Essays on Verbal and Visual Representation*. Chicago: University of Chicago Press, 1994.

Lorenz, Lee. *The Art of The New Yorker, 1925–1995*. New York: Alfred A. Knopf, 1995.

Mouly, Françoise. *Covering The New Yorker: Cutting-Edge Covers from a Literary Institution*. New York: Abbeville Press, 2000.

Martegani, Micaela. *Costantino Nivola in Springs*. Exhibition catalogue. Southhampton, New York: The Parrish Art Museum, 2003.

Mankoff, Robert, ed. *The Complete Cartoons of The New Yorker*. Introduction by David Remnick. New York: Black Dog & Leventhal, 2004.

The Complete New Yorker (DVD Collection). Introduction by David Remnick. New York: Random House, 2005.

Smith, Joel. *Steinberg at The New Yorker*. Introduction by Ian Frazier. New York: Harry N. Abrams, 2005.

Topliss, Iain. *The Comic Worlds of Peter Arno, William Steig, Charles Addams, and Saul Steinberg*. Baltimore and London: The Johns Hopkins University Press, 2005.

ARTICLES

"Steinberg." *PM's Sunday Picture News, Magazine Section*, May 9, 1943, pp. 22–23.

Author unknown. "The Job of Being Absurd." *Newsweek*, July 9, 1945, p. 97.

Buzzi, Aldo. "L'Architetto Steinberg." *Domus*, no. 213 (September 1946), pp. 19–21.

Louchheim, Aline B. "The Favored Few." *Art News* 45 (September 1946), pp. 14–17, 51–52.

Devree, Howard. "It's Funny—But Is It Art?" *The New York Times Magazine*, September 6, 1946.

Politzer, Heinz. "The World of Saul Steinberg: A Mirror Reflecting the Forlornness of Modern Man." *Commentary* 4 (October 1947), pp. 319–24.

[Mili, Gjon]. "The Walls Have Laughs." *'48 The Magazine of the Year* (June 1948), pp. 114–17.

Authors unknown. "Barroom Art in the Modern Manner" and "Art on the High Seas." *Architectural Forum* 88 (April 1948), pp. 148–52.

Lynes, Russell. "After Hours." *Harper's Magazine* 196 (June 1948), pp. 574–76.

Author unknown. "Cincinnati's Terrace Plaza." *Architectural Forum* 89 (December 1948), pp. 81–96.

Rudofsky, Bernard. "For the Honor of the Fleet: Murals for American Export Liners." *Interiors* 108 (December 1948). Fold-out feature with six panels of Steinberg's mural reproduced at full-page scale.

Naef, Hans. "Steinberg, Humorous Artist." *Graphis*, no. 26 (1949), pp. 112–21.

Author unknown. "Modern Art Goes to Sea." *Fortune* 39 (May 1949), pp. 94–98.

Lynes, Russell. "Chez Atmosphere." *Harper's Magazine* 199 (November 1949), p. 101.

Design and Paper 30 (New York: Marquardt & Co., c. 1950). Issue devoted to Steinberg, titled "Saul Steinberg, Visual Historian."

Kapp, Isa. "Civilization and Steinberg." *The Reporter*, June 20, 1950, pp. 33–36.

Pitz, Henry C. "Saul Steinberg: Mad, Savage, Enigma?" *American Artist* 15 (February 1951), pp. 40–41, 72.

Castans, Raymond. "Steinberg, premier dessinateur américain." *Paris Match*, April 14, 1951.

Louchheim, Aline B. "Steinberg: Artist and Humorist." *The New York Times*, February 3, 1952, p. X9.

Lynes, Russell. "Steinberg's Stuff." *Harper's Magazine* 204 (April 1952), pp. 96–97.

Litvinoff, Emanuel. "Conversation with Steinberg." *Jewish Observer and Middle East Review*, May 30, 1952, pp. 16–17.

"Steinberg: The Scalpel." *Esquire* 38 (August 1952), pp. 62–63. Photographs of Steinberg at work by Hans Namuth.

Motta, Flavio. "Saul Steinberg no Brasil." *Habitat: Revista das Artes no Brasil*, no. 9 (1952), cover and pp. 17–20.

Gasser, Manuel. "Steinberg Takes a New Turn." *Graphis*, no. 53 (1954), pp. 208–11.

Constable, Rosalind. "Saul Steinberg, a Profile." *Art Digest* 28 (February 1, 1954), pp. 9, 24, 29.

Young, Vernon. "The World of Steinberg." *Gentry*, no. 10 (Spring 1954), pp. 68–71.

Lynes, Russell. "A Man Named Steinberg." *Harper's Magazine* 209 (August 1954), pp. 44–52.

Author unknown. "Murals by Modern Masters." *Design* 54 (November 1954), pp. 39–41, 44.

B.B.P.R. "Il Labirinto dei ragazzi." *Casabella* 203 (November–December 1954), pp. 50–55.

McCallum, Ian. "Labyrinth at Milan." *The Architectural Review* 116 (December 1954), cover and pp. 401–03.

Author unknown. "XT: The Shapes to Come." *Fortune* 50 (December 1954), pp. 120–27.

Gasser, Manuel. "Steinberg as an Advertising Artist." *Graphis*, no. 67 (1956), pp. 376–85.

Author unknown. "Steinberg at Brussels." *Newsweek–International Edition*, April 28, 1958, p. 39.

Curjel, Hans. "Expo '58." *Graphis*, no. 78 (1958), pp. 288–311.

Author unknown. "Americans at Brussels: Soft Sell, Range & Controversy." *Time*, June 16, 1958, pp. 70–75.

Emmerich, André. "The Artist as Collector." *Art in America* 46 (Summer 1958).

Author unknown. "Vingt masques sinistres de mi-carême: le dernier gag de Steinberg." *Paris Match*, March 14, 1959, pp. 18–19.

Author unknown. "The Faces of Steinberg." *Harper's Bazaar* 93 (December 1959), pp. 118–19.

Gasser, Manuel. "Graphic Irony." *Graphis*, no. 86 (1959), pp. 500–09.

Gebhard, David. "Saul Steinberg and Paul Klee." *Artforum* 1 (February 1963), pp. 15–17.

Egly, Max. "Klee, Steinberg, MacLaren." *Image et Son: Revue de Cinéma*, no. 182 (March 1965), pp. 58–62.

Gablik, Suzi. "Meta-trompe-l'oeil." *Art News* 64 (March 1965), pp. 46–49.

Lynes, Russell. "Steinberg and the Others." *Harper's Magazine* 231 (December 1965), pp. 30–34.

Rosenberg, Harold. "Saul Steinberg's Art World." *Art News* 65 (March 1966), pp. 51–54, 67–68.

Schonberg, Harold C. "Artist Behind the Steinbergian Mask." *The New York Times Magazine*, November 13, 1966, pp. 48–51, 162–69.

Kramer, Hilton. "The Comic Fantasies of Saul Steinberg" (exhibition review). *The New York Times*, December 4, 1966. Reprinted in Kramer, *The Age of the Avant-Garde: An Art Chronicle of 1956–1972.* New York: Farrar Straus and Giroux, 1973, pp. 377–80.

Kozloff, Max. "Art" (exhibition review). *The Nation*, December 19, 1966, p. 683.

Rosenberg, Harold. "Steinberg: A Unique Artist–A Specialist in the Riddles of Identity." *Vogue* (January 1, 1967), pp. 96–99, 137–38, 146.

Krug, Mary M. "Enigmatic Steinberg Discusses Residency." *The Torch* (Smithsonian Institution) 12 (April 1967), p. 3.

Ashbery, John. "Saul Steinberg: The Stamp of Genius." *Art News* 68 (November 1969), pp. 45, 72, 74.

Glueck, Grace. "A Way to Stamp Out Art." *The New York Times*, November 9, 1969, p. D28.

Ashbery, John. "Saul Steinberg: Callibiography." *Art News Annual* 36 (1970), pp. 53–59.

Dupin, Jacques. "Steinberg et la Société anonyme." *XXe Siècle* 35 (June 1973), pp. 138–43.

Hess, Thomas B. "Saul Steinberg vs. The Mickey Mouse Mugger." *New York*, March 5, 1973, pp. 74–75.

Gill, Brendan. "Saul Steinberg's Surprise." *Horizon* 21 (April 1978), pp. 66–73.

Hughes, Robert. "The Fantastic World of Steinberg" (exhibition review). *Time*, April 17, 1978, cover and pp. 92–96. Reprinted in Hughes, *Nothing If Not Critical: Selected Essays on Art and Artists.* New York: Alfred A. Knopf, 1989, pp. 279–84.

Kanfer, Stefan. "Art May Be Long, Says Saul Steinberg, But It Should Be Worth Laughing At Too" (exhibition review). *People*, May 29, 1978, pp. 78–81.

Masheck, Joseph. "Saul Steinberg's Written Pictures" (exhibition review). *Artforum* 16 (Summer 1978), pp. 26–30.

Hollander, John. "Sphinx" (exhibition review). *The New York Review of Books*, June 15, 1978.

Lynes, Russell. "Steinberg's 'Stuff.'" *Architectural Digest* 39 (December 1982), pp. 42, 48.

MacDonald, Stephen. "New Yorker Cover Depicting Gotham Begets a Multitude–Saul Steinberg's 1976 Painting Is Purloined and Parodied to the Dismay of the Artist." *The Wall Street Journal*, December 20, 1984.

Leiser, Erwin. "Saul Steinberg." *Frankfurter Allgemeine Magazin*, May 30, 1986, pp. 14–22.

Treib, Marc. "Maps of the Mind." *Print* 41 (March–April 1987), pp. 112–17.

Power, William. "It's a Unique View of Rest of World From Manhattan–New Yorker Magazine Cover Protected by Copyright, Judge Says in Poster Case." *The Wall Street Journal*, June 25, 1987.

Berger, Mitch. "Saul Steinberg's Secret WWII Cartoons." *Bull's Eye: The Magazine of Editorial Cartooning* 1 (June 1988), pp. 19–21.

Kunstschrift 34 (July–August 1990). Issue devoted to Steinberg, titled "De ferme kras en het verlegen lijntje." Articles by Mariette Haveman, Melchior de Wolff, Jan Blokker, Evert van Uitert, and Rudy Kousbroek.

Simic, Charles. "Don Quixote Charging a Pineapple." In Simic, *Orphan Factory: Essays and Memoirs.* Ann Arbor: University of Michigan Press, 1997, pp. 78–83.

Boxer, Sarah. "Saul Steinberg, Epic Doodler, Dies at 84." *The New York Times*, May 13, 1999, pp. A1, B10.

Gopnik, Adam. Obituary. *The New Yorker*, May 24, 1999, p. 55.

Blake, Peter. "Cartoon Critic: Saul Steinberg's Drawings Were Often Witty Criticisms of Contemporary Architecture." *Architecture* 88 (September 1999), cover and pp. 106–09.

Bellow, Saul. "Saul Steinberg." *The Republic of Letters*, no. 7 (November 1999), pp. 28–31. Text of eulogy delivered at memorial service for Steinberg.

Manea, Norman. "Made in Romania." *The New York Review of Books*, February 10, 2000, pp. 44–46.

Kramer, Jane. "Mission to China." *The New Yorker*, July 10, 2000, pp. 59–65.

Gopnik, Adam. "What Steinberg Saw." *The New Yorker*, November 13, 2000, pp. 141–47.

Danson, Lawrence. "An Heroic Decision." *Ontario Review* 53 (Winter 2000–01), pp. 57–68.

Frazier, Ian. "Eulogy for Saul Steinberg." *McSweeney's*, no. 6 (2001), pp. 28–33. Text of eulogy delivered at memorial service for Steinberg.

Belpoliti, Marco, and Gianluigi Ricuperati, eds. *Riga*, no. 24 (2005). Issue devoted to Steinberg. 39 texts, among them 9 previously unpublished.

INTERVIEWS

Adelman, Skippy. "Saul Steinberg's Secret Underwear." *PM*, March 10, 1946, Magazine section, p. 5.

R.C. "Cinq minutes avec Steinberg qui, pour completer sa collection, a acheté à Paris un chapeau de gendarme." *Carrefour* (April 29, 1953).

Author unknown. "Labirinto Steinberg [*sic*]." *Linea Grafica* (Milan) (September–October 1954), pp. 262–63.

Ashton, Dore. "A Victorian Dialogue with Saul Steinberg." Unsigned typescript, c. 1954. YCAL, box 8.

Rodman, Selden. "Saul Steinberg." In Rodman, *Conversations with Artists*. New York: Devin-Adair Co., 1957, pp. 181–85.

Jones, John. Transcript of recorded interview, October 12, 1965. Archives of American Art, Smithsonian Institution, Washington, D.C.

Vanden Heuvel, Jean (Jean Stein). "Straight from the Hand and Mouth of Steinberg." *Life*, December 10, 1965, pp. 59–70 (drawings from *The New World* with artist's commentary).

Parinaud, André. "J'enseigne aux hommes à nager en les poussant dans l'eau." *Art et Loisirs*, March 16–22, 1966. Reprinted in German in *Saul Steinberg: Collagen und Zeichnungen*. Exhibition catalogue. Hamburg: Hamburger Kunsthalle, 1968, pp. 13–15.

Mark, Norman. Interview published as sidebar to Franz Schulze, "Steinberg's Endless Innovations." *Chicago Daily News*, February 18, 1967, Arts page.

Karrer-Kharberg, Rolf. Transcript of two interviews, spring 1967. YCAL, box 100, folder "Correspondence 1968–69."

Schneider, Pierre. "Steinberg at the Louvre." *Art in America* 55 (July–August 1967), pp. 82–91. Reprinted in Schneider, *Louvre Dialogues*. New York: Atheneum, 1971, pp. 81–98.

Brioschi, Luigi. "Gli italiani pensano troppo alla pensione: Conversazione con Saul Steinberg." *La Fiera Letteraria* (Rome), no. 34, August 22, 1968, pp. 2–3.

Glueck, Grace. Cassette recording (mislabeled "Esther Rolick interview") and hand-edited transcript of recorded interview, 1970. Archives of American Art, Smithsonian Institution, Washington, D.C.

——. "The Artist Speaks: Saul Steinberg." *Art in America* 58 (November–December 1970), pp. 110–17.

Agarwal (Thompson), Meera E. "Steinberg's Treatment of the Theme of the Artist: A Collage of Conversations." Unpublished paper, Vassar College, December 1972. YCAL, box 78, folder "Meera Agarwal on ST."

Cummings, Paul. Transcript of recorded interview, March 27, 1973. Archives of American Art, Smithsonian Institution, Washington, D.C.

Schneider, Pierre. "Les vertiges de Steinberg." *L'Express*, October 22–28, 1973, pp. 54–55.

Dupin, Jacques. Transcript of a recorded interview conducted in French, January 11, 1978. Copy of translation, SSF.

Gruen, John. Transcript of recorded interview, January 19, 1978, with Steinberg's hand emendations. YCAL, box 67.

——. "Saul Steinberg" (1978). In Gruen, *The Artist Observed: 28 Interviews with Contemporary Artists*. Chicago: A Cappella Books, 1991.

Gopnik, Adam. Multiple typed drafts and galley proofs of collaboratively scripted "talks" with Steinberg, 1986–93, with Steinberg's hand emendations. YCAL, boxes [48] and 67.

——. "Le Nain de la Maternelle." *Egoïste* 1, no. 12 (1992), pp. 100–05.

O'Brien, Elaine. Recorded interview with Steinberg on Harold Rosenberg, March 1993. Recording at YCAL, transcript at SSF.

Works in the Exhibition

Untitled (Autopsy), c. 1936–38
Ink on paper, 13 x 9⅝ in. (33.1 x 24.5 cm)
Angelini Collection
Cat. 1

Untitled (Zia Elena), 1937
Ink on paper, 13³⁄₁₆ x 9⅝ in. (33.5 x 24.5 cm)
Angelini Collection
Cat. 2

Untitled (Seated Group), c. 1941
Gouache on cardboard, 12 x 12 in. (30.5 x 30.5 cm)
Collection of Lawrence Danson
Cat. 3

Strada Palas, 1942
Ink, pencil, and watercolor on paper, 14⅞ x 21¾ in.
(37.8 x 55.2 cm)
The Saul Steinberg Foundation, New York, SSF 1894
Cat. 4

Cassino, 1945
Ink over pencil on paper, 14½ x 23⅛ in. (36.8 x 58.7 cm)
The Saul Steinberg Foundation, New York, SSF 1224
Cat. 5

Head, 1945
Ink over pencil on paper, 14½ x 23¾ in. (36.8 x 60.3 cm)
The Saul Steinberg Foundation, New York, SSF 1892
Cat. 6

Monuments: The Important People, 1945
Ink over pencil on paper, 14 x 23 in. (35.6 x 58.4 cm)
The Saul Steinberg Foundation, New York, SSF 1905
Cat. 7

Feet on Chair, 1946
Ink over pencil on paper, 9⅞ x 9¼ in. (25.1 x 23.5 cm)
Collection of Anton van Dalen
Cat. 11

Underground, 1946
Ink on paper, 23 x 14 in. (58.4 x 35.6 cm)
Collection of Richard and Ronay Menschel
Cat. 8

Ruth N., East Jamaica, Vermont, August 1947, 1947
Ink on paper, 11 x 14 in. (27.9 x 35.6 cm)
The Saul Steinberg Foundation, New York, SSF 3890
Cat. 9

B Movie, 1948
Ink, colored pencil, crayon, watercolor, pencil, rubber
stamps, and collage on paper, 14½ x 23⅛ in. (36.8 x 58.7 cm)
The Saul Steinberg Foundation, New York, SSF 1887
Cat. 10

Woman in Tub, 1949
Gelatin silver print, 12¾ x 11¼ in. (32.4 x 28.6 cm)
The Saul Steinberg Foundation, New York, SSF 6404
Cat. 13

Santa Claus as Christmas tree, 1949 or later
Offset printing, black-and-white lineshot, 7 x 5 in.
(17.8 x 12.7 cm)
Published by The Museum of Modern Art
Collection of Tom Bloom
Cat. 23A

Untitled (Art Viewers), c. 1949
Ink on paper, 18½ x 14⅛ in. (47 x 35.9 cm)
Collection of Carol and Douglas Cohen
Cat. 12

Three Liberties, 1949–51
Ink and watercolor on paper, 14 x 23 in. (35.6 x 58.4 cm)
The Saul Steinberg Foundation, New York, SSF 6470
Cat. 16

Parade 2, 1950
Ink, watercolor, and pencil on paper, 14 x 23 in.
(35.6 x 58.4 cm)
The Saul Steinberg Foundation, New York, SSF 166
Cat. 17

Women, 1950
Ink on paper, 14⅜ x 23 in. (36.5 x 58.4 cm)
The Saul Steinberg Foundation, New York, SSF 4540
Cat. 15

Cowboys, 1951
Ink on paper, 14 x 22 in. (35.6 x 55.9 cm)
The Saul Steinberg Foundation, New York, SSF 1927
Cat. 18

Ex-Voto: Execution of King, 1951
Ink, crayon, pencil, and colored pencil on paper,
14⅜ x 19¼ in. (36.5 x 48.9 cm)
The Saul Steinberg Foundation, New York, SSF 1384
Cat. 19

Large Document, 1951
Ink, rubber stamp, and collage on paper, 29 x 23 in.
(73.7 x 58.4 cm)
Private collection, New York
Cat. 21

Passport, 1951
Ink, thumbprints, rubber stamp, and collage on folded and
stained paper, 14¾ x 11⅝ in. (37.5 x 29.5 cm)
Collection of Richard and Ronay Menschel
Cat. 20

Piazza San Marco, Venice, 1951
Ink and colored inks on paper, 23 x 29 in. (58.4 x 73.7 cm)
Collection of Hedda Sterne
Cat. 22

Excavation, 1951–52
Ink on gelatin silver print, 13⅞ x 10⅞ in. (35.2 x 27.6 cm)
The Saul Steinberg Foundation, New York, SSF 6403
Cat. 14

Santa Claus and birds in tree, 1952 or later
Offset printing, color halftone, 5½ x 4½ in. (14 x 11.4 cm)
Published by Hallmark Cards, Inc.
Collection of Tom Bloom
Cat. 23B

Untitled (Florida Types), 1952
Ink and collage on paper, 30 x 24 in. (76.2 x 61 cm)
The Saul Steinberg Foundation, New York, SSF 1960
Cat. 28

Cornices, c. 1952
Ink on paper, 14½ x 19⅜ in. (36.8 x 49.2 cm)
The Saul Steinberg Foundation, New York, SSF 1997
Cat. 24

Untitled (Ironwork Pier), c. 1952
Ink on paper, 23 x 29 in. (58.4 x 73.7 cm)
The Saul Steinberg Foundation, New York, SSF 170
Cat. 29

Group Photo, 1953
Ink, thumbprints, and rubber stamp on paper, 14 x 11 in.
(35.6 x 27.9 cm)
Collection of Richard and Ronay Menschel
Cat. 27

Techniques at a Party, 1953
Ink, colored pencil, and watercolor on paper, 14½ x 23 in.
(36.8 x 58.4 cm)
The Saul Steinberg Foundation, New York, SSF 1990
Cat. 26

Vichy Water Still Life, c. 1953
Ink, pencil, watercolor, Duco lacquer, wash, veneer, and
collage on paper, 14½ x 23 in. (36.8 x 58.4 cm)
The Saul Steinberg Foundation, New York, SSF 7026
Cat. 25

Diary, 1954
Ink and watercolor on paper, 14¼ x 23 in. (37.5 x 58.4 cm)
Collection of Richard and Ronay Menschel
Cat. 30

The Line, 1954
Ink on paper folded into twenty-nine sections, 18 x 404 in.
(45.7 x 1026.2 cm)
The Saul Steinberg Foundation, New York, SSF 3749
Cat. 31

Stadium at Night (Ebbets Field), 1954
Ink, watercolor, and colored pencil on paper, 22⅞ x 29 in.
(58.1 x 73.7 cm)
The Saul Steinberg Foundation, New York, SSF 2089
Cat. 33

Untitled (Couple), 1955
Ink, colored pencil, and packing tape on paper, 17¾ x 13 in.
(45.1 x 33 cm)
Private collection
Cat. 34

Road, Samarkand, USSR, 1956
Ballpoint pen on paper, 19 x 24 in. (48.3 x 61 cm)
The Saul Steinberg Foundation, New York, SSF 267
Cat. 35

Elevated, 1957
Ink, crayon, and watercolor on paper, 14¾ x 23¾ in.
(37.5 x 60.3 cm)
The Saul Steinberg Foundation, New York, SSF 4552
Cat. 32

Curtain design for Rossini, *The Count Ory*, 1958
Ink, watercolor, and colored pencil on paper, 14½ x 23 in.
(36.8 x 58.4 cm)
The Saul Steinberg Foundation, New York, SSF 2061
Cat. 38

Small Town with Small Town Skyscraper, 1958
Ink on paper, 30 x 22 in. (76.2 x 55.9 cm)
The Saul Steinberg Foundation, New York, SSF 4470
Cat. 37

Untitled (Racetrack Crowd), c. 1958
Ink and colored pencil on paper, 14½ x 23 in.
(36.8 x 58.4 cm)
The Saul Steinberg Foundation, New York, SSF 310
Cat. 36

Motels and Highway, 1959
Ink and ballpoint pen on paper, 22 x 30 in. (55.9 x 76.2 cm)
The Saul Steinberg Foundation, New York, SSF 1127
Cat. 39

Six Masks, 1959–65
Pencil, crayon, ink, rubber stamps, and colored pencil on cut
brown paper bags, approx. 14½ x 7¾ in. (36.8 x 19.7 cm)
each
The Saul Steinberg Foundation, New York, SSF 2024, 2029,
4039, 4056, 6503, 6510
Cat. 40

Abstinentia, Pietas, Sapientia, Dignitas, 1961
Ink on paper, 23 x 14 in. (58.4 x 35.6 cm)
The Saul Steinberg Foundation, New York, SSF 5365
Cat. 43

Erotica I, 1961
Ink and colored pencil on paper, 14½ x 23 in.
(36.8 x 58.4 cm)
The Saul Steinberg Foundation, New York, SSF 1216
Cat. 42

Summer Mask, c. 1961 (face), 1966 (body)
Crayon, colored pencil, pencil, and collage on cut paper,
32 x 22 in. (81.3 x 55.9 cm)
The Saul Steinberg Foundation, New York, SSF 11
Cat. 41

Untitled (Cat Garden), 1962
Ink, colored pencil, watercolor, and collage on paper,
17 x 15¼ in. (43.2 x 38.7 cm)
Collection of Carol and Douglas Cohen
Cat. 46

Allegory, 1963
Ink and watercolor on paper, 22¼ x 28¾ in. (56.5 x 73 cm)
Collection of Carol and B.J. Cutler
Cat. 44

Untitled (Paris/Sardinia), 1963
Ink, red ballpoint pen, crayon, watercolor, colored pencil,
and pencil on paper, 23⅛ x 14⅜ in. (58.7 x 36.5 cm)
The Saul Steinberg Foundation, New York, SSF 7163
Cat. 45

Untitled (Initials), 1964
Ink, colored inks, and colored pencil on paper,
19¾ x 14½ in. (50.2 x 36.8 cm)
The Saul Steinberg Foundation, New York, SSF 916
Cat. 47

Biography, 1965
Watercolor, ink, and pencil on paper, 22 x 15 in.
(55.9 x 38.1 cm)
The Saul Steinberg Foundation, New York, SSF 2016
Cat. 49

November 26, 1965, 1965
Ink and colored pencil on paper, 14½ x 23 in.
(36.8 x 58.4 cm)
The Saul Steinberg Foundation, New York, SSF 2241
Cat. 48

Two screen designs for Stravinsky, *The Soldier's Tale*, 1967
Ink, colored pencil, marker pen, crayon, rubber stamp,
pencil, and watercolor on paper, 14½ x 23 in. (36.8 x
58.4 cm) each
The Saul Steinberg Foundation, New York, SSF 2070, 2073
Cat. 50

Indians, Cyclists, Artists, 1968
Rubber stamps and ink on paper, 23¼ x 29 in.
(60.3 x 73.7 cm)
The Saul Steinberg Foundation, New York, SSF 6358
Cat. 52

Spiral, 1968
Pencil and colored pencil on paper, 19⅝ x 25½ in.
(49.8 x 64.8 cm)
The Saul Steinberg Foundation, New York, SSF 1373
Cat. 51

Artists and War, 1969
Rubber stamps, pencil, and colored pencil on paper,
23 x 29 in. (58.4 x 73.7 cm)
The Saul Steinberg Foundation, New York, SSF 1105
Cat. 53

Louse Point, 1969
Oil and rubber stamps on prepared board, 18 x 24 in.
(45.7 x 61 cm)
The Saul Steinberg Foundation, New York, SSF 6141
Cat. 61

Nine Postcards, 1969
Rubber stamps and postcards mounted on board,
20 x 24⅝ in. (50.8 x 62.5 cm)
The Saul Steinberg Foundation, New York, SSF 6461
Cat. 54

Wyoming, 1969
Ink, pencil, and watercolor on paper, 14¼ x 23 in.
(36.8 x 58.4 cm)
The Saul Steinberg Foundation, New York, SSF 704
Cat. 55

Artist, 1970
Pencil, colored pencil, ink, and rubber stamps on paper,
22½ x 28½ in. (57.2 x 72.4 cm)
The Saul Steinberg Foundation, New York, SSF 6341.
Cat. 62

Bleecker Street, 1970
Ink, pencil, colored pencil, and crayon on paper,
29⅜ x 22⅜ in. (74.6 x 56.8 cm)
Collection of Michael Ulick
Cat. 66

Bucharest in 1924, 1970
Ink, pencil, and colored pencil on paper, 23⅛ x 29 in.
(58.7 x 55.9 cm)
Private collection, New York
Cat. 63

Konak, c. 1970
Colored pencil, pencil, rubber stamps, and collage on
paper, 23 x 31½ in. (58.4 x 80 cm)
The Saul Steinberg Foundation, New York, SSF 6427
Cat. 64

Untitled (Pineapple), c. 1970
Pencil, colored pencil, collage, watercolor, ink, and rubber
stamps on lithographically imprinted paper, 23½ x 30 in.
(59.7 x 76.2 cm)
The Saul Steinberg Foundation, New York, SSF 1397
Cat. 65

I Do, I Have, I Am, 1971
Ink, marker pens, ballpoint pen, pencil, crayon,
gouache, watercolor, and collage on paper, 22¾ x 14 in.
(57.8 x 35.6 cm)
The Saul Steinberg Foundation, New York, SSF 912
Cat. 67

Five False Paintings, c. 1971
Mixed media on wood, maximum height 42⅞ in.
(108.9 cm); assembled width 30 in. (76.2 cm)
The Saul Steinberg Foundation, New York
Standing Man, SSF 6179; *Marcel Duchamp*, SSF 5643;
Woman in Doorway, SSF 5635; *Man in Doorway*, SSF
5637; *Mondrianerie*, SSF 5641
Cats. 56–60

Sixteen Landscapes, 1972 and 1979 or later
Oil and pencil on paper, 20 x 29 in. (50.8 x 73.7 cm)
The Saul Steinberg Foundation, New York, SSF 4194
Cat. 68

Street War (Cadavre Exquis), c. 1972–74
Pencil, crayon, colored pencil, and ballpoint pen on two
joined sheets of paper, 21 x 13½ in. (53.3 x 34.3 cm)
The Saul Steinberg Foundation, New York, SSF 737
Cat. 69

Milanese II, 1973
Ink, pencil, colored pencil, and rubber stamps on paper,
18½ x 29¼ in. (47 x 74.3 cm)
The Saul Steinberg Foundation, New York, SSF 5184
Cat. 70

The West Side, 1973
Ink and colored pencil on paper, 19 x 25 in.
(48.3 x 63.5 cm)
The Saul Steinberg Foundation, New York, SSF 6506
Cat. 75

The Politecnico Table, 1974
Mixed media assemblage on wood, 28¼ x 23¼ in.
(71.8 x 59.1 cm)
Collection of Richard and Ronay Menschel
Cat. 71

Breakfast Still Life, c. 1974
Pencil and colored pencil on paper, 23⅛ x 14⅞ in.
(58.7 x 37.8 cm)
The Saul Steinberg Foundation, New York, SSF 4777
Cat. 72

Untitled (Energy, Part 3), 1975
Ink over pencil on paper, 14½ x 23 in. (36.8 x 58.4 cm)
The Saul Steinberg Foundation, New York, SSF 699
Cat. 74

View of the World from 9th Avenue, 1975
Ink, wax crayon and graphite on paper, 20 x 15 in.
(50.8 x 38.1 cm)
Collection of Sivia Loria
Cat. 76A, variant of cat. 76.

View of the World from 9th Avenue, 1976
Ink, pencil, colored pencil, and watercolor on paper,
28 x 19 in. (71.1 x 48.3 cm)
Private collection, New York
Cat. 76

Papantla (Veracruz), Mexico, 1977
Colored pencil and pencil on paper, 14¼ x 20½ in.
(36.2 x 52.1 cm)
The Saul Steinberg Foundation, New York, SSF 6266
Cat. 77

Manassas, Virginia, 1978
Pencil, colored pencil, and marker pens on paper,
22¾ x 28¾ in. (57.8 x 73 cm)
Collection of Carol and Douglas Cohen
Cat. 78

Dal Vero (Sigrid and Papoose), September 10, 1979, 1979
Pencil and colored pencil on paper, 14 x 17 in.
(35.6 x 43.2 cm)
The Saul Steinberg Foundation, New York, SSF 4202
Cat. 73

The American Corrida, c. 1981
Colored pencil and pencil on two sheets of paper,
21 x 16⅞ in. (53.3 x 42.9 cm)
The Saul Steinberg Foundation, New York, SSF 4184
Cat. 79

Ocean, 1983
Ink, marker pens, colored pencil, ballpoint pen, and crayon
on paper, 19⅝ x 25¾ in. (49.8 x 65.4 cm)
The Saul Steinberg Foundation, New York, SSF 4193
Cat. 81

Ten Women, 1983 and 1996
Color proof, etching on paper, 20⅞ x 29⅝ in. (53 x 75.2 cm)
The Saul Steinberg Foundation, New York, SSF 2691
Cat. 93

Giacometti's Face, c. 1983
Colored pencil and pencil on paper, 11 x 14 in.
(27.9 x 35.6 cm)
The Saul Steinberg Foundation, New York, SSF 3535
Cat. 82

November (Long Shadows), 1985
Pencil and crayon on paper, 19½ x 25⅝ in. (49.5 x 65.1 cm)
The Saul Steinberg Foundation, New York, SSF 2245
Cat. 80

Broadway, 1986
Ink, pencil, and collage on paper, 14½ x 23 in.
(36.8 x 58.4 cm)
The Saul Steinberg Foundation, New York, SSF 6466
Cat. 83

Library, 1986–87
Pencil and mixed media on wood assemblage,
68½ x 31 x 23 in. (174 x 78.7 x 58.4 cm)
Collection of Carol and Douglas Cohen
Cat. 84

Untitled (Headlights), 1988
Pencil, watercolor, and colored pencil on paper, 18½ x 24 in.
(47 x 61 cm)
The Saul Steinberg Foundation, New York, SSF 2239
Cat. 85

Untitled (Streetscape), late 1980s
Black pencil and pencil on paper, 23 x 29 in.
(58.4 x 73.7 cm)
The Saul Steinberg Foundation, New York, SSF 4832
Cat. 86

Untitled (Floral Still Life), 1989
Pencil, crayon, and colored pencil on paper, 19⅝ x 26⅞ in.
(49.8 x 68.3 cm)
The Saul Steinberg Foundation, New York, SSF 4169
Cat. 87

Untitled (The Blue Dog), c. 1990
Oil pastel and pencil on paper, 17¾ x 23⅞ in.
(45.1 x 60.6 cm)
The Saul Steinberg Foundation, New York, SSF 2302
Cat. 89

Untitled (Canal Street), c. 1990
Marker pen on paper, 18 x 23¾ in. (45.7 x 60.3 cm)
The Saul Steinberg Foundation, New York, SSF 2111
Cat. 88

The Flat Earth, 1991
Pencil, crayon, and colored pencil on paper, 27 x 35 in.
(68.6 x 88.9 cm)
The Saul Steinberg Foundation, New York, SSF 400
Cat. 90

The Signature, 1991
Marker pen, carved and stained wood glued to paper,
20¾ x 29½ in. (52.7 x 74.9 cm)
The Saul Steinberg Foundation, New York, SSF 6439
Cat. 94

Delacroix (after Nadar), 1994
Pencil and colored pencil on paper, 14¾ x 13⅛ in.
(37.5 x 33.3 cm)
The Saul Steinberg Foundation, New York, SSF 6435
Cat. 91

2000, 1996
Pencil, ink, watercolor, crayon, and collage on paper,
21½ x 14⅛ in. (54.6 x 35.9 cm)
The Saul Steinberg Foundation, New York, SSF 924
Cat. 92

CASE OBJECTS

Views of Paris, 1949
Silk fabric printed by Patterson Silks, 38 x 65 in.
(96.5 x 165.1 cm)
The Saul Steinberg Foundation, New York, SSF 9021
Cat. 112 (illustrated on p. 45)

Talk balloon with artist and dog, c. 1965
Ink, oil, and rubber stamp on cut primed canvas,
3½ x 21¼ in. (8.9 x 54 cm)
The Saul Steinberg Foundation, New York, SSF 5045
Cat. 107 (illustrated on p. 23)

Tango Bergamasco, c. 1965
Oil, ink, crayon, incising, and collaged foil and paper on cut
sheet metal, 15¼ x 15¾ in. (38.7 x 40 cm)
The Saul Steinberg Foundation, New York, SSF 4770
Cat. 96 (illustrated on p. 69)

1971 Datebook, 1971
Pencil, paint, and pastel on wood, 4⅛ x 2⅝ x ¼ in.
(10.5 x 6.7 x .6 cm)
The Saul Steinberg Foundation, New York, SSF 6189
Cat. 108 (illustrated on p. 196)

Camera, 1974
Paint, ink, foil, can lid, bottle cap, metal strips, hinges,
pushpin, and string on wooden block, 5⅛ x 3½ x 1⅛ in.
(13 x 8.9 x 2.9 cm)
Dedicated in ink on underside: FOR SIGRID SAUL ST. 74
The Saul Steinberg Foundation, New York, SSF 5996
Cat. 109 (illustrated on p. 196)

Hammer and pocket watch boxed set, c. 1974
Marker pen, crayon, pastel, paint, brass hinges, hook-and-
eye fasteners on wood, hammer, and pocket watch, 6¼ x
12½ x 2½ in. (15.9 x 31.7 x 6.4 cm)
The Saul Steinberg Foundation, New York, SSF 5706
Cat. 97 (illustrated on p. 69)

Machine gun, c. 1974
Crayon, pencil, and rubber stamp on carved wood,
7½ x 28¼ in. (19.1 x 71.8 cm)
The Saul Steinberg Foundation, New York, SSF 5625
Cat. 95 (illustrated on p. 192)

Montauk Highway map, c. 1975
Pencil, marker pen, and gouache on bored and cracked
wood, 8⅝ x 5¼ x 1½ in. (21.9 x 13.3 x 3.8 cm)
The Saul Steinberg Foundation, New York, SSF 5651
Cat. 101 (illustrated on p. 40)

Liberty as Struwwelpeter, c. 1980
Marker pen, crayon, pastel, pencil, and gouache on tongue-
and-groove board, 9¾ x 7 x ⅝ in. (24.7 x 17.8 x 1.6 cm)
The Saul Steinberg Foundation, New York, SSF 5654
Cat. 102 (illustrated on p. 219)

1881 year box, c. 1981
Paint, pastel, marker pen, crayon, varnish, and brass hinges
on incised wood, 3½ x 6 x 2 in. (8.9 x 15.2 x 5.1 cm)
The Saul Steinberg Foundation, New York, SSF 6044
Cat. 111

Three false envelopes, posted August–September 1982
Pencil, colored pencil, paint, rubber stamps, varnish, incis-
ing, crayon, ballpoint pen, postal stamps, and American and
Italian postmarks on gessoed wood, 4 x 7½ x 1/16 in.
(10.2 x 19.1 x .2 cm) each
The Saul Steinberg Foundation, New York,
SSF 4650, 4651, 4652
Cats. 98–100 (illustrated on p. 69)

Dog tag, c. 1988
String tied to incised and punched metal, 1¼ x 2¼ in.
(3.8 x 5.7 cm)
The Saul Steinberg Foundation, New York, SSF 5674
Cat. 110 (illustrated on p. 196)

Isaiah Berlin, c. 1988
Crayon, pencil, and pastel on wood, 6¾ x 4⅞ x 1⅛ in. (17.1
x 12.4 x 2.9 cm)
The Saul Steinberg Foundation, New York, SSF 6050
Cat. 104 (illustrated on p. 219)

Open book (Death as Liberty and portrait), c. 1990
Pencil, paint, oil, marker pen, and ink on canvas mounted
on carved gessoed wood, 4¾ x 14¾ x ⅞ in. (12.1 x 37.5 x
2.2 cm)
The Saul Steinberg Foundation, New York, SSF 5910
Cat. 103 (illustrated on p. 15)

**Open book (Le ravisseur de la Jaconde and figures in a
landscape)**, c. 1990
Paint, photocopy, marker pen, crayon, pencil, paper,
watercolor, rubber stamp, and ink wash on carved wood,
12⅞ x 5½ x ½ in. (32.7 x 14 x 1.3 cm)
The Saul Steinberg Foundation, New York, SSF 6055
Cat. 106 (illustrated on p. 219)

Ovid, *Tristia*, c. 1997
Pencil, crayon, and pastel on wood, 9¾ x 6¾ x ⅝ in.
(24.8 x 17.1 x 1.6 cm)
The Saul Steinberg Foundation, New York, SSF 6054
Cat. 105 (illustrated on p. 14)

PRINTED MATTER

A selection of books and periodicals featuring Steinberg's
work as cover art, illustration, pictorial feature, cartoon,
and advertising, 1940s–60s.

Photograph and Reproduction Credits

Index

Page references in *italic* refer to illustrations. Unless otherwise indicated, italicized titles are works by Steinberg. Untitled works are indexed under their descriptive titles.

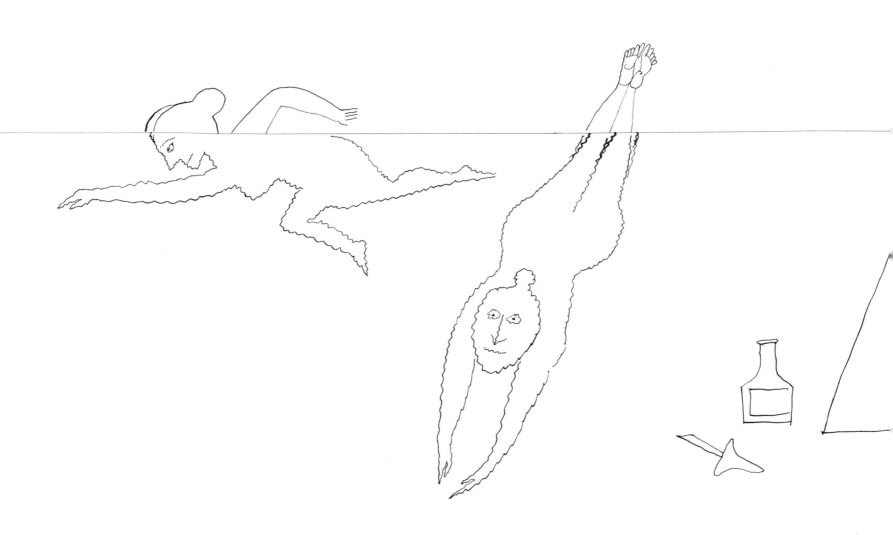

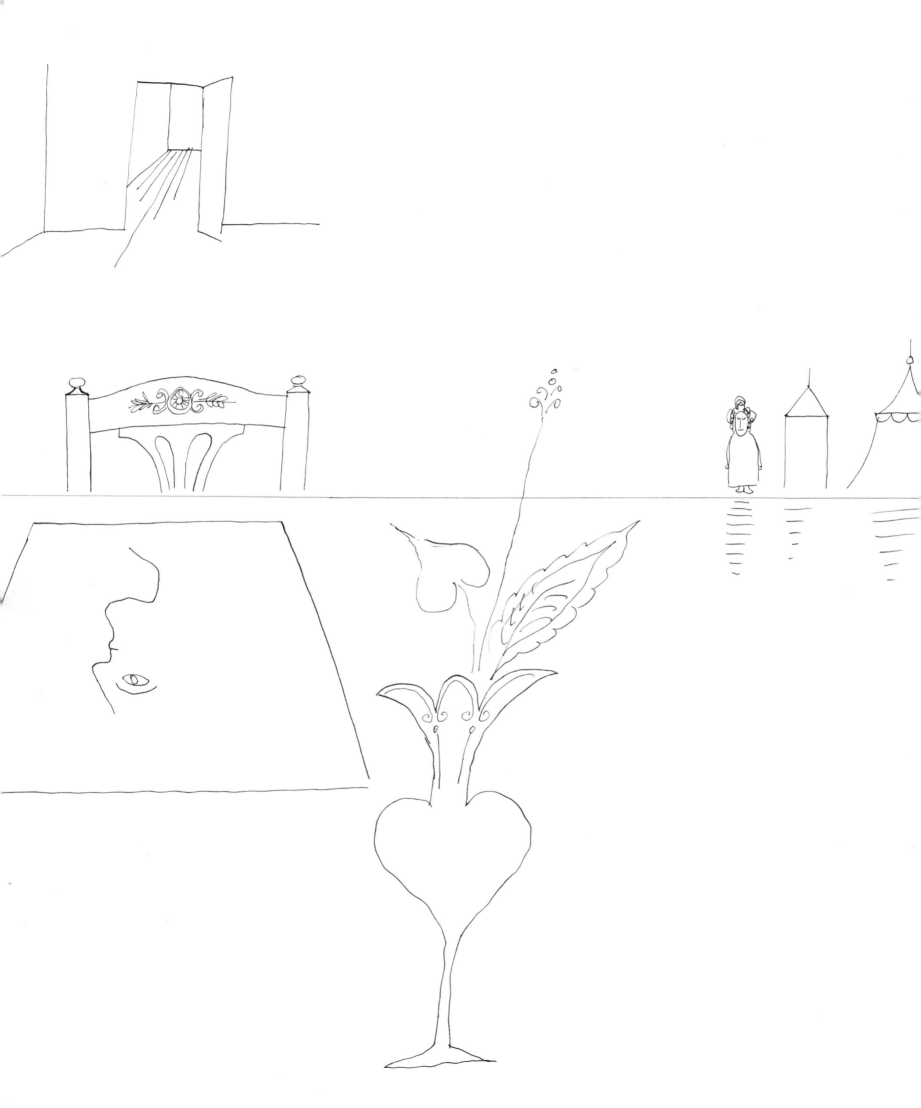